MINIDOKA

MINIDOKA

AN AMERICAN CONCENTRATION CAMP

TERESA TAMURA

To Kathy & Brian,
A story to remember...
Teresa Tamura

CAXTON PRESS
2013

Library of Congress Cataloging-in-Publication Data

Tamura, Teresa, 1960-
 Minidoka : an American concentration camp / Teresa Tamura.
 Pages. cm

ISBN 978-0-87004-573-8 (hardback)
 1. Minidoka Relocation Center–History. 2. Minidoka Relocation Center–Pictorial works. 3. Japanese Americans–Evacuation and relocation, 1942-1945. 4. Japanese Americans–Interviews. 5. World War, 1939-1945–Concentration camps–Idaho. 6. Concentration camps–Idaho–History. 7. World War, 1939-1945–Japanese Americans. I. Title.

 D769.8.A6T373 2013
 940.53'1779633–dc23

 2013026482

Book design by Jocelyn Robertson

Printed in the United States of America
CAXTON PRESS

In honor of the *Issei* and *Nisei* who showed us *shiren*, Japanese for trial, test, challenge, hardship — the school of adversity. By enduring, one becomes stronger, better.

試練

CONTENTS

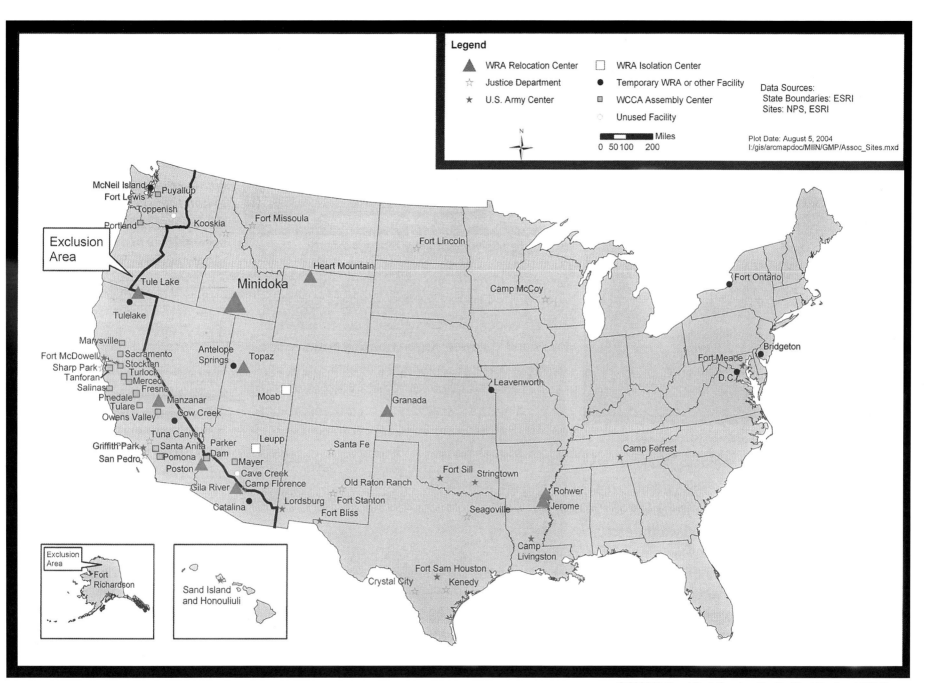

Legend

▲ WRA Relocation Center ☐ WRA Isolation Center

☆ Justice Department ● Temporary WRA or other Facility

★ U.S. Army Center ▪ WCCA Assembly Center

 ○ Unused Facility

N

Data Sources:
State Boundaries: ESRI
Sites: NPS, ESRI

Miles
0 50 100 200

Plot Date: August 5, 2004
I:/gis/arcmapdoc/MIIN/GMP/Assoc_Sites.mxd

McNeil Island
Fort Lewis
Puyallup
Toppenish
Portland
Kooskia
Fort Missoula
Fort Lincoln
Fort Ontario

Exclusion Area

Tule Lake
Minidoka
Heart Mountain
Camp McCoy

Tulelake

Marysville
Fort McDowell
Sacramento
Sharp Park
Stockton
Tanforan
Turlock
Salinas
Merced
Fresno
Pinedale
Tulare
Owens Valley
Tuna Canyon
Griffith Park
Santa Anita
San Pedro
Pomona
Poston

Antelope Springs
Topaz
Moab

Manzanar
Cow Creek

Parker Dam
Leupp

Mayer
Cave Creek
Gila River
Camp Florence
Catalina
Lordsburg

Santa Fe

Old Raton Ranch
Fort Stanton
Fort Bliss

Granada

Leavenworth

Fort Sill
Stringtown

Seagoville

Crystal City
Fort Sam Houston
Kenedy

Camp Livingston

Rohwer
Jerome

Camp Forrest

Bridgeton
Fort Meade
D.C.

Exclusion Area
Fort Richardson

Sand Island and Honouliuli

PREFACE

It was January 2001, the conclusion of Bill Clinton's two-term presidency. A news story in the *Seattle Times* caught my eye. The simple headline read: "In memory of Minidoka." On Jan. 17, 2001, Clinton designated 72.75 acres of the original Minidoka War Relocation Center as the 385th National Park Service unit. I was living in Hailey, Idaho, at the time and was between jobs as photo editor for an online environmental news service and photography instructor at a private school in nearby Sun Valley. I knew about the mass incarceration of Japanese and Japanese Americans at Minidoka but had never visited the site. Jim Simon, assistant metro editor at the *Times*, wrote: "Little remains of the Minidoka site, northeast of Twin Falls, except memories and a historical marker…Executive Order 9066, signed by President Franklin D. Roosevelt on Feb. 19, 1942, effectively ordered the evacuation of all Japanese Americans on the West Coast . . . In 1988, Congress passed legislation authorizing $20,000 reparation payments to all camp survivors and an apology for the internment . . ."

The story took me by surprise. I thought about growing up in Nampa, Idaho, less than three hours from Minidoka, and asked myself why, in my 40 years, I had never seen the site. Like so many other Japanese and Japanese American elders, my grandparents and parents never discussed the incarceration when I was young. How arbitrary it seemed that my family had been able to remain in their homes while others of the same Japanese heritage from as far away as Alaska were forced to abandon theirs — property, businesses, jobs, pets and friends all left behind — to live behind the barbed wire of a concentration camp. I searched for books specifically about Minidoka, the second of ten relocation centers to earn NPS status. I found none. What was left of the site? What happened to the people who lived there? Could photographs help prevent something like this from happening again?

When I was an undergraduate at Idaho State University in Pocatello, I enrolled in a mass communications course taught by journalism professor Conrad Smith. I learned about yellow journalism, the late nineteenth century newspaper circulation war between William Randolph Hearst and Joseph Pulitzer, and "yellow peril," the threat and fear of "Oriental hoards" overtaking the West, an idea spread and reinforced by the press. Outside class, Smith told me about a camp in Idaho where thousands of Japanese and Japanese Americans, also known as *Nikkei*, were imprisoned during World War II. He urged me to look into the camp, a place I passed every time I drove back and forth between school and my parents' home in Nampa. But this was in the late '70s and early '80s when *Nikkei,* including my parents, said nothing about Minidoka. Smith's suggestion only made me feel uncomfortable and self-conscious.

MY PARENTS, Warren Tamura and Chiye Hamada, were *Nisei* (second-generation Japanese Americans) born and raised in Caldwell,

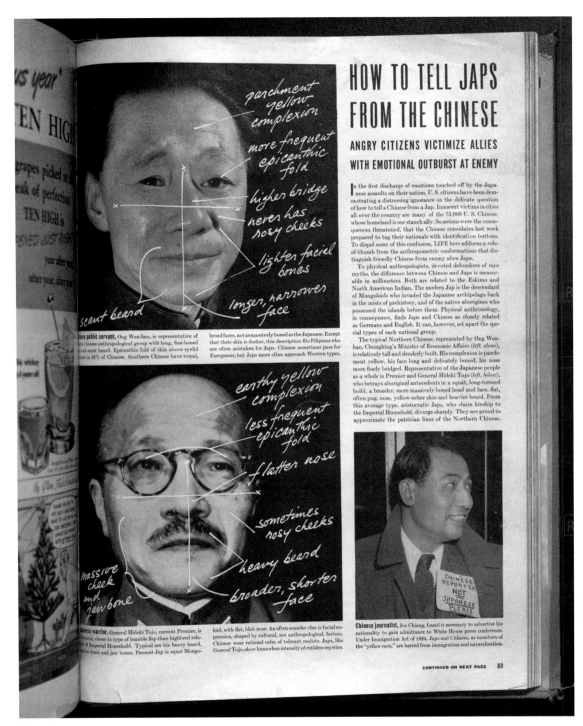

HOW TO TELL JAPS FROM THE CHINESE

ANGRY CITIZENS VICTIMIZE ALLIES WITH EMOTIONAL OUTBURST AT ENEMY

In the first discharge of emotions touched off by the Japanese assaults on their nation, U. S. citizens have been demonstrating a distressing ignorance on the delicate question of how to tell a Chinese from a Jap. Innocent victims in cities all over the country are many of the 75,000 U. S. Chinese, whose homeland is our stanch ally. So serious were the consequences threatened, that the Chinese consulates last week prepared to tag their nationals with identification buttons. To dispel some of this confusion, LIFE here adduces a rule-of-thumb from the anthropometric conformations that distinguish friendly Chinese from enemy alien Japs.

To physical anthropologists, devoted debunkers of race myths, the difference between Chinese and Japs is measurable in millimeters. Both are related to the Eskimo and North American Indian. The modern Jap is the descendant of Mongoloids who invaded the Japanese archipelago back in the mists of prehistory, and of the native aborigines who possessed the islands before them. Physical anthropology, in consequence, finds Japs and Chinese as closely related as Germans and English. It can, however, set apart the special types of each national group.

The typical Northern Chinese, represented by Ong Wen-hao, Chungking's Minister of Economic Affairs (*left, above*), is relatively tall and slenderly built. His complexion is parchment yellow, his face long and delicately boned, his nose more finely bridged. Representative of the Japanese people as a whole is Premier and General Hideki Tojo (*left, below*), who betrays aboriginal antecedents in a squat, long-torsoed build, a broader, more massively boned head and face, flat, often pug, nose, yellow-ocher skin and heavier beard. From this average type, aristocratic Japs, who claim kinship to the Imperial Household, diverge sharply. They are proud to approximate the patrician lines of the Northern Chinese.

parchment yellow complexion

more frequent epicanthic fold

higher bridge

never has rosy cheeks

lighter facial bones

longer, narrower face

scant beard

earthy yellow complexion

less frequent epicanthic fold

flatter nose

sometimes rosy cheeks

heavy beard

massive cheek and jaw bone

broader, shorter face

Chinese public servant, Ong Wen-hao, is representative of... Chinese anthropological group with long, fine-boned... scant beard. Epicanthic fold of skin above eyelid... in 85% of Chinese. Southern Chinese have round, broad faces, not as massively boned as the Japanese. Except that their skin is darker, this description fits Filipinos who are often mistaken for Japs. Chinese sometimes pass for Europeans; but Japs more often approach Western types.

Japanese warrior, General Hideki Tojo, current Premier, is... closer to type of humble Jap than highbred relatives of Imperial Household. Typical are his heavy beard, cheek and jaw bones. Peasant Jap is squat Mongoloid, with flat, blob nose. An often sounder clue is facial expression, shaped by cultural, not anthropological, factors. Chinese wear rational calm of tolerant realists. Japs, like General Tojo, show humorless intensity of ruthless mystics.

Chinese journalist, Joe Chiang, found it necessary to advertise his nationality to gain admittance to White House press conference. Under Immigration Act of 1924, Japs and Chinese, as members of the "yellow race," are barred from immigration and naturalization.

CHINESE REPORTER NOT JAPANESE PLEASE

CONTINUED ON NEXT PAGE 81

LIFE MAGAZINE published this article and photos on Dec. 22, 1941, two weeks after Pearl Harbor was bombed. The story appeared on page 81.

Idaho, next door to Nampa. Both of them graduated from Caldwell High School in 1941. In the 1940 census, Canyon County (Nampa, Middleton, Huston, Parma and Caldwell) reported 149 *Nikkei*, the fourth highest concentration in Idaho. There were 36 *Nikkei* families living within the county before World War II.[1] (Idaho's population at the time was 524,873.[2]) After Minidoka closed and the war ended in 1945, the state's *Nikkei* population more than doubled as the camp population migrated to areas that provided opportunities for work. By 1950, the *Nikkei* population in Idaho had grown to 1,980 (from 1,191); in Canyon County, where my parents lived, the population from 1940 to 1950 increased to 413.[3] (These figures pale in comparison to Washington state's pre-war *Nikkei* population of 14,565, 68 percent of whom resided in King County, home of Seattle's original *Nihonmachi*, or Japantown, community.[4] Sixty-eight percent of all mainland *Nikkei* lived in California and comprised 2.4 percent of the state's population.[5])

For *Nikkei* in Idaho, traditions that existed before World War II ceased after it. My parents remembered celebrating *Tenchosetsu*, the Emperor of Japan's birthday, as children. The Treasure Valley's version seemed more like an excuse for a festive party — lots of traditional Japanese food and games for children — than actual fanfare for the emperor. My parents spoke to their parents in an informal Japanese dialect brought over to the states in the early 1900s that few in Japan today would be able to decipher. When my parents and I visited Japan in 1993, my dad tried again and again to converse in the Japanese he knew. It wasn't until we were on the train headed for the Hamada family home an hour from Hiroshima that someone finally understood him. Before the war, there was a tradition in my mom's family that each daughter spend two years in Japan to better learn the language and cultural traditions of tea ceremony and *ikebana*, the art of flower arrangement. Ame (Hamada) Kobayashi, my mom's sister, lived with her Japanese aunt and uncle in Hiroshima from the spring of 1940 through the winter of 1946. When "Little Boy" exploded on Aug. 6, 1945, Ame happened to be in the Toyko area. On her return to Hiroshima by train, she found her aunt and uncle at the Hamada family home outside the city. Her aunt had been injured by falling debris; her uncle eventually succumbed to "atomic bomb sickness." After Ame returned to America, she met and married Sam Kobayashi, a Military Intelligence Service Language School graduate and U.S. Army veteran who had been incarcerated in Jerome, Arkansas, along with his family. She and Sam then settled in Southern California, where she continues to live since his passing.

[1] U.S. War Department, *Final Report Japanese Evacuation from the West Coast, 1942* (Washington, D.C., 1943), 413.

[2] U.S. Census Bureau, *Race for the United States, Regions, Divisions and States: 1940* (Washington, D.C., U.S. Census Bureau Internet release, 2002), Table A-10, <http://www.census.gov/population/www/documentation/twps0056/tabA-10.pdf>.

[3] Robert C. Sims, "The 'Free Zone' Nikkei," in *Nikkei in the Pacific Northwest*, ed. Louis Fiset and Gail M. Nomura (Seattle: University of Washington Press, 2005), 249.

[4] U.S. War Department, *Final Report Japanese Evacuation from the West Coast, 1942* (Washington, D.C., 1943), 412.

[5] Ibid., 383.

When I was growing up, it seemed as though my parents knew every *Nikkei* in Idaho. The *Nikkei* community in Nampa-Caldwell was comparatively small, so whenever I saw another Japanese person in a public place like Karcher Mall, I always exchanged a nod, a silent acknowledgment that felt like a secret handshake. And I figured my parents probably knew that person.

Our family attended annual picnics organized by the Japanese American Citizens League (JACL), a special time when the entire *Nikkei* community gathered to eat and play games. It was a chance to see familiar faces like Roy and Nori Oyama. It was only when I saw Roy and Nori again at the 2004 Minidoka Pilgrimage that I discovered they had been incarcerated there. Soon after the pilgrimage, they invited me to their home in Caldwell, and I learned more of their story. Roy and Nori had worked for my grandfather when they were first released from the camp. They were part of a large group who had nowhere else to go but the labor camp in Caldwell. Roy, back in Idaho after military duty in Germany from 1944 to 1946, topped onions alongside Nori (Hayashida), his future wife.

I had just turned 10 when the movie *Tora! Tora! Tora!* was released in 1970. Movie critic Roger Ebert described the film as "one of the deadest, dullest blockbusters ever made." My parents took me a Sunday matinee screening in Boise. We were the only *Nikkei* in the audience. As we watched Darryl Zanuck's epic production unfold, culminating in the bombing of Pearl Harbor, I felt very self-conscious of my Japanese-ness and relieved that the theater was nearly empty. When we walked out, I felt ashamed for what the Japanese military had done. I remember trying not to squint as we left the dark theater, aware that my eyes were already "slanted." My parents said nothing.

WHEN EXECUTIVE ORDER 9066 was signed, a jagged line demarcated the "West Coast," slicing through Washington, Oregon, California, Arizona and eventually all of Alaska. This line determined where 120,000 *Nikkei* residents would be shipped, which incarceration site would hold them prisoners. Idaho fell within the Western Defense Command Area, which restricted *Nikkei* but remained outside the military's "exclusion zone." The reason some *Nikkei* were not forced to live behind barbed wire was simple: they lived on the right side of the line, literally.

Of the generations that descended from *Nikkei* on either side of the incarceration line, *Sansei*, or third generation *Nikkei*, like me have only known freedom to pursue our interests. I was fortunate to come of professional age at a time when editors in the newspaper

industry were committed to diversifying newsrooms. My first published picture as a photographer for the *Los Angeles Times* was of Andrew Tuchiya taken in 1989. Tuchiya was 93 at the time, living in a nursing home and waiting to receive the Presidential letter of apology and redress from the U.S. government through the Civil Liberties Act of 1988. I've tried, without success, to find out if he lived long enough to see that day. The article accompanying my photo, "Justice Delayed: Elderly Japanese Internees Wait for Government to Fulfill Reparations Promise" by Jonathan Gaw, can be read online, but Tuchiya's name is not mentioned, and no photographs are included.

Another initiative in the legislation which deemed unconstitutional the events that followed Executive Order 9066 was the creation of the Civil Liberties Public Education Fund (CLPEF). The $3.3 million fund generated 135 grants designed to educate the public about the mass relocation and incarceration of Japanese and Japanese Americans during the war. The grants funded books, paintings, websites, video productions, museum exhibitions and digital photo archives including the work of Toyo Miyatake, a professional photographer incarcerated in California's Manzanar War Relocation Center. No Civil Liberties funds went into this book; I mention the grants because some of the projects that did receive support informed my material.

AS I DOCUMENTED a place and an event that existed only in remnants and memories, my project expanded well beyond its original conception. I discovered and met more and more *Nikkei* incarcerated without due process. My understanding of that time, its impact on the present and my connections to it deepened dramatically as I met and came to know people who lived through the shock. My research provided context and perspective to their stories and the pictures that remain from the period. My primary sources, the people who were imprisoned in Minidoka, range in age from an elder who was 36 at the time of incarceration to those who were born in the camp.

If I, as a Japanese American, had lived through World War II, the one thing I would have wanted to keep is a camera. Cameras were among several items listed as contraband in Public Proclamation No. 3, dated March 24, 1942. All "enemy aliens" and "persons of Japanese ancestry" caught with a camera were "guilty of a misdemeanor and upon conviction shall be liable to a fine of not to exceed $5,000 or to imprisonment for not more than one year, or both, for each offense." (The same fine today would amount to $70,668.) Miyatake, the Los Angeles photographer who smuggled a lens and film into Manzanar, had another point of view: "It is my duty to record the facts as a photographer so that this kind of thing should never happen again," he said.

What I came to understand in the making of *Minidoka: An American Concentration Camp* is that the dislocation, hardships and suffering only made stronger and more resilient the spirit of those who were incarcerated. I also realized that something as simple as proper names — in my family's case, Virginia Lee, Douglas Warren, Connie Jo and Teresa Lynn, which sound like members of a country-western band — was a conscious effort to assimilate into mainstream Anglo culture and demonstrate that we were Americans. So often, the "gain" of one culture is the loss of another.

THESE AMBIGUOUS, SIDE-BY-SIDE HISTORICAL MARKERS were erected along State Route 25 during Idaho's centennial in 1990. (What once read together as "Prehistoric Man"/ "Hunt" became "Prehistoric Hunters" / "Hunt.") Anyone looking for the Minidoka National Historic Site would not see it from this location. Nor for new visitors does the "Hunt" sign make the connection between Hunt (what locals called the internment camp) and the Minidoka site.

To facilitate mail delivery to the camp, "Hunt" was assigned as its official postal designation. According to the National Park Service, the War Relocation Authority chose the name in honor of Wilson Price Hunt, a businessman and explorer who passed through the area in 1812. Others link the name to Frank W. Hunt, Idaho's fifth governor, who served the state from 1901 to 1903. Jerome County officials confirm that there was never an incorporated town called Hunt.

On Feb. 12, 2012 the *Times-News*, the daily newspaper in Twin Falls, published "Idaho High Court Hears Big Sky Farms Lawsuit Appeal." At issue in the story was a permit to establish a 13,000-animal feedlot near Minidoka. "The operation will be located about 1 ½ miles away from the Minidoka National Historic Site, former home of the Hunt Camp . . ." Later that summer, the decision to approve the feedlot was upheld by the Idaho Supreme Court.

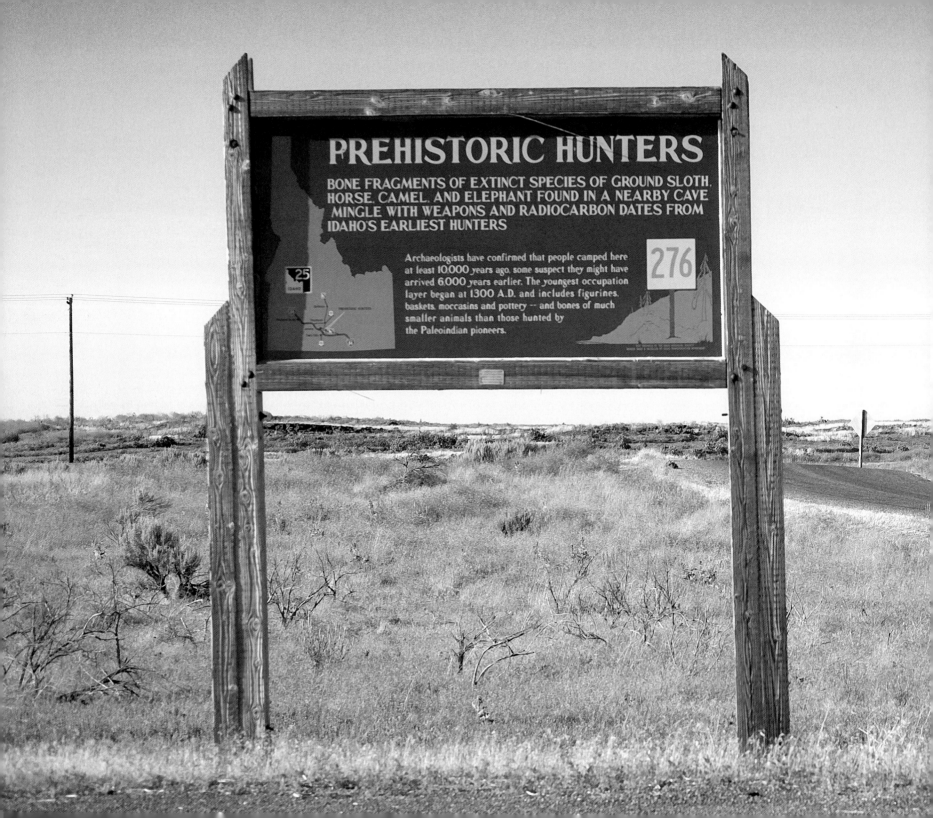

PREHISTORIC HUNTERS

BONE FRAGMENTS OF EXTINCT SPECIES OF GROUND SLOTH, HORSE, CAMEL, AND ELEPHANT FOUND IN A NEARBY CAVE MINGLE WITH WEAPONS AND RADIOCARBON DATES FROM IDAHO'S EARLIEST HUNTERS

Archaeologists have confirmed that people camped here at least 10,000 years ago. some suspect they might have arrived 6,000 years earlier. The youngest occupation layer began at 1300 A.D. and includes figurines, baskets, moccasins and pottery -- and bones of much smaller animals than those hunted by the Paleoindian pioneers.

276

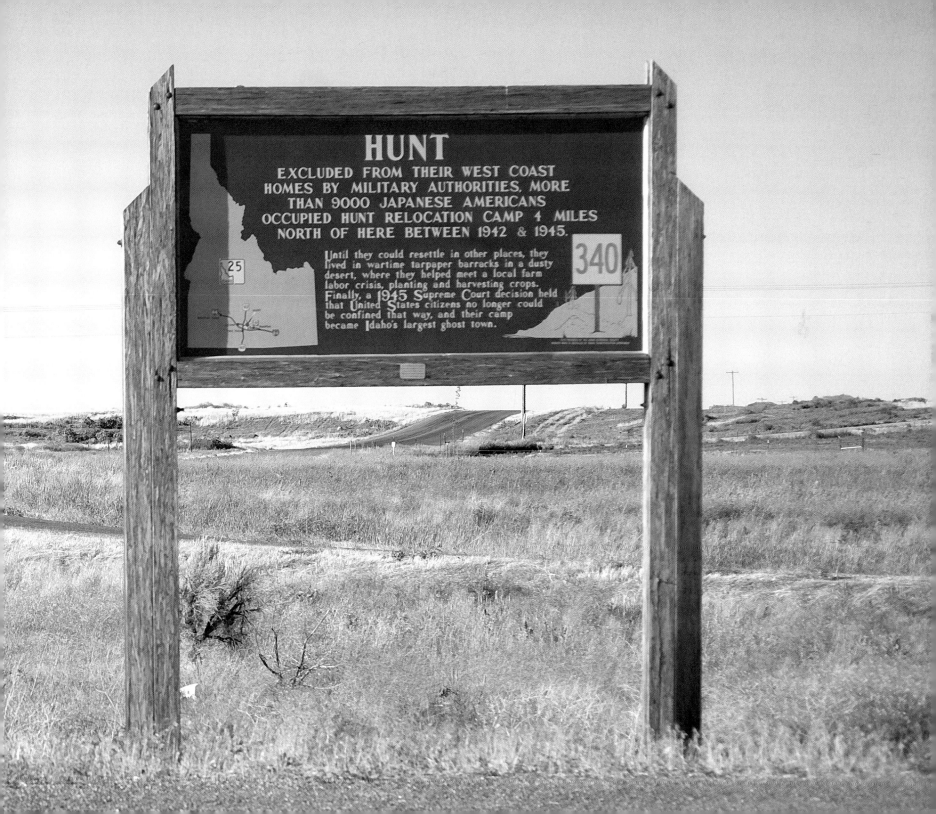

HUNT

EXCLUDED FROM THEIR WEST COAST
HOMES BY MILITARY AUTHORITIES, MORE
THAN 9000 JAPANESE AMERICANS
OCCUPIED HUNT RELOCATION CAMP 4 MILES
NORTH OF HERE BETWEEN 1942 & 1945.

Until they could resettle in other places, they
lived in wartime tarpaper barracks in a dusty
desert, where they helped meet a local farm
labor crisis, planting and harvesting crops.
Finally, a 1945 Supreme Court decision held
that United States citizens no longer could
be confined that way, and their camp
became Idaho's largest ghost town.

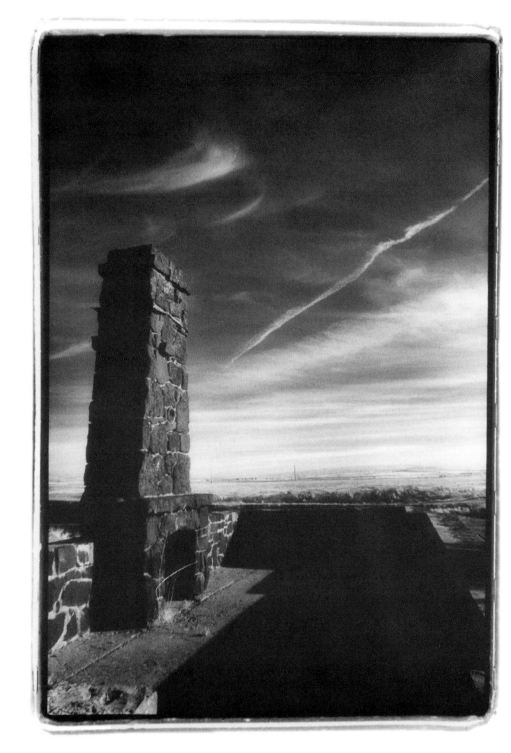

2001 (Oct. 25)
Jerome, Idaho
35mm B&W infrared film

THE RECEPTION BUILDING at the entrance of the original Minidoka War Relocation Center featured a fireplace made of basalt boulders quarried from the area by incarcerees. The fireplace remains intact at the site.

WHY MINIDOKA?

"At our best and most fortunate we make pictures because of what stands in front of the camera, to honor what is greater and more interesting than we are." — Robert Adams, *Why People Photograph* (1994), p. 179

On the day that infamously became 9/11 — Sept. 11, 2001 — I turned 41. I lived in Idaho at the time, and I, like others, spent that day in disbelief and sorrow, watching coverage of the World Trade Center towers disintegrating in New York City, the Pentagon smoking in Washington, D.C., and rescue crews futilely combing debris for survivors from the airplane crash in southern Pennsylvania. Interspersed with these scenes was historic footage of the bombing of Pearl Harbor. The attacks were horrifying; the coverage was troubling. Japanese ancestry — my ancestry — was used as a reason to incarcerate tens of thousands of American citizens after Pearl Harbor. In my lifetime, could another ethnic group be targeted and imprisoned in American concentration camps, where Japanese and Japanese American citizens were forced to live during World War II? My photo project about the Minidoka Internment National Monument, which I began in March 2001, took on fresh relevance, though I had no idea then what story would unfold from the people I met and the connections I discovered.

When I looked for Minidoka on a map of Idaho, I found it near Burley, not Twin Falls. The town of Minidoka, confused even now with the Minidoka historic site, is in Minidoka County, near Minidoka National Wildlife Refuge and Minidoka Dam, the first of 15 dam projects (1904) on the Snake River. The Minidoka postmaster told me so many people stopped by the post office to ask directions to the site that the office began to supply written directions to get there. Maps in print and on the Internet now show the location of the site.

In *Idaho Place Names, A Geographical Dictionary* (1988), Lalia Boone notes that the name Minidoka "is undoubtedly Indian, but the exact meaning is in dispute . . . Some say Minidoka means 'well, spring'; there was no source of water such as a well or spring until 1946, but there was certainly great need from both. Others say the word is Shoshoni and means 'broad expanse,' because the broadest portion of the Snake River Plain lies here. The latter seems more logical."

In March 2001, I attended a lecture titled "Art in the Camps" at the public library in Hailey, Idaho. The speaker was Robert C. Sims, professor of history emeritus and former dean of the College of Social Sciences and Public Affairs at Boise State University. After retiring from teaching, Sims traveled the state giving talks about Minidoka, Japanese Americans in Idaho and art made by *Nikkei* in the American concentration camps. His lecture was my introduction to Minidoka.

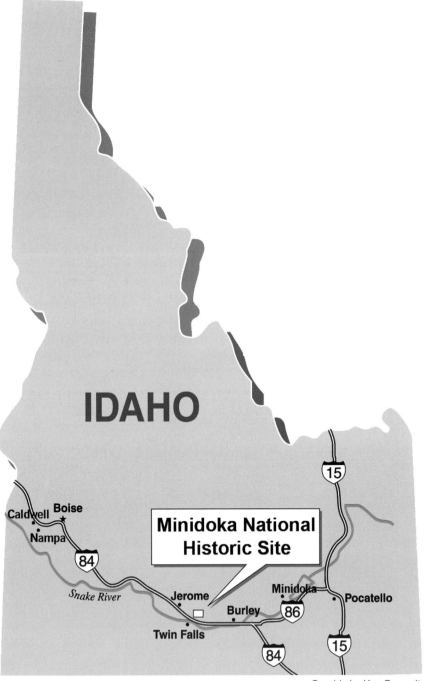

Graphic by Ken Barnedt

Sims first learned of the *Nikkei* imprisonment in 1970 as a PhD candidate at the University of Colorado in Boulder. The scholar and guest lecturer who introduced him to the subject was Roger Daniels, author of *Concentration Camps U.S.A.* (1971). A few months later, Sims began his teaching career at BSU. He also started to research and interview Japanese Americans in Idaho. "When I became aware of the existence of Minidoka as part of that story, I really began to work on the topic," Sims told me. Years later he served on the Friends of Minidoka board and the NPS general management planning team for Minidoka.

One of the artists Sims discussed in "Art in the Camps" was painter Roger Shimomura, originally from Seattle. Shimomura was a toddler when he and three generations of his family were incarcerated at Minidoka. After the war, he studied graphic design at the University of Washington and painting at Syracuse University, where he received an MFA. I met and photographed him in April 2001 at the opening of his exhibition, "An American Diary," at the Boise Art Museum.

In the catalog to his show, Shimomura, now Distinguished Professor of Art Emeritus at the University of Kansas, noted: "I discovered for the first time, as well, what it was like to create individual canvases whose ultimate impact was dependent upon having a dialogue with the accompanying text." My portrait of Shimomura was the first image for my project; his paintings and accompanying text were my artistic inspiration.

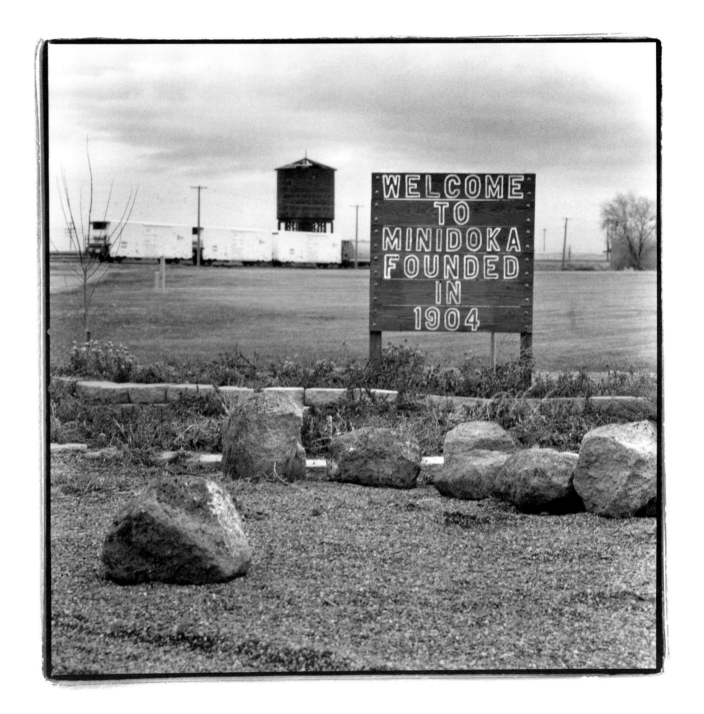

2006 (Jan. 7)
Minidoka, Idaho
120 B&W T-Max 400 film

THE POPULATION of the town
of Minidoka was 112 in 2010.

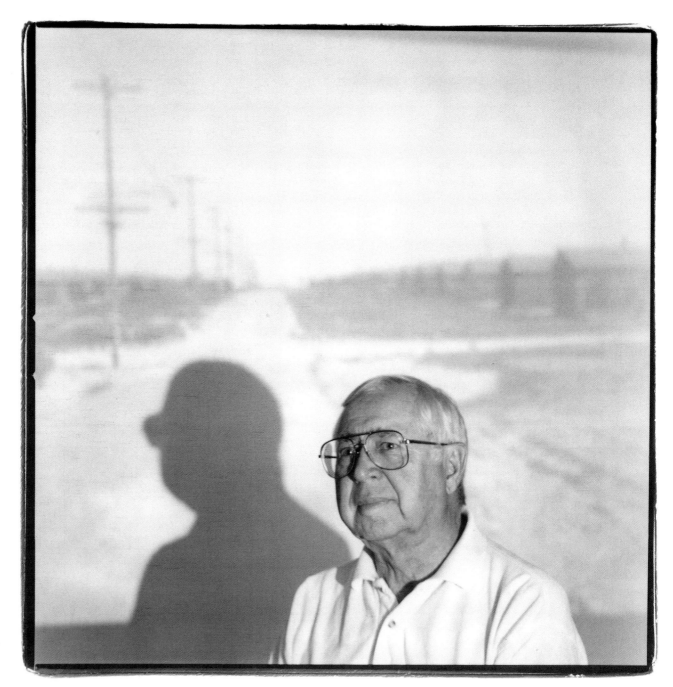

2002 (July 28)
Boise, Idaho
120 B&W T-Max 100 film

ROBERT C. SIMS devoted more than 40 years of research to the Minidoka War Relocation Center and *Nikkei* in Idaho.

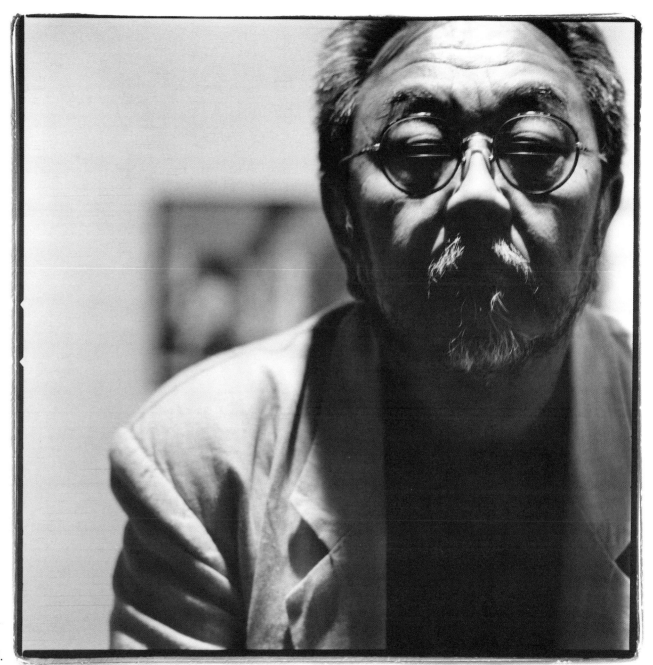

2001 (April 19)
Boise, Idaho
120 B&W T-Max 100 film

ROGER SHIMOMURA'S series of paintings, "An American Diary," was funded in part by a grant from the Civil Liberties Public Education Fund.

When finally I drove through the Magic Valley in southern Idaho to see the Minidoka site for the first time, I was filled with mixed emotions. It was, coincidentally, Oct. 25, 2001, the day before the USA PATRIOT Act became law. (The acronym stands for Uniting and Strengthening America by Proving Appropriate Tools Required to Intercept and Obstruct Terrorism.) When I arrived at the site in the center of Jerome County, I was disappointed to see how little of the physical camp remained. The site was a giant checkerboard of fields in shades of green, gold and tan, with houses spread out across the landscape like a game that had been abandoned two or three moves before the end. All I could make out of the original site were the basalt stone structures near a sign that read: "This is the site of the Minidoka Relocation Center." A lone chimney towered over the flattened landscape. I grabbed my camera equipment and left my car in the turnout that served as a parking lot looking out to the North Side Canal. It was the canal, or more specifically, the plentiful irrigation water it held, that had transformed much of southern Idaho from dusty sagebrush desert to verdant farmland.

Forty percent of Jerome County, one of Idaho's leading agricultural producers, is devoted to farming and ranching. Some of Idaho's famous potatoes are grown on land that was part of the Minidoka site. Other cash crops include alfalfa hay, silage corn, barley, winter and spring wheat, sugar beets and beans. The surrounding area is known for hunting, fishing and world-class skiing. In 1942, Ernest Hemingway, one of the Sun Valley area's most famous residents, hunted game birds with actor Gary Cooper an hour's drive from where *Nikkei* were confined.

Agriculture was and still is associated with Minidoka. At a potato growers convention in Boise in the 1970s, Masa Tsukamoto, a farmer from Blackfoot, approached Sen. Frank Church, D-Idaho, after his keynote speech. Tsukamoto, an Idaho native and active member of the Pocatello/Blackfoot chapter of the JACL, led the group's effort to preserve the Minidoka site. Church embraced the initiative, and Tsukamoto and his wife, Midori, spent a summer in a bureaucratic maze tracing ownership of the property to the Bureau of Reclamation. In 1979, the Minidoka site was listed on the Register of National Historic Places.

In the years of the incarceration, Tsukamoto took his parents to Minidoka to visit friends. His father, Kuniichi Tsukamoto, had immigrated to America in 1912 from Hiroshima Prefecture to help build the railroad. Of the friends they visited, Setsugo Hosokawa came from the same area of Japan. The two men, *Issei*, or first-generation Japanese in America, worked on the railroad together. Hosokawa then settled in Seattle.[1]

[1] Masa and Midori Tsukamoto, interview by author, July 29, 2008.

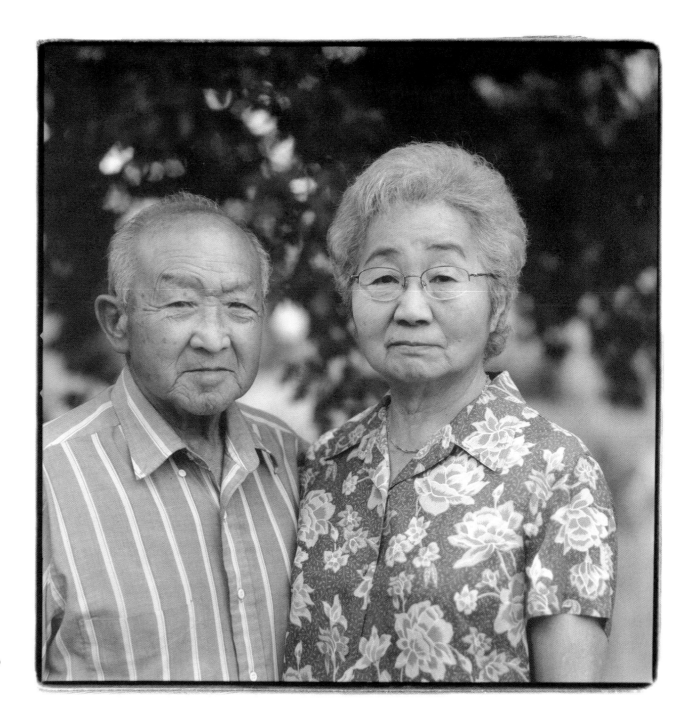

2008 (July 29)
Boise, Idaho
120 B&W Tri-X film

MASA AND MIDORI (Endow)
Tsukamoto were raised on Idaho
farms in the Blackfoot area.

The Hosokawa name was familiar to me because of the writing of Bill and Robert (Bob) Hosokawa, Setsugo's sons, both of whom worked as journalists. Bill Hosokawa, author of ten books including *Nisei, The Quiet Americans*, along with his wife, Alice, and young son, Michael, were assigned to the incarceration camp in Heart Mountain, Wyoming. (Husband-and-wife team Otto Hagel and Hansel Mieth were assigned to photograph Heart Mountain for *Life,* but the magazine never published the pictures.) Robert Hosokawa, a graduate of Whitman College in Walla Walla, Washington, and his new wife, Yoshi, were among the "advance crew" — the first to arrive at the unfinished Minidoka War Relocation Center.

Robert Hosokawa recounted the train trip to Minidoka from Puyallup in a journal entry from camp dated Aug. 10, 1942: "…continued on to Huntington, just within the Oregon boundary. It was there that I woke up at five o'clock. Yoshi was still curled uncomfortably and her coat wrapped tightly about her and her head pressed hard against the window's edge . . . soon we were across the Snake River and into Idaho…Everybody is badly grimed from all the travel dirt and soot and dust . . . perhaps Minidoka will be a jungle of sagebrush but we know that with our labor and water, the soil will be transformed into a clean, productive greenness. We do not know what the future holds as we draw near our new home. We're going to need an abundance of faith and courage and hope."[2]

Both Hosokawa brothers helped launch newspapers in their respective camps. I showed Robert Hosokawa a photo taken in June 1943 of *Nikkei* in "the project" newspaper office in Idaho. He didn't recognize any of the seven people in the picture, but it reminded him of how he came up with the paper's name, *The Minidoka Irrigator.* "Minidoka, from a farming standpoint, was in the middle of irrigation country," he told me. "That's why it was there. Canals ran around the camp and because of these canals and irrigation, this countryside is able to have crops. People get livelihoods from it. In the same way, this newspaper would irrigate the minds of the people."[3]

Huntington, coincidentally, had come up in a conversation with my uncle a week before I met Hosokawa. I learned my that my maternal grandfather, Junji Hamada, also from Hiroshima Prefecture, had helped build the stretch of railroad track at Huntington[4] — the very tracks used to transport *Nikkei* from Camp Harmony, a fairground turned assembly center in Puyallup.

[2] Robert Hosokawa, interview by author, May 23, 2008.
[3] Ibid.
[4] Ken Hamada, interview by author, May 17, 2008.

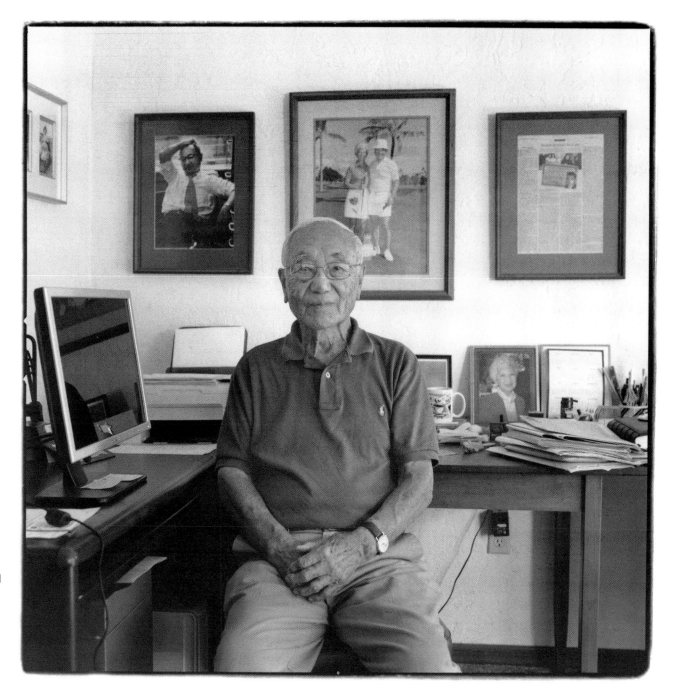

2008 (May 20)
Winter Springs, Florida
120 B&W Tri-X film

ROBERT HOSOKAWA kept his trusty Royal portable typewriter with him from Seattle to Puyallup, Washington, to Minidoka. He used it to write newspaper stories and record journal entries in camp. From Minidoka, Hosokawa went to Independence, Missouri to work for a newspaper.

With the passage of the Chinese Exclusion Act of 1882, all Chinese immigration to America came to a halt. Cheap labor replacements were needed in agriculture, lumber, mining and the railway system,[5] so young Japanese men were recruited to work. In Japan, family property is traditionally passed down to the first son, or *chonan*.[6] This tradition was a motivating factor for many young Japanese men such as my grandfather, Toyosaburo "Tom" Tamura, a third son, to leave their homeland. My other grandfather, Junji Hamada, was a *chonan*. He believed he could better help his family by working in America and sending money home. Both grandfathers came from remote agricultural villages in Hiroshima Prefecture during a difficult economic period in Japan. Junji's ship landed in 1906. He worked for Union Pacific, laying railroad track through places like Huntington in northeastern Oregon. After Junji married and started a family with his wife, Kuniko (Nakatani), he left Union Pacific to start a farm near Blackfoot in eastern Idaho. The family eventually settled in Caldwell in 1923.

The Blackfoot area was also home to Hero Shiosaki. His father, Kiichi Shiosaki, a railroad section foreman in Rockford, Idaho, was abruptly fired from his job in the wake of Pearl Harbor at the age of 64. All *Nikkei* who worked for the Southern Pacific, Union Pacific and Western Pacific railroads were "told to leave the premises and move out of the company housing immediately because they were thought to be security risks."[7] Hero's parents had to scramble. "People weren't hiring too many Japanese, especially if you couldn't speak English," he told me. "You were worse off. My parents rented a house and just lived there. Mike [his younger brother] and I were in the Army and we helped them out. With the two checks, they managed to survive."[8]

The U.S. government was responsible for the loss of hundreds of railroad and mining jobs held by *Nikkei*. Redress was granted to these workers as well as eligible family members in February 1998. Shiosaki and his brothers applied. They were among 327 workers and their family members to receive compensation.

Before he was drafted into World War II, Hero had completed vocational training for automobile body and fender repair through Idaho State University in Pocatello. When he returned to Idaho, he worked as an insurance claims adjuster. After he retired, he

[5] Yuji Ichioka, *The Issei: The World of the First Generation Japanese Immigrants, 1885-1924* (New York: The Free Press, 1988), p. 12.
[6] Lauren Kessler, *Stubborn Twig: Three Generations of a Japanese American Family* (Corvallis: Oregon State University Press, 2005), 6.
[7] "Redress for Railroad Workers and Miners," Nikkei for Civil Rights & Redress, retrieved Aug. 21, 2012,
 <http://www.ncrr-la.org/NCRR_archives/railroadworkers_miners/railroadworkers_miners.htm>.
[8] Hero Shiosaki, interview by author, March 4, 2008.

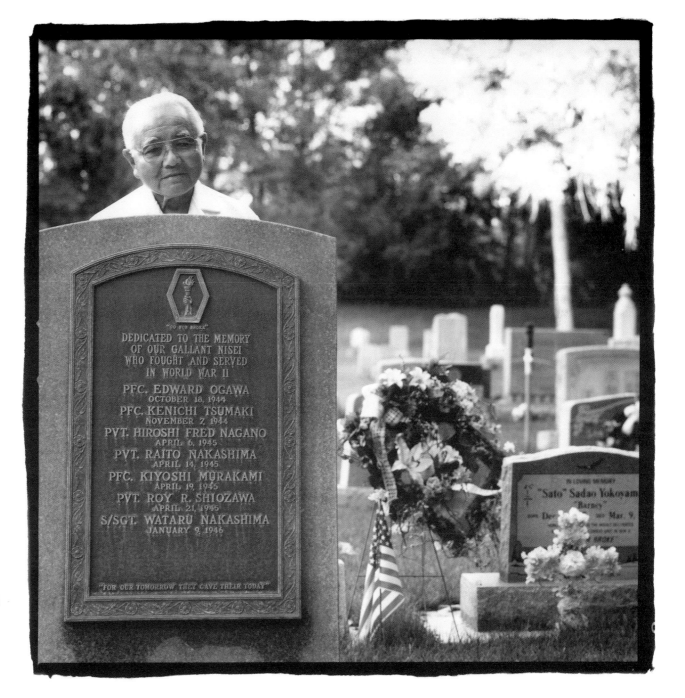

2002 (July 10)
Pocatello, Idaho
120 B&W T-Max 100 film

"IF WE KNOW THE STORY, then we have to share it," says Hero Shiosaki, a member of the 442nd Battalion, a U.S. Army division composed almost entirely of Japanese American men during World War II.

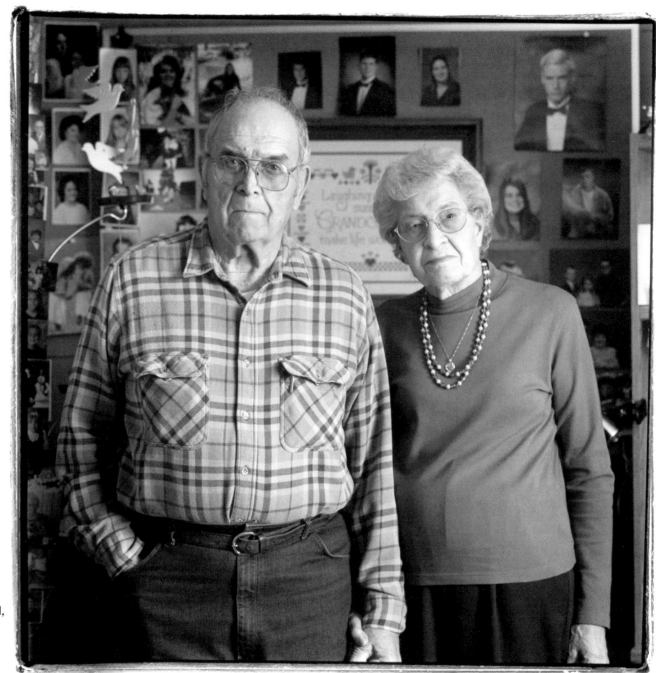

2002 (March 15)
Jerome, Idaho
120 B&W T-Max 400 film

JOHN AND ELFRIEDA HERRMANN, used to own property near the original entrance to the historic Minidoka site.

was active in the Pocatello/Blackfoot JACL and gave talks about *Nikkei* experiences during World War II, from the incarceration at Minidoka to the battlefields of Europe. "I knew some of the boys who were killed from the Pocatello area," Hero told me. "Six of my friends were killed. I want to let people know of the sacrifices of these families."[9] On two occasions Hero drove more than 500 miles to speak to high school students in Eureka, Montana, near the Canadian border. In his late 80s and no longer able to drive long distances, Shiosaki volunteered at the I.T. Stoddard Elementary School in Blackfoot, helping second-graders learn to read.

After the Minidoka War Relocation Center was closed — barracks and buildings auctioned, moved, and replaced with homes, some converted from former barracks — the land became farms. The site was divided into parcels that were distributed through a lottery system. John W. Herrmann was one of the lottery winners. He had moved to Idaho from Colorado at the urging of a friend who had been awarded a parcel. Herrmann applied for a lot and came away with land near the entrance of the incarceration site. Both men met their future wives at Trinity Lutheran Church in Eden, Idaho, the nearest town. Herrmann married Elfrieda Krohn, and the newlyweds lived in the building once known as Fire Station No. 1. His friend married Elfrieda's sister. The young women were daughters of Gerhard Krohn, a farmer in Eden. When the Herrmann property became part of a special demonstration project called "Farm-In-A-Day" in 1952, a two-bedroom, 1,042 square-foot model house was added on the premises. The couple moved in and raised two sons and three daughters there. "I've talked and visited with more Japanese because of where my house is," Herrmann noted when I spoke to him in 2002. A veteran of World War II and the Korean War, Herrmann added: "Something I don't like on that sign that they have out there is that it says, 'concentration camp.' I've been to Dachau where people were gassed and cremated. A concentration camp is where they kill people."[10]

The NPS does not currently use "concentration camp" in its site signage. Sims, an Idaho historian, recounted how a 1998 exhibition on Ellis Island about the *Nikkei* incarceration caused controversy over use of the term. The title of the show was "America's Concentration Camps: Remembering the Japanese-American Experience." The Jewish community and representatives of the Japanese American National Museum agreed upon explanatory text.[11] Sims offered a similar clarification, quoting Sen. Daniel K. Inouye: 'Suffering has

[9] Hero Shiosaki, interview by author, July 10, 2002.
[10] John Herrmann, interview by author, March 9, 2002.
[11] Robert C. Sims, interview by author, June 14, 2008.

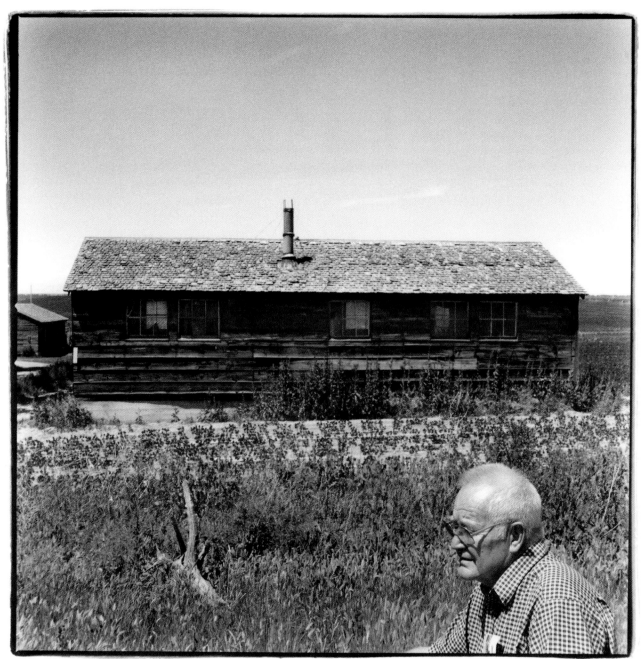

2006 (July 9)
Burley, Idaho
120 B&W T-Max 400 film

BILL VAUGHN'S father bought a
Minidoka barrack at auction in 1946
and cut it into three sections: one
to house workers, one for a granary,
and one for a milking barn.

14

many faces. Jewish suffering has the most terrible face. But suffering is suffering."[12] In 2011, the JACL passed a "Power of Words" emergency resolution recommending the use of terms including "American concentration camp," "incarceration camps" and "illegal detention centers." [13] The United States Holocaust Memorial Museum in Washington, D.C., posts information online to help educate the public about genocide in general and the Nazi concentration camp system in particular. Concentration camps are defined by their intended purpose: "forced labor," "prisoner-of-war" and "killing centers."

Bill Vaughn was 9 years old when his father hired, by permission of the goverment, *Nikkei* from the Minidoka War Relocation Center to save the family's carrot seed crop. The Vaughns owned 80 acres in Hazelton, a community 11 miles from the Minidoka site. Vaughn, now a board member of Friends of Minidoka, a nonprofit organization established in 2003, explained that carrots had been declared a "critical crop," a means to improve the eyesight of U.S. Air Force pilots. Forty years after the war, browsing through a Washington, D.C. bookstore, Vaughn came upon a book called *Soul of a Tree*. He bought it after noticing that the author, George Nakashima, had made references to Eden and Hunt. Back home Vaughn checked his father's ledgers and saw Nakashima's name listed as one of the farm laborers. He called the renowned architect and woodworker at his studio in New Hope, Pennsylvania, and they exchanged stories. Vaughn invited Nakashima to Idaho to speak at a convention for architects and offered to take him back to Minidoka to visit the site. Nakashima accepted but died before the trip.[14]

The war and its effects — forced evacuations — impacted *Nikkei* in many ways, depending on age and economic circumstance. The majority of Idaho's first-generation *Nikkei,* including my paternal and maternal grandparents, worked as farmers and truck gardeners, selling and delivering vegetables to local markets. Early on, *Issei* were "aliens ineligible for citizenship" because of the Naturalization Act of 1790 (restricted citzenship to a 'free white person') and the Immigration Act of 1924 (halted further immigration from Japan). As "aliens," Japanese nationals were unable to buy or lease land in many states, including Idaho, Arizona, California, Oregon, Washington, Montana, New Mexico, Nebraska, Texas, Kansas, Louisiana, Minnesota and Missouri.[15] It wasn't until the McCarran-Walter Act in 1952 that Japanese immigrants could become naturalized citizens and buy land in their own names instead of the names of their American-born children.

[12] Somini Sengupta, "What Is a Concentration Camp? Ellis Island Exhibit Prompts a Debate," *New York Times,* March 8, 1998,
 <http://www.nytimes.com/1998/03/08/nyregion/what-is-a-concentration-camp-ellis-island-exhibit-prompts-a-debate.html>.
[13] "Power of Words," Japanese American Citizens League, Aug. 16, 2011, <http://jaclpowerofwords.org/>.
[14] Bill Vaughn, correspondence to author, Feb. 18, 2007.
[15] Ronald Takai, *Strangers from a Different Shore* (Boston: Little, Brown and Company, 1989), 207.

For *Nikkei* living in Idaho's Canyon County during the war saw an influx of newcomers, mainly students and laborers on work and study release from Minidoka. The social scene vastly improved with their presence. My mom, Chiye (Hamada) Tamura, often recalled weekend dances, especially those held at the I.O.O.F. Hall in Caldwell. My dad, Warren Tamura, then a student at College of Idaho, was a scholarship athlete who played football and basketball and had aspirations of becoming a coach. Many of his teammates had been confined at Minidoka. In the C of I yearbook, several *Nikkei* students listed their hometown as "Hunt," the locals' name for Minidoka.

Before he was drafted, my dad finished two years of college and welcomed his oldest sister, Mae (Tamura) Takahashi, back to the family home in Caldwell. She, her husband and his family, left Seattle during "voluntary relocation," a short-lived, early pre-"evacuation" plan to disperse *Nikkei* on an individual basis. I didn't understand the climate of the era or the reason Mae moved until I started my book project. Chase Clark, Idaho's governor from 1941 to 1943, was notorious for his anti-Japanese attitude and positions. Clark vehemently opposed any individual *Nikkei* relocations to Idaho. On Feb. 27, 1942, he told a congressional committee in Seattle: "Japanese would be welcome in Idaho only if they were in 'concentration camps under military guard.'"[16] Clark's statement came a week after President Roosevelt issued Executive Order 9066, allowing military authorities to evict *Nikkei* from their homes along the West Coast and southern Arizona.

My father was a member of Company C in the 100th Battalion of the 442nd Regimental Combat Team, a segregated unit of Japanese American soldiers. He celebrated his 22nd birthday in a foxhole in southern Italy, wondering if he'd make it home. (He did.) During his time in the Army he made new friends with soldiers from many other states. One lifelong friend, Robert "Bob" Sato, grew up the son of a farmer in rural Sumner, Washington, near Puyallup. Sato was among the first group of students to graduate from Hunt High School (Class of 1942). In his later years, Sato told his wife, Lucy (Yoshioka) Sato, that if the incarceration had not happened, he probably would have ended up a farmer. Instead, Sato earned a college degree in civil engineering from the University of Washington and worked for the U.S. Army Corp of Engineers for most of his career.

[16] *Idaho Daily Statesman*, Feb. 16, 1942, cited in Robert C. Sims, "Impact of the Wartime Relocation on Idaho's Economy," *Japanese American Contributions to Idaho's Economic Development*, 1978, p. 17.

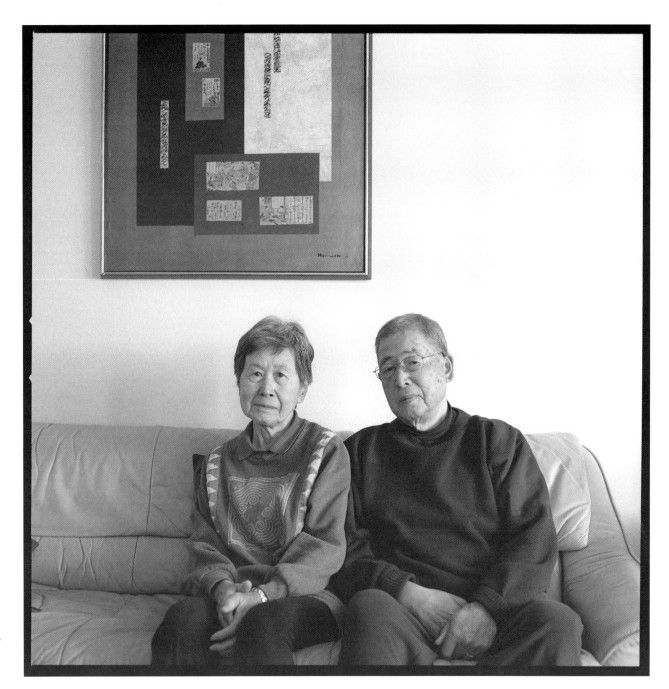

2008 (April 15)
Seattle, Washington
120 B&W Tri-X film

BOB AND LUCY SATO were incarcerated in Minidoka as teens but didn't know each other until they were adults living in Seattle.

Lucy Sato had always wanted to be a nurse and thinks she would have become one regardless of Minidoka. She grew up in Seattle's Central District near her family's grocery store. The Yoshioka family, seven in all, lived in Minidoka's Block 24, Barrack 3B. Lucy graduated in three years from Hunt High School and received clearance to leave camp with her older sister. They moved to Philadelphia. Lucy's sister attended the Baptist Institute; Lucy completed more high school studies, went on to Temple University Hospital School of Nursing and enrolled in the U.S. Nurse Cadet Program. She received a stipend and wages for her training, earned her RN license and worked as an operating room nurse for two years before returning to Seattle. She attended the University of Washington and earned a BS degree in Nursing and a MN in Nursing. Her parents returned to Seattle after the war, and moved back into the home they owned and became naturalized citizens.

A few years before he died, my dad told me that, until Pearl Harbor, he had known discrimination only in the abstract. After the attack that brought America into World War II, people that my dad thought were his friends no longer spoke to him on the street or returned his wave. Other *Nisei* told me about barbers who would not cut *Nikkei* hair, restaurants that refused to serve *Nikkei* customers, and areas where *Nikkei* could not live. My dad knew fellow *Nikkei* who earned college degrees but could not find jobs in their chosen field during and after the war. Their only option was to return to work on family farms. Faced with that prospect, my dad chose not to return to college after he returned home. Instead, he took over his father's truck garden business. Twenty years later, when my dad was offered a job at a farm cooperative in Nampa, he asked his future boss, "Are you sure you want to hire a Japanese?" He recalled one incident in his twenty-three years of work at the co-op when a former Bataan P.O.W. "just chewed me up and down about the war . . . I said, 'Mister, I went to the same war you did, but maybe I wasn't treated like you. I still fought for the country just like you did.'"[17]

Before my mom died in 1997, we went on a drive to see the places she used to live. No two homes were more than 15 miles apart. When America entered the war, her family was forced to move because their house was near the upper dam at Lake Lowell, a manmade reservoir in Nampa used for recreation and irrigation. During the war, all dams, bridges, railroads and airports were designated "sensitive" areas. When my uncle, Ken, was born two days after Pearl Harbor was attacked, my grandmother, Kuniko, was

[17] Warren Tamura, interview by author, July 14, 2006.

nervous, not because it was her first delivery in a hospital, but because of the heightened fear and suspicion she sensed toward any *Nikkei*. Though my family resided in the so-called "free zone"— the area outside Military Area 1— *Nikkei* everywhere endured severe restrictions during the war. Bank accounts of "aliens" like my grandparents were frozen.[18] Towns enforced curfews.[19] Residents were forced to speak English.[20]

Nikkei families in America did have ties to Japan, chief among them other family members. Like many other *Issei*, Tokumatsu Yamaguchi came to the states for work and saved money for his family in Japan. He worked in the timber industry in Washington. His son, Hajime Yamaguchi, was born in Japan in 1941, the same year as Pearl Harbor. Tokumatsu applied for repatriation while imprisoned in Minidoka, transferred to the segregation center in Tule Lake, and returned to his family in Japan in 1948, when Hajime was in the second grade. Tokumatsu's younger brother, Jack Masajiro Yamaguchi, who was also assigned to the Minidoka site, chose to remain in America to raise his family. Jack later wrote the book, *This Was Minidoka*. Hajime translated the text from English to Japanese.

When Tokumatsu Yamaguchi lived in Minidoka, he worked first in the sanitation department. A few months later, he moved into a "warehouseman" position. A WRA payment record shows he was paid at the rate of a skilled worker, $16 a month. In April 1943, Tokumatsu logged 192 hours of work, for which he received $16 plus a monthly clothing allowance of $3.75. His income for the year was $237. Tokumatsu notes on Form WRA 26, Rev. 1, "Individual Record," that his previous employer, Pacific National Lumber Co. in National, Washington, paid him $6.80 a day to work at the sawmill pond gathering lumber. His 1942 individual income tax return shows a salary of $889.98. On form WRA-126, REV., "War Relocation Authority Application for Leave Clearance" stamped May 20, 1943, Tokumatsu indicated his desire to return to work at Pacific National. Because the company was located within the exclusion zone, Tokumatsu's wish was denied.

Dorothy (Ozawa) Hirai, a Minidoka survivor now of Twin Falls, remembers another Washington timber town, Selleck. Her father, Frank Nagayoshi Ozawa, supervised Pacific State Lumber there for ten years until the company went bankrupt in 1939. She

[18] Robert C. Sims, "The 'Free Zone' Nikkei," in *Nikkei in the Pacific Northwest,* ed. Louis Fiset and Gail M. Nomura (Seattle: University of Washington Press, 2005), 241.

[19] Ibid, 244.

[20] Ibid, 246.

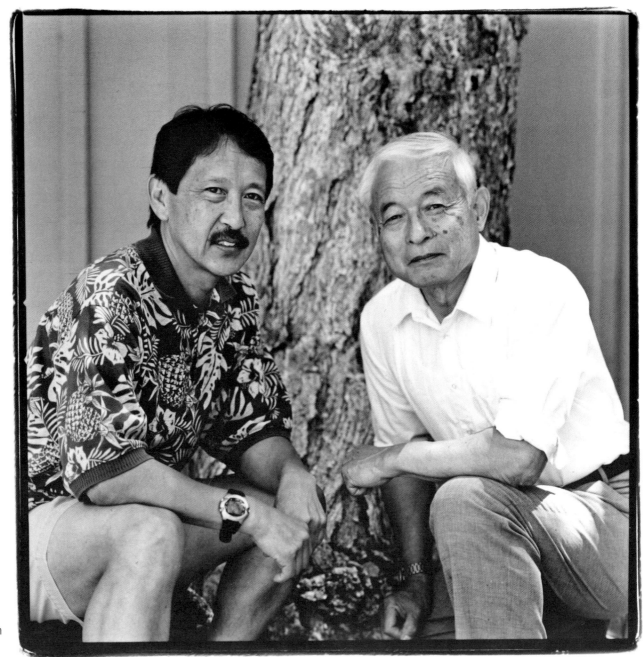

2004 (June 27)
Twin Falls, Idaho
120 B&W T-Max 400 film

HAJIME YAMAGUCHI, right, traveled from Japan in 2005 to see his American cousin, Gordon Yamaguchi, and attend the Minidoka Pilgrimage. Hajime returned to Idaho for pilgrimages in 2007, 2009 and 2012.

2004 (June 27)
Jerome, Idaho
B&W 120 T-Max 400 film

MITSUYE YAMADA and her children attended the Minidoka Pilgrimage in 2004. Left to right: Hedi Mouchard, Stephen and Kai Yamada, and Jeni Yamada.The same photograph appeared on the front page of *The Baltimore Sun* on Sunday, Dec. 5, 2004.

remembers learning Japanese from *Sensei* (Japanese for teacher) Yamaguchi, who taught *Nikkei* children after their regular school day. Now in her 90s, Dorothy laments giving up language lessons when she was a junior in high school, just when Sensei Yamaguchi was going to teach her how to write with a brush. "I wanted to learn that but I got tired of school and I quit," she said. The younger students met from 4 p.m. to 5 p.m. five days a week. The older ones — in this case, just Dorothy — met from 7 p.m. to 9 p.m. five days a week.[21] At the Minidoka Pilgrimage in 2012, Hajime Yamaguchi sat beside Dorothy Hirai at an outdoor barbeque, neither of them yet aware of how closely their pasts were connected.

While some *Issei* decided to return to Japan during and after the war, many more like Jack Kaichiro Yasutake chose to remain in America. Yasutake, a translator for the U.S. government in Seattle, was arrested on Dec. 7, 1941, and sent to Montana and then shipped to New Mexico while the rest of his family was incarcerated in Idaho. I met his oldest child, daughter Mitsuye (Yasutake) Yamada, and her family, at the Minidoka Pilgrimage in 2004. They were accompanied by Erika Niedowski, a staff reporter for *The Baltimore Sun,* the daily newspaper in Baltimore, where Mitsuye's oldest daughter, Jeni Yamada, lives with her family. Niedowski's stories about the Yasutake-Yamada family, and Mitsuye Yamada's recollections of Minidoka were published in December 2004 as a three-part series series titled "Return to Minidoka: An American Journey." (In a small-world connection from more than 30 years ago, Jeni Yamada graduated from Pasadena High School in California and worked on the yearbook staff with my husband, Keith Raether).

David Sakura, a biochemist turned investment banker, inadvertently connected to his past at Minidoka after the Bancroft Library of the University of California Berkeley launched its online collection of Japanese American Relocation Digital Archives (JARDA) in 2000.[22] "I was really stunned when I came across a photograph of myself and my two brothers in the archive," Sakura told me. "I can remember getting off the train. It was at night with spotlights on us and confusion and chaos all around. A soldier with a rifle came up to me and said, 'Hi David.' I wondered, *How in the world does he know my name?* Well, it turned out we all wore name tags." Sakura found additional photos of his family including aunts and uncles. Before the incarceration, the extended Sakura family lived in Eatonville, another small logging community in Washington.[23]

[21] Dorothy Hirai, telephone interview by author, Oct. 28, 2012.

[22] University of California, Calisphere – JARDA – About the Japanese American Relocation Digital Archives (JARDA), <http://www.calisphere.universityofcalifornia.edu/jarda/about.html>.

[23] David Sakura, Skype interview by author, May 20, 2009.

The Sakura brothers provided good publicity for Minidoka because David's father and three uncles volunteered for the U.S. Army. Several photographs of the Sakuras are in both the JARDA and NARA photo collections. On July 23, 1943, the *Rocky Mountain News* in Denver carried a story with the headline "Nisei-Yanks Show Zeal in Army Combat Team to Prove Loyalty to U.S." that featured the Sakura brothers. The story begins: "Twenty-five years ago old Toyozo Sakura called his four young sons to his deathbed in his home in Seattle, Washington, and said to them: 'My sons, you are of the Japanese race, but you are citizens of the country whose soil has blessed us. After I have gone it is my wish that you conduct yourselves with dignity and that you honor and serve this country of your birth.'"

Sam Toyozo Sakura was a Christian who left his family's home in the village of Tsuwano after his parents died. They had owned a sake factory. He came to America to live in religious freedom, landing in Seattle in 1890. He was a founding member of the Japanese Baptist Church in Seattle, where Pastor Emory "Andy" Andrews was the minister. He wrote Japanese calligraphy and various forms of Japanese poetry: *haiku, tanka,* and *waka.* "My grandfather died in the great influenza epidemic of 1918 and left a widow with nine children,"[24] David Sakura noted.

David's son, Dan, was a senior policy advisor for the Council on Environmental Quality and played a crucial behind-the-scenes role in preserving Minidoka as a national historic site. Dan flew from Washington, D.C., to Twin Falls to tour the Idaho location on Jan. 8, 2001. One of the locals he met was Maya Hata Lemmon, a community volunteer and grant writer who drafted the recommendation to preserve the Minidoka site. Lemmon had been incarcerated at Gila River, Arizona. She remembers watching Dan page through bound copies of the *Minidoka Irrigator* archived at the Jerome County Historical Museum, thinking to herself, "*He is so young to be representing the White House.*"[25]

The Jerome County Historical Museum, housed in the old train depot in downtown Jerome, has a complete archive of the *Minidoka Irrigator,* as well as a collection of donated artifacts. One of its volunteers, David Freshour, a native of Idaho, spent several months combing through weekly issues of the *Irrigator* dating from Feb. 27, 1943 to July 28, 1945. He recorded the names of every birth,

[24] Ibid.
[25] Maya Hata Lemmon, email correspondence to author, Jan. 27, 2010.

2009 (May 20)
Walla Walla, Washington
35mm digital image converted to B&W

DAVID SAKURA talks from his home in Boston via Skype.
24

death, wedding, anniversary in the camp, as well as anyone serving in the U.S. military, so that visitors could easily find information. Peg Roberson, museum curator and secretary of the JCHS, noted, "We're the only place I know of that has such a file."[26]

The Idaho Farm and Ranch Museum (IFARM), ten miles from the Historical Museum along U.S. Highway 93, is a spinoff project. IFARM features two Minidoka barracks, one used for various displays, and one dedicated to the site. In 2011, the NPS moved a third off-site barrack and camp mess hall back to Block 22.

A number of resources, several online, are available to people interested in learning more about *Nikkei* experiences during World War II. The National Archives and Records Administration is headquartered in Washington, D.C., with regional facilities across the country. The National Archives at College Park, Maryland, a 1.8 million-square-foot facility dedicated in 1994,[27] houses some 3,060 images related to the Minidoka War Relocation Center in the RG210 Series CMA and CMB. Of thirteen boxes containing a visual narrative of Minidoka, one is a shoebox-size container of prints. The others hold negatives.[28] Unfortunately, all of the negatives and several of the prints I wanted to include from the collection had minimal caption information or none at all. All of the photos were taken

1942 (Aug. 27)
Eden, Idaho
Electronic copy photo.
National Archives ARC ID 538270, Photo No. 210-G-D79
Photo by Francis Stewart

GERALD, 5, DAVID, 6, AND CHESTER SAKURA, JR., 1 ½. *"These little evacuees, along with 600 others from the Puyallup assembly center, have just arrived here and will spend the duration at the Minidoka War Relocation Authority center."* (War Relocation Authority caption)

[26] Marguerite (Peg) Roberson, telephone interview by author, Jan. 28, 2009.
[27] James Worsham, "How the National Archives Evolved Over 75 Years of Change and Challenges," *Prologue Magazine*, Summer 2009, Vol. 41, No. 2, <http://www.archives.gov/publications/prologue/2009/summer/history.html>.
[28] Holly Reed, email correspondence to author, June 3, 2010.

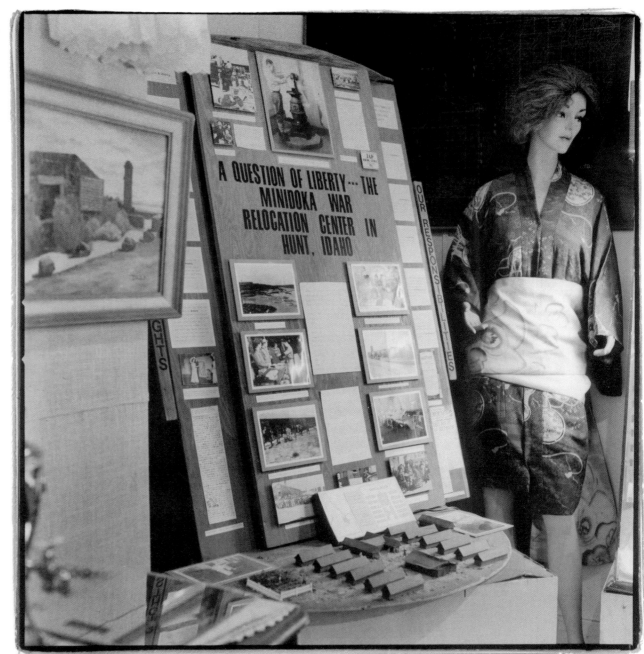

2006 (Jan. 6)
Jerome, Idaho
120 B&W T-Max 400 film

FOR MORE THAN 20 YEARS the
Jerome County Historical Museum
has displayed a permanent
collection of items related to the
Minidoka War Relocation Center.
The Jerome County Historical
Society, established by Clair and
Virginia Ricketts in 1981, opened
the museum in 1986.

under the direction of the War Relocation Authority (WRA) and used primarily for publication in newspapers and magazines. In one instance, a photograph of the Nishi family barrack interior was widely circulated because its wallpapered walls suggested a warm, homey environment. The public perception of the incarceration was profoundly shaped by these images.

Edward McCarter, chief of the Still Picture branch at NARA, noted: "In the '90s . . . a special project called the Electronic Access Project was funded . . . Of the total of some 150,000 records across NARA units [or series], some 50,000 were from stills — a lot, but a drop in the bucket given that we had some 11,000,000 images at that time." These images are preserved in cold storage, a climate-controlled room kept at 35 degrees in a 10,500-square-foot space.[29] The NARA Archival Research Catalog (ARC) makes the photos available online. When I visited NARA facilities in 2005, additional security measures had been installed in response to 9/11. Researchers had to pass through airport-style security to go to work.

The largest selection of archival images I found documented the mass relocation of *Nikkei* to the incarceration site in Manzanar near the Sierra Nevada Mountains in central California. Photographers such as Dorothea Lange (1985-1965), hired by the WRA, recorded the plight of *Nikkei* in California. Her photograph of an Oakland grocery store owner taken in April 1942 shows a large storefront banner with block letters that shout: "I AM AN AMERICAN." Lange, best known for her "Migrant Mother" photograph taken during the Great Depression, made the image as a photographer for the Farm Security Administration, a unit of the Department of Agriculture. She continued to work for the government during World War II, but restrictions were put on the story she could tell. Images of barbed wire, watchtowers and armed soldiers were off-limits. The government wanted the successful sequestration of *Nikkei* documented, but not too well documented.[30]

Ansel Adams (1902-1984) also photographed the *Nikkei* in Manzanar. Several of his most famous landscape photographs were made during four trips to the camp from October 1943 to July 1944. Adams knew the director of Manzanar, Ralph Merritt, and worked there independently — an outsider looking in — free from the dictates of an editor. In the introduction to *Born Free and Equal: The*

[29] Edward McC arter, email correspondence to author, Aug. 25, 2012.
[30] Dinitia Smith, "Photographs of an Episode That Lives in Infamy," *The New York Times*, Nov. 6, 2006,
 <http://www.nytimes.com/2006/11/06/arts/design/06lang.html?_r=0>.

Story of Loyal Japanese Americans, Manzanar Relocation Center, Inyo County, California, Adams wrote that he felt compelled to act, "Moved by the human story unfolding in the encirclement of desert and mountains, and by the wish to identify my photography in some creative way with the tragic momentum of the times . . ."[31] Yet, government restrictions also applied to Adams. The photos in his book contain no barbed wire, no watchtowers, no armed guards. His 242 original negatives and 209 photographic prints of Manzanar are permanently archived at the Library of Congress.[32]

"First published by US Camera in 1944, *Born Free and Equal* was not welcomed by the American public and copies were burnt at public ceremonies," Dawn Sumner noted in a review of Adams' work. "The book is a very open and personal response to the plight of the Japanese imprisoned at Manzanar. After first establishing a connection with the reader through descriptions of the land, the people and the camp environment, Adams attempts to address 'The Problem' in the final chapter. Here he is concerned with what the future will hold for Japanese Americans once the War is over."[33]

The Library of Congress website entry for *Born Free and Equal* notes: "The book received positive reviews and made the *San Francisco Chronicle's* bestseller list for March and April of 1945. A hardcover edition of *Born Free and Equal* (Bishop, CA: Spotted Dog Press, 2001) is available which corrects surname and chronological errors found in the original and includes essays by former internees Archie Miyatake and Sue Kunitomi Embrey."[34]

Included in Miyatake's essay are several portraits of his father, Toyo Miyatake, the Los Angeles studio photographer confined at Manzanar. Also depicted is Toyo's handmade camera with a lens he had smuggled into the camp. The elder Miyatake's early photo efforts were clandestine; eventually he worked as a photographer for Manzanar administrators. "When my father asked Mr. Merritt if he could set up a photo studio inside the camp, Merritt consented, provided that a white photographer snap the shutter,"[35] Archie recalled. After Edward Weston, a well-known fine arts photographer based in Los Angeles at the time, talked to Merritt, Toyo was given permission to work more freely.[36] He made approximately 1,500 exposures during his time at Manzanar from 1942 to late 1945.[37]

[31] Ansel Adams, *Born Free and Equal: The Story of Loyal Japanese Americans, Manzanar Relocation Center, Inyo County, California* (Bishop: Spotted Dog Press, 2001), 13.
[32] Library of Congress, *American Memory,* "Ansel Adams's Photographs of Japanese-America Internment at Manzanar," <http://memory.loc.gov/ammem/collections/anseladams/index.html>.
[33] Dawn Sumner, "Born Free and Equal: The Story of Loyal Japanese Americans by Ansel Adams," *Photo Life,* January 2003, 64.
[34] Library of Congress, American Memory, "Ansel Adams's Photographs of Japanese-America Internment at Manzanar: Born Free and Equal," <http://memory.loc.gov/ammem/collections/anseladams/aamborn.html>.

Alan Miyatake, Toyo's grandson, now owns and manages the family portrait studio that houses his grandfather's historic negatives and prints.[38]

Photographs speak a universal language and often serve as our social conscience. They move us to create new laws that effect social justice. William Henry Jackson (1843-1942) produced images that convinced Congress to establish Yellowstone as America's first national park. Jacob Riis (1849-1914) improved living conditions in New York City's immigrant neighborhoods through his first book, *How the Other Half Lives.*

In Aldous Huxley's book, *The Art of Seeing,* published in 1942 when *Nikkei* were being incarcerated, the nearly blind author retrained his eyes in order to see again. Huxley wrote the book to "repay a debt of gratitude" to Dr. W.H. Bates, who created visual exercises to improve one's vision. In a section subtitled "Causes of Visual Mal-Functioning: Misdirected Attention," Huxley wrote: "Attention is essentially a process of discrimination — an act of separating and isolating one particular thing or thought from all the other things."[39]

This idea of "misdirected attention" stays with me. Where would *Nikkei* be today had the sweeping relocation not happened? The mass

1942 (Dec. 9)
Minidoka Relocation Center, Hunt, Idaho
Copy photo, 120 film taken June 4, 2005, College Park, Maryland
National Archives Photo No. 210-G-A758
Original photo by Francis Stewart

"MRS. NISHI reads a bedtime story to little Eime at this War Relocation Authority center for evacuees of Japanese ancestry." (War Relocation Authority caption)

Of 102 Minidoka photos posted online by NARA, seven feature the Nishi family.

[35] Adams, *Born Free and Equal,* 18.

[36] Ibid, 19.

[37] Gerald H. Robinson, *Elusive Truth: Four Photographers at Manzanar* (Nevada City: Carl Mautz Publishing, 2002), 43.

[38] Alan Miyatake, telephone interview by author, Oct. 4, 2012.

[39] Aldous Huxley, *The Art of Seeing* (New York: Harper & Brothers Publishers, 1942), 67.

incarceration caused catastrophic losses for many *Nikkei*. It changed their thinking and that of the dominant culture. At the same time, as Sims notes, "*Nisei* veterans . . . it was hard to deny them because they had made such a contribution. I don't think the experience that Japanese Americans had in rising to the status of model minority could have been achieved as quickly or as solidly had there not been that record of the 442nd." Laws changed, new opportunities opened up, and many *Nikkei* resumed their education and received degrees. Some spoke up for social justice. After the war, the majority of *Nikkei* dispersed and integrated into mainstream society.

My dad always believed that the younger generation of *Nikkei* would be able to overcome what happened in America during and after World War II. I think we have, but outmarriage has also changed the culture from one of a distinct race to a mix of many. "Outmarriage, so much more prevalent among Japanese Americans than any other racial minority in the nation, can be seen as a natural step in the assimilation process, a sign that Japanese Americans are increasingly accepted as equals by white society," writes Lauren Kessler in *Stubborn Twig: Three Generations in the Life of a Japanese American Family*. "Or it can be viewed without any political context: a simple matter of people falling in love with the partners of their choice. But with an outmarriage rate now between 60 and 70 percent (compared with 13 percent for Chinese Americans and 16 percent for Mexican Americans), it seems likely that something else is at work in the lives of the *Sansei*. In fact, it may be that outmarriage, the mingling of the races, is the ironic result of a distinct history of American racism."[40]

Outmarriage, I came to learn, could be beneficial or perilous to couples married in the 1940s. I found a story in a 1942 edition of the *Ketchikan Alaska Chronicle* that showed a benefit: "Japanese women, legally married to white men who are citizens, or married to natives, are exempted from the evacuation order."[41] In another area of the country, I read about a Caucasian woman named Estelle Peck Ishigo. She volunteered to accompany her Japanese-American husband, Arthur Shigeharu Ishigo, to the Pomona Assembly Center in California before they were shipped to the Heart Mountain War Relocation Center in Powell, Wyoming. They had married in 1928 and were imprisoned together for three-and-a-half years. Their story is featured in a display at the Heart Mountain Interpretive Center in Powell.

[40] Lauren Kessler, *Stubborn Twig: Three Generations of a Japanese American Family* (Corvallis: Oregon State University Press, 2005), 255.
[41] *Ketchikan Alaska Chronicle*, "Japs May Take 1000 Pounds of Baggage," April 17, 1942, 5.

The physical characteristics of *Nikkei* continue to change as they partner with spouses of different ethnicities. I've seen children who are one-quarter Japanese but show no trace of Japanese in their facial features. If *Nikkei* today were to be incarcerated solely on the basis of the 1/16th blood quantum required during World War II, many would bear little resemblance to the Japanese facial characteristics defined in a 1941 *Life* magazine article and photo. (See Preface.)

The summer after I graduated from college, angry, unemployed auto workers in Detroit beat Vincent Chin to death. "The incident on June 19, 1982, seemed an almost perfect metaphor for anti-Asian sentiment in America. It was ignorant; [Ronald] Ebens and [Michael] Nitz presumed Chin, a 27-year-old Chinese American, was Japanese. It was economically motivated; the two auto workers blamed the Japanese — and, mistakenly, Chin — for the ailing U.S. auto industry and the consequential loss of jobs. And it was horribly violent; the use of a baseball bat as a murder weapon was a brutal act and an equally brutal reminder of Americana."[42] When I stepped into my own Nissan Stanza thirty years ago, I sometimes thought of Chin.

In my daily life, events and stories related to Minidoka continue to echo around me. Over the Memorial Day weekend in 2010, NPR broadcast "The Silent Generation: From Saipan to Tokyo." In the program, veterans of World War II recounted memories that haunted them decades later. One American Marine allowed that killing Japanese was "like killing rattlesnakes." He added: "I didn't always have that feeling in Europe about some poor German family man. I guess I felt that way until I heard the cries of Japanese women and they cried just like American women." Photographer Joe Rosenthal pointed out that three of the six men who raised the flag on Iwo Jima in his Pulitzer prize-winning photo were killed before they got off Mount Suribachi. Another American soldier freely admitted he felt grateful to President Truman for ordering the bombing of Hiroshima and Nagasaki, ending the war with Japan on Aug. 15, 1945.[43] In remembering the suffering and sacrifices of earlier generations of Japanese Americans, especially the *Issei*, I sometimes wonder even now: Could fear, prejudice and resentment create another place like the Minidoka War Relocation Center?

Speaking at a Minidoka reunion in Las Vegas in 2001, former U.S. Foreign Service Officer Lucius Horiuchi reflected on his experience

[42] Alethea Yip, "Remembering Vincent Chin," *AsianWeek,* June 5-13, 1997, <http://asianweek.com/061397/feature.html>.
[43] Interviews by Helen Borten. *The Silent Generation: From Saipan to Tokyo.* Public Radio Exchange, May 30, 2010.

on a presidential policy team created to address the Iranian hostage crisis of 1979-81. "Some members of the team wanted 'camps' to be reopened to be ready to hold all Iranian and Americans of Iranian parentage," he said. "In times of national stress, of pending war or of war, many may again turn against those who can be labeled and categorized — be it hyphened Americans or whomever some in the majority wish to be rid of."[44] Horiuchi said these words before 9/11.

Roger Daniels, who devoted much of his professional life to research, writing and lecturing about the mass incarceration of *Nikkei*, agrees with Horiuchi. "The Civil Rights Movement and the war in Vietnam in the 1960s and '70s; the redress process in the 1980s and '90s; the treatment of Arab Americans and others after 9/11 — all of these things have changed the way we look at the things that happened in 1942. A number of people have criticized me over the years because I've always said that this sort of thing under the right set of circumstances could happen again. I don't hear that criticism anymore."[45]

Daniels, now in his 80s, was "absolutely stunned" that American citizens could be locked up as they were during World War II. "You really have to go back to the winter of 1944-45 in New York City, when I met, I think, the first *Nisei* . . . the first Japanese person I ever met in my life, who was an attorney who had been in a camp . . . I knew that there were camps. I thought they were for enemy aliens. He was a lawyer." After government records became public, Daniels went on author and edit more than 20 books on Asian American history, including *Concentration Camps U.S.A.* (1971).[46]

In a lecture at the University of California at Berkeley on Sept. 14, 2010, Daniels spoke about the consequences of national fear. "If terrorist attacks on American soil had continued after September 11, would the current government reaction have been so moderate [to Muslims in America]? And, were there to be a recurrence of such attacks, would there not be those in our security establishment who would argue that the moderation after 9/11 was a contributing factor in the renewed assaults?"[47]

On July 22, 2004 the *Final Report of the National Commission on the Terrorist Attacks Upon the United States* was released. More than 1,200 people across the world were interviewed, and well over two million documents were reviewed. In Chapter 11 of the report, titled "Foresight — and Hindsight," "imagination" is cited as the first of four types of failures that the 9/11 attacks revealed.

[44] Lucius Horiuchi, correspondence to author [March 8, 2007], *Remarks at Minidoka Reunion*, Las Vegas, April 2001, 3.

[45] Roger Daniels, interview by author, Nov. 17, 2007.

[46] Ibid.

[47] Roger Daniels, "The Japanese American Incarceration Revisited: 1941-2010," *UC Berkeley Graduate Council Lecture Series*, Sept. 14, 2010, <http://grad.berkeley.edu/lectures/event.php?id=740&lecturer=476>.

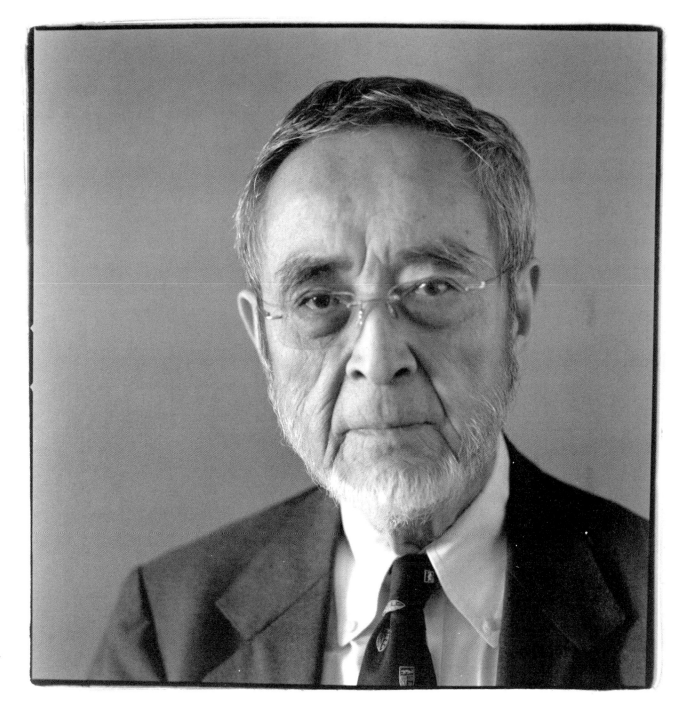

2007 (Feb. 16)
Sonoma, California
120 B&W Tri-X film

LUCIUS HORIUCHI served as a diplomat in occupied Japan after World War II.

33

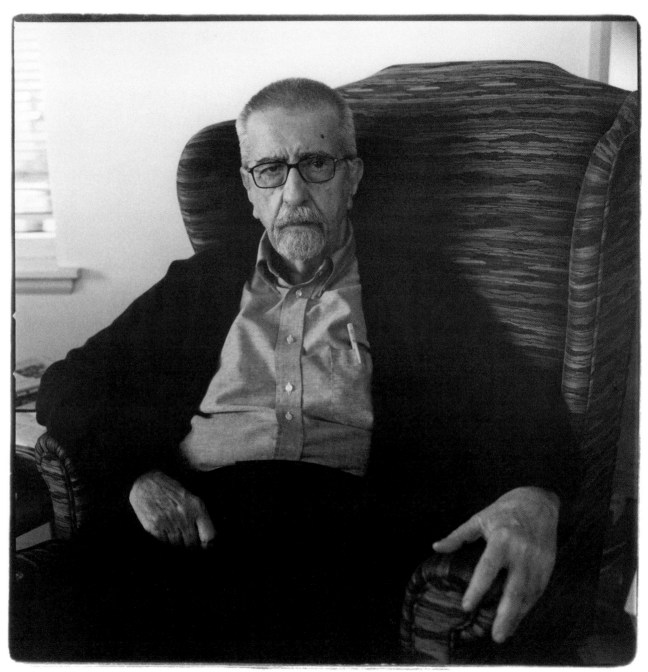

2007 (Nov. 17)
Bellevue, Washington
120 B&W Tri-X film

ROGER DANIELS earned his PhD from the University of California at Los Angeles in 1961. He is the Charles Phelps Taft Professor History Emeritus at the University of Cincinnati.

"Imagination is not a gift usually associated with bureaucracies. For example, before Pearl Harbor the U.S. government had excellent intelligence that a Japanese attack was coming, especially after peace talks stalemated at the end of November 1941 . . . It is therefore crucial to find a way of routinizing, even bureaucratizing, the exercise of imagination. Doing so requires more than finding an expert who can imagine that aircraft could be used as weapons."[48]

More than 30 years ago, when I asked my parents why they never told me about Minidoka, they simply said it was because our family didn't have to go there. At the time, I accepted their answer because I knew little about the events that transpired before, during and after World War II. If my parents were alive today, I would question them about their answer. I didn't experience 9/11 directly, but it certainly had an impact. My purpose with this book is to assemble, through photographs, personal accounts and historical details, the human story of Minidoka to better understand our history and make clear the impact of America's concentration camps. I will not forget the people of those camps or their stories.

While this book was in production, Peter Black, senior historian at the United States Holocaust Memorial Museum, replied to a concern I had about the use of "concentration camp" to describe Minidoka. "As Nazi propagandists always took pleasure in pointing out, the concept of a 'concentration camp' is an Anglo-American invention and was first used at the beginning of the 20th century by the British in suppressing the Boer Rebellion in South Africa and by the U.S. in crushing the Filipino independence movement," Black explained. "Since the Nazi regime redefined the concept of concentration camp, both in image and in practice, the camps in the United States where U.S. authorities incarcerated U.S. citizens of Japanese descent have been officially referred to as detention camps or, more shamefully and euphemistically, ' relocation centers.' In the pre-1933 U.S. context of the phrase 'concentration camp,' these facilities might well have been referred to as concentration camps. Nor would it be illegitimate to call them concentration camps today, though, since 1933/34 the term conjures up Buchenwald and Dauchau."

Minidoka was an American concentration camp.

[48] *The 9/11 Commission Report, Final Report of the National Commission on the Terrorist Attacks Upon the United States* (New York: W.W. Norton & Company, 2004), 344.

MINIDOKA REVISITED
Mitsuye Yamada

1 PRELUDE

The train stops at
the end of the tracks.
Literally.
The tracks simply sink into
the Idaho desert sand.
Disappear.

1942, a sunny April day
Several hundred young and
old men, women and children
from Seattle transported
by train from the temporary
Assembly Center
at the Puyallup Fairgrounds.
We were rickety bussed farther
into the desert.

All of us carry
an assortment of bags, sacks,
bundles, and babies, in our arms.
After twelve hours we arrive
at a gate in a fenced-in area.
What we see below the shades
of the bus window:
rows of tar-papered barracks
surrounded by barbed-wire fences.

We enter the gated compound,
I suck in my breath.
The air is dry.
I look back.
Outside the fences are blankets
of low, round, gray sagebrush
stretched out wide for miles and miles.

We are then "processed" in a long hall that will become our "recreation hall" where most of our community gatherings will be held, and "mess hall" where all our meals will be served. Each family is assigned to one of six rooms in the barracks. Because of my brother Tosh's job as an intern at the camp hospital, we are given a room in a barrack near the hospital: Block 4, Room 4. We enter our room with our bags. There are five cots lined up against the four walls. Each of us quickly takes possession of one of the cots, dropping bags on the thin canvas mattresses.

For our family of five, this cozy room will be our "home" for the next few years.

We try to make sense of our family situation. Our father is not with us, as he was labeled "Dangerous Enemy Alien" and sent elsewhere. We wonder: was it because he had been in the U.S. for thirty-six years but remained 'unnaturalized?' But we also know that all Japanese born in Japan (including Mother and me) are in the same situation. (Ten years later in 1952, the passage of the McCarran-Walter Act made it possible for us to become naturalized citizens.) This is 1942, Mother and I are also "Enemy Aliens," though not as dangerous, it seems, for the FBI has not arrested us and held us in a prison camp like my father. We were only "evacuated" and forced into a concentration camp. My three brothers — Mike, Tosh, and Joe; who range in age from 9 to 21 — are natural-born American citizens. We were a family of six, three "aliens" and three American citizens, but all are forced into prison or concentration camps in the desert just the same.

This is Minidoka, sometimes referred to as Hunt. Sometimes as Eden or even Twin Falls. This place with multiple names is Somewhere. For us it is Nowhere.

2 MINIDOKA HOSPITAL

Minidoka quickly turned into a "normal community" with its own government, schools and hospital. Two of the major changes in our lives were that Mother no longer cooked our meals, and we no longer ate together as a family. We ate our meals in a large mess hall with our friends and our co-workers. Since Tosh and I both worked long hours in the hospital, we hardly saw Mother or our brothers. We simply went to the dining hall with whomever we happened to be with when the dinner bell rang. We also became somewhat insulated from the other activities in the camp. Tosh worked as an intern in the main hospital; I was a nurse's aide in the emergency clinic. All of us, including the doctors and nurses, worked eight-hour shifts: 8 a.m. to 4 p.m., 4 p.m. to midnight, or midnight to 8 a.m.

The emergency clinic was a separate barrack, with a reception room at the front entrance. There were several examining rooms behind the reception room. On day duty, we were kept very busy with a stream of patients who came to emergency with minor complaints, most of which could be handled by me and other nurses' aides, or by the head nurse, Natsuko Yamaguchi. Occasionally, the camp ambulance driver brought more serious cases to the clinic. We would then call the doctors. I remember Dr. Suzuki and Dr.

Hasegawa, two dedicated doctors who worked in the main hospital for $19 a month. Trained professionals such as pharmacists were paid $16 a month, and lowly aides such as Tosh and I were paid $12 a month. I preferred the "swing shift" because there was very little activity during that time. That shift was from 4 p.m. to midnight, when I walked "home" through the dark, still, eerie desert air back to our family barrack.

Some patients came in with mild or vague complaints, but since we were never very busy we served them anyway. With few fresh vegetables and fruit in our diet, many of us had indigestion at one time or other. Some patients came into emergency in extreme discomfort in search of laxatives. Sam, one of the ambulance drivers, would escort the patients into the emergency reception room calling out "Minidoka Constipation Camp Hospital!" Sam kept me entertained on slow evenings with his corny humor. Once, when I had an inflammation in my eye, he referred to me as the "Case of the Japanese Sty."

Most of the time, there was only the hushed silence of the vast dark desert all around me, and I read and wrote at my desk with few interruptions. The Webster's Dictionary that I slipped into one of my two suitcases (each of us was allowed to bring two suitcases) came in handy on those evenings. I discovered that there was a "Directory of Colleges and Universities" in the back of the book. I decided to write to several of them for applications and sent letters to a dozen small colleges that did not require application fees and might be Christian schools. Only a few schools responded, all of them with rejection letters.

It has been more than six decades since the day we arrived at Minidoka. There have been many wars since then, but World War II is a war that most *Nisei* — those who lived through it — will never forget. Vivid images embedded in my memory of those days have not faded after all these years: the frantic voice of the newscaster on the radio announcing the bombing of Pearl Harbor, the four FBI agents who appeared at our front door to arrest our father, the meticulous search of our house by the agents, the temporary detention at the Puyallup Fairgrounds, the mass removal to the desert camp in Idaho, our 20-by-20-foot room in that desert camp, the stifling heat, the dust storms. It all began on that fateful day, Dec. 7, 1941.

3 DEC. 7, 1941

My two brothers, Tosh and Joe, and I had just returned from church, where we heard from our minister's son of the bombing of Pearl Harbor by Japanese planes. Mother had stayed behind to attend a women's group meeting. We were in a state of shock and disbelief and hurried home to huddle around the radio in our living room. The doorbell rang. I ran to the door expecting to see Mother who, I assumed, had forgotten her key. Instead, there were four grim-faced men in suits standing on our porch. One of them demanded, "We want to speak to Jack Yasutake."

"He's not home," I said, "He has his poetry club meeting every first Sunday of the month at a restaurant downtown."

This was probably more information than they needed, but in my nervousness I needed to blab about something I thought was inconsequential. I did not have the presence of mind to ask them who they were or why they wanted to speak to our father. Instead, I obeyed their gruff demand for the name and address of the restaurant. One of the men left. The three other men entered the house with their guns drawn. By this time my brothers had joined me at the front door.

"Where's your mother?" one man asked as we stood before him in wide-eyed puzzlement.

"She's still at church to attend a meeting," I said.

"Who else is in the house?"

This time Tosh responded. "Our older brother is sick and is in his room."

When the man said, "Get 'im." Joe, who was 9, was about to run up the stairs to get Mike when the man barked, "No! Call 'im!"

Mike, in his bathrobe and slippers, was already halfway down the stairs and leaning over the banister to see what was going on. One of the men flashed his badge and said they were agents of the Federal Bureau of Investigation, and that they had orders to search our house. "We don't want any trouble from any of you, okay?" We all nodded our heads.

The second agent told us rather gently, "All right now, y'all sit down over there," gesturing toward the living room sofa with his gun. The four of us sat crowded together on the sofa. He then perched himself on the ottoman facing us, one hand resting on his knee.

The third and fourth agents searched the house. One agent went into the dining room, where my father had his desk, and began to look through his desk drawers. The other went out the front door and returned with some cardboard boxes in his arms. They proceeded to fill the boxes with papers from my father's desk. All the while Joe kept fidgeting, and at one point he turned and lifted up a slat of the Venetian blind to look out the window. He jumped and quickly sat down when the agent guarding us barked, "Turn around, boy!"

One of the agents went upstairs. He returned with a uniform on a coat hanger.

"Whose is this?"

"It's mine," Tosh said.

"What is it, and who gave it to you?"

"It's my ROTC uniform. I belong to the ROTC at the University of Washington."

The agent shrugged his shoulders, tossed the uniform on the floor and went back upstairs.

The two agents took books from the bookcases in the dining room and living room and flipped through the pages. They put all the Japanese books in boxes. They took down pictures and hangings on the walls and tore open the backs of the frames. They enlisted our help in rolling up the area rugs in the dining room and living room and ripped up some of the floorboards with an ax. They took out stacks of dishes from the kitchen cupboards and examined each plate as if expecting to find something hidden between the dishes.

Suddenly the front door opened. Mother entered and cried out in Japanese, "What's going on? Who are these people?"

The agent guarding us stood up and yelled, "Speak English! Don't speak Japanese!" He ordered Mother to sit down. We all sat quietly in the living room, not daring to speak.

The doorbell interrupted the silence. The agent guarding us went to the front door. Mr. Yamazaki, a friend of our father who was also our gardener, was standing on the porch. He looked past the agent and said to Mother, *"Tondemo nai koto da nah? Yasutake san ni tazune ni kita jo."* ("What a terrible thing to happen! I came to ask Mr. Yasutake what we should do!")

This was a revelation for me. Apparently, people were always consulting my father for advice whenever something unexpected happened. Mr. Yamazaki saw the agent with his gun and became very nervous. He said, *"Oh, yoroshii, nan demo nai, sayonara."* ("Oh, that's all right, it was nothing, goodbye.")

The agent shouted, "Don't speak Japanese. Speak in English!"

That made Mr. Yamazaki even more nervous. He retreated very quickly and was about to leave when the agent ordered him to sit in the living room with us. Filled with fear, he came into the room and sat down. He sat with us for several hours, not saying a word. The silence was occasionally broken by the ringing telephone, but we did as we were told. We did not answer the phone. We just sat, looking straight ahead, giving each other a glance or two now and then.

The agents left about four hours later, carrying boxes filled with papers and books. (Years later, when the boxes were returned to us, we learned that they had taken all the letters my parents received over the years from numerous relatives in Japan, my father's copious journal notes, manuscripts of his community club speeches written in Japanese, sundry clippings from Japanese newspapers and magazines, and some Japanese books.) Mr. Yamazaki departed without saying a word as soon as the agents' car was out of sight. The telephone stopped ringing.

That evening, when our father did not come home for supper, Mother called several of his poetry club members. They hung up the phone when she asked if he was with them. I don't think any of us slept that first night. We sat around the dining room table and waited in vain for him to come home.

The following morning we received a short, cryptic telephone call from Mr. [Raphael] Bonham, director of the Immigration and Naturalization Service, where my father had worked as an interpreter for twenty-three years. He whispered, "Jack is here in our holding cell." He told us that he might be able to arrange a short meeting with my father that day if Mother came during the lunch hour. But, he warned her, it might be for only a few minutes. Tosh drove Mother and me to the immigration office, and indeed the meeting lasted only a few minutes as my father and other men were being transported to the dining hall for lunch. It wasn't a private meeting, but my father reassured us that he was okay, and that we shouldn't worry about him. He also managed to tell us that there was some money in the safe in the closet. The other men passed us single file on the other side of a wide hallway. There was a confusion of voices, all shouting at us, "Please call my wife and tell her I am here!" Mother and I were sobbing so hard we could not see the men to identify them.

4 MANAGING MONEY MATTERS WITHOUT PAPA

The immediate problem facing our family in the weeks following our father's absence was how to pay for our groceries. We discovered his bank accounts had been frozen by the government. Our family was not unlike most Japanese families. Our father was the head of the household. He held the purse strings and made all the decisions for Mother and the children. Tosh said, "Let's look around the house to see if we can find some loose change."

Each of us was assigned to look in our rooms, our closets, our coat and pants pockets, our dresser drawers. The change we managed to collect amounted to less than $40.

"This might last us for about a week," Mother said.

I had no idea, never having been asked to be involved in our family's finances.

"Don't worry," Joe said. "Maybe the war will be over by then."

The rest of us looked at each other. We had not considered such a possibility.

Mike remembered that each of us had a school bank account. "Let's see how much we have in our accounts," he said.

Every Tuesday was "bank day" at our school. Mother would give each of us 25 cents, and we would take our little bankbooks to school to deposit the money in our accounts. This had been a weekly ritual since kindergarten.

"Bring your bankbooks here," Mike said. The sum of our four accounts was about $300. We heaved a sigh of relief. We might have enough money to last for a few weeks.

A week later, I looked at the pile of unopened mail on our father's desk. I asked my brothers, "Do you think we should open Papa's mail?"

As it turned out, the mail contained bills from the telephone, gas, water and electric companies. I was shocked. It never occurred to me that the utilities I had been enjoying all these years were not free and automatic. Our father was paying for these services every month! What would happen if we didn't pay for them? Then Mother remembered what my father said about the cash in the safe. But there had been no time for him to give her the combination to the safe when we saw him at the immigration office. I was surprised when Mother said one of my father's friends was a "safe cracker." What an unusual profession, I thought. Mother called this friend and asked him to come over. When the safe was opened, we found $1,000 in cash. We now had enough money to pay the utility bills.

With no income, we reviewed our options. My oldest brother, Mike, had tuberculosis and had been bedridden for the past year. Joe, the youngest of the three boys in the family, was only 9. It was up to Tosh, a first-year student at the University of Washington, and me, a senior at Cleveland High School, to look for employment. We combed the want ads for men. There were no jobs for someone like Tosh, who had limited qualifications and experience. We looked at the want ads for women. There were a few ads for housekeepers and babysitters. I had enough credits to graduate, so I didn't feel a need to return to school. Besides, in this emergency, going to school

seemed the least important thing to do. I went to work as a housekeeper and babysitter for a photographer and his family. My salary of $15 a week, including room and board, was the only source of income for our family until we were removed from our home in April 1942 under Executive Order 9066.

5 "THE FBI CAME JUST WHEN WE WERE VOTING"

Several years after the end of the war, when our family reunited in Chicago, my father's best friend, Mr. Sekiguchi, told us what happened the day after the FBI agent left our house and went to Maneki Restaurant to arrest my father. I always enjoyed talking to Mr. Sekiguchi because he was always full of interesting information. He was the only person I knew who read *The New York Times* every day. Mr. Sekiguchi, a scholar of Japanese literature, helped my father publish the weekly newsletter for the Japanese Chamber of Commerce in Seattle. My father was president and Mr. Sekiguchi was vice president of the JCC for many years, until their happy active lives ended abruptly with the war. They were arrested by the FBI and incarcerated in the same series of prison camps away from their families. They eventually ended up in the prison camp in Lordsburg, New Mexico, but were separated when my father was transferred to a prison camp in Crystal City, Texas. After their release, they reunited in Chicago.

Mr. Sekiguchi was the first person to call on us to pay his respects when our father died suddenly of a massive stroke on March 31, 1953. I explained to him that Mother was resting after a difficult day and my older brothers Mike and Tosh were out making funeral arrangements. I invited him to sit at the dining room table and have a cup of tea with me. It was a rare opportunity for me to hear about my father's relationship with his best friend.

"You know, Mitsuye-san, I miss your father too, but his death is entirely normal. This is the way it should be so you must not be too sad." I was taken aback by this comment.

"What do you mean?"

"Your father is the oldest in the family. It is the right order of things that he would be the one to die first. Now if Jeni-chan (my daughter was 18 months old then) died now, it would really, really be tragic. She has a whole life ahead of her that she would be deprived of if that happened. Your father lived a full life and was very happy. He had a college degree and a satisfying career, superior to any *Issei* in Seattle. After years of incarceration during World War II, he recovered and regained his position as leader of the community. He saw all four of you grow up and become successful human beings. He saw the birth of two grandchildren. He was enjoying life. It was a happy end for him."

Mr. Sekiguchi's words were comforting when my heart was breaking. I remembered that he was someone my father had to sneak out to be with because Mother disapproved of him. She felt Mr. Sekiguchi was a bad influence on my father, who always drank too

much when they went out carousing together. It didn't help that he often referred to my father as his "drinking partner." When they were together, they would make the rounds of bars on Clark Street and come home singing, happily drunk. Mother complained, "This outrageous behavior has been going on ever since Seattle days." It seemed she never understood that my father also loved Mr. Sekiguchi because he was, among other things, a font of information and an intellectually stimulating person to be around.

That evening, Mr. Sekiguchi and I sat in our dining room and reminisced about the "good old times" he and my father had together. Then he told me about the day my father was arrested by the FBI, a story I had never heard.

"I will never forget the day he was arrested, he said. "We were having our regular *Senryu Kai* meeting at Maneki Restaurant."

My father had a lifelong interest in poetry and literature and had founded and organized a poetry club among his friends in Seattle. Unlike *haiku*, which is prone to abstraction and symbolism, *senryu* poems provide an outlet of expression for daily frustrations, repressed thoughts, and unabashed hopes and dreams. During their daylong meetings on the first Sunday of the month, club members dined, wined, gossiped, argued, and finally, composed.

"We were in the middle of voting when the FBI agent came," Mr. Sekiguchi recalled.

"Voting?" I asked.

"Yes, voting. It's a long story," he said.

Fortunately for me, Mr. Sekiguchi, unlike most of my father's *Issei* friends, spoke fluent English. It was a narrative he told to me with few interruptions.

"Usually at these meetings, we would first discuss a variety of possible subjects, almost always amicably. But that day, news of Pearl Harbor had us all on edge, and we argued and argued. Each of us had a poem in our hearts that we wanted to write right away. All fifteen of us were worried about our parents and relatives in Japan. We were all torn between love of the country where we were born and raised, and love of America, our adopted country and the country of our children. One poet's family — his wife and three children — had just sailed for Japan on the last ship. It used to take two weeks to cross the ocean. They were probably still in the middle of the Pacific Ocean. Would they arrive safely? This man was beside himself with worry. On this day we didn't need the hour usually allotted for composing a few poems. After only fifteen minutes of writing, we were all anxious to share our poems with each other.

"Your father brought out a roll of butcher paper, and we helped him pin it up on the wall. Then there was a moment of hushed silence. The calligrapher dipped his brush in the *sumi* (black ink) and stood before the paper waiting for someone to tell him what to write. One of the poets spoke. He held up his small strip of paper and intoned his poem. The calligrapher brushed his poem onto the butcher paper in beautifully fluid script. Then the second poet recited his poem, and so on until all the men had at least one or two of their poems brushed onto the butcher paper by the calligrapher.

"Then the calligrapher dipped another brush in red ink and held it in the air, the signal for the voting to begin. The first person to speak up was your father. He said he would vote for 'number three from the left.' The calligrapher put a red dot over that poem. When

someone else voted for the same poem, the calligrapher brushed a circle around the dot over that poem. Soon most of the poems on the butcher paper had red circles over them, some with many circles, some with only one or two. The one with the most circles was the winner. Your father usually had a small gift for the winner. Perhaps your mother picked it out: a comb, a pen, a cigarette holder.

"On this day, before the winner could be determined, an FBI agent entered the room. We did not know at first who he was for he did not identify himself.

'Which one of youse is Jack Yasutake?' he shouted. All of us were startled. We turned toward your father, who immediately identified himself.

'Come with me,' the agent said. He started to escort your father out of the room. Then he saw the butcher paper on the wall.

'What are those?'

'They are poems,' your father said.

'What are poems?'

'They are short sayings,' your father explained.

'Whose sayings? Who wrote them?'

'We did,' your father said, gesturing at us sitting around the table.

'Why do you have all those targets up there? And why do you write poems anyway?'

"Those of us who understood the English word "target" were astonished. Targets! These writings with their harmless red circles must have looked suspicious and threatening to this agent.

"Your father looked surprised and was speechless, so unusual for him. How to explain the targets? Why do we write poems? So I tried to help.

'The red marks over the poems are for marks of excellence, and we write about something that is on our minds at the moment,' I said.

"The agent pointed to one of poems and asked the man sitting closest to him, 'What does this one say?'

"The man probably did not understand his question so he said nothing. Your father translated the poem into English: 'That one says that the poet yearns for his mother in Japan.'

"You know that *senryu* poems are often humorous or ironic in some way. In normal times, it would be funny, a grown man yearning for his mother in Japan, but because of the state of shock we were all in at the time, this poem seemed sad or poignant. We might have laughed at the humor in normal times, but none of us felt like laughing then.

"The FBI agent impatiently tore down the butcher paper with all the poems, rolled it into a big messy ball and tucked it under his arm. He grabbed your father by the elbow with his other hand and said, 'Come with me,' and they both went out the door. Several days later, I, too, was arrested, and your father and I were reunited at the detention center."

6 FATHER AND THE FBI

Jack Kaichiro Yasutake was among several hundred Japanese men on the West Coast who were arrested by the FBI on the day Japanese naval planes bombed Pearl Harbor. Those arrested in Seattle were first detained in the holding cell of the Immigration and Naturalization Service Building. Many were released a few days or weeks later, but we learned that my father was transferred to a camp in Missoula, Montana. A few months later we heard he was sent to a prison camp in Santa Fe, New Mexico, and finally to a "permanent" camp in Lordsburg. While he was at the immigration building, Mr. Bonham called Mother every few days to reassure her that "Jack is doing quite well." This gesture of kindness, unfortunately, created some problems for my father. There were rumors that his fellow inmates, who got wind of Mr. Bonham's calls, began to suspect that he was "planted" by the government to spy on them. One of his close friends, released after a few days of detention, contacted Mother to tell her he was concerned about our father's safety. Then she received word that he was transferred out of the INS detention and sent to a prison camp in Montana. We weren't sure whether to feel relieved or sad. Once he was taken from Seattle, we no longer had news about his welfare.

The FBI spent more than three years after arresting my father looking for reasons to explain why they had arrested him. They were very thorough. They interviewed many of his friends, colleagues and acquaintances, trying to find someone who might have something incriminating to say about him. They also sought out "illegal" Japanese immigrants to whom my father may have unknowingly sold life insurance policies over the years. (He had a lucrative second job selling insurance for the Sun Life Insurance Company of Canada.) Mother heard from some of these men that the agents had asked them, "Did Mr. Yasutake threaten to turn you in if you didn't buy insurance from him?"

"Thank goodness, Papa was an honest man and everyone knew that," Mother would say years later, "It was so very fortunate he was well-liked by everyone and had no enemies."

Mr. Bonham, my father's immediate supervisor as well as his good friend, agreed with Mother's assessment.

"That was a fearful time for everyone. Nobody was safe during those years. Even I could have been arrested by the FBI for supporting your father. But how could I not? Jack was the perfect example of someone who fulfilled the Great American Dream because of his implicit belief in education. He rose from a penniless farm boy from Japan, worked his way through Stanford University and then worked for us as interpreter in our immigration office! Every one of us who worked with him admired him greatly."

His fellow inmates in the prison camps also recognized my father's good nature and competence. He was elected "Governor of Lordsburg" in the prison camp. When the news reached us in Minidoka, Mother exploded, "What? What is the matter with that man? It is just exactly this type of 'busy-bodyness' (perhaps "sticking one's neck out" might be a closer translation to the Japanese expression, *deshabatte*) that got him into trouble in the first place."

Mother's anger at my father was always brief. Often it turned to laughter, for she would see the humor in the situation. She would

often amend her outbursts. "He is a kind and gentle man and a natural leader."

Long after my father's death, my mother's love and respect for him continued to grow. My father was always full of stories, and those stories became favorite topics of conversation when we spoke of him.

"Remember," Mother would say, "how he used to boast that he was able to talk to the German prisoners in the Lordsburg prison camp during World War II (Italian and German sailors were picked up at sea after their ships were sunk) because he studied German at Stanford? He would always say, 'You see how important college education is!'"

I also remember him telling us how he spent his days in the Lordsburg prison camp. He said he "wrote letters home to the mamas" of the U.S. soldiers who were guarding the camp. They were "poor Southern boys," he explained, who never learned to read or write and were relegated to guarding Japanese prisoners instead of fighting in the war. The irony of a Japanese P.O.W. writing "Dear Mama" letters in English for U.S. soldiers seemed to escape him.

7 LEAVING CAMP

According to my friend, political activist Yuri Kochiyama, in early 1943, after about a year of managing the incarceration of 120,000 people of Japanese descent in ten camps in the states of Arkansas [2], Arizona [2], California [2], Colorado, Idaho, Utah and Wyoming, "the War Relocation Authority did the math and

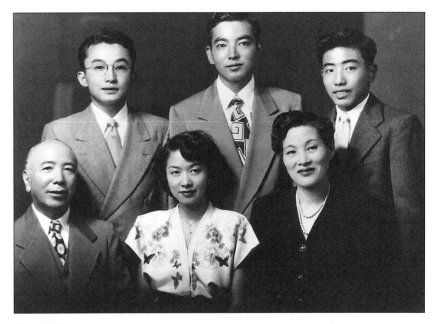

Circa 1949
Chicago, Illinois
Electronic copy photo.
Courtesy Wm. Toshio Yasutake

FRONT ROW, left to right: Jack Kaichiro Yasutake, Mitsuye (May), Hideko; back row, left to right: William Toshio, Mike and Joe.

discovered the camps were costing them too much money, money they could be using for the war effort. So, they decided to persuade the young people to leave as soon as they could." This was in response to my question about my late brother, Mike, who had declared himself a pacifist and became one of the so-called "No-No Boys." Many of the men who answered "no" to two key questions on the loyalty oath were shipped to the camp in Tule Lake, where troublemakers were sent. He said he responded "no" to Question 17: "Are you willing to forswear allegiance to the Emperor of Japan?" Mike said he checked "no" because he had never sworn allegiance to the Emperor in the first place. He also responded "no" to Question 28, which read: "Are you willing to bear arms to defend your country against the enemy?" Mike checked "no" because he is a pacifist. For some reason, Mike's questionnaire was apparently overlooked, and he was allowed to leave for Cincinnati in 1943. Yuri's explanation was that Mike applied just when the War Relocation Authority, the administrator of the camps, was actively trying to reduce the number of people in the camps and were no longer checking answers to the questionnaires.

There were three avenues of escape for young people: acceptance to a college or university, acceptance for employment or acceptance to the military.

My older brothers and I were able to take advantage of each of these escape routes. Mike was accepted by the University of Cincinnati, I obtained employment as a food server at the same university, and Tosh volunteered for the U.S. Army. I had collected dozens of rejection letters from colleges and universities to which I applied, presumably because of my "enemy alien" status. Fortunately, Floyd Schmoe, a Quaker volunteer who came to Minidoka to help us apply for schools and jobs, found a way by which I could leave camp with Mike. It turned out to be the best advice I could have received. A month later, my brother and I left for Cincinnati.

Soon after our departure, Tosh left for basic training in Mississippi. He became a medic in the 442nd Infantry Regiment and deployed to France and Italy, where he was wounded and received a Purple Heart. He was in the 442nd Regimental Combat Team, the most highly decorated infantry regiment in the history of the U.S. Army.

Mike and I arrived in Cincinnati and lived for a month in a hostelry managed by the Quakers. Since this was a temporary arrangement, I went to the Dean of Women's office at the University of Cincinnati to inquire about housing for students and workers around the campus area. The dean asked me if I planned to enroll in the fall. I meekly replied, "No," unwilling to tell her why. She persisted. "Why not?"

What followed was an amazing conversation that changed the course of my life. I had resigned myself to work as a kitchen helper, for perhaps the duration of the war, because of my "enemy alien" status. The dean picked up the phone, talked to the admissions director, and told me to go to the admissions office and register. It was as simple as that. By October 1943, Mike and I were carrying a full schedule of classes and working two, sometimes three jobs. During my second year, I moved to New York City and finished my undergraduate work at New York University.

Mother, who was left in Minidoka with Joe after her three older children left, learned that it was possible for my father to be transferred to a "family camp" in Crystal City, Texas. She and Joe could join him there. She agonized over this decision because, unlike the concentration camps we were in, Crystal City was a "real" P.O.W. camp under the control of the U.S. Department of Justice. She worried that if she were to submit to going there, her young son, Joe, might be saddled with a "prison record" the rest of his life. When she was persuaded that that would not happen, she and Joe left for Texas, where they were finally reunited with my father.

8 MINIDOKA PILGRIMAGE

On Jan. 17, 2001, President Clinton signed a bill that designated the Minidoka site a historical monument under the 1906 Antiquities Act. In 2004, 18 members of my extended family (including my three brothers and their families) were among a group of former inmates and their families who were bussed to the desert of Idaho — for a reunion. Jeni, my older daughter, and her sons, Aaron, Jason and Adam, flew in from Baltimore to experience this pilgrimage with me. We rumbled through the barren land dotted with sagebrush. I was reminded of the end-of-the-world feeling I had when we were transported there more than six decades ago. Time had transformed the area somewhat, but not much. There were a few houses with gardens and green front lawns sitting forlornly amidst the sagebrush. Green trees and bushes lined both sides of the canal that I remembered flowing just outside the barbed-wire fence.

A couple of original barracks had been reconstructed to house an exhibit of memorabilia from the camp days. [The barrack displays were kept at the Idaho Farm and Ranch Museum in Jerome at the time.] As we walked through the exhibits, what struck me was the sense that most of us had lived mechanically through those war years in a barbed-wire camp. Our minds must have been elsewhere as we went through the motions of going to sleep on our cots in our small rooms, getting up and getting dressed, going to the mess hall for meals, and moving on to our daily activities. This pilgrimage was an opportunity to relive our time in the desert. Decades removed from the imprisonment, there were fewer inhibitions in talking about camp. During an evening session, a few of us shared our feelings about the experience. Some wept openly as they spoke. The memories still felt raw and searing.

9 AFTERTHOUGHTS

In retrospect, I am astonished by how uninformed and ignorant we were about our civil and constitutional rights as citizens and permanent residents of the United States. My two older brothers and I were not children in 1942. Except for our 9-year-old brother, Joe, we were all in our late teens, all products of the public school system in Seattle. We had never heard of executive orders until 9066 was imposed on us. We did not realize the racist nature of the evacuation order that singled out those of Japanese ancestry but not

those of Italian and German origin. We had a vague notion that we were targeted because we looked like the enemy, and that it would be difficult to distinguish the loyal and the disloyal among us. Given that reasoning, didn't the German and Italian Americans also look like the enemy and wouldn't they be even more of a threat to national security since it was impossible to distinguish the loyal and disloyal among them from other white Americans? An executive order seemed to us a power given to presidents for very grave and important matters of national security that we should obey without question. I did not know until years later that executive orders were used for routine administrative matters until Franklin D. Roosevelt exercised his authority to allow the U.S. military to designate certain areas of the West Coast states as "military zones" from which "any or all persons may be removed." Although 9066 did not mention persons of Japanese ancestry per se, it led to the removal of the Japanese Americans from the West Coast in 1942.

It never occurred to us that our constitutional rights were being violated. The Fifth Amendment states in part "…no person shall be deprived of life, liberty or property without due process of law." This was a constitutional safeguard that should have protected us. Perhaps our ignorance should not be surprising, considering the fact that the U.S. Supreme Court at the time declared the order to be constitutional. Although the Commission on Wartime Relocation and Internment of Civilians found, in December 1982, that the incarceration of Japanese Americans was "not justified by military necessity," it is still assumed by the general public that the removal of people of Japanese ancestry from the West Coast was done for reasons of national security. This misrepresented and misunderstood chapter in American history should be included in our textbooks, and all American children should be made aware of how easily their own civil rights can be violated.

These days, when the subject of my incarceration during World War II comes up, my friends ask how I felt consigned to a concentration camp. "Aren't you angry and bitter?" they ask. They are surprised when I tell them that I didn't really think very much about my own situation at the time. The situation with our father was so dire that, even as the evacuation order came and we were herded into the two camps in Puyallup and Minidoka, nothing that was happening to us seemed as bad as our father being charged with espionage by the very government that employed him. Foremost on our minds at that time, and what we talked about among ourselves, was: what was going to happen to Papa? What incriminating evidence did they have against him? What kind of prison was he in? Would he be deported to Japan on the Gripsholm ocean liner? There were rumors that Japanese prisoners were going to be exchanged for Americans who wished to return to the U.S. on this repatriation ship. We felt completely helpless and ineffectual. My brother, Tosh, at least found a way that he thought would help our father's case: volunteering for the U.S. Army.

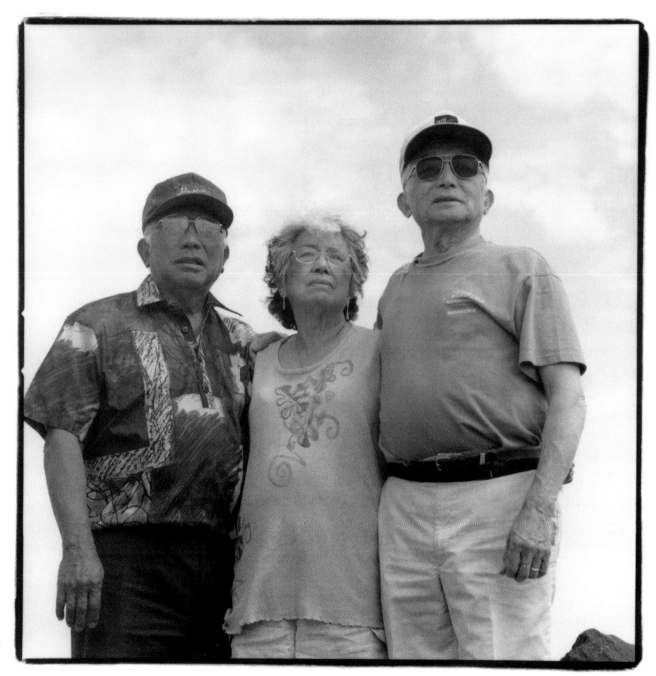

2004 (June 27)
Jerome, Idaho
120 B&W T- Max 100 film

LEFT TO RIGHT: Joe Yasutake, Mitsuye (Yasutake) Yamada, and William T. Yasutake at the Minidoka site during the 2004 pilgrimage.

10 EPILOGUE

In 1941, most *Issei*, first-generation immigrant Japanese such as my parents, were middle-aged. Many of them had come to the United States in the early 1900s with dreams of bettering their lives and the lives of their families. They lived through harsh times: the Depression and discrimination against Asians. After twenty or more years of unrelenting labor, by early 1941, they were finally enjoying a more leisurely lifestyle. Their lives were quite similar to most middle-class American families. Many like my parents were able to buy homes through the names of their American-born sons. (*Issei* were ineligible by law to purchase property or become naturalized citizens.) They became proud owners of small businesses. Their children did well in school, many of them graduating from high school as valedictorians and salutatorians before enrolling in college. Up and down the West Coast, robust Japanese communities were growing with churches, shops, Japanese restaurants and community centers.

The people whose lives were most tragically impacted by World War II and the concentration camp experience were these *Issei*. Many of the *Nisei* and *Sansei*, the second and third generations, left camp and settled into communities throughout the country. *Issei* never recovered from the emotional impact of the Japanese bombing of Pearl Harbor. The country of their birth and the country of their American-born children were at war. Their loyalties to their adopted country were under suspicion. Most *Issei*, then in their late 40s or 50s, were unable to resume their former lives after spending four years in a prison camp. The lives they spent decades to build had been demolished, and they became dependent on their now-grown children.

I am in awe of my own parents' heroic efforts to restore their lives to "normal" after their devastating experiences during the war. After my father's release from prison, they settled in Cincinnati. The only employment open to them was domestic work that provided lodging and meals for themselves and their youngest son, Joe. My father, an educated man and respected community leader in his pre-war days, was not too proud to work as domestic help again, a job he had held during his student years. My parents worked for a wealthy family, my mother as housekeeper and cook, my father as gardener and handyman, for about two years. Fortunately, my father's former status was restored when he was offered a position as executive director of the Chicago Resettlers Committee, an organization formed to help the Japanese find housing and employment after the camps were closed in 1947. He held this job until he died in 1953.

"**THE EVACUATION** was impelled by military necessity. The security of the Pacific Coast continues to require the exclusion of Japanese from the area now prohibited to them and will so continue as long as that military necessity exists. The surprise attack at Pearl Harbor by the enemy crippled a major portion of the Pacific Fleet and exposed the West Coast to an attack which could not have been substantially impeded by defensive fleet operations. More than 115,000 persons of Japanese ancestry resided along the coast and were significantly concentrated near many highly sensitive installations essential to the war effort. Intelligence services records reflected the existence of hundreds of Japanese organizations in California, Washington, Oregon and Arizona which, prior to December 7, 1941, were actively engaged in advancing Japanese war aims." — J.L. DeWitt, Lieutenant General, U.S. Army Commanding. *Final Report Japanese Evacuation from the West Coast 1942.* Washington, D.C., *1943*

"**THE FEDERAL GOVERNMENT** contended that its decision to exclude ethnic Japanese from the West Coast was justified by 'military necessity.' Careful review of the facts by the Commission has not revealed any security or military threat from the West Coast ethnic Japanese in 1942. The record does not support the claim that military necessity justified the exclusion of the ethnic Japanese from the West Coast, with the consequent loss of property and personal liberty." — *Personal Justice Denied: Report of the Commission on Wartime Relocation and Internment of Civilians.* Washington, D.C., June 1983

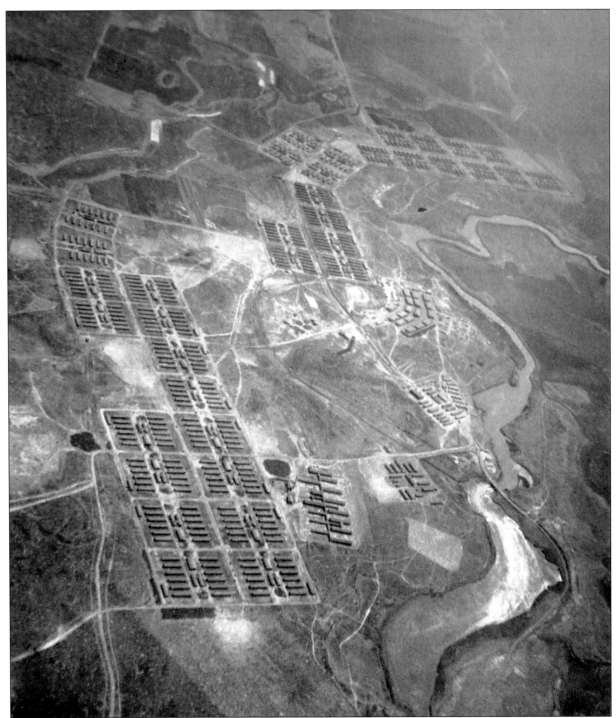

Circa 1943
Hunt, Idaho
Aerial view, Minidoka War Relocation Center

Copy photo, 35mm digital taken July 17,
2012, Walla Walla, Washington.
The Minidoka Interlude

54

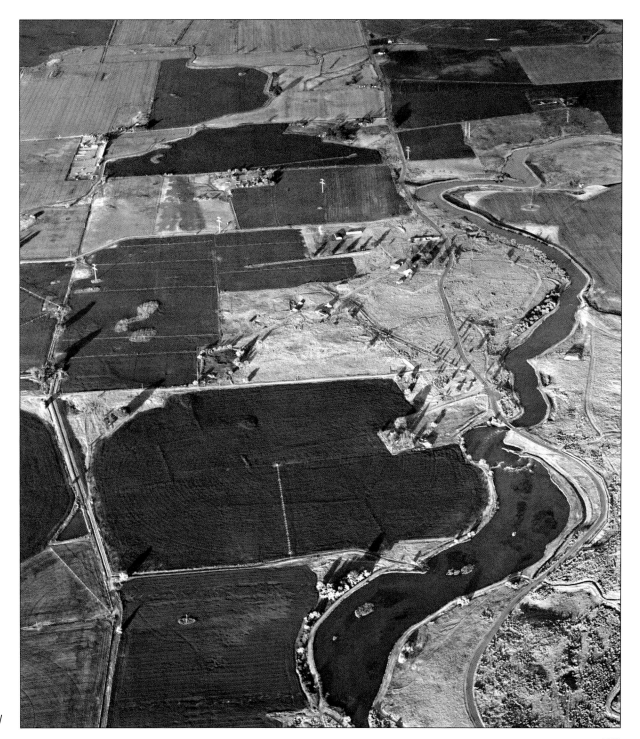

2012 (July 9)
Jerome, Idaho
Aerial view, Minidoka National Historic Site

35mm digital image converted to B&W

"... it was a real desperate feeling when I saw Idaho for the first time."

— journalist Robert Hosokawa, en route to imprisonment at Minidoka

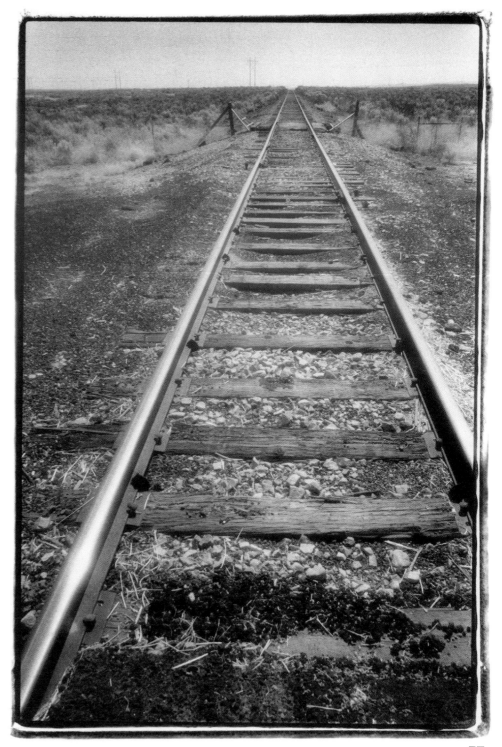

2002 (Aug. 5)
Jerome, Idaho
B&W 35mm infrared film

"AS EARLY AS 1892, 1,000 Japanese were at work on the Oregon Short Line, the rail line that cuts across southern Idaho, roughly paralleling the Snake River's course.

For the next ten years, Japanese constituted the largest group at work on the rail lines of the state. The progress of Idaho was upon their backs."

— Robert T. Hayashi, *Haunted by Waters: A Journey through Race and Place in the American West,* 2007, p. 52

WAR RELOCATION AUTHORITY
Midland Savings Bldg.
Denver, Colo.

NO: D-76

DAT^E: 8/17/42

PHOTO LOCATION: Eden, Idaho

DATA: A train bringing approximately six hundred evacuees from the assembly center at Puyallup, Washington. Buses, used to transport these people to the Minidoka War Relocation Authority center, are waiting at the siding.

Photographer: FRANCIS STEWART

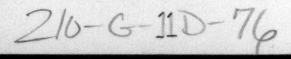

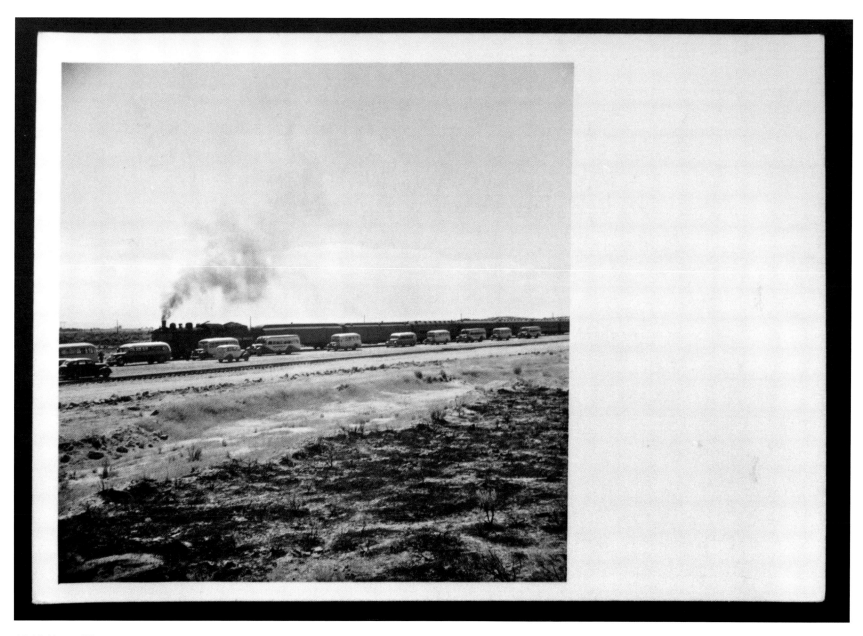

1942 (Aug. 17)
Eden, Idaho
Copy photo, 120 film taken June 4, 2005, College Park, Maryland.
National Archives Photo No. 21-G-D76
Photo by Francis Stewart, WRA

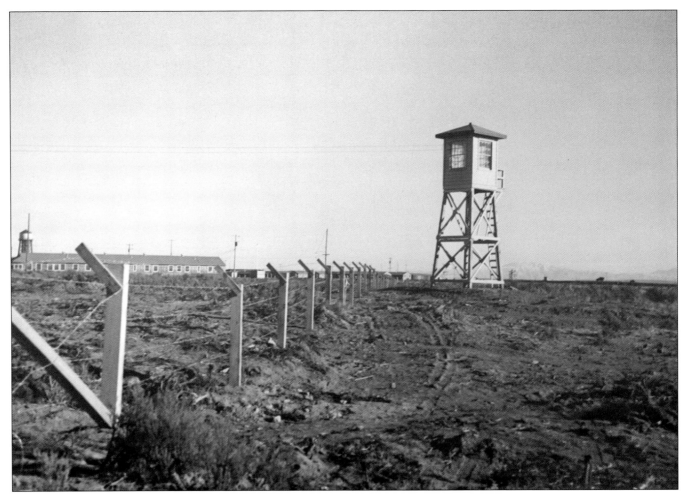

1942 (Nov. 10)
Minidoka War Relocation
Center, Hunt, Idaho
Johnson & Son, Boise, Idaho
No. 106
Copy photo, 35mm digital
taken Aug. 16, 2005,
Portland, Oregon.
Courtesy Oregon Nikkei
Endowment, Portland,
Oregon

"WATCH TOWERS [sic] are being constructed at vantage points on the outskirts of the camp. The reason for the towers is being discussed by many Japanese and some appointed personnel. Some say they are fire lookouts and others maintain that the sole purpose is to have them manned by soldiers with machine guns to prevent the escape of any evacuee." — Arthur Kleinkopf, *Relocation Center Diary: 1942-1946,* Oct. 26, 1942 entry, p. 38 [Kleinkopf first served as superintendent of student teachers and was promoted to superintendent of education at the site.]

2002 (Aug. 1)
Jerome, Idaho
B&W 35mm infrared film

61

"IN NOVEMBER OF 1942, an incident occurred which disrupted the peace of the community. Much to the amazement of the colonists, workers began to erect a barbed-wire fence around the perimeter of the city. Eight watch towers [sic] were also raised, and Minidoka rapidly took on the appearance of a concentration camp. Although the administration claimed that the watch towers [sic] would be used as fire lookouts, the inhabitants were convinced that they were designed to serve a sinister purpose. The barbed-wire fence was also more than 'a line of demarcation of the center limits.' It was symbolic of their imprisoned state. Most of the inhabitants had felt from the beginning that the Japanese exclusion order was unconstitutional, and they did not think that they should be regarded as prisoners or subjected to humiliating treatment." — Donald E. Hausler, *History of the Japanese-American Relocation Center at Hunt, (sic)* [Jerome County], Idaho, 1964, p. 24

2009 (July 7)
Jerome, Idaho
B&W 35mm infrared film

"THE POPULATION of this unusual new Idaho community, created as a result of the military decision to remove all persons of Japanese ancestry from the West Coast war zone, stood at 9,385 tonight (Sept. 12) making it the eighth largest city in the state and lifting Jerome county to ninth position among the communities." — *Times-News,* Twin Falls, Idaho, Sept. 13, 1942

2004 (June 25)
Jerome, Idaho
B&W 35mm infrared film

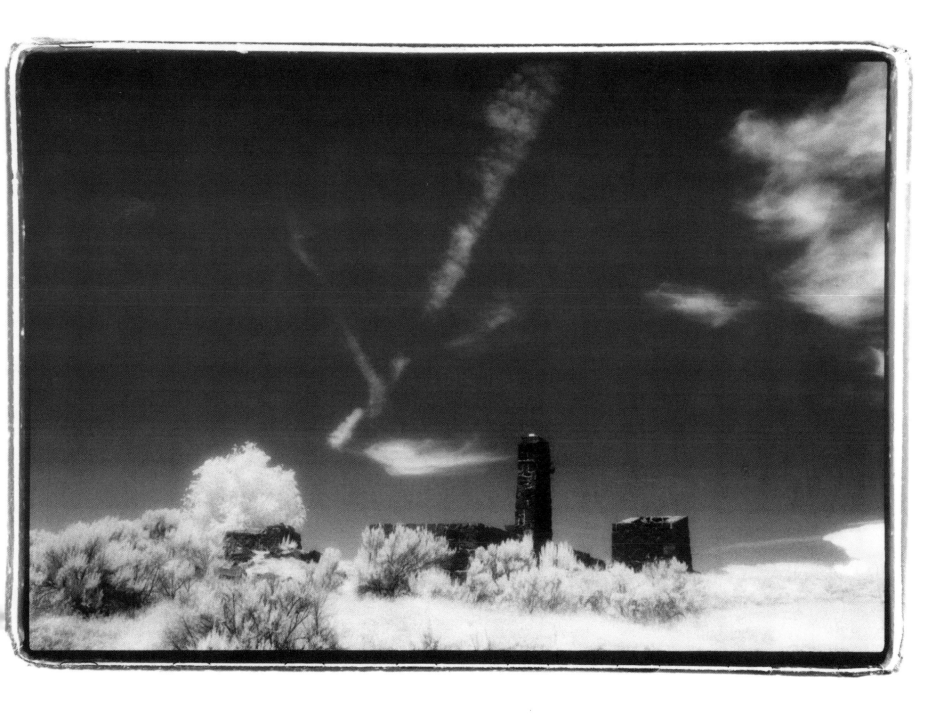

65

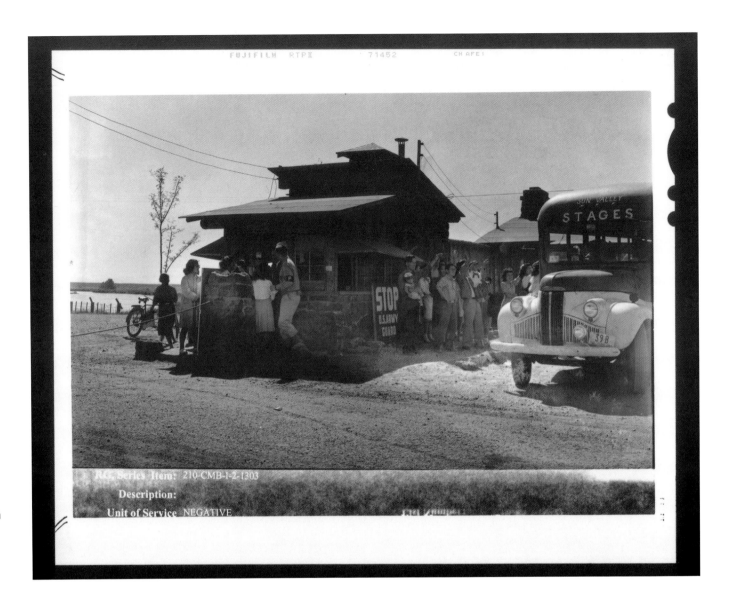

Circa 1942-1945
Minidoka War Relocation
Center, Hunt, Idaho
Duplicate 4x5 negative.
National Archives Photo
No. 210-CMB-I2-1303

"**AS WE PASSED** through the gate at noon we were stopped by the guard who demanded to see our passes. By mistake, I pulled a calling card from my billfold and held it up for inspection. We were waved on. I thought how easy it would be to forge a pass if all inspections were like this one." — Arthur Kleinkopf, *Relocation Center Diary: 1942-1946,* Dec. 17, 1942 entry, p. 22

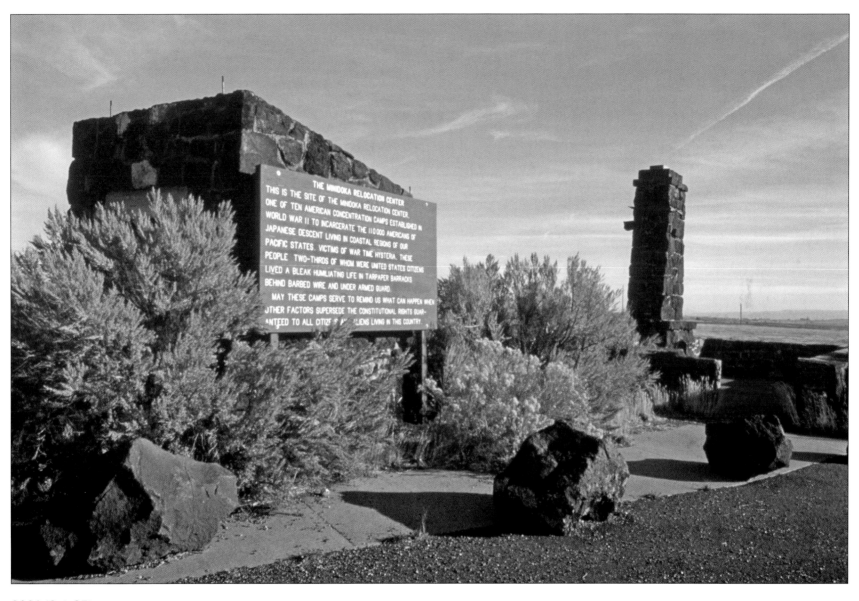

THE MINIDOKA RELOCATION CENTER

THIS IS THE SITE OF THE MINIDOKA RELOCATION CENTER,
ONE OF TEN AMERICAN CONCENTRATION CAMPS ESTABLISHED IN
WORLD WAR II TO INCARCERATE THE 110,000 AMERICANS OF
JAPANESE DESCENT LIVING IN COASTAL REGIONS OF OUR
PACIFIC STATES. VICTIMS OF WAR TIME HYSTERIA, THESE
PEOPLE, TWO-THIRDS OF WHOM WERE UNITED STATES CITIZENS,
LIVED A BLEAK HUMILIATING LIFE IN TARPAPER BARRACKS
BEHIND BARBED WIRE AND UNDER ARMED GUARD.

MAY THESE CAMPS SERVE TO REMIND US WHAT CAN HAPPEN WHEN
OTHER FACTORS SUPERSEDE THE CONSTITUTIONAL RIGHTS GUAR-
ANTEED TO ALL CITIZENS AND ALIENS LIVING IN THIS COUNTRY.

2001 (Oct. 25)
Jerome, Idaho
Color 35mm slide, digital scan converted to B&W

THE ENTRANCE to the Minidoka National Historic Site is in the same location as it was during World War II. The sign hanging on the side of the Gate House, left, was removed in 2002 because it was not an original feature. The Gate House and Reception Building, background right, were made of basalt quarried from the area. The chimney is 16 feet high.

68

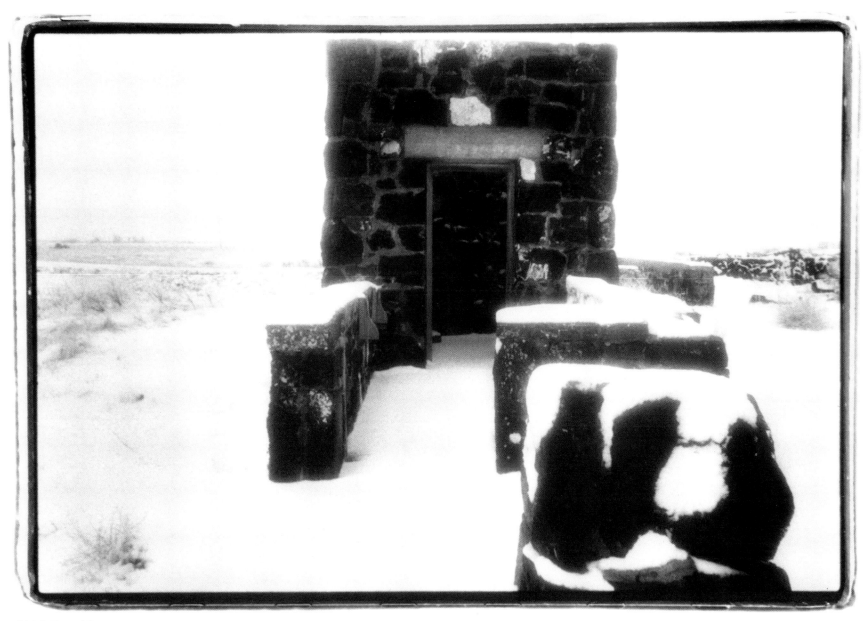

2006 (Jan. 17)
Jerome, Idaho
B&W 35mm infrared film

"WHEN SNOW FELL, drifting into soft dunes and caught on roof tops [sic], benches, sagebrush, and the branches of trees, Minidoka was transformed from a dreary gray arrangement of repeated barracks into a sparkling fairyland. . . . The temperatures went down to zero but nature provided a view to warm the heart." — Jack Yamaguchi, *This Was Minidoka,* 1989, p. 25

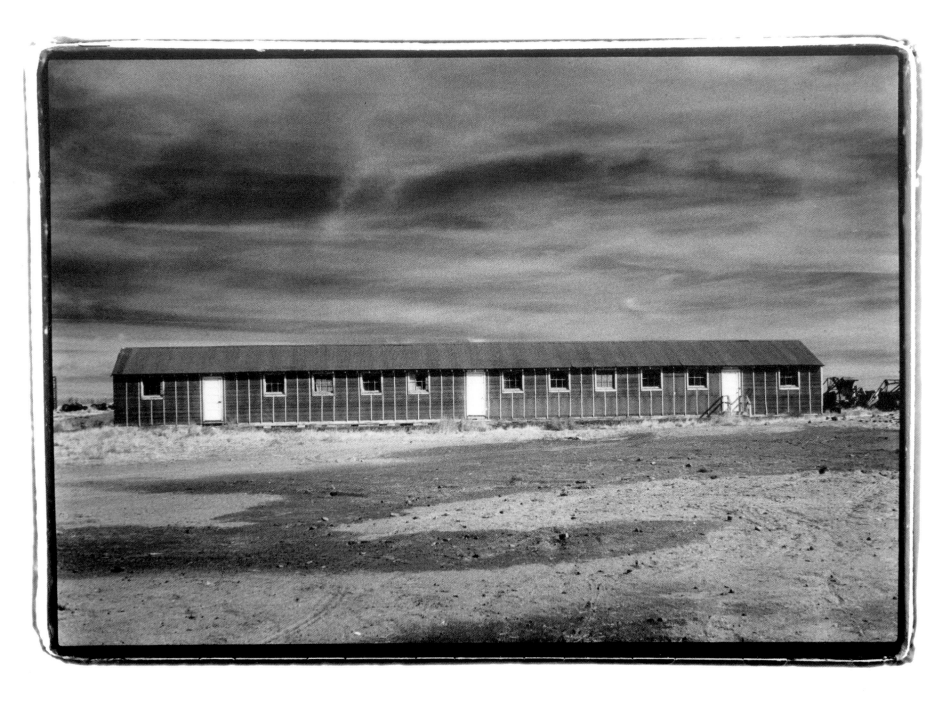

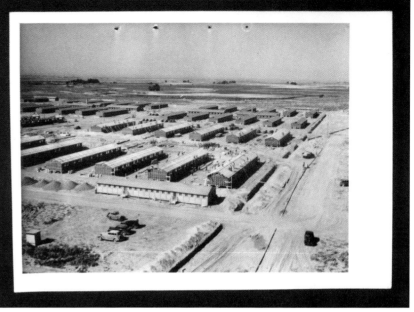

1942 (Aug. 18)
Minidoka War Relocation Center, Hunt, Idaho
Copy photo, 120 film taken June 4, 2005, College Park, Maryland.
National Archives Photo No. 210-G-D104
Photo by Francis Stewart, WRA

1942 (Aug. 18)
Minidoka War Relocation Center, Hunt, Idaho
Copy photo, 120 film taken June 4, 2005, College Park, Maryland.
National Archives Photo No. 210-G-D108
Photo by Francis Stewart, WRA

IN 1942, Morrison Knudsen Corp. of Boise was awarded a $4.6 million contract to construct the barracks, hospital and administrative buildings at Minidoka, as well as the roads and railroads leading to the camp.

Each barrack measured 20-by-120 feet and was divided into six apartment units. Twelve barracks created a block; the incarerees lived in 36 blocks which spanned a width of three miles.

After World War II, several of the barracks were moved from Minidoka to a labor camp in Jerome, Idaho. In 1999, two of the barracks were relocated at a cost of $5,000 each to the Idaho Farm and Ranch Museum (IFARM), also in Jerome.

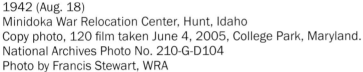

2001 (Oct. 25)
IFARM, Jerome, Idaho
B&W 35mm infrared film

"COULD WE DO any less and be Americans? Could we do any more and be fair to the taxpayers?" — unnamed Army tour guide quoted in "Nothing Luxurious or Fancy at Jap Camp," *Times-News,* Aug. 14, 1942, p. 7

"THERE WAS A FAMILY of nine in a one-room apartment, size 20 ft. by 20 ft." — Arthur Kleinkopf, *Relocation Center Diary: 1942-1946,* Nov. 19, 1942 entry, p. 57

"EACH ROOM was equipped with only cots and blankets. When we left our homes on the West Coast, we were allowed to take only what we could carry with us..." — Thomas Takeuchi, *The Minidoka Interlude,* reprinted 1989 (*The Minidoka Interlude* is a "souvenir annual" of group portraits, candid scenes and recollections from the camp. The yearbook was reprinted with an introduction by Takeuchi 45 years after it was created. He was the editor.)

2002 (March 15)
IFARM, Jerome, Idaho
B&W 35mm Tech-Pan film

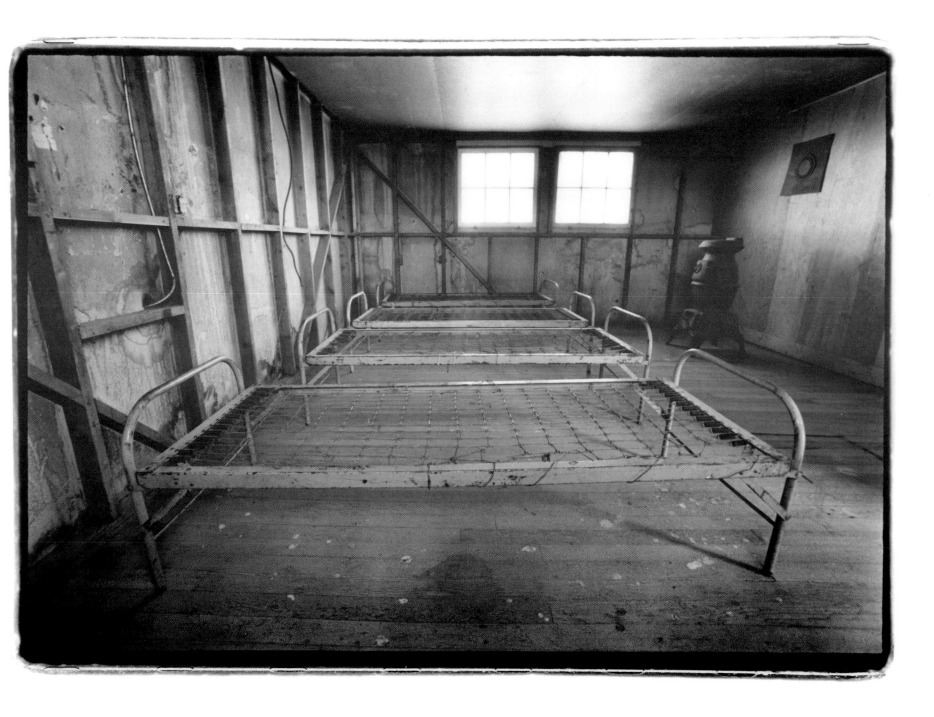

AUGUST 16 (1942) — "Main movement of evacuees sweats into camp at rate of 500 a day. Choice wood disappears from lumber pile under cover of darkness. Same wood makes auspicious debut a few days later re-named cabinets, tables and chairs in resident apartments." — "Looking Back Through the Files," *Minidoka Irrigator*, Vol. III, no. 31, Sat. Sept. 25, 1943, p. 4

THESE CHAIRS WERE DESIGNED for children and constructed of scrap wood from the Minidoka War Relocation Center. The chairs were given away when the center was closed. The set pictured here was donated to the Jerome County Historical Museum by a Caucasian woman who wishes to remain anonymous. The handmade chairs are on loan to IFARM in Jerome.

2002 (March 15)
Jerome, Idaho
B&W 35mm Tech-Pan film

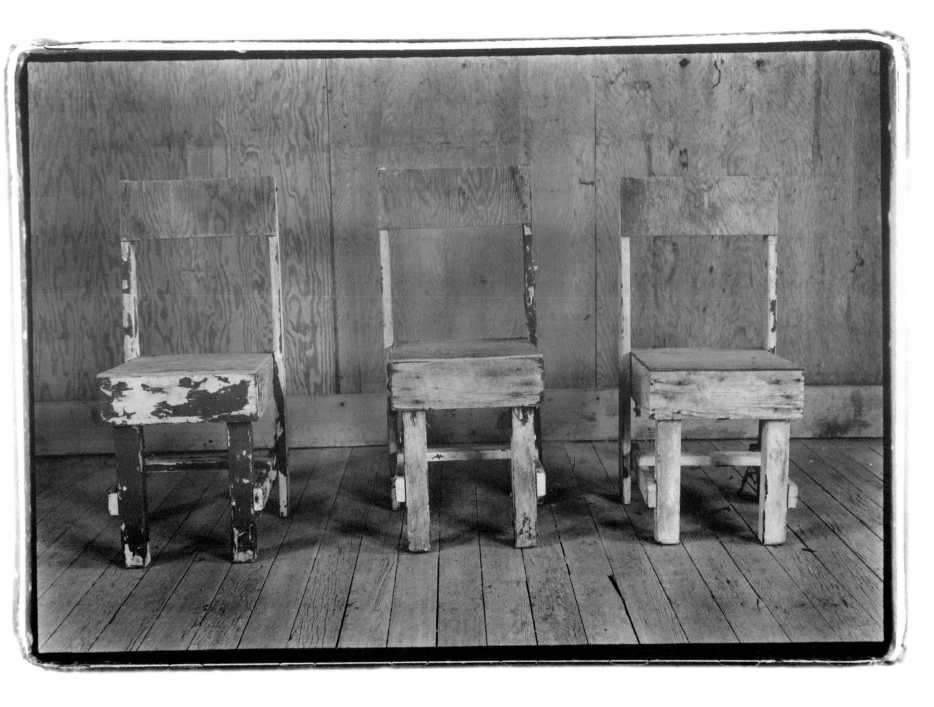

THIS HOUSE, once a barrack at the Minidoka War Relocation Center, is located directly across the street from the old main gate to the site. Carl Aberle leased the property in 1991 from T.C. Robison, the original homesteader of the property after Minidoka was closed. Aberle and his son, Carl Jr., lived in the house.

Aberle used another barrack on the property as a dairy barn for cows and winter shelter for calves. A fire destroyed a third barrack in the fall of 2000. Aberle and his son moved to North Dakota in the summer of 2003, and another tenant took over the property.

The Conservation Fund purchased the 98-acre property in December 2008. Nine acres, including the repurposed barracks, were conveyed to the National Park Service in December 2010 as an addition to the Minidoka National Historic Site. The remaining 89 acres were sold to a private buyer and became part of a conservation easement which may be transferred to the NPS at a later date.

2001 (Nov. 11)
Jerome, Idaho
B&W 35mm infrared film

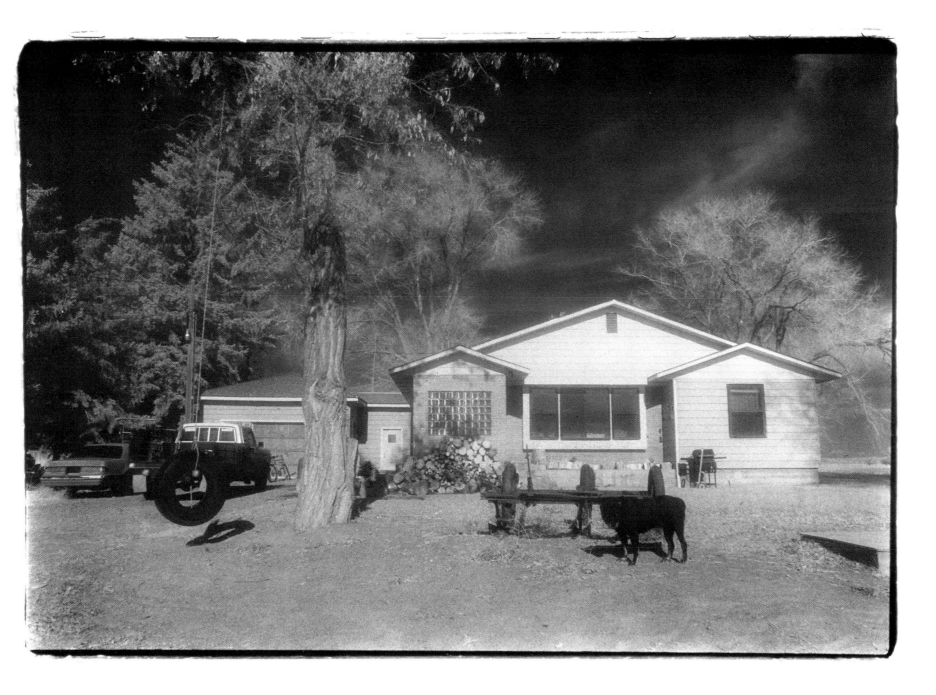

A SIX-ACRE PARCEL of the former Minidoka War Relocation Center was dedicated in a public ceremony on Aug. 18, 1979, after being listed on the National Register of Historic Places. The property formerly owned by T.C. Robison is seen in the background across the road.

Eleven years later, the Minidoka War Relocation Center was named an Idaho Centennial Site.

President Bill Clinton signed a proclamation in 2001 designating 72.75 acres of the original site as the Minidoka Internment National Monument. Five years later, representatives of the National Park Service asked members of Congress to remove "internment" from the name. "The agency says it's a legal term that does not accurately reflect the U.S. government's imprisonment of thousands of American citizens simply because they were of Japanese descent," Christopher Smith reported in an Associated Press story on July 1, 2006.

In 2008 the Minidoka Internment National Monument became the Minidoka National Historic Site.

2001 (Nov. 11)
Jerome, Idaho
B&W 35mm infrared film

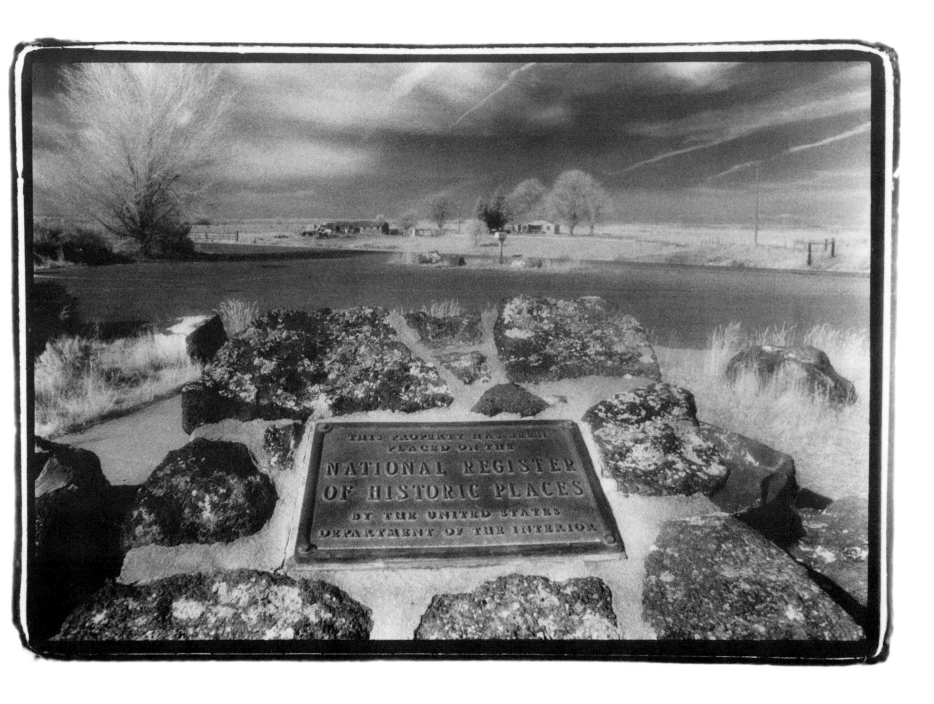

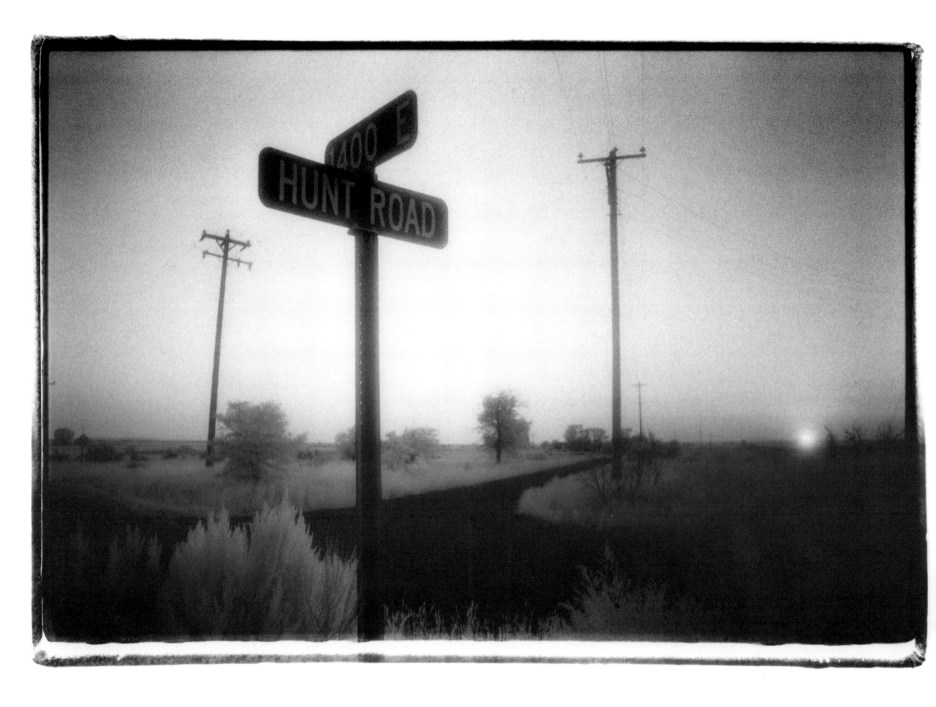

HUNT ROAD was constructed and paved by the Jerome County highway department in the 1950s after the Minidoka War Relocation Center was closed. The dirt lane in the background used to be the main "entrance road" through the historic site. Only 300 feet of the original lane remains and is now a service road to the Herrmann homestead.

2002 (Aug. 5)
Jerome, Idaho
B&W 35mm infrared film

2002 (June 12)
Jerome, Idaho
B&W 35mm infrared film

A STORAGE CELLAR for root crops such as potatoes was constructed by incarcerees at Minidoka in 1943, less than a mile from the main entrance. Half of the cellar belonged on property later owned by Elfrieda and John Herrmann, original homesteaders and Farm-in-a-Day recipients.

The 30-by-200-foot structure, built partially underground and insulated with tarpaper and straw, was partially restored in 2003. The Conservation Fund and Friends of Minidoka purchased the 128-acre Herrmann property in 2006. The property became part of the National Park Service site in December 2010. The entire structure is now part of the Minidoka National Historic Site.

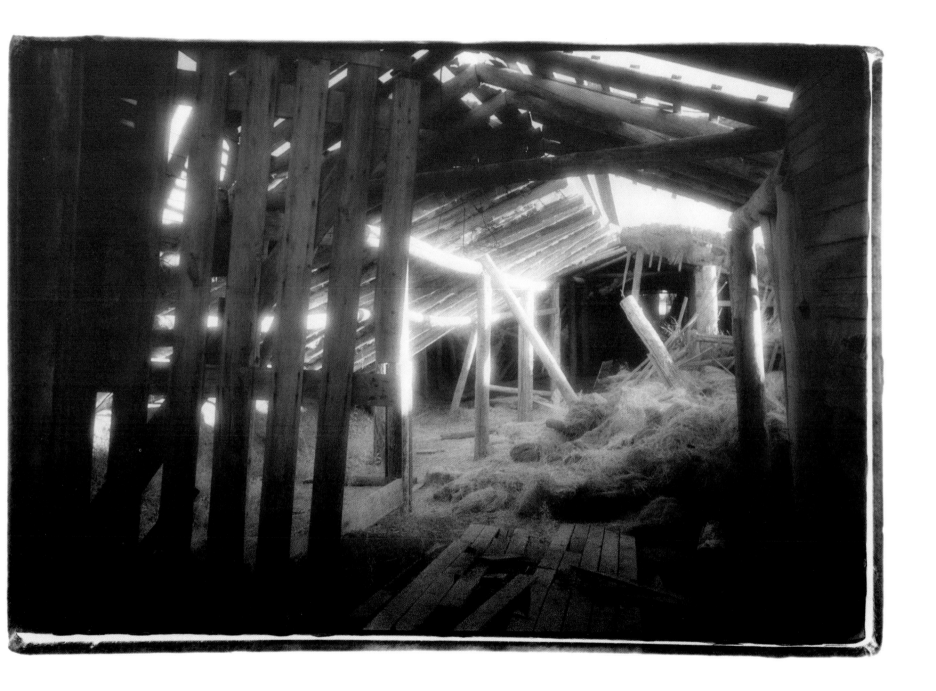

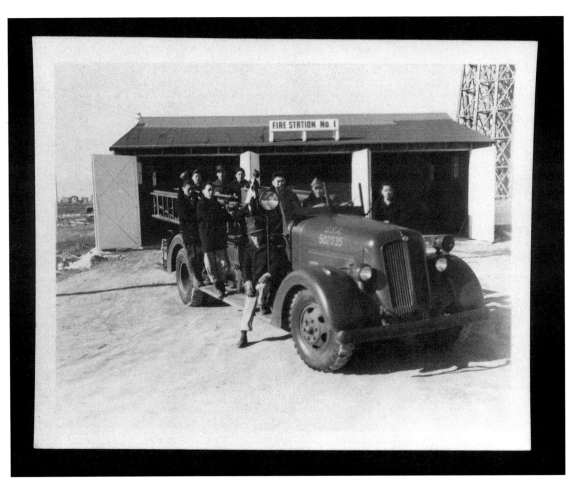

Circa 1942-1945
Minidoka War Relocation Center, Hunt, Idaho
Copy photo, 120 film taken June 4, 2005,
College Park, Maryland.National Archives
Photo No. 210-CMA-R1 MK-131

FIRE STATION No. 1 is one of few Minidoka structures that remain in their original location. After World War II, the family of the late John Herrmann, a veteran of WWII and the Korean War, owned the building and 128 acres around it. The fire station served as a storage facility. It is now part of the National Park Service site.

Two fire stations serviced the entire 33,000-acre dentention center. Both stations were operated by volunteers who were incarcerated there. Fire Station No. 1 was located close to administration and staff housing.

2002 (Aug. 1)
Jerome, Idaho
35mm B&W infrared film

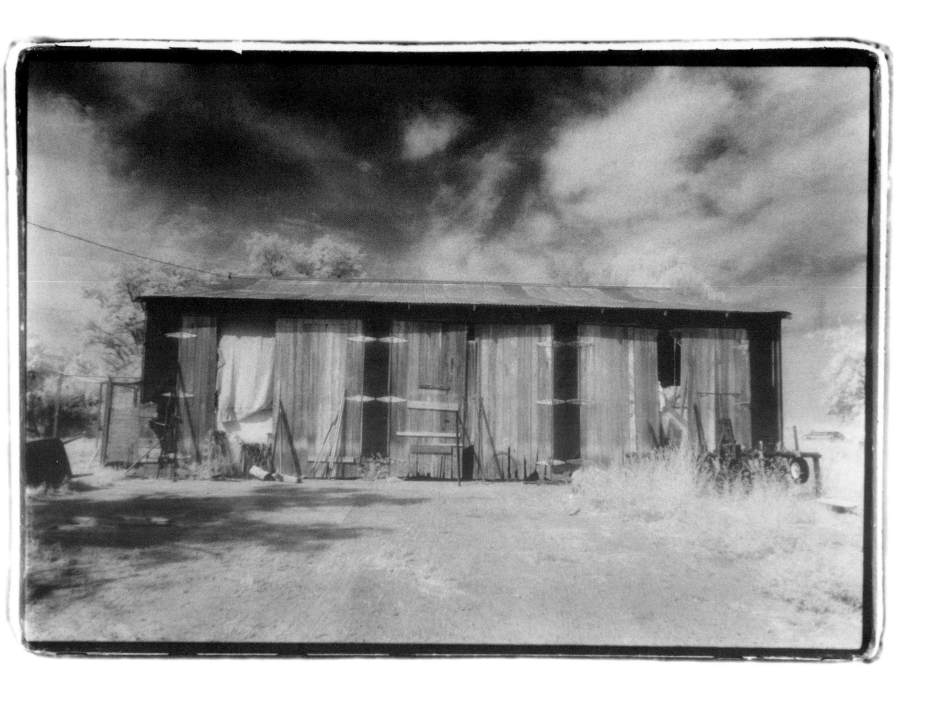

85

WHAT REMAINS OF "Warehouse Building 5" is thought to be in its original location. According to the NPS General Management Plan, this structure, originally the Motor Repair and Tire Shop, will be used for an interpretive center and visitor services.

The warehouse and three other historic buildings were on ten acres of U.S. Bureau of Reclamation land. In 2006 Sen. Mike Crapo, R-Idaho, sponsored legislation to transfer the property. "I ask my colleagues to join me in enacting this small land transfer that we might move a step closer toward properly memorializing an important but often forgotten chapter of our nation's history," Crapo said from the U.S. Senate floor.

2004 (June 25)
Jerome, Idaho
B&W 35mm infrared film

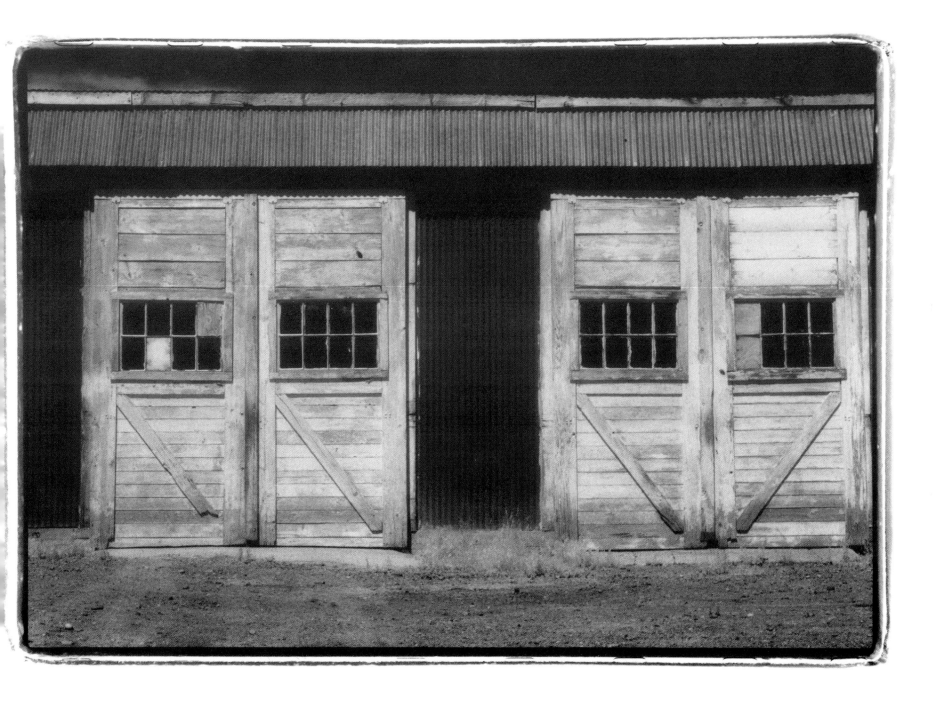

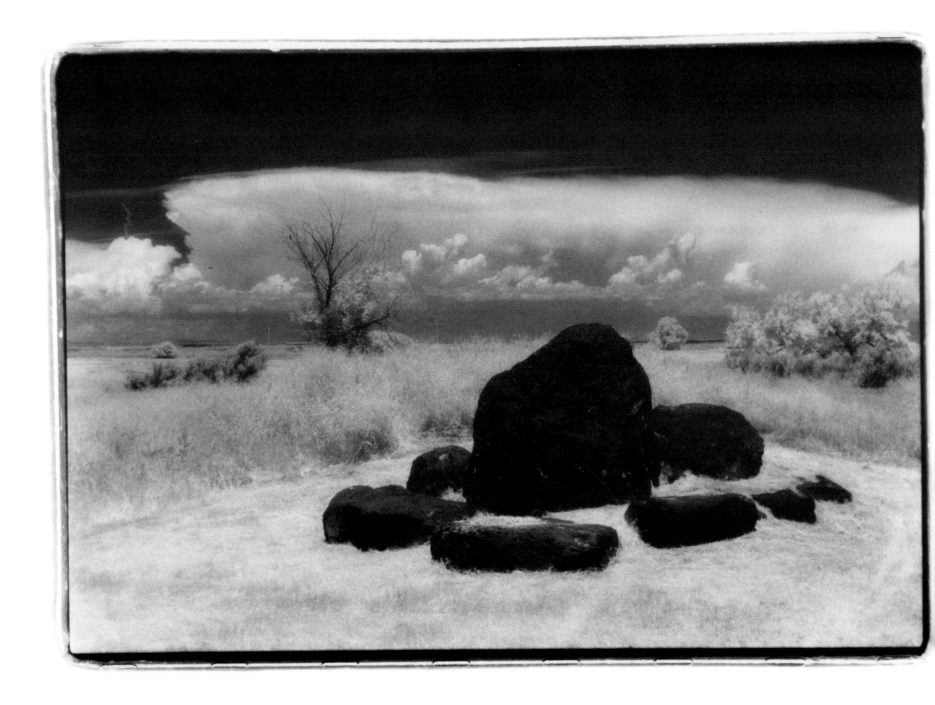

A JAPANESE-STYLE ROCK GARDEN near the main entrance to the Minidoka War Relocation Center remains as it was designed more than seventy years ago. The basalt boulder formation is the last remaining rock garden on the original historic site.

Research conducted by Anna Tamura (no relation to author) confirms that the rock garden was part of a community park constructed under the supervision of Fujitaro Kubota. Kubota owned a nursery in the Seattle area and designed what is now Kubota American Japanese Garden, an area landmark there. He was assigned to live in Block 26 at Minidoka.

2004 (June 25)
Jerome, Idaho
B&W 35mm infrared film

2006 (June 22)
Missoula, Montana
120 B&W Tri-X film
Courtesy of The Historical Museum at Fort Missoula, used by
permission. All rights reserved.

"**THE BOARD** could make one of three decisions:
- Internment for the duration of the war.
- Release on parole to return home. [Home being one of the war relocation centers.]
- Unconditional release, which would place the detained man in the 'custody' of an American citizen." — Carol Van Valkenburg, *An Alien Place, The Fort Missoula, Montana, Detention Camp 1941-1944* (p. 60)

THE ALIEN DETENTION CENTER at Fort Missoula is open to the public. The original barrack was moved back to the site in 1995 and houses interpretive displays. L.J. Richards, former senior curator, created the exhibit pictured here.

In the aftermath of the attack on Pearl Harbor, Japanese men who were leaders in their communities or members of groups associated with Japan were immediately arrested and taken from their homes and families. They became wards of the Immigration and Naturalization Service under the U.S. Department of Justice. Those from Seattle went to Fort Missoula, a detention camp for "enemy aliens," where loyalty hearings determined their fate.

The INS controlled Fort Missoula from April 13, 1941, to July 1, 1944. Fort Missoula housed nationals from Italy, Japan and Germany. Its maximum capacity was 2,100. Most of the men from Seattle had families consigned to Minidoka.

2002 (Aug. 25)
Missoula, Montana
B&W 35mm infrared film

90

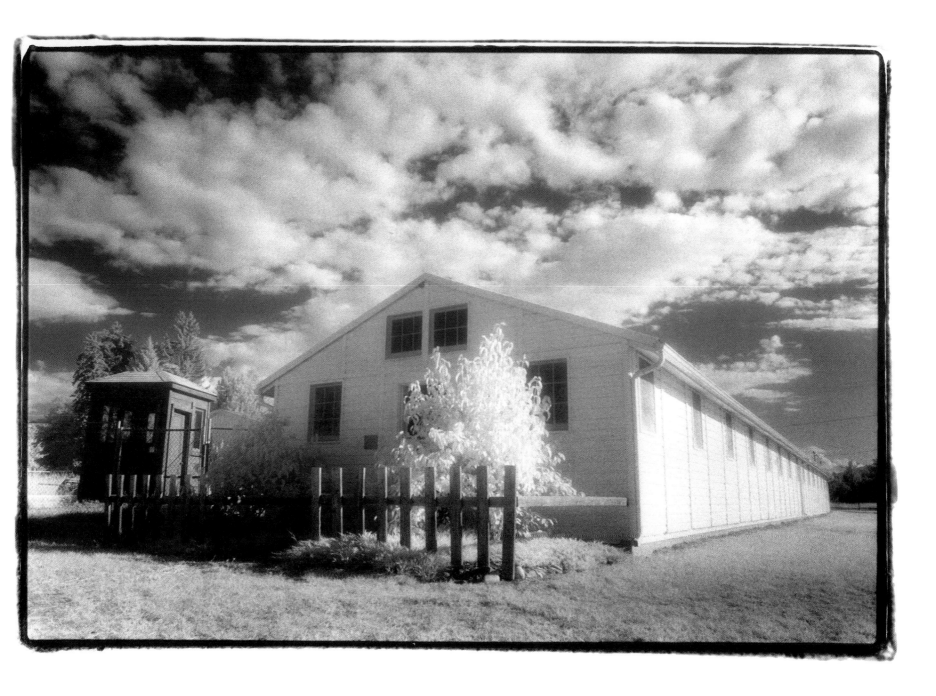

"... **A JAP'S A JAP.** They are a dangerous element, whether loyal or not. There is no way to determine their loyalty. It makes no difference whether he is an American citizen, theoretically. He is still a Japanese and you can't change him." — Lt. Gen. John L. DeWitt, quoted during a House Naval Affairs subcommittee, excerpt from "DeWitt Raps Japanese: Will Fight Return to Pacific Coast," *Minidoka Irrigator*, April 17, 1943, p. 1

"WHILE NEWSPAPERS AND MAGAZINES were provided relatively free access in their coverage of the evacuation procedure, by the time the assembly centers and then the concentration camps were in full operation, the images were strictly controlled by the military and the WRA [War Relocation Authority]." — Karen Higa and Tim B. Wride, "Manzanar Inside and Out: Photo Documentation of the Japanese Wartime Incarceration," *Reading California: Art, Image, and Identity, 1900-2000,* (2000), p. 317

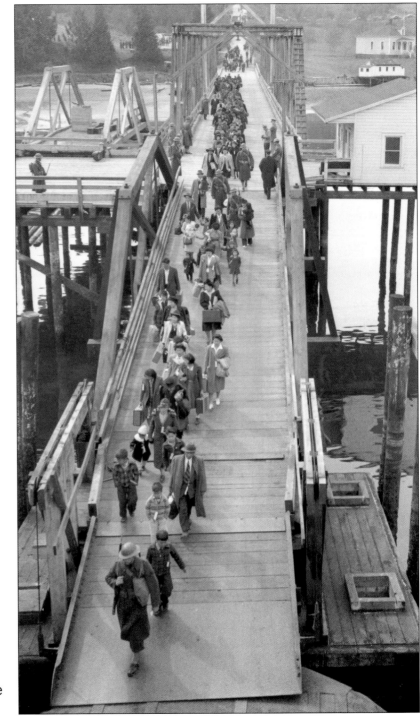

1942 (March 30)
Bainbridge Island, Washington
Duplicate photo P128053
Courtesy *Seattle Post-Intelligencer* Collection,
Museum of History and Industry, Seattle, Washington

A *SEATTLE POST-INTELLIGENCER* photograph captures the
forced removal of *Nikkei* from Bainbridge Island, Washington.
Kitamoto is the small child in dark clothes in the middle-left
area of the photo. Directly behind him, his mother carries one
sister. His other sister, partially hidden behind another adult, is
seen only as an outstretched arm holding her mother's hand.
Related photos from the forced removal were published on Page
7 of the March 31, 1942 edition of the *Post-Intelligencer*.

2002 (Aug. 8)
Bainbridge Island, Washington
120 B&W Tri-X film

FRANK KITAMOTO, a dentist on Bainbridge Island, Washington, helped spearhead an effort to erect a granite memorial near the Bainbridge site where, on March 30, 1942, his mother, her children and the rest of the Japanese and Japanese American community on the island were loaded onto a ferry and relocated to the Manzanar War Relocation Center in California.

Kitamoto keeps old photographs that document the "evacuation" and march down Taylor Avenue to the old Eaglesdale Ferry Dock on Bainbridge. He was a 2-year-old toddler at the time. His father had already been shipped to Fort Missoula in Montana; his mother was left to care for a son and three daughters. In 1943 the family was reunited at Minidoka.

In 2008, the *Nidoto Nai Yoni* (Let It Not Happen Again) Memorial on Bainbridge Island was designated a national historic site as a satellite unit of the Minidoka National Historic Site.

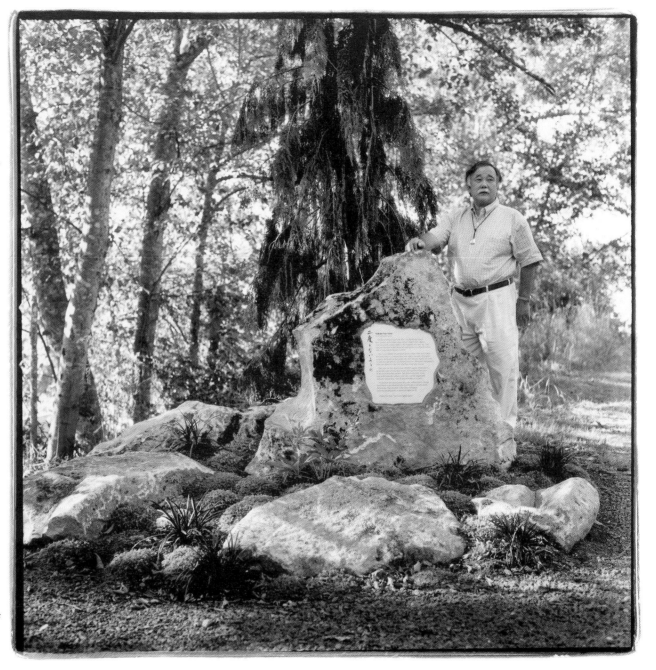

95

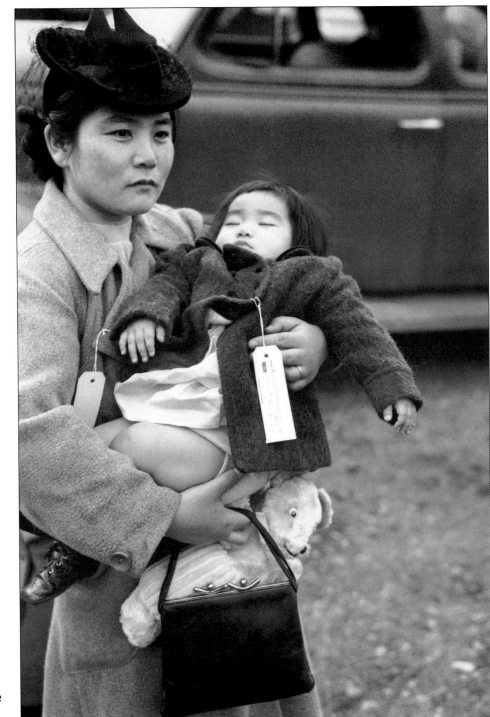

1942 (March 30)
Bainbridge Island, Washington
Duplicate photo P128050
Courtesy *Seattle Post-Intelligencer* Collection,
Museum of History and Industry, Seattle, Washington

FUMIKO HAYASHIDA, left, holds her 1-year-old daughter, Kayo Natalie, during the forced removal of Japanese and Japanese Americans from Bainbridge Island, Washington. The image was not published in the *Seattle Post-Intelligencer's* original coverage of the event but has since been reproduced in books and newspapers and used in the movie *Snow Falling on Cedars*. Fumiko Hayashida was pregnant with her third child, Saturo Leonard, who was born on Aug. 14, 1942 in the Manzanar War Relocation Center in California. Hayashida and her children were transferred to Minidoka in February 1943.

2003 (Aug. 2)
120 B&W Tri-X film
Seattle, Washington

FUMIKO HAYASHIDA and her daughter, Kayo Natalie Ong, at the "Minidoka Remembered" reunion in Seattle, Washington, August 2003.

Fumiko Hayashida was born on Bainbridge Island, Washington, on Jan. 21, 1911. When she was 95, she testified before a House subcommittee in Washington, D.C., in support of legislation designating the Bainbridge memorial as a national monument. Three years later she was honored by the Seattle chapter of the Japanese American Citizens League (JACL) for raising awareness about the denial of civil rights to some 110,000 people of Japanese ethnicity. At 100, she was among a group from the Only What We Can Carry (OWWCC) project who shared their experiences as part of an educational event at the Manzanar National Historic Site.

Her daughter, Natalie Ong, served for 12 years on the city council of El Lago, Texas, where she lives with her husband, Al. They adopted two children and now have three grandchildren. Natalie has no memories of Minidoka or Manzanar.

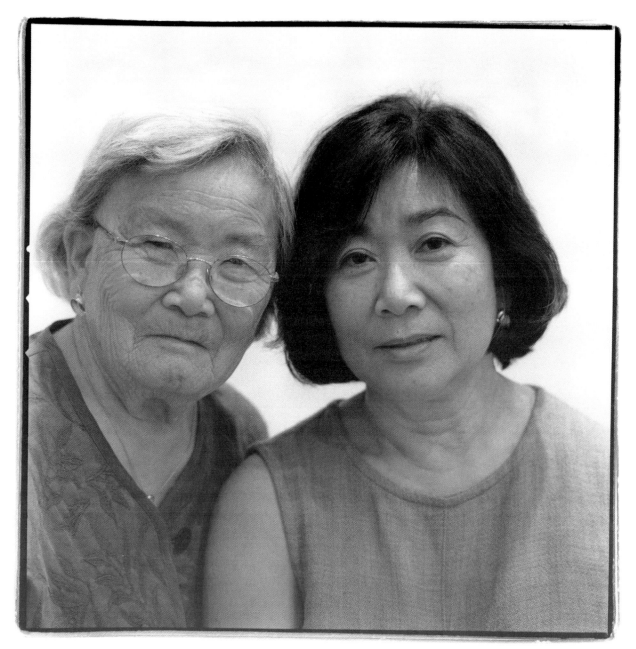

2002 (Aug. 9)
Seattle, Washington
120 B&W Tri-X film

TAKASHI HORI was 24 when "evacuation" signs were posted around Seattle. Frantic friends and neighbors, unable to take all of their possessions with them, asked his family to store items in the basement of their property, the Panama Hotel (in background). The Horis gladly obliged.

After the war, many items remained unclaimed. When Hori sold the Panama Hotel in 1985, he offered to clear out the basement for new owner Jan Johnson. She declined, recognizing the historical significance of the family possessions. Many of the items remain at the hotel today.

Sabro Ozasa, Seattle's first Japanese architect and a graduate of the University of Washington, designed and built the hotel in 1910.

Jamie Ford's historical fiction best seller, *Hotel on the Corner of Bitter and Sweet (2009),* features the Panama Hotel.

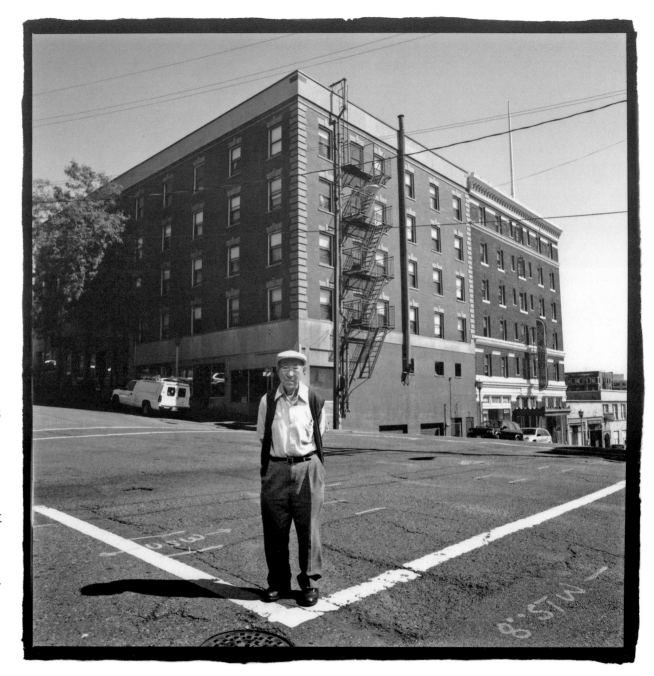

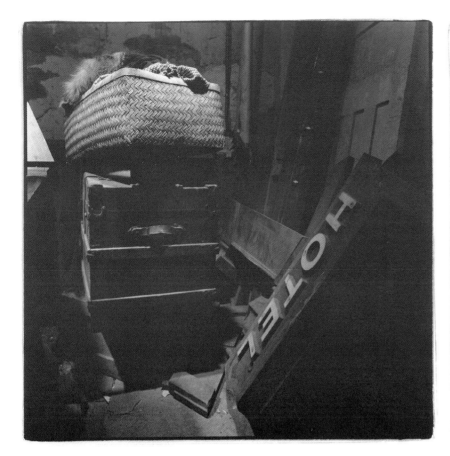

2003 (Aug. 5)
Seattle, Washington
120 B&W Tri-X film

JAN JOHNSON opened a teahouse in the Panama Hotel. A hole was cut in the floor and covered with plexiglass to provide a window into the basement where unclaimed possessions can be seen (left). Common household items (right) still remain in the basement.

"**MY FAMILY** with nine children departed beloved Seattle on May 18, 1942, and entered Puyallup. After that, our happy family life was all broken up. We retired every night with the ten o'clock bugle, but I could not sleep from thinking of the children's future and the deep sorrow in my heart." — Theresa Hotoru Matsudaira, 1981

THE FAIRGROUNDS in Puyallup, Washington, served as a temporary assembly center called Camp Harmony. Thousands of *Nikkei* from Washington and Alaska lived there through the summer of 1942. Theresa Hotoru (Umeda) Matsudaira was among them. Her transfer from Puyallup to Minidoka was delayed until she delivered her daughter, Ida, on Sept. 3, 1942.

In testimony for the U.S. Commission on Wartime Relocation and Internment of Civilians on Sept. 10, 1981, Matsudaira noted that Theresa was her baptismal name. She was a devout Roman Catholic convert, an *Issei* who immigrated to America in 1921 as the 19-year-old bride of Thomas Tokuhisha Matsudaira. Before the war, "Tommy" worked for the Kodiak Company salmon cannery and as an "opener" for a Japanese oyster company on an Indian reservation.

After their incarceration in Idaho, the Matsudairas returned to Seattle. "We had a house in Seattle, poor as it was, so on March 14, 1945, we came home with our new baby and a 90-year-old man who came from Yamaguchi-ken, Japan, whom we had met through [a] friend. When we reached home, the house had been burglarized and there was not a thing left."

The *Seattle Times* published a feature story, "The Matsudaira Family," on June 14, 1992. The story notes: "[Theresa and Thomas] reared 14 children (11 now alive), putting them all through parochial school. She became a U.S. citizen in 1948 despite speaking no English (she had an interpreter). She was among the first *Issei* to become a U.S. citizen after immigration restrictions were lifted. Husband Thomas became a citizen a few years later. He died in 1967."

This portrait of Matsudaira was included in a special exhibition about Northwest *Nikkei* women in 1994 at the Burke Museum in Seattle. She was 92 at the time, still living in her own home and tending a garden.

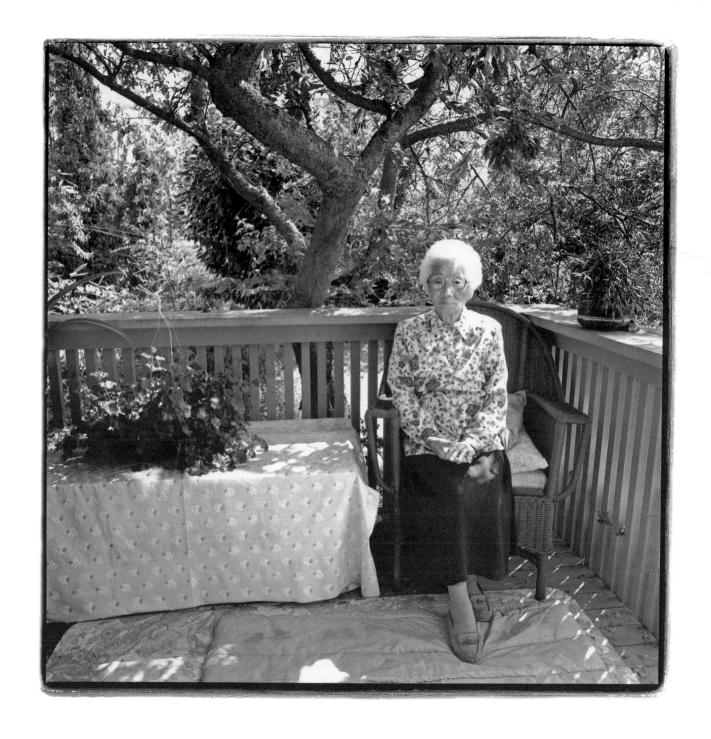

1994 (Aug. 18)
120 B&W T-Max 400 film
Seattle, Washington

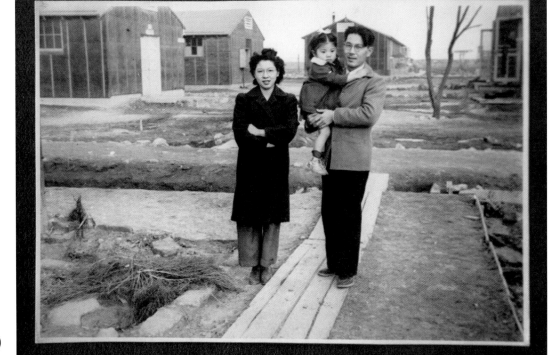

Circa 1944
Minidoka War Relocation Center, Hunt, Idaho
Courtesy Fumiye (Betty) Ito
Copy photo, 35mm digital taken April 26, 2008,
Alhambra, California

FAMILY PHOTOS were rarely taken at the
Minidoka War Relocation Center because
cameras were banned. A visitor took this
photograph. From left to right: Fumiye (Betty)
Ito, Ayleen Ito Lee and Kenji Ito.

FUMIYE (BETTY) ITO saved a scrapbook of newspaper clippings documenting the trial of her husband, Kenji Ito, a Seattle-born attorney and University of Washington graduate. Kenji was charged with "acting as an agent for Japan without registering as such with the State Department." He was acquitted on April Fools' Day — just before he and his family were forced to leave Seattle.

The family was sent to Camp Harmony in Puyallup, Washington, before being transferred to Tule Lake, a relocation center in northern California. The family requested a transfer to Minidoka to be with Fumiye's parents and family, and it was granted. Their second child, Glenna, was born at Minidoka.

Kenji was encouraged by friends to practice law in California. After Minidoka closed, he and Fumiye started a new life in Southern California. The couple had two more children.

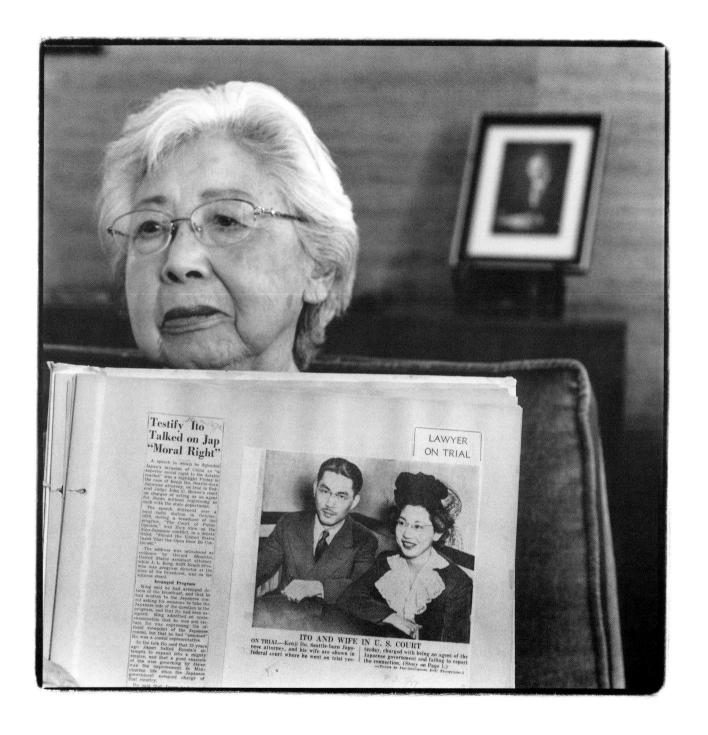

2008 (April 26)
Alhambra, California
120 B&W Tri-X film

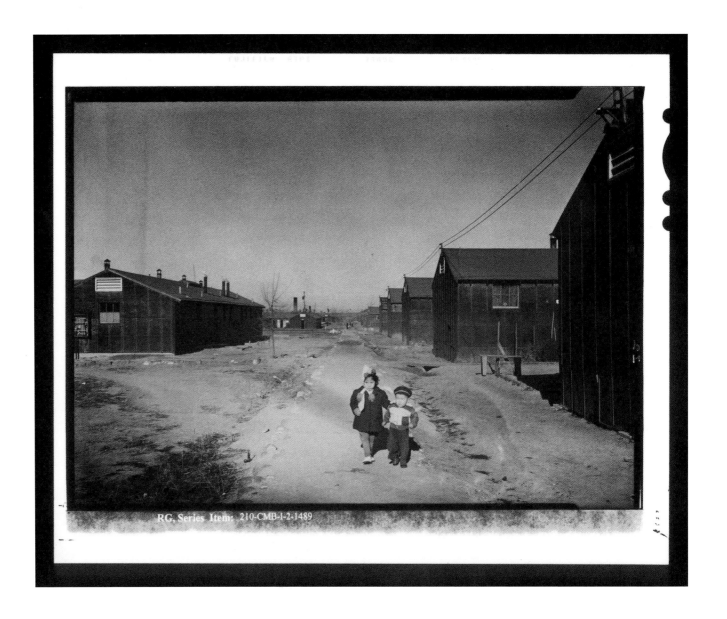

RG. Series Item: 210-CMB-1-2-1489

Circa 1943-1945
Minidoka War Relocation
Center, Hunt, Idaho
Duplicate negative
National Archives Photo
No. 210-CMB-1-1-1489

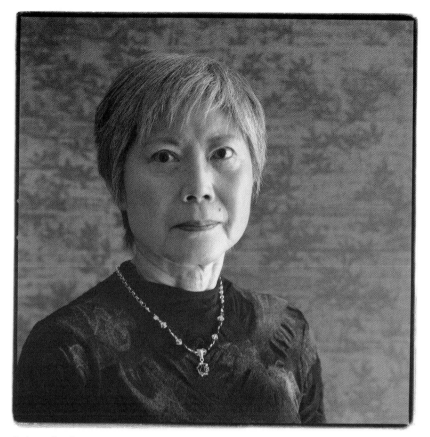

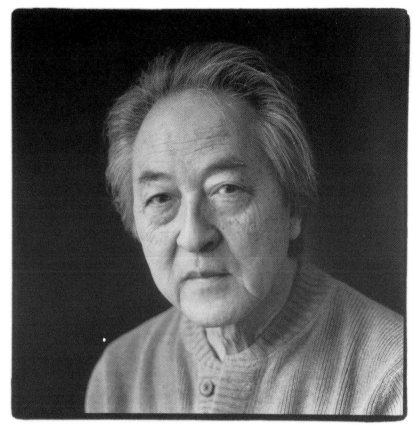

Ayleen Ito Lee
2008 (April 26)
Alhambra, California
120 B&W Tri-X film

Ken Yamaguchi
2010 (Jan. 29)
Renton, Washington
120 B&W Tri-X film

AYLEEN ITO LEE and Ken Yamaguchi were neighbors in Block 44 at Minidoka. Ken's father, Jack Yamaguchi, worked as business manager of the camp newspaper, the *Minidoka Irrigator*. Jack received special permission to use a camera, as taking pictures was restricted in Minidoka. Ayleen and Ken are the children in the archival photo taken by Jack.

Ayleen was born in Seattle; her family moved to California after their incarceration. Though her father never talked about Minidoka, and she was too young to remember living there, her father's pictures and her mother's stories were her proof. She graduated from Stanford Law School in 1981 and worked at Dorsey & Whitney LLP in Palo Alto, California, specializing in technology and corporate transactions primarily in Silicon Valley. In 2010 she joined Royse Law Firm, PC.

Ken was born on June 25, 1943, in Minidoka. When his parents were alive, they pointed out that he was the boy in the archival photo, a duplicate of which they kept in a scrapbook at home. A Vietnam veteran, Ken worked as a manufacturing engineer for Paccar in Bellevue, Washington, for twenty-three years before he retired in 2000.

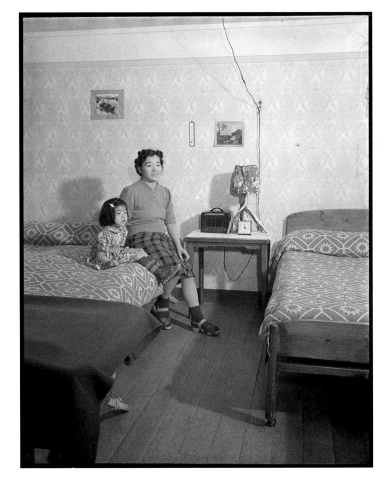

1942 (Dec. 9)
Minidoka War Relocation Center, Hunt, Idaho
Digital copy photo emailed Aug. 20, 2012.
National Archives Photo No. 210-G-A775
Photo by Francis Stewart, WRA

"MINIDOKA RELOCATION CENTER. Mrs. Eizo Nishi, and Eime, four, daughter. All the furniture in this evacuee apartment was constructed from scrap material. The wall paper [sic], drapes and other furnishings were purchased from a mail-order house." (War Relocation Authority caption)

EMIKO (AMY) NISHI KAWAMOTO was 3 years old when she and her family were sent to Minidoka. They lived in Block 36, Barrack 7C. Kawamoto still remembers skating inside the barrack and bumping into the potbelly stove in the laundry room, burning her chin. She also recalls victory gardens, amateur talent shows, baseball games (with her father on the field), the howls of coyotes at night and a rattlesnake in the sagebrush. "Because I was so young, I was not aware of the gravity of the situation. . . . I must give praise to all those who helped make everyday life bearable," Kawamoto later wrote in an essay for a Minidoka reunion.

Her mother, Hiroko (Yorioka), was a *Kibei*, an American citizen educated in Japan. When she married Eizo Nishi, an illegal immigrant in 1929, she lost her U.S. citizenship. The couple stayed in Seattle and leased and operated the OK Hotel. After the war, they moved to the Chicago area, where they leased and operated another hotel before buying their own property. In 1953, Hiroko and Eizo applied for and became U.S. citizens.

Amy remained in the Chicago area and married Morris Kawamoto. Their son will take over the business they own and operate. (The characters on the necklace Amy is wearing in the photo at right are in *hiragana*, indicating "E-mi-ko.")

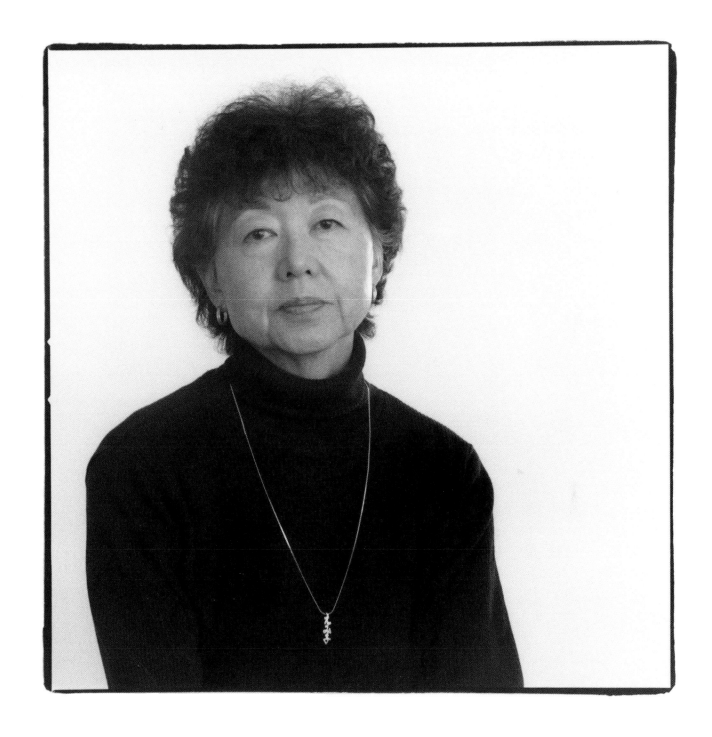

2006 (Oct. 5)
Lincolnwood, Illinois
120 B&W Tri-X film

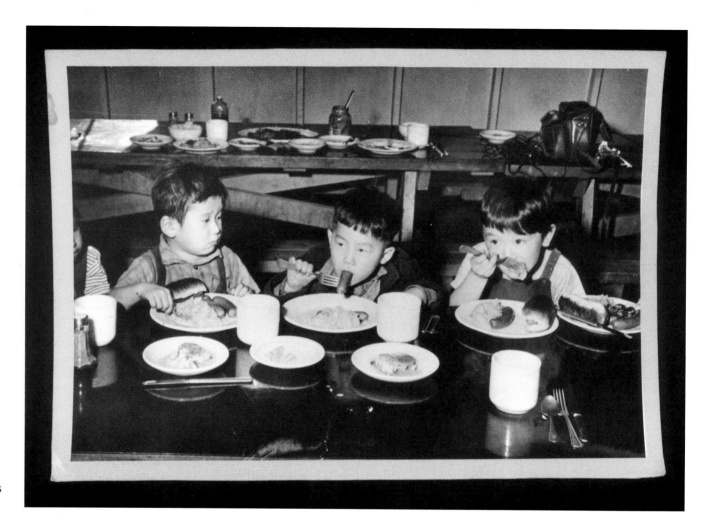

Published 1944 (Dec.23)
Minidoka War Relocation
Center, Hunt, Idaho
Copy photo, 120 film taken
June 4, 2005, College Park,
Maryland. National Archives
Photo No. 210-CMA-CA-7

"**CONSIDERED ONE OF THE BEST** pictures of the year, the appealing photo above catches the youngsters in the midst of consuming their noon meal of wieners and spuds. The tyke on the left seems to be wondering at the rapid disappearing act of the wiener and having doubts about the general taste of it. Evidently the two other boys are too hungry to wait. Forks are so darn inconvenient . . . why can't we use hands?"— *The Minidoka Irrigator,* Dec. 23, 1944, p. 2

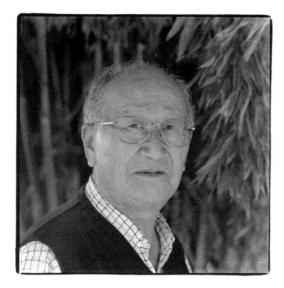

Gordon Hirai
2009 (Oct. 11)
Seattle, Washington
120 B&W Tri-X film

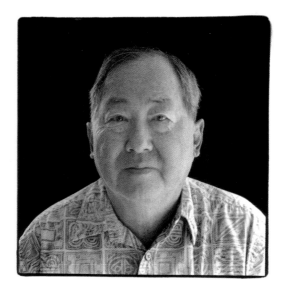

Taro Ogawa
2010 (Feb. 28)
Fountain Valley, California
120 B&W Tri-X film

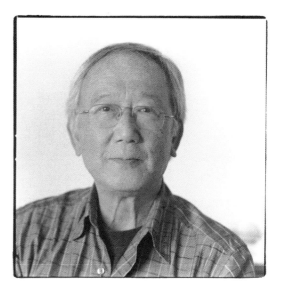

Tom Hirai Jr.
2009 (Oct. 11)
Seattle, Washington
120 B&W Tri-X film

THE CHILDREN in *The Minidoka Irrigator* photo are (from left to right): Gordon Hirai, Taro Ogawa and Tom Hirai Jr. The boys lived in the same block — Block 10 — but in different barracks. Gordon and Tom are *Sansei*, third-generation Japanese Americans. The Hirai brothers live in the Seattle area. Gordon, now retired, was an auto technician for fifty years. Tom Jr. is a commercial artist and has his own silkscreen business.

Before the war, their father, Tom Hirai, operated a greenhouse and nursery with his father. After the war, he worked three jobs to make ends meet.

Taro Ogawa, a *Nisei*, or second-generation Japanese American, lived in Fountain Valley in the Los Angeles area. He received an electrical engineering degree from Washington State University and worked for the Los Angeles Department of Water & Power. He retired after thirty years and cared for his mother during her last years. He died in 2012.

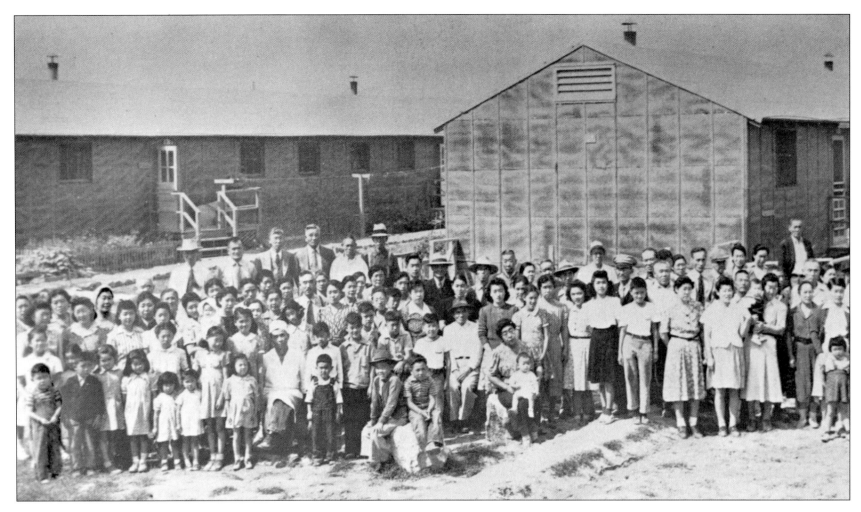

Circa 1943
Minidoka War Relocation Center, Hunt, Idaho
Copy photo, 35mm film taken March 4, 2002, Hailey, Idaho.
The Minidoka Interlude

THIS GROUP PHOTOGRAPH captures the residents of Block 6 at Minidoka. Roger Shimomura, now an internationally acclaimed artist, is the boy standing in the front row, far left, with striped T-shirt and overalls. His grandmother is in the back row, third from the left, wearing a white bandana.

2001 (April 19)
Boise, Idaho
120 B&W Tri-X film

BORN ON JUNE 26, 1939, in Seattle, Roger Shimomura was 3 years old when he and his family were sent to the Minidoka War Relocation Center. A celebrated painter and Distinguished Professor of Art Emeritus at the University of Kansas, Shimomura has created several series of paintings depicting life in the camp.

This picture was taken in April 2001 at the Boise Art Museum in conjunction with Shimomura's exhibition, "An American Diary." The paintings included in the show were based on diaries kept by his grandmother, Toku Machida Shimomura, a picture bride from Japan who immigrated to America in 1912.

Shimomura was recently honored as a U.S.A. Fellow in Visual Art, one of only seven visual artists in the country to have received this distinction.

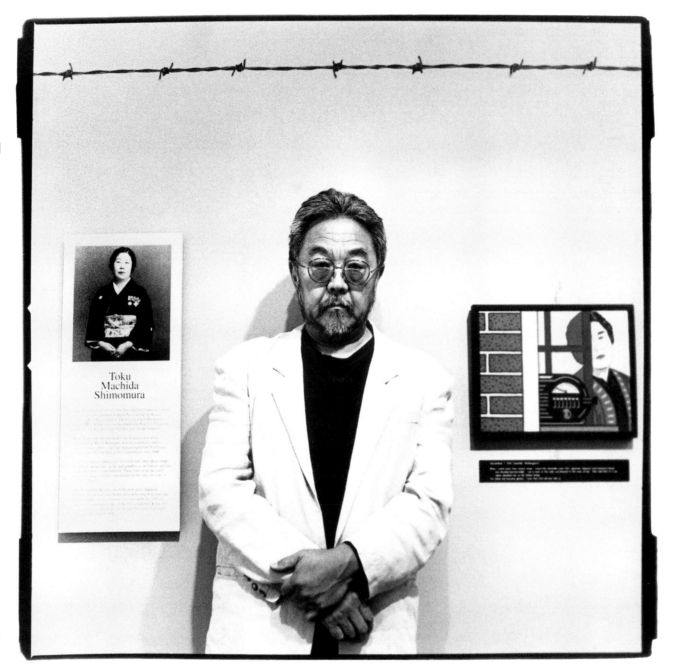

TOO YOUNG TO REMEMBER

Minidoka, Idaho — War Relocation Center

I do not remember the Idaho winter winds,
knee deep mud that oppressed 10,000 souls
or the harsh summer heat and dust.

I do not remember miles of clotheslines,
mounds of soiled diapers, clatter of family crowded
into barracks, the greasy closeness
of canned Vienna sausage,
of pungent pork and sour brine
exuding from the mess halls.

Floating in the amniotic fluid,
tethered in sea salt, odors
nourished by fear and sadness —
my Mother's anxieties
enveloped and nurtured me.

Maybe it was the loss of her home,
the sudden evacuation,
being betrayed by her country.
Or maybe it was the stillborn child
she referred to as It,
sexless blob of malformed tissue,
a thing without a face that would have been
my older sibling.
My aunt described it as *budo*,
a cluster of grapes.

I recall what Barry, my psychiatrist friend,
said about parents emotionally distancing themselves
from children born immediately after a stillbirth.

Sixty years later on drizzly Seattle days,
when November skies are overcast,
and darkness begins at 4 p.m.,
I feel my mother's sadness
sweep over me like a cold wind from Idaho.

I search for Minidoka,
unravel it from the memories of others.
Like a ruined sweater, I untwist the yarn,
strands to weave a tapestry
of pride and determination —
the "children of the rising sun" once banished
to desert prisons, return from exile
with tattered remnants, wave them overhead,
time-shorn banners salvaged from memories
woven in blood and anguish.

I wish I could remember
Minidoka. I would trade
those memories for the fear and sadness
imbedded in my genes.

— Lawrence Matsuda, "Too Young to Remember,"
from *A Cold Wind From Idaho,* published by Black
Lawrence Press (2010)

113

"**DAD NEVER TALKED ABOUT [MINIDOKA],**" poet Lawrence Matsuda said in an Associated Press story about the 2006 pilgrimage to the site. "That was the noble thing to do." Matsuda, whose Japanese name is Utaka, was one of 489 babies born in Minidoka War Relocation Center from 1942 to 1945 (*The Evacuated People: A Quantitative Description,* p. 138). He was too young to remember anything of his own incarceration, but he witnessed the personal losses, struggles and suffering associated with Minidoka after his family returned to Seattle with the closure of the camp.

Matsuda went on to earn a PhD in education and worked for the Seattle School District as a teacher, administrator and principal for twenty-seven years. His collection of poetry, *Cold Wind From Idaho*, was published in 2010. Matsuda also contributed a chapter about growing up in Seattle after World War II in the book *Community and Difference: Teaching, Pluralism, and Social Justice* published in 2005.

The University of Washington Alumni Association (UWAA) honored Matsuda with its Distinguished Service Award in 2004 for his help in founding the Multicultural Alumni Partnership. Matsuda served as the first Asian American president of UWAA and established the UWAA Diversity Committee during his tenure.

Matsuda was also instrumental in the creation of the Japanese American Remembrance Garden, pictured here, on the campus of Seattle University, where he taught.

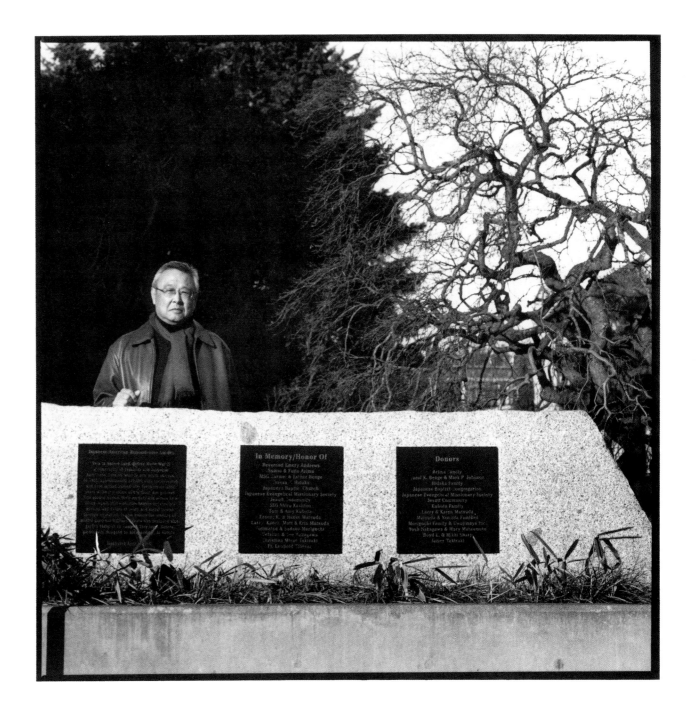

2007 (Nov. 16)
Seattle, Washington
120 B&W Tri-X film

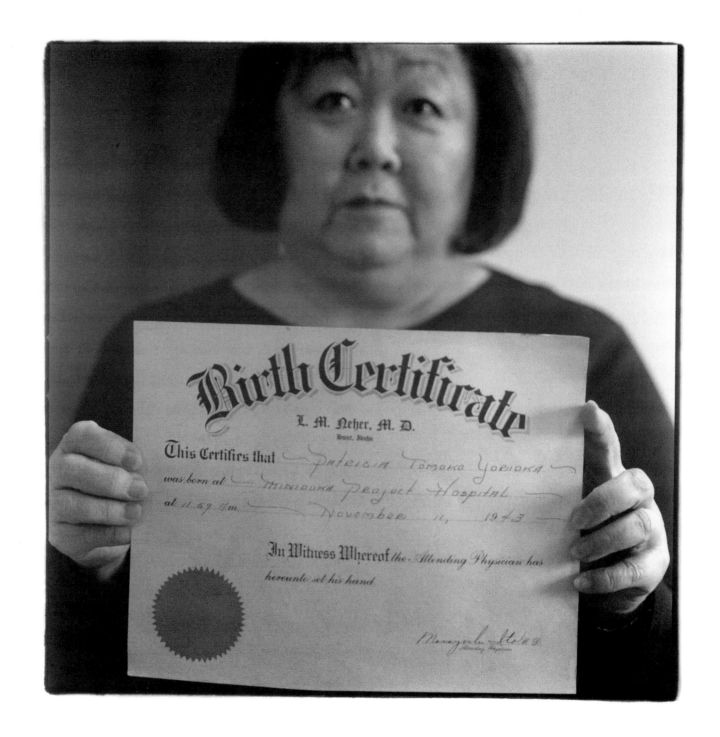

2007 (March 26)
Vancouver, Washington
120 B&W Tri-X film

LIKE OTHERS BORN IN MINIDOKA, Patricia Tomoko Yorioka has no memory of the camp. "But my mother said that I got sick a lot because the milk would be kept in a tub of ice and sometimes would spoil," she recalled.

Her parents, Kengo Yorioka and Chiyeko (Chikata) Yorioka, were both *Kibei*, born in the United States (Seattle) but educated in Japan. They married on Jan. 12, 1940, on Vashon Island, Washington, through an arrangement made by a "go-between."

Patricia was the second of four children, the only one to be born in Idaho. A farmer in Spokane, Washington, sponsored her father, and the family moved there after leaving Minidoka. She earned a Bachelor's degree in education from Eastern Washington University and taught second and third grades on Oahu, Hawaii for twenty-nine years. She retired in 1995 and moved back to the mainland, where she lived with and cared for her parents until their deaths.

Patricia attended pilgrimages to Minidoka in 2010 and 2012. She recounted her experience in 2010 in an e-mail:

"We were told to bring anything that we had from the camp that we may want to share. I had found a picture published in the Twin Falls newspaper of my grandmother (who was a nurse at the Minidoka Hospital) holding a baby that was born in the camp. They had sent the photo to my grandmother with the name of the baby and date. In my haste, I forgot the photo but was able to call my sister and get the name of the baby and the date of birth.

"On the first day, they held a welcoming barbeque at a local park and they passed out our pilgrimage packets with info, etc. In it was a list of all the attendees and where they were from. The baby's name was on the list . . . she was sitting at the next table . . . I met her mom and she also said that she has the picture of my grandmother, too."

(In the newspaper photograph, Patricia's grandmother, Mitsu Yorioka, is holding Karen (Hirai) Olen, born on June 26, 1943 to Tom and Dorothy Hirai. Tom and Dorothy appear elsewhere in this book.)

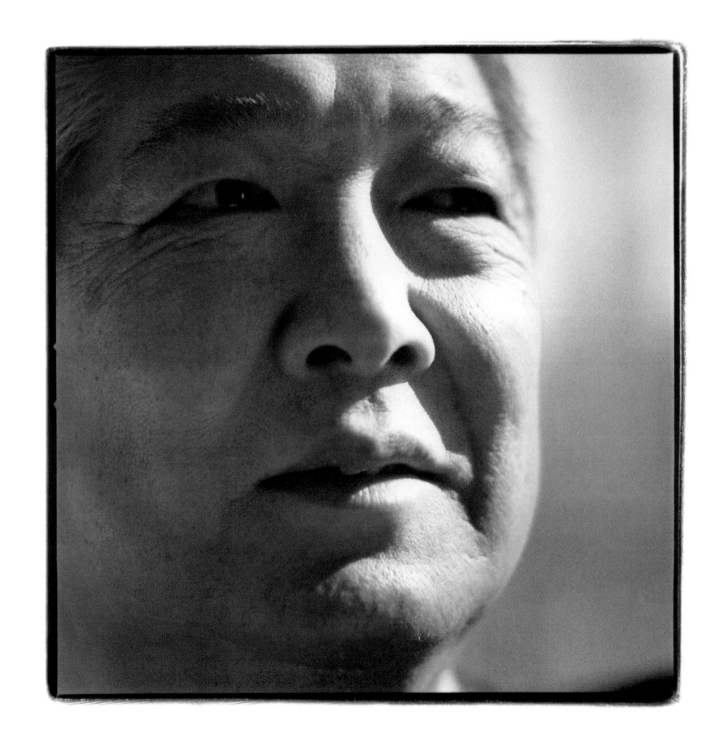

2008 (April 21)
Eagle River, Alaska
120 B&W Tri-X film

118

1945 (March 15)
Eagle River, Alaska
35mm digital copy photo

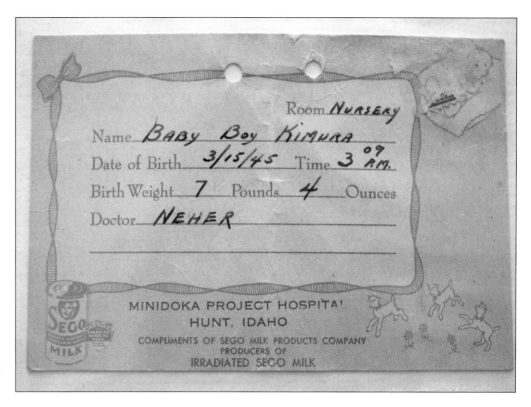

KERRY KIMURA'S PARENTS were married in Minidoka; he and his brother were born there.

Before Kerry was born, his father worked on the Anderson Ranch Dam project in Idaho. His family was granted a work release to move from Minidoka. There were no hospitals where they lived, so his parents paid $200 to use the facility at Minidoka for Kerry's delivery.

Their father, William, was born in Seattle. His family settled in Anchorage before World War II. There they owned and operated a laundry business and restaurant. Kerry Kimura's mother, Minnie, grew up in Cordova, Alaska. The Kimura family history is featured in the Anchorage Museum at Rasmuson Center.

Kerry's paternal grandfather, Harry Kimura, was a cook on board the U.S.S. Arizona, where he prepared meals for President Theodore Roosevelt. Roosevelt wrote a letter that allowed Harry to remain in America.

Kerry, too, received a letter from a U.S. president: President Bill Clinton. On Sept. 16, 1996, Clinton wrote: "Today, on behalf of your fellow Americans, I offer my sincere apologies for the actions that unfairly denied Japanese Americans and their families fundamental liberties during World War II. . . . In retrospect, we understand that the nation's actions were rooted deeply in racial prejudice and wartime hysteria. We must learn from the past and dedicate ourselves as a nation to renewing the spirit of equality and our love of freedom. Working together, we can make the most of our great diversity."

Kerry retired as U.S. Postmaster in Anchorage in 2007.

MILDRED MIDORI (SUKO) TSUTSUMI (left), Sakiko (Kawaguchi) Shimizu (center), and Michiko Mary Harada (right) are linked by Minidoka: All three women were born in the camp in 1943. After the war, their families returned to Seattle, where Mildred, Sakiko and Michiko continue to live. Old photo albums, family stories, books and exhibits remind them of the Minidoka experience.

Though cameras were prohibited in the camp, some snapshots surfaced after the war. Midori has a series of baby photos taken before her first birthday. A barrack covered in tarpaper is the backdrop for a group shot with her parents.

All three women devoted their careers to education. Mildred and Sakiko were elementary school teachers. Michiko was the secretary supervisor at Seattle Central Community College. The group gathers regularly with other friends who were born in Minidoka.

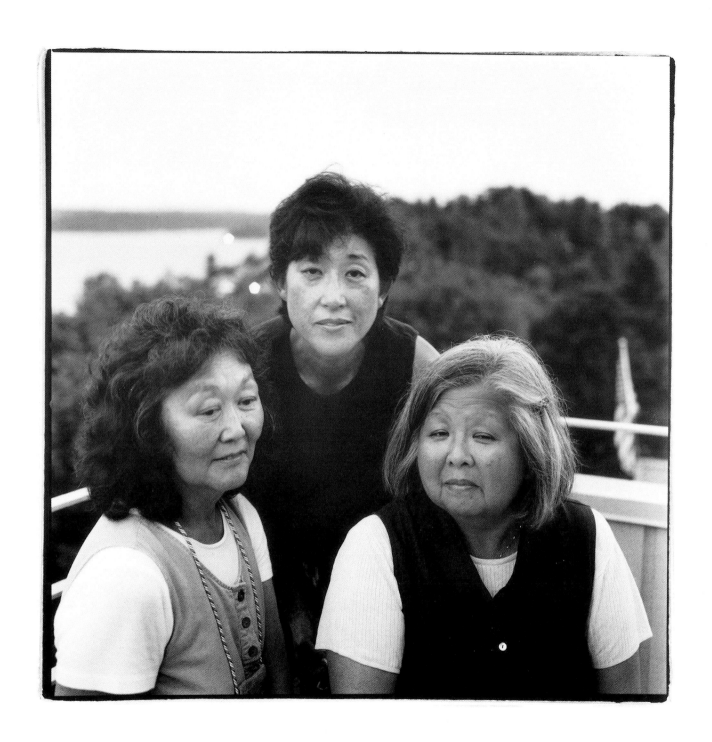

2002 (Aug. 9)
Seattle, Washington
120 B&W T-Max 400 film

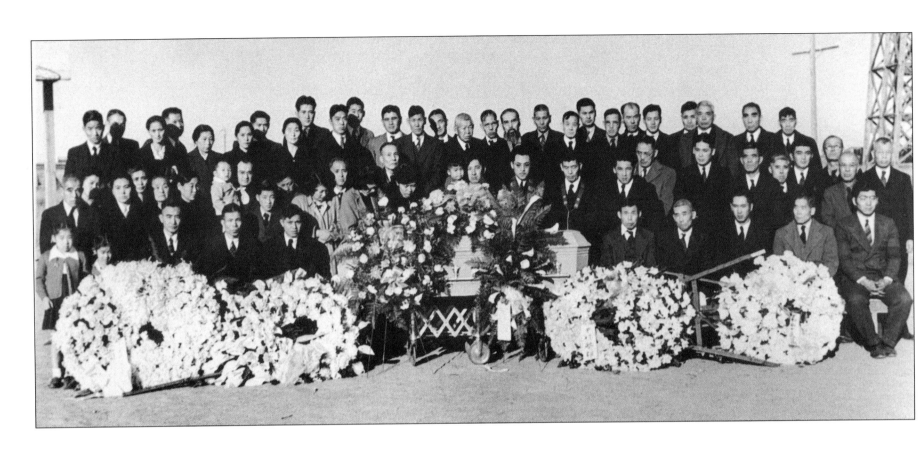

1944 (December)
Minidoka Relocation Center, Hunt, Idaho
Copy photo (cropped), 35mm digital taken June 18, 2006, Sacramento, California
Courtesy Kimura family

IN THIS GROUP PHOTO, family and friends mourn the loss of Hisayo (Okubo) Kimura, one of 193 Japanese Americans and Japanese who died while incarcerated in Minidoka. (*The Evacuated People: A Quantitative Description*, p. 145) Hisako Nishimura and Utako Kimura (left and right, respectively, on the facing page) were two of her 12 children. (In the group shot, they are the young women with heads bowed immediately to the left of the woman in the hat behind the casket.) The Kimuras were Buddhist of the Jodo Shinshu sect. The family kept Hisayo's ashes in their barrack until the war ended and they returned to Sacramento. The Kimuras were among a group of Californians who were transferred from Tule Lake to Minidoka in the fall of 1943. Because of an earlier stroke, Hisayo was transported in the "sleeper car" and admitted to the Minidoka Project Hospital, where she remained until her death a year and a half later.

Both Utako and Hisako were born in Sacramento. Utako graduated from Hunt High School on the Minidoka site in 1944. Both of the teenagers traveled to nearby farms in Rexburg and Burley to harvest potatoes on work release while they were incarcerated.

2006 (June 18)
Sacramento, California
120 B&W Tri-X film

123

"SEVERAL RELIGIOUS ORGANIZATIONS were represented at Minidoka, including the Catholic Church, six Protestant denominations, and three Buddhist sects . . . The 2,000 Minidoka Buddhists received a weekly newspaper, Buddhism in Minidoka, which was published in both English and Japanese. Aside from the regular Sunday services, the Buddhist sects sponsored adolescent and adult devotional meetings." — Donald E. Hausler. History of the Japanese-American Relocation Center at Hunt [Jerome County], Idaho, 1964, p. 43

THE *BUTSUDAN,* or household Buddhist altar, belonged to the parents of Yoichi "Cannon" Kitayama while they were incarcerated in Minidoka. Yosakichi and Kuni (Araki) Kitayama were Buddhists from Toyama, Japan, on the western seaside of the country. They settled in Portland's Old Town and operated the Royal Palm Hotel from 1926 to 1942.

2004 (July 10)
Portland, Oregon
120 B&W T-Max 100 film

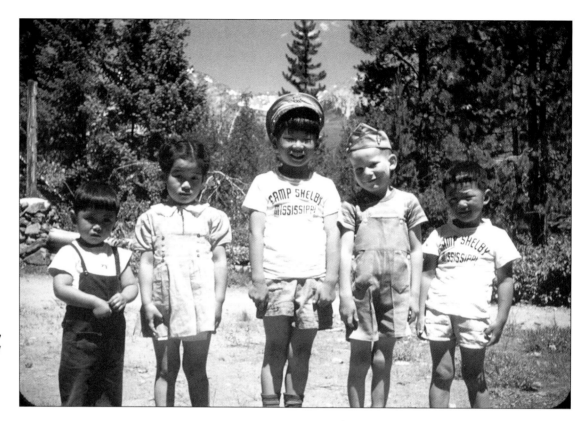

1943 (July)
Sun Valley, Idaho
Copy photo, electronic scan of 35mm color slide.
Courtesy Rev. Emery E. Andrews photo collection

Left to right: Jerry Okada, Elaine Teraoka, David Sakura, Brooks Andrews, and Jerry Sakura on an outing at Cathedral Pines Baptist Campground north of Sun Valley, Idaho.

"MOTHER'S DAY 1942 was the first Sunday that our church was completely vacant. . . . It was a heartbreaking time.
All my friends were gone . . . My country was saying these people, my friends, are the enemy. Well, I'm friends with these people, does that make me one of the enemy also?" — Brooks Andrews, 2007

BROOKS ANDREWS was 5 years old when he and his family moved from Seattle to Twin Falls. His father, Rev. Emery E. Andrews, followed his Japanese Baptist Church congregation to Minidoka. Brooks Andrews remembers how his father was thrown out of a restaurant and refused gasoline in Twin Falls because of his association with the Japanese community.

Brooks Andrews was the guest speaker at a 2003 reunion in Seattle for the Minidoka community. He subsequently suffered a major depression. He recovered and is now writing a memoir. In 2006 he became minister of pastoral care at the Seattle Japanese Baptist Church, where his father served. Five years later he was named interim senior minister.

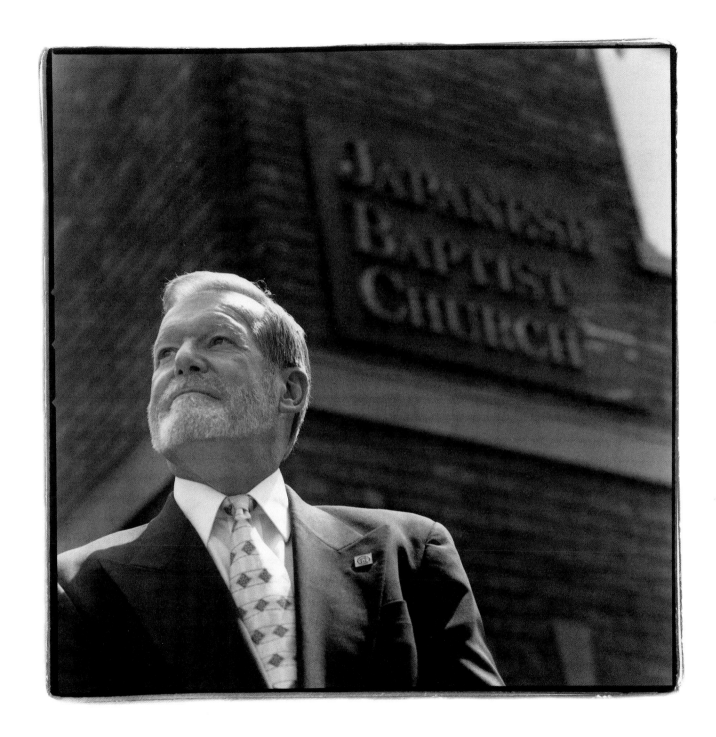

2003 (Aug. 3)
Seattle, Washington
120 B&W T-Max 400 film

Circa 1943
Minidoka War Relocation Center, Hunt, Idaho
Copy photo, 35mm digital taken April 16, 2008, Seattle, Washington.
Memoirs 1943
Hunt High School yearbook

Arthur Kleinkopf
Director Student Teachers

"**THERE WERE TWO** main reasons for the diary. First, it was felt that War Relocation Centers and their stories would be a unique chapter in American history and that day-by-day recordings of events behind the scenes in them would have much historical value. Secondly, such a diary would prove valuable in helping to solve some of the many racial problems of minority groups." — Arthur Kleinkopf, *Relocation Center Diary: 1942-1946*

ARTHUR KLEINKOPF, superintendent of education at the Minidoka War Relocation Center, kept "daily observations" from Sept. 26, 1942, to Dec. 31, 1946. His wife, Edith, who taught sixth grade at the camp, typed the 600-page diary, a copy of which is kept at Twin Falls Public Library. A Mormon missionary took another copy to Japan, where it remains.

Arthur Kleinkopf's son, Jerry, provided the collection of photos, yearbook and diary in the photograph on the facing page.

2002 (March 15)
Twin Falls, Idaho
B&W Tech-Pan 35mm film

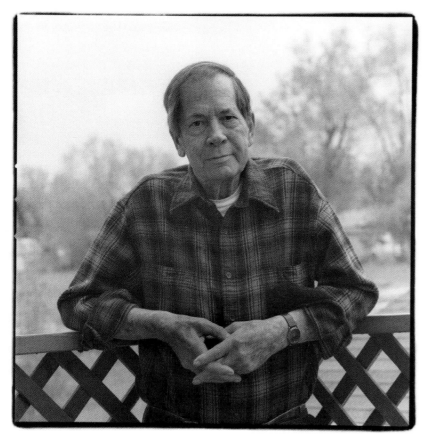

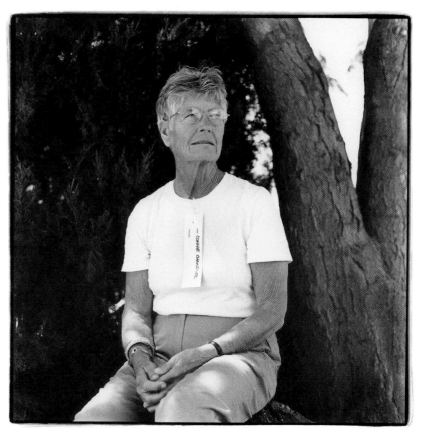

Mike Mann
2010 (May 10)
West Valley, Utah
120 B&W Tri-X film

Connie Thorson Chandler
2006 (July 8)
Twin Falls, Idaho
120 B&W Tri-X film

MIKE MANN, left, and Connie (Thorson) Chandler, right, were children of employees who worked at the Minidoka War Relocation Center. They attended kindergarten together at Huntville School, one of two elementary schools on the site. Howard Mann was the supply officer in the Procurement Unit. Mary Mann was in charge of "steno" pool. Louis Thorson, was assistant construction superintendent. Both families lived on-site in special housing.

In remarks to her parents on Connie's first report card, Connie's teacher wrote: "Connie Lu is cheerful and usually interested but there are times when she seems to feel strange, and not exactly part of the group. No doubt, a good deal of this is due to the great difference in background, and some of it may be because of being an only child."

Mike Mann worked at Sperry Utah Company, a defense subcontractor, for 39 years. Connie Thorson raised three children and lives on Lopez Island, Washington.

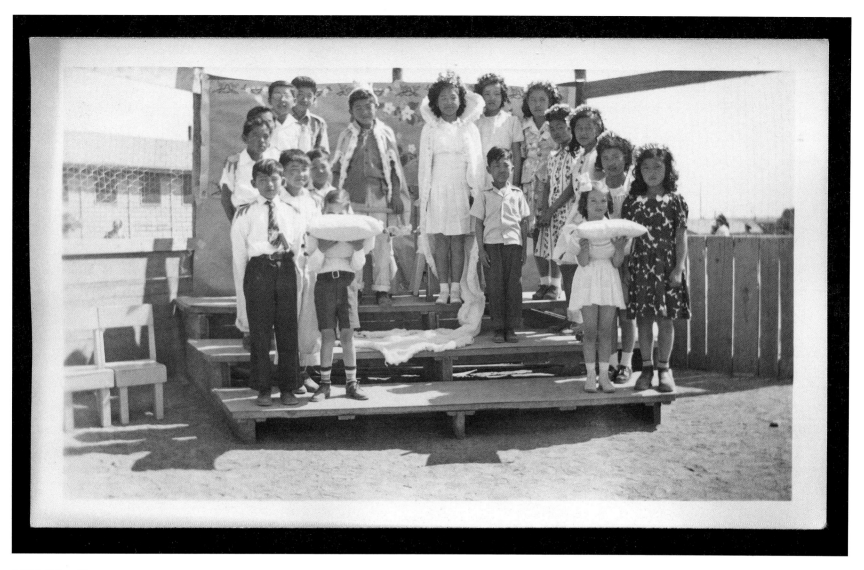

1944 (May 1)
Minidoka War Relocation Center, Hunt, Idaho
Copy photo, 35mm digital taken May 10, 2010, West Valley, Utah.
Courtesy W. Howard & Mary Mann photo collection

KINDERGARTEN STUDENTS Mike Mann and Connie Thorson hold satin pillows for the crowns of the May Day king and queen at the Minidoka War Relocation Center. Connie recalled how she put peanuts in her eyes the night before so that they "wouldn't look so big and round." She said she was tired of not looking like all of her classmates.

Circa 1943
Minidoka War Relocation Center, Hunt, Idaho
Copy photo, 120 film taken June 17, 2006,
Sacramento, California.
Memoirs 1943

TOSHIKO (SHOJI) ITO (pictured on the right, third
from the bottom row) was a junior in the 1943 edition
of *Memoirs*, the yearbook for Hunt High School at
Minidoka.

After Ito retired as head of the cosmetology department at Citrus Community College in Azusa, California, she wrote *Endure, A Novel.* The book was her way of answering questions posed by her granddaughter, Nicole Shinoda, about Ito's experience at Minidoka. Ito found it too difficult to write her autobiography in the first person, so she created a 17-year-old character named Tomi. Ito was the same age as Tomi, a junior in high school, when Pearl Harbor was bombed.

In the preface to her book, Ito wrote: "It is my intention to convey to my granddaughter how fragile freedom really is and that it is not to be taken lightly and thrown around casually as a 'constitutional right.' She should know that what happened in 1942 was the result of another era in our government's history, one marked by racial discrimination, political travesty and war hysteria. To its credit, the government has since admitted the injustice of Executive Order 9066."

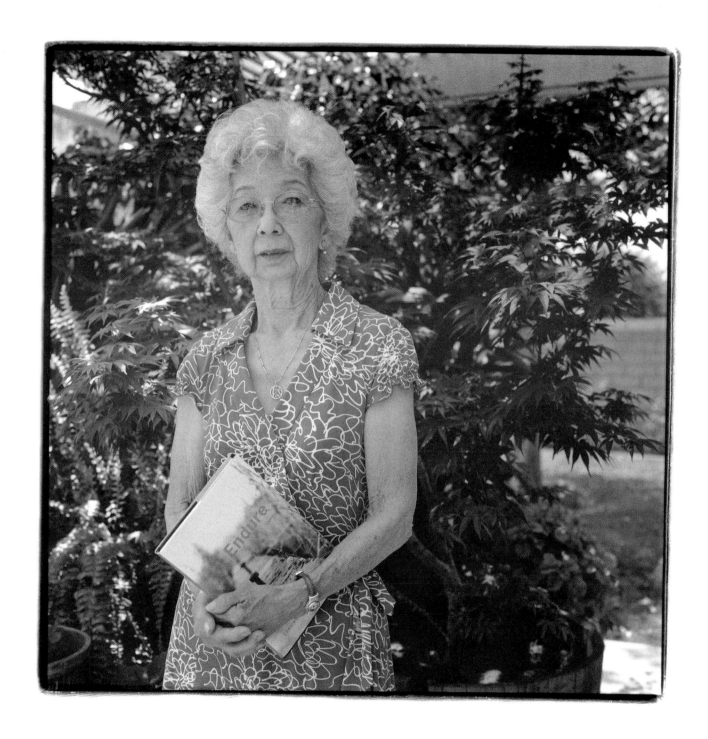

2008 (April 27)
Diamond Bar, California
120 B&W Tri-X film

ROBERT W. COOMBS, right, visited with James Nishimura, a former student, at the "Minidoka Remembered" *bento* (Japanese for lunch) picnic at Carkeek Park in Seattle, the final gathering in a three-day reunion held Aug. 1-3, 2003. Some 800 former incarcerees, friends and family members attended the event. The day before leaving for the 2003 reunion, Coombs was diagnosed with bladder cancer. He survived until May 13, 2009.

Coombs was one of the few teachers who taught Minidoka students from the beginning to the end of their incarceration. He lived on site in the men's staff dormitory while he prepared the curriculum. He taught public speaking, English and social studies to tenth- and eleventh-graders. After Minidoka closed, he married a fellow Minidoka teacher, Marguerite Askew.

Nishimura was born in Seattle and came to Minidoka as a teenager. His sister and brother-in-law, both of whom were interned, worked for a farmer in Eden and thus were allowed to live off-site. Nishimura lived with them for a year in high school; the rest of the time he lived in the camp. After the war, his family relocated to the East Coast instead of returning to Seattle. Nishimura worked for an electronics firm and eventually became an entrepreneur in the cable TV industry. He retired at 56 and remained in New York for the rest of his life.

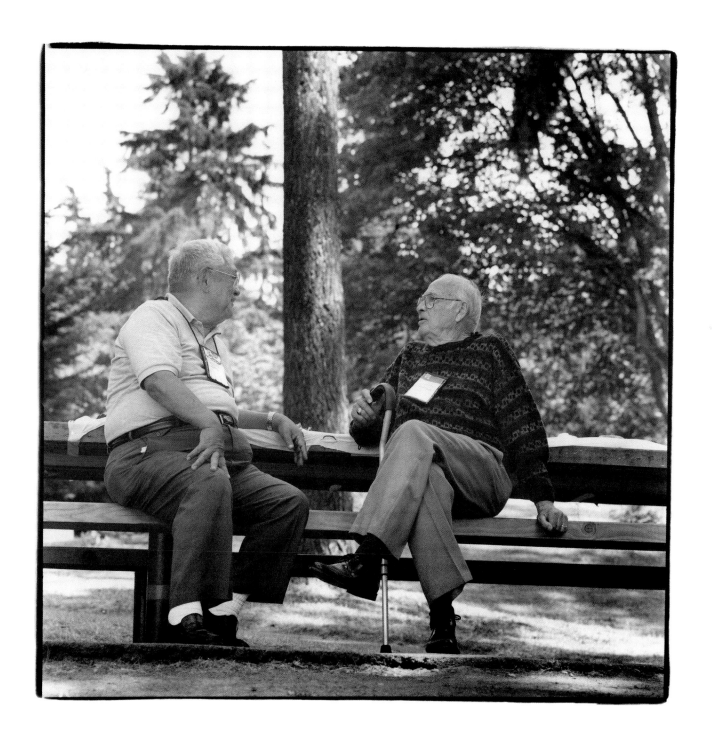

2003 (Aug. 3)
Seattle, Washington
120 B&W T-Max 400 film

Helen Amerman Manning
Circa 1945
Minidoka War Relocation Center, Hunt, Idaho
35mm digital copy photo taken Oct. 10, 2009, Seattle, Washington.
Memoirs 1945

"**MY THREE YEARS** on the [Minidoka] project were probably the most significant in my life. [long pause] I felt that I made a difference in the lives of my students. And I was very fortunate that the Minidoka high school had the highest proportion of students of any of the relocation project high schools to have students go on post-high school to either professional schools or college. I count a number of outstanding students that I have had that certainly are outstanding for any high school. One was the chief of the legal services in the U.S. Department of Treasury [Calvin Ninomiya]. Another was a lifetime Foreign Service officer in the State Department and counsel in a number of Asian cities [Lucius Horiuchi]. Any number of college professors [former sociology professors Dr. Eugene Uyeki, Case Western Reserve University, and Dr. Teruo Jitodai, San Francisco State University, were mentioned], attorneys, doctors and so on. I'm still in contact with a number of my former students." — Helen Amerman Manning, interview with author, June 18, 2006, Fremont, California

HELEN (AMERMAN) MANNING earned degrees from Michigan State University, Stanford University and, after leaving Minidoka, the University of Chicago (PhD). Her jobs at Minidoka included student relocation officer, guidance officer, junior class adviser, and teacher of English and "present-day literature." She was a native of New Jersey.

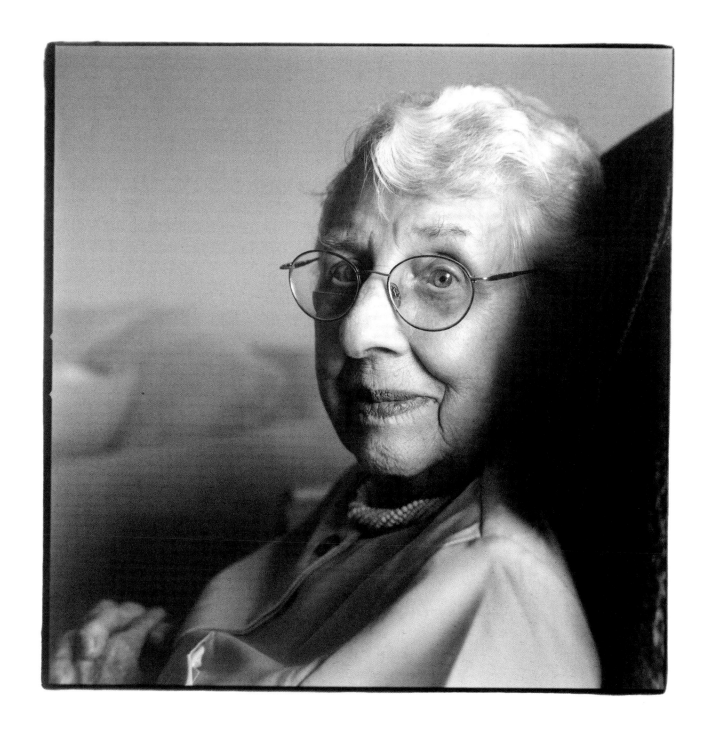

2006 (June 18)
Fremont, California
120 B&W Tri-X film

137

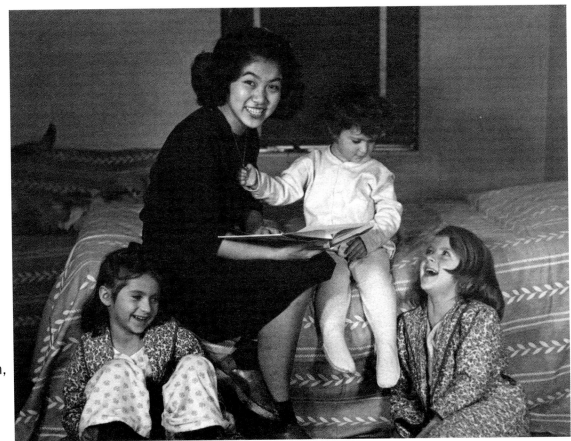

Circa 1943
Toledo, Ohio
Photograph by Robert Gross
Copy photo, 35mm digital taken Sept. 14, 2008,
Walla Walla, Washington.

TAKEKO "TAK" YOKOYAMA, 16, with her young charges (left to right): Nan, 6, Beth, 2, and Robin, 7, the daughters of Robert and Helen Gross of Toledo, Ohio. The Gross sisters met Tak in Seattle in July 2008 for a reunion.

Tak (Yokoyama) Todo wanted to get a better education. She left her parents and youngest sister in Minidoka in August 1943 and accompanied her oldest sister to Toledo, Ohio. They found jobs in homes close enough that they could visit each other on days off. Tak lived and worked as a nanny ("school girl") for Robert Gross, owner of Gross Photo Supply Company, while she attended Toledo's DeVilbiss High School. In her senior year, she changed jobs, lived with a married couple and graduated in 1945. She returned to Minidoka briefly before settling in Seattle with her family.

"After my senior year, I went back to Minidoka as soon as the season was over. Mr. Gross — because they had the photo supply company — he let me use his camera. He said, 'Go back there and take pictures because other people won't have [a camera].' I didn't realize how important it would have been to take pictures of the camp and everything else."

Todo worked in backroom operations for securities businesses in Seattle and San Francisco for twenty-five years. She became a stockbroker at 50 and retired in 2001 after twenty-four years.

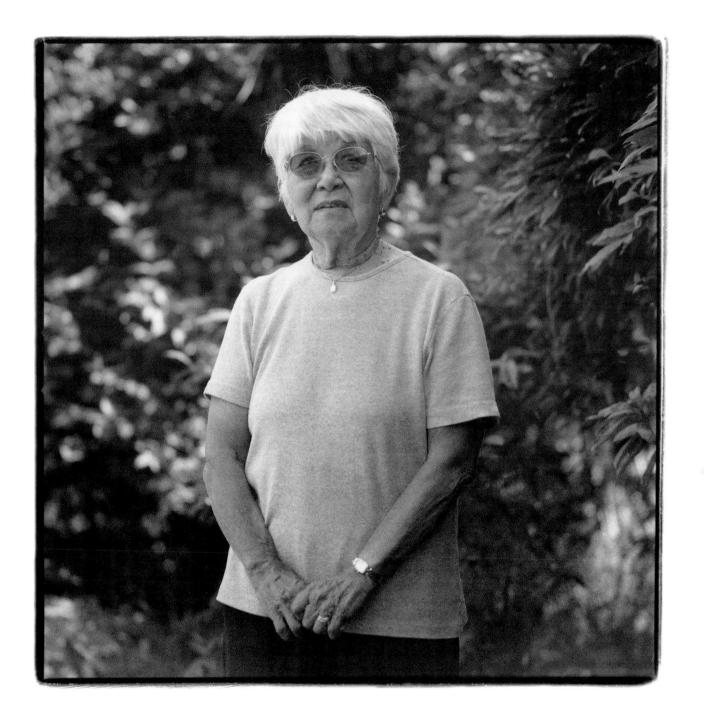

2008 (August 23)
Shoreline, Washington
120 B&W Tri-X film

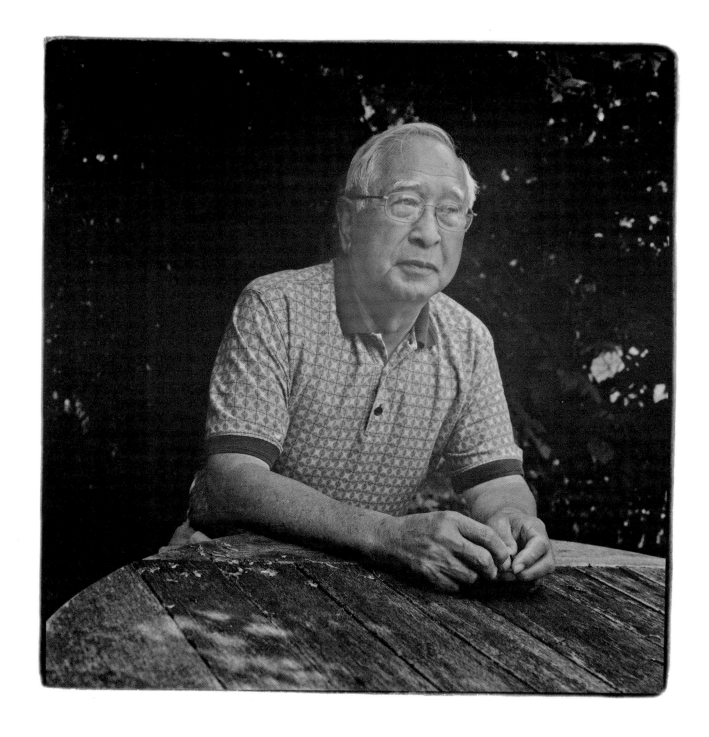

2008 (August 23)
Shoreline, Washington
120 B&W Tri-X film

FRANK MURAMATSU was born in Portland, Oregon, the second son of seven children born to Matsutaro and Kyo Muramatsu. His father was a vegetable farmer. In 1937 the family was forced to move after the city claimed the farmland for Portland's new airport. Frank and his older brother wanted to remain in the same school, so Matsutaro found another property adjacent to the airport.

"When the war started, we were the suspect farmers," Frank Muramatsu said. "[People believed] Hirohito had planted all of us all around the airport to aid the incoming enemy."

Ten Muramatsus, including Frank's paternal grandfather, shared two adjoining barrack apartments in Minidoka. They lived in Block 34, Barrack 4C and D. Frank was the senior class president of Hunt High School's Class of 1944 but left Idaho before he could preside over graduation. He finished high school early and began studies at Drake University in Iowa before he was drafted in 1944.

After Muramatsu served in the Philippines, he returned to the United States and married Margie Yoshizawa in 1947. He graduated with an engineering degree from Iowa State University with the help of the G.I. Bill. In 1952 The Boeing Company hired Muramatsu. He worked at Boeing for thirty-five years before retiring in 1987. In the 1960s, Muramatsu worked on NASA's Project Apollo, specifically on the Saturn rocket that sent Apollo astronauts to the Moon and put the Skylab space station into orbit.

DR. RUBY (INOUYE) SHU was a student at the University of Washington when she and her family were sent to Minidoka from Seattle. Her parents, Tsuyoshi and Yayoi (Iseka) Inouye were from Ehime-ken on Shikoku, the smallest of Japan's four main islands. They had six children and operated a restaurant in downtown Seattle. Everyone helped out; Ruby worked as a waitress while going to school.

She left Minidoka on study release in January 1943 to finish her undergraduate degree at the University of Texas in Austin. She went on to Philadelphia to earn a degree at Women's Medical College of Pennsylvania. She and a Japanese American classmate, Kazuko Uno, were the only students who at first weren't assigned internships due to prevailing prejudice. "Dr. Ruby," as she preferred to be known, went on to become the first female Japanese American physician in Seattle. She started her practice in 1949 and retired in 1995 at age 70. She delivered 1,066 babies during her forty-six year career, including one the day before and one several hours after her own hospitalization to give birth to her second child.

She and her husband, Dr. Evan Shu, raised a son and two daughters. The couple helped create a nursing home for Seattle's aging *Nikkei* population.

During a "Community Stories" interview in 2011 for the City of Seattle cable channel, Dr. Ruby said: "When people ask me about internment, I don't have the right to talk about internment because I wasn't there long, you know, just a few months as compared to years for other people. A lot of it stirs up emotions in me because, when it actually happened, I think we kept our emotions down. Those years I was in medical school from '44 to '48, they were terrible years of war in the Pacific and Europe. All that while being immersed in medical studies, I was pretty oblivious to it. But now when I read about it, it makes me shudder."

1994 (August 12)
Seattle, Washington
120 B&W T-Max 400 film

Minidoka Population 1942 - 1945

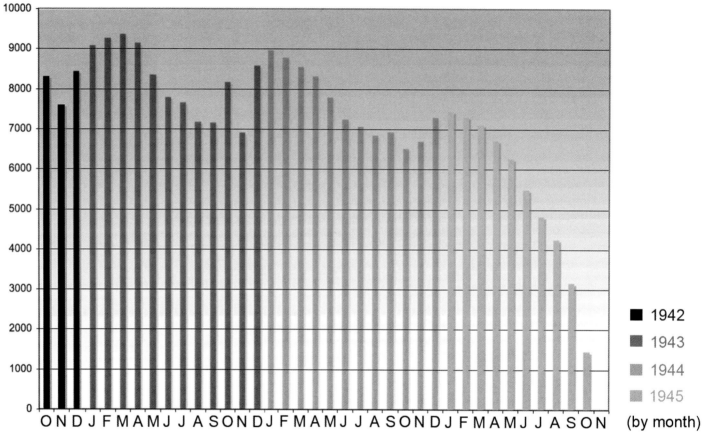

Source: 1942-1944. Hausler, p. 71; original source: War Relocation Authority, Seventh Semiannual Report, July 1 to December 31, Washington, D.C., 1944. p. 50. 1945 population decline. Hausler, p. 78; original source: Eighth Semi-Annual WRA Report, p. 67).

1942		1943		1944		1945	
Oct. 1942	8,311	Jan. 1943	9,091	Jan. 1944	8,964	Jan. 1945	7,439
Nov. 1942	7,597	Feb. 1943	9,274	Feb. 1944	8,784	(West Coast ban lifted)	
Dec. 1942	8,438	(segregated Nisei		Mar. 1944	8,549	Feb. 1945	7,314
		volunteer combat team)		Apr 1944	8,333	Mar 1945	7,117
		Mar. 1943	9,375	May 1944	7,799	Apr 1945	6,722
		Apr 1943	9,152	June 1944	7,250	May 1945	6,263
		May 1943	8,351	July 1944	7,058	June1945	5,496
		June 1943	7,801	Aug. 1944	6,842	July 1945	4,819
		July 1943	7,666	Sept. 1944	6,930	Aug. 1945	4,244
		Aug. 1943	7,183	Oct. 1944	6,510	Sept. 1945	3,167
		Sept. 1943	7,164	Nov. 1944	6,697	Oct. 1945	1,467
		Oct. 1943	8,175	Dec. 1944	7,297	Nov. 1945	none
		(Tule Lake arrivals)					
		Nov. 1943	6,923				
		Dec. 1943	8,595				

"... **THE WRA ENCOURAGED VOLUNTARY,** permanent relocation to the Midwest and East ... Minidoka had the highest relocation rate for all centers. In 1943, the average monthly rate of leaves, both permanent and temporary, was 22 per 1,000 residents, in contrast to the rate of 14 per 1,000 for all centers." — James M. Sakoda, "The 'Residue': The Unresettled Minidokans, 1943-1945," *Views From Within,* 1989, p. 258

THROUGH SPONSORSHIPS, internees deemed loyal to the United States were allowed to leave the Minidoka War Relocation Center for work, school or military service. They were issued identification cards with destinations typed on the cards. Robert Hosokawa's card read "Independence, Mo."

Forced from their home in Seattle by Executive Order 9066, Hosokawa and his wife, Yoshi, packed his Royal portable typewriter for the trip to Camp Harmony in Puyallup and eventually Minidoka. Yoshi was photographed at Camp Harmony for a *Seattle Post-Intelligencer* story published May 25, 1942. The picture accompanied a story with this headline: "Camp Harmony Japs Living Up to Name, Seattle Evacuees Making Best of Site, Despite New Conditions."

The couple arrived at Minidoka in August 1942. Thomas Howells, an English professor at Whitman College in Walla Walla, Washington, quickly helped Robert, a 1940 graduate and president of the college's senior class, find employment as news editor of the *Inter-City News* in Independence. Before the Hosokawas' first child, David, was born there in July 1943, Robert wrote an essay for the *Christian Science Monitor* titled "I am an American with a Japanese face." In it Hosokawa noted that he was "one of 60,000 *Nisei* Americans born in the States of Japanese parents" (May 22, 1943).

Hosokawa's career as a journalist and university professor took him to Iowa, Wisconsin, New York, Minnesota, back to Missouri and finally to Florida for a teaching post and retirement.

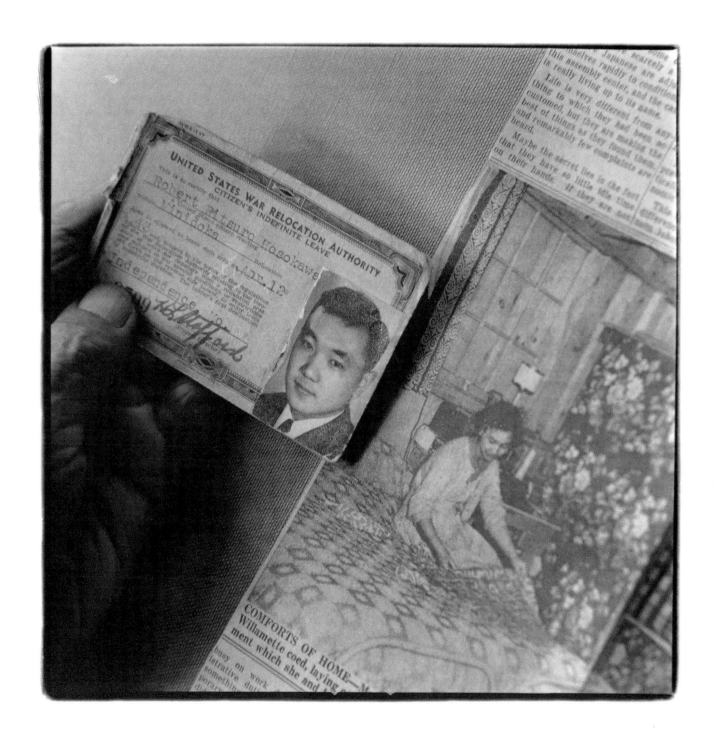

2008 (May 20)
Winter Springs, Florida
120 B&W Tri-X film

1945 (May)
New Hope, Pennsylvania
Digital copy photo. Courtesy of Bancroft Library, University
of California, Berkeley; Vol. 40, Sect. E, WRA No. G-875.
Photograph by Gretchen Van Tassel

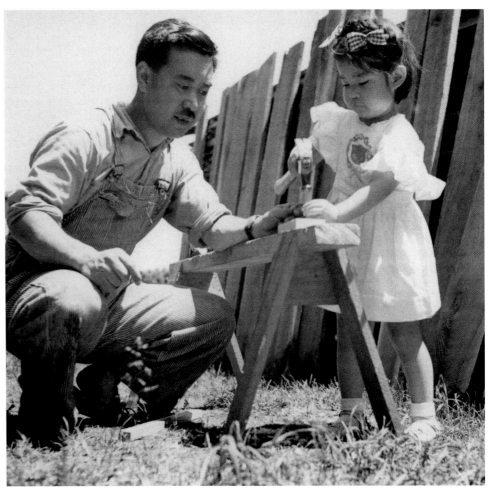

"LITTLE MIRA NAKASHIMA is following in her father's footsteps as she drives a nail into a piece of wood outside of his workshop. George Nakashima, an architect, formerly of Seattle and Minidoka, is now living in the country near New Hope, Pennsylvania, with his wife, Marion, and 3-year-old Mira. In a small workshop, which he has set up, he is designing furniture for Hans Knoll, Associates, a wholesale furniture firm in New York City, and is making pieces for individual customers and for his own use. Mira spends a lot of time with her father in the workshop, has learned to use a hammer, drill, end plane, scorns miniature tools." (War Relocation Authority caption)

MIRA NAKASHIMA sits in the "Mira Chair" created by her father, George Nakashima, one of the leading innovators of twentieth century furniture design, during an exhibition of his work at the Sun Valley Center for the Arts in Ketchum, Idaho. The gallery is less than two hours from the Minidoka War Relocation Center site. Mira was only 6 weeks old when the Nakashima family was first incarcerated.

George Nakashima learned a number of techniques from a Japanese woodworker at Minidoka. Out of necessity, he began to make furniture for his family from found objects at the camp. The Nakashimas were sponsored by architect Antonin Raymond, under whom Nakashima had worked in Japan after graduating from the University of Washington and M.I.T. They settled in Pennsylvania in 1943.

The woodworking shop Nakashima established in New Hope in 1945 is still in operation. He died in 1990, seven years after he accepted the Order of the Sacred Treasure, an honor bestowed by the Emperor of Japan and the Japanese government. His wife, Marion, passed away in 2004. Mira Nakashima and her staff continue to design and make furniture in the conception and style of her father's work. She hopes to preserve the Nakashima home, studio workshop and furniture business for future generations.

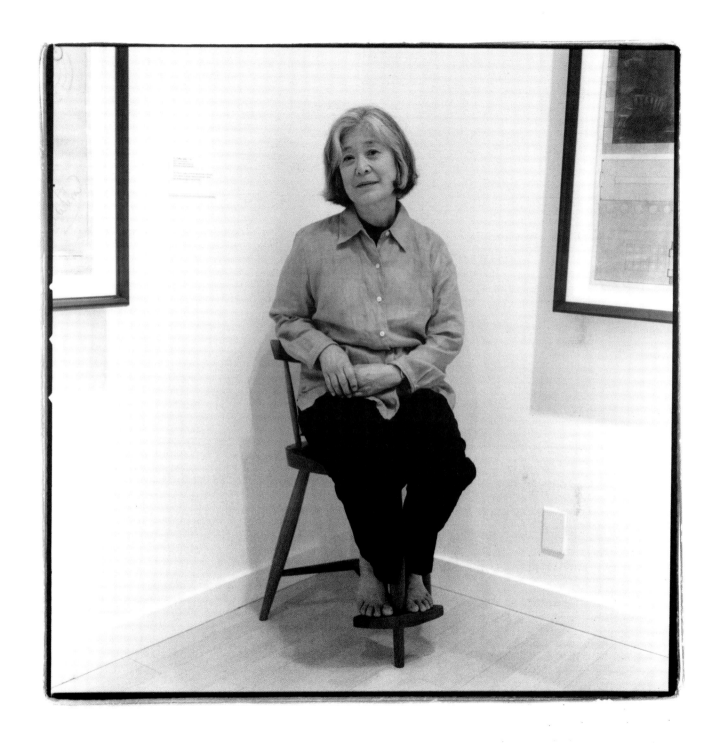

2004 (July 16)
Ketchum, Idaho
120 B&W Tri-X film

149

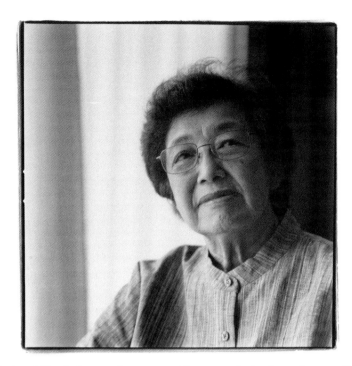
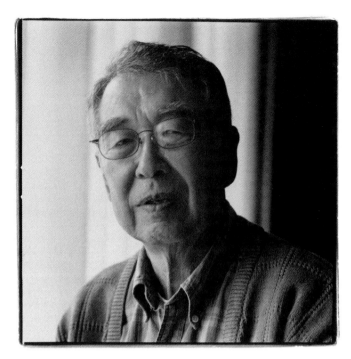

IN 1943, Marion and Robert Tsutakawa, too young to remain in America on their own, repatriated to Japan with their parents. The family boarded the Gripsholm during the vessel's second trip to exchange prisoners of war, diplomats, women and children.

Their father, George Joji Tsutakawa, was incarcerated in Montana and New Mexico after the U.S. entered World War II. He joined his family in Minidoka after an 18-month separation. Repatriation to Japan was seen as the only way to reunite Tsutakawa's entire family; his oldest son had been sent to Okayama Prefecture to live with his paternal grandmother in 1936.

Marion and Robert found school in Japan difficult because they could not speak or read Japanese. Marion, then 15, felt ostracized. Her home economics class in Japan taught her how to roast grasshoppers and grind them for *furukaki*, a topping sprinkled on rice. But she didn't remember being hungry enough to eat it. Robert, technically an eighth-grader, attended fifth grade to adjust to the language.

Marion married Jim Kanemoto in 1952. They raised four children, and she worked as a school nurse. Her class-action lawsuit, "Marion Kanemoto vs. Janet Reno," enabled 215 of 345 repatriates who were minors to receive redress and presidential apology in 1993. She was actively involved in the Florin Chapter of the JACL and its oral history project. Kanemoto also participated in the documentary film, "Children of the Camps," by Dr. Satsuki Ina.

Robert enlisted in the U.S. Army and served in the Korean War as an interrogator, often translating Japanese into English. He married Teruko Tsujihara in 1961, and the couple raised three children. He earned a PhD in statistics from the University of Chicago, taught at the University of Missouri for twenty-nine years and served as department chair for six years before retiring in 1997. He moved to California in 2009 to be closer to his family.

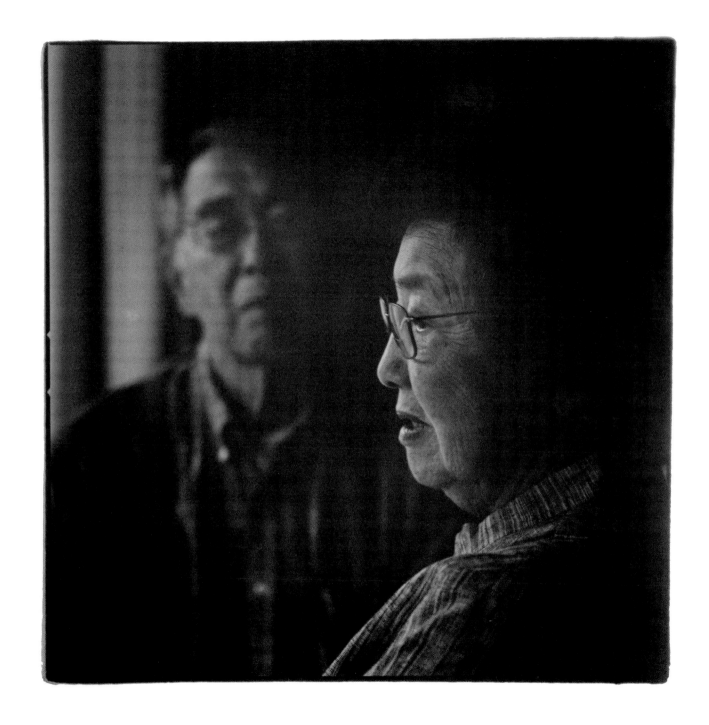

2005 (Aug. 10)
SeaTac, Washington
120 B&W Tri-X film

"**COUNTING JUST MALE CITIZENS** between the ages of 18 and 37, the ratio of volunteers to that population for all the camps was 17.14 to 1, that is, one such person volunteered for every 17.14 such persons in camp. When broken down by camp, the figure for Minidoka showed the highest ratio of volunteers per population, 5.37 to 1. The next highest camp, Granada, was 13.06 to 1." — Roger Daniels, *Asian America,* (1988), Table 6.5, p. 252

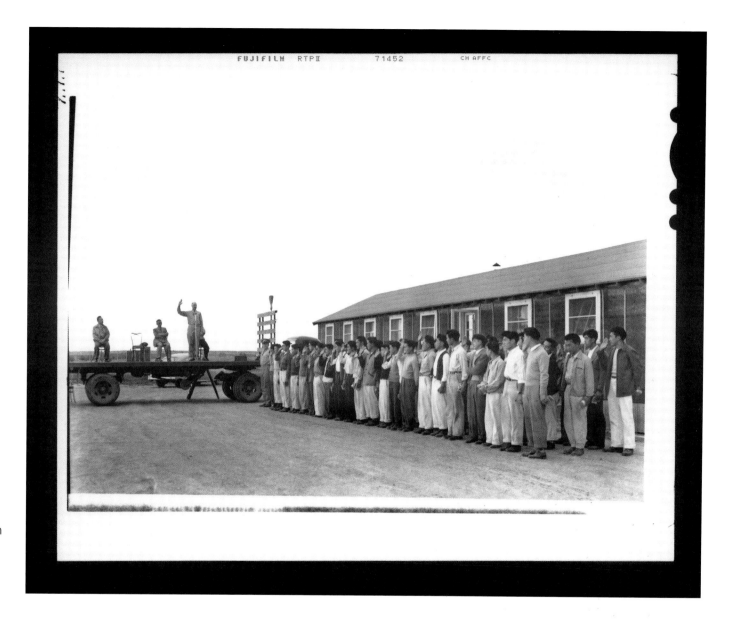

Circa 1943-1945
Minidoka War Relocation
Center, Hunt, Idaho
Duplicate 4x5 negative.
National Archives Photo
No. 210-CMB-I-1-1084

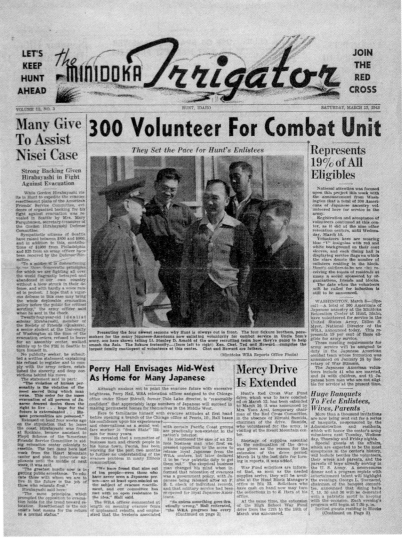

1943 (March 13) publication date
Minidoka War Relocation Center, Hunt, Idaho
Digital copy.
The Minidoka Irrigator

"**PRESENTING** the four newest reasons why Hunt is always out in front. The four Sakura brothers, pacemakers for the many Japanese-Americans now enlisting voluntarily for combat service in Uncle Sam's army, are here shown telling Lt. Stanley D. Arnold of the army recruiting team how they're going to help smash the Axis. The Sakura fraternity — (from left to right) Ken, Chet, Ted and Howard — comprise the largest family contingent of volunteers at this center. Chet and Howard are fathers."— *The Minidoka Irrigator,* March 13, 1943

DAN SAKURA, former vice president for government relations for The Conservation Fund, is the grandson of Chet Sakura, one of four Sakura brothers who volunteered for military duty from Minidoka. Dan's father, David, the oldest of Chet's three children, was 7 at the time.

"I went to Idaho in January 2001 to conduct outreach to the local community as part of our effort to develop a recommendation to the President [Bill Clinton] to use his authority under the Antiquities Act to establish a national monument," Dan recalled. At the time, Sakura was senior policy advisor for the Council on Environmental Quality in Washington, D.C.

Secretary Bruce Babbitt sent a memo to the President: ". . . the Japanese American Internment sites represent a tangible reminder of the grave injustice done to Japanese Americans. The Department looks forward to implementing these recommendations to help ensure that this period in American history is never forgotten." The historic site now encompasses some 290 acres of the original detention center.

2006 (July 8)
Twin Falls, Idaho
120 B&W Tri-X film

155

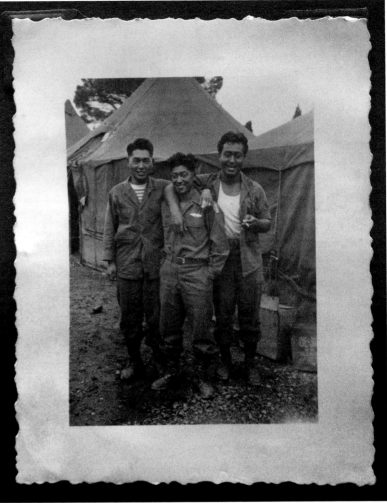

Circa 1945
Livorno, Italy
Copy photo, 35mm digital taken Oct. 29, 2008, Walla Walla, Washington.
Courtesy of Warren Tamura photo collection

WARREN TAMURA, Bob Sato and Akira Washio pose at Livorno, Italy, while serving in the 4th Platoon of Company C in the 100th Battalion of the 442nd Regimental Combat Team during World War II.

BOB SATO, the fourth of six children, was born on a farm near Puyallup, Washington. His birth name was Satoshi; his first-grade teacher assigned him the name Robert.

Sato was 16 when Pearl Harbor was bombed. He recalls his father, a truck farmer, telling his children as they were forced from their home: "I don't know where they're taking us. I don't know how long we're going to be [there]. I don't know if we'll ever be able to come back. Just remember: This is your country, and you have to act accordingly."

Sato graduated in the first commencement at Minidoka's Hunt High School in July 1943. Less than a year later, at 19, he was drafted and served in the Army while his parents remained incarcerated in Block 19, Barrack 7B.

After the war, Sato worked as an engineer for the Army Corps of Engineers for twenty-seven years. He was the project manager for Libby Dam on the Kootenai River in Montana. He then worked as a private consultant for Lewis County Public Utility District before retiring in 1995. He served as a planning committee member for the Minidoka National Historic Site; Northwest fundraising chairman for the National Japanese American Memorial in Washington, D.C.; commander of the Seattle Nisei Veterans Committee; Seattle chapter president of the Japanese American Citizens League; and Pacific Northwest district governor of the JACL, through which he helped pass the Civil Liberties Act of 1988.

2008 (April 15)
Seattle, Washington
120 B&W Tri-X film

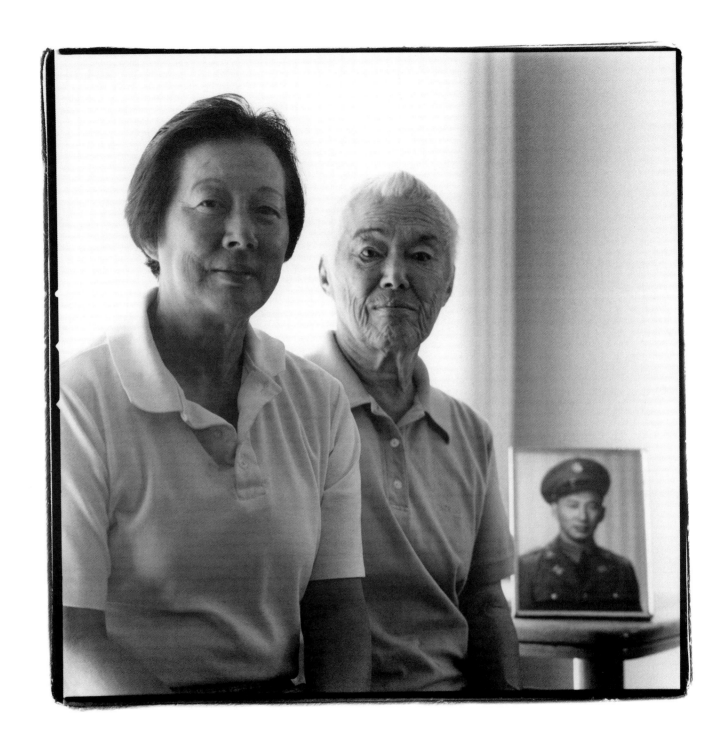

2003 (Aug. 4)
Seattle, Washington
120 B&W T-Max 400 film

KIM NAKAMURA gave birth to her daughter, Janice, at Minidoka on June 3, 1943. Ned Nakamura, her husband of two years, was a 442nd Regimental Combat Team sergeant and squad leader. He was killed by the Germans in France while on patrol during the rescue of the Lost Battalion in eastern France in October 1944.

Released from Minidoka in the spring of 1945, Nakamura took her daughter to Sydney, Nebraska, where she worked for a year and a half. They returned to Seattle and live there now.

Kim worked in civil service for twenty years; she retired from the FBI office in Seattle. For thirty years she volunteered as a teacher's aide at Beacon Hill Elementary School. Janice taught 7th grade science for twenty years before retiring from the Seattle School District.

"I don't have that many good memories about Minidoka," Kim allowed, "and Janice doesn't ask too many questions about it."

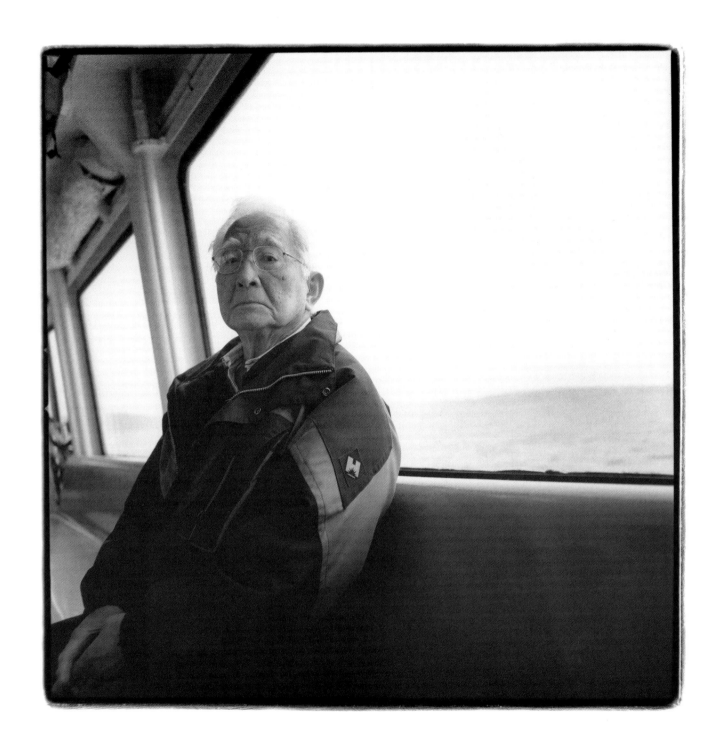

2008 (April 15)
Steilacoom, Washington
120 B&W Tri-X film

"ON OCTOBER 6, 1944, thirty of the convicted Minidoka resisters boarded a small ferry in Steilacoom, Washington, for a quick trip to the federal penitentiary at McNeil Island . . . Among the grim group on the ferry was Gene Akutsu. As he moved across the cold waters of the Puget Sound toward the island jail, the young man could not help but note the irony that two and one-half years earlier the government had forced them from this region as suspected subversives. Now it was forcing them back as convicted felons." — Eric L. Muller, *Free to Die for Their Country,* (2001), p. 161

GENE AKUTSU was 19 when he and his older brother, Jim, were ferried from Steilacoom, Washington, to McNeil Island. The brothers were among 30 convicted draft resisters from Minidoka. Sixty-three years later, Akutsu rode the ferry to McNeil Island again, but only to be photographed.

The day after Pearl Harbor was bombed, Kiyonosuke Akutsu, Gene's father, was one of several *Nikkei* in Seattle who were taken into custody. Kiyonosuke, an *Issei*, was deemed an "enemy alien" and detained for two years.

Gene's mother, Nao (Fukui) Akutsu, was a homemaker who helped her husband with a shoe repair business. "She and Dad were outcasts from their own people. The land of opportunity turned to a life of grief, heartache and loneliness," Gene recalled. Nao took her own life in September 1946.

In December 1947, President Truman pardoned the draft resisters, a time Akutsu regrets his mother never lived to see. On May 11, 2002, the JACL officially apologized to the draft resisters in a special ceremony. Akutsu said it was one of the highlights of his life.

When asked what he wanted people to remember most about his experience, Akutsu said, "I believe the government was completely wrong to accuse all Japanese Americans of not being trustworthy. We are Americans."

"I DREAMED about being an artist. I went to art school, became an activist who believed in certain things and enjoyed himself," Frank Yamasaki recalled.

Yamasaki was one of 30 young men incarcerated at Minidoka who were convicted of draft resistance during World War II. Though he would have failed the pre-induction physical because of tuberculosis, he refused to appear for his induction on the principle that U.S. citizens were being imprisoned without a trial. Yamasaki served a three-year sentence at McNeil Island near Tacoma, Washington. He later worked as a commercial artist and art director at Criterion Films, KIRO and KING-TV in Seattle, and at King Screen, a documentary film company.

He met his wife, Sadie Kaisaki, in art school. They married in 1952 and raised two daughters.

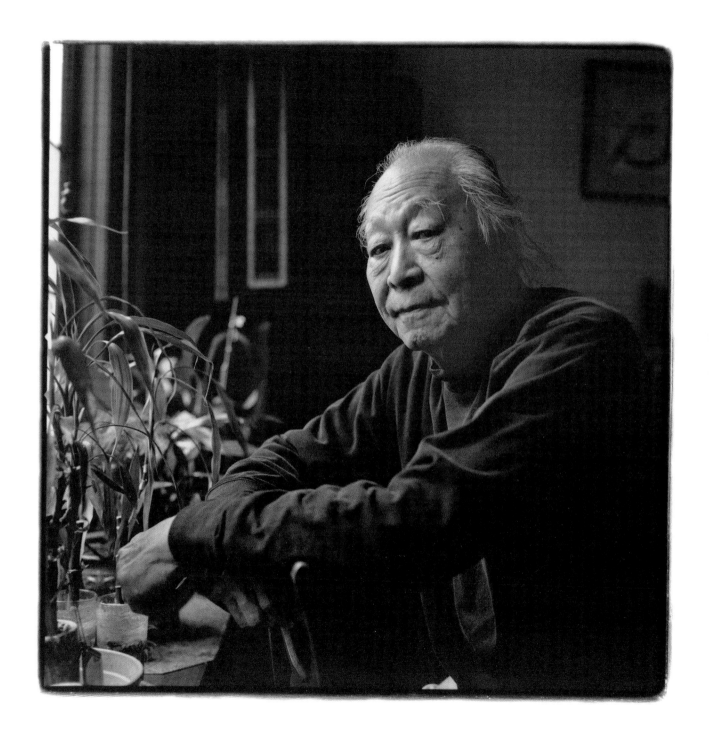

2008 (April 14)
Lake Forest, Washington
120 B&W Tri-X film

MATSUYE (ISHIDA) KOTO was 19 when she was transferred from the Tule Lake camp in northern California to Hunt Camp. "Mats," as friends called her, was born in Salem Oregon. Her family operated a small truck farm in the Lake Labish area, just north of her birthplace.

Mats met her husband, Tom Koto, when he was home on furlough from the Army. Her cousin served with Tom at Fort Snelling, Minnesota, and introduced them while she was incarcerated at Minidoka and Tom came to visit. Tom was a *Nisei* from the area. His father, Tojiro "Tom" Koto, was an early *Issei* settler in Twin Falls, Idaho, who built the Koto building on Main Street in 1920.

After one date and a year of correspondence through letters, the couple married in January 1946. Together they operated a restaurant in Shoshone, Idaho. In 1958 they moved to Twin Falls and opened a highly regarded restaurant, Koto's Cafe, while raising three children. The restaurant closed twenty years later.

Tom, an Idaho native, died on Jan. 27, 2002. The American Legion presented an American flag to Mats in honor of her husband of fifty-six years. Mats, born on Jan. 2, 1925, died in Twin Falls on Jan. 31, 2011.

Of her two surviving children, Thomas "Tom" E. Koto, Jr., remains in Idaho. He is an athletic trainer and Durable Medical Equipment specialist in Boise.

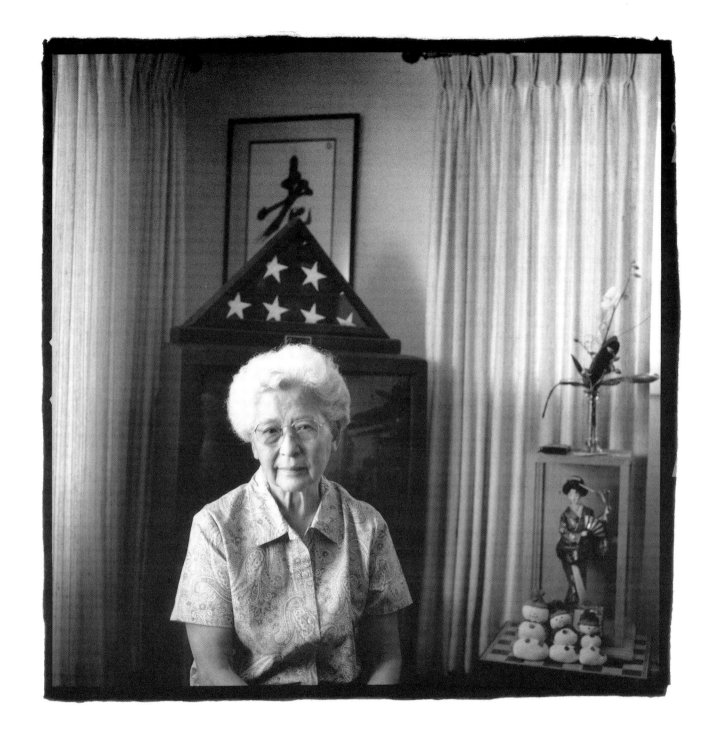

2002 (July 11)
Twin Falls, Idaho
120 B&W T-Max 100 film

165

1943 (Sept. 14) publication date
Times-News, Twin Falls, Idaho
Copy photo, 120 B&W film taken April 19, 2008,
Anchorage, Alaska.

ITALY SURRENDERED TO THE ALLIES on Sept. 8,
1943. The *Times-News* caption reads: "Cheerfully scanning
the *Times-News* headlines of Italy's surrender are these four
Eskimo-Japanese young men now working in Magic Valley
farm fields. Left to right, Donald Moto, James Moto, Peter
Heyano and Taylor Moto."

"I WANTED TO BE a good American and be drafted with
the rest of them," said Pete Heyano, who at 86 still fit
into his World War II uniform after more than sixty years.
Heyano served in Belgium, where he met his wife, Rosa.
They raised eight children in Ekuk, Alaska, before moving
to Anchorage in 1991. When Heyano died in 2011,
he and Rosa had 14 grandchildren and nine great-
grandchildren.

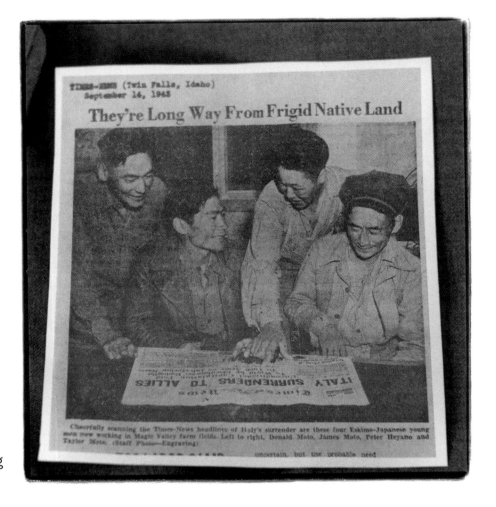

Heyano was born in the Alaskan village of Nushagak to a Japanese father and Yup'ik mother. Had his mother been alive during
World War II, she could have chosen to remain in Alaska or accompany her husband and two sons to Minidoka.

The patch on Heyano's uniform is the insignia for Communications Zone personnel in the European Theater of Operations. The
twin thunderbolts represent ground and air forces "breaking the chains now enslaving Europe." They also form the "V for Victory"
symbol, common to both U.S. and British forces.

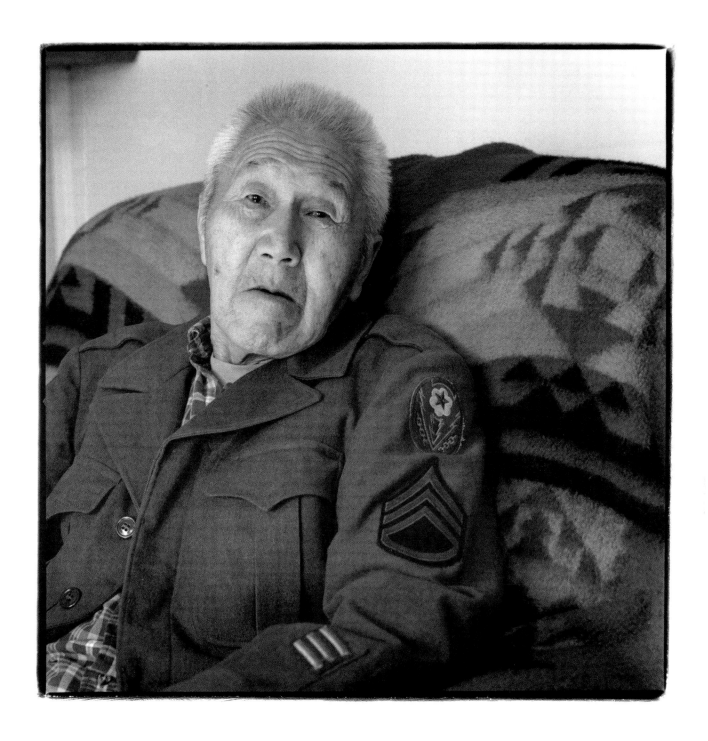

2008 (April 19)
Anchorage, Alaska
120 B&W Tri-X film

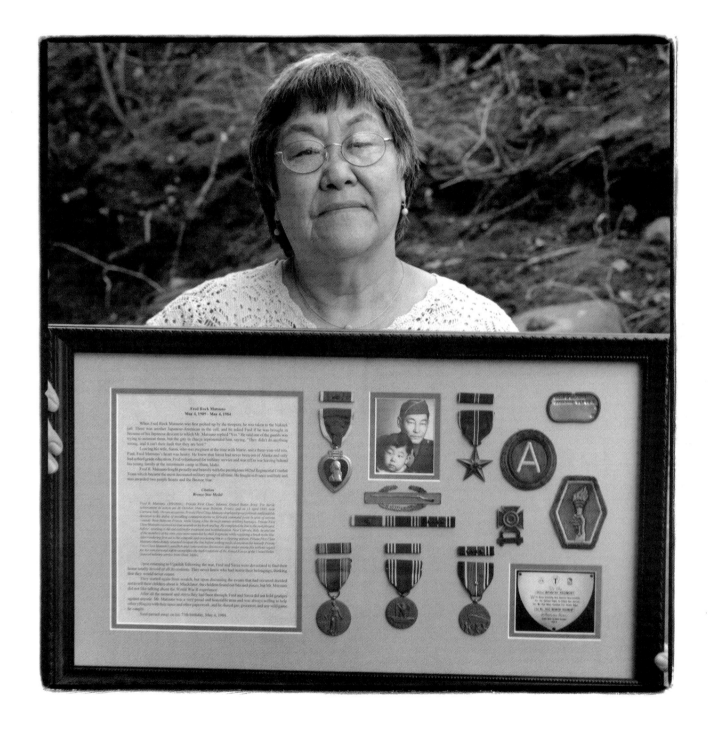

2008 (April 21)
Wasilla, Alaska
120 B&W Tri-X film

168

"**IT WASN'T UNTIL** I was in high school in Haines [Alaska], when our history teacher started talking about [the incarceration], that I really realized, you know, the full impact. And even then, I didn't really know because there was very little in the history books," said Marie Matsuno Nash, who was born at the Minidoka War Relocation Center.

Her father, Fred Rock Matsuno, was one of nearly 1,000 Japanese Americans who served in the Army while their families remained in Minidoka. Born in Hawaii, Fred earned a Purple Heart and the Bronze Star as a private first class with the 442nd Regimental Combat Team in France and Italy. Marie Matsuno's mother, Sassa, was a native Alaskan Aleut. She and Fred made their home in Ugashik, a small fishing village on the northwestern coast of the Alaska Peninsula. The village had no running water or electricity.

After the war, the Matsuno family returned to Ugashik. Marie graduated from college and worked for U.S. Senator Ted Stevens for twenty-nine years, during which time they helped to secure reparations for Alaskan Aleuts who were relocated after the bombing of Pearl Harbor.

SEPTEMBER 3 [1943]

"When the evacuees first came to Hunt in the summer and fall of 1942 they tended to settle in groups or certain areas according to the geographical locations from whence they came on the Coast. The people from the Portland area were more or less congregated in one part of the Center while those from Seattle and nearby towns had a tendency to settle in another part. Now few of the evacuees are willing to move from one area to another. Some say it's like moving to a foreign country when they leave the 'Portland Area' and go to 'Seattle Area' and from the 'Seattle Area' to the 'Portland Area.'" — Arthur Kleinkopf, *Relocation Center Diary: 1942-1946,* Idaho and Pacific Northwest History Collection, Twin Falls Library, p. 254

"[THE PEOPLE OF MINIDOKA] are significant because we are still living," Yoshitada Nakagawa maintains. "Most monuments and stories are written after the people are gone, and, because of this history, it no longer is an ethnic Japanese American story. Minidoka is an American story, a part of our history. It is validated because of what happened on 9/11. The constancy of racism, fear, freedom, justice and peace will always be questioned. We were the last major group in America to be incarcerated as a group. No other group since has, but it doesn't mean it can't happen again."

Nakagawa was born in 1932. His family operated a small grocery store where Seattle University is now located. He believes that *Issei* like his parents suffered the most from the incarceration and related activities during and after World War II. He sees their punishment as ironic, given that *Issei* culture practiced nonviolence and respect of authority.

Nakagawa earned a degree in sociology from the University of Washington in 1956. He began his work career as a stock boy and retired as president of Osborn and Ulland, a sporting goods chain, after forty-five years. He received an honorary doctorate from American Baptist Seminary of the West in 2007. Four years later, Nakagawa was awarded the highest lay award from the American Baptists Churches USA at its biennial convention.

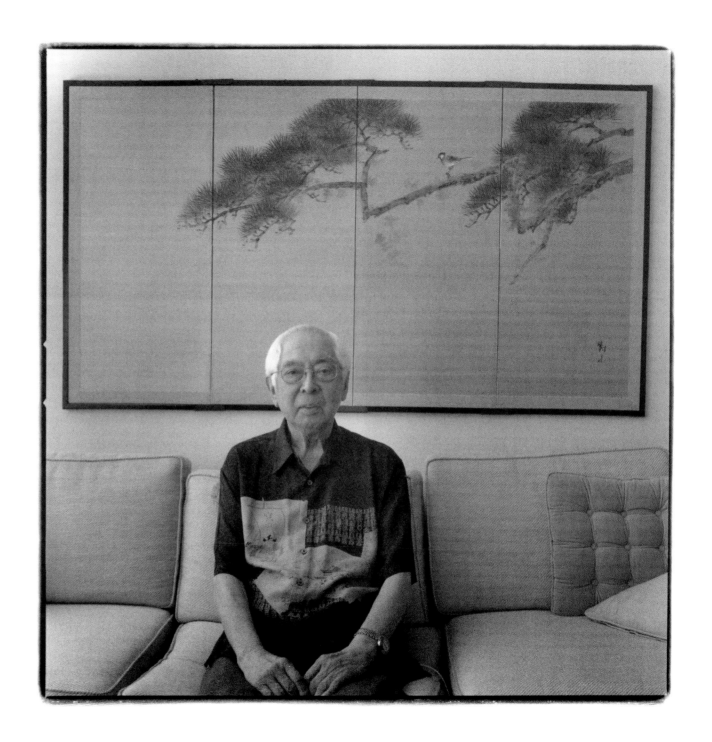

2008 (May 22)
Mercer Island, Washington
120 B&W Tri-X film

IN THE FALL OF 1941, May Yoneko (Daty) Namba was hired as a part-time clerk at Stevens Grade School in Seattle. She rode the bus to work, clerked for four hours a day and earned $6 a week. "I was elated with my job," Namba recalls. On Feb. 24, 1942 she and 26 other *Nisei* women employed in Seattle schools signed a letter of resignation to the Seattle School Board. The letter read in part:

"We, the undersigned American citizens of Japanese ancestry, have learned that our presence as employees in the Seattle School system has been protested by certain persons and organizations. . . . We take this step to prove our loyalty to the school system and the United States by not becoming a contributing factor to dissension and disunity when national unity in spirit and deed is vitally necessary to the defense of and complete victory of America. . ."

Namba's father, Noburo Daty, an import/export businessman in Seattle, was arrested on the night of the attack on Pearl Harbor. He was sent to Missoula, Montana; Fort Stanton, Texas; and Lordsburg, New Mexico before being released in May 1945. During that time, Namba was sent to Minidoka along with her mother, Masuyo, older brother, Henry Isamu (who subsequently volunteered for the U.S. Army) and two younger sisters, Carol Tokuko and Anne Haru.

Namba left Minidoka before it closed and relocated to Spokane. She returned to Minidoka briefly before moving to Chicago, where she worked for three years. She returned to Seattle at the request of her parents, only to move to Portland in 1948 after she married Tomomi ("Tom") Namba, an Oregonian she met in Minidoka.

On April 2, 1986, Washington Governor Booth Gardner signed legislation granting redress to the 27 Seattle School District teachers, along with four city and 40 state *Nikkei* employees dismissed during World War II. Namba reapplied for employment with the school district. She is a board member of Friends of Minidoka, a nonprofit organization devoted to "upholding the legacy of the Japanese American incarceration experience."

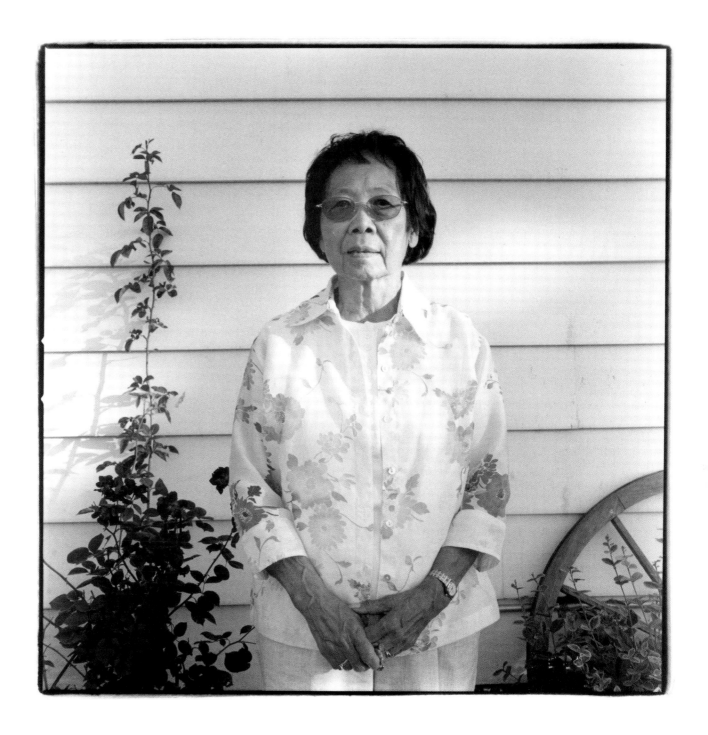

2006 (July 8)
Jerome, Idaho
120 B&W Tri-X film

GORDON YAMAGUCHI was born after his parents were incarcerated in Minidoka. "Jack" Masajiro Yamaguchi and "Dorothy" Asako (Yamanaka) married in April 1942 so they could remain together through the mass relocation. They had two children in Idaho and three more when they resettled in Renton, Washington after the war. Jack worked at Olympic Foundry and served as financial secretary for the local workers' union.

This Was Minidoka, published in 1989, is the product of a recorded talk and slide show that Jack and Dorothy created in 1972 to educate the public when few people were willing to discuss the mass incarceration. Dorothy explains in the preface that, after Jack retired, he began sorting through boxes from camp that hadn't been opened in twenty-five years — since October 1945. "Among them was [a] box of photographs from Minidoka, and all the memories of those years in camp returned to flood his mind and heart of that time in which he was imprisoned with his family and fellow Japanese."

Gordon Yamaguchi graduated from the University of Washington School of Dentistry in 1977 and opened his own practice in Olympia, Washington, more than thirty years ago. His son, Garret, graduated from the same dental school in 2008 and joined his father's practice. Gordon's wife, Lynn, and daughter, Marlene, also work there. They have another daughter, Keriann.

"I remember being called a 'Jap,'" Gordon recalled in a story published in *The Olympian* newspaper to promote Asian Pacific American Heritage Month. "I was just a little kid and I cried. I went home to my parents and they told me to be proud of who I was . . . My parents wanted to help make sure that something like this would never happen to another group in this country."

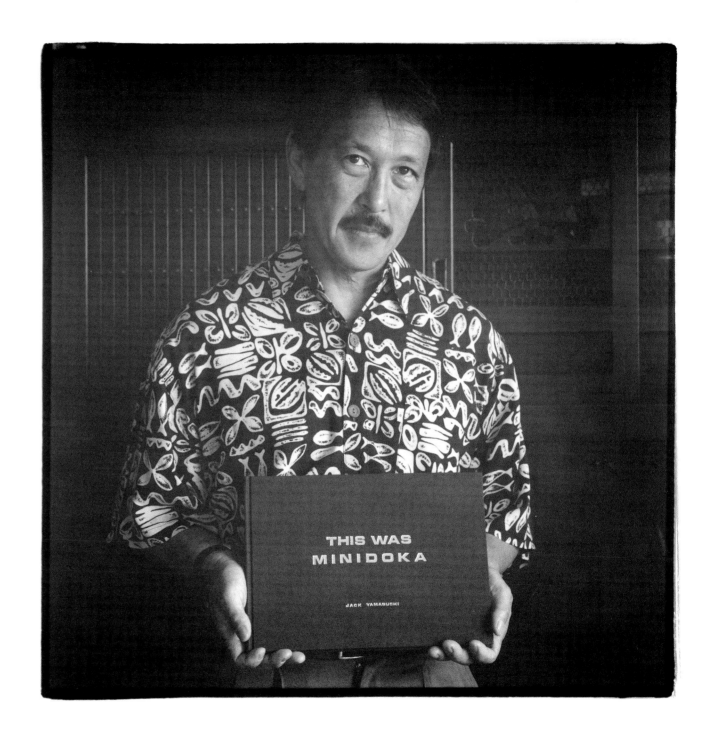

2004 (July 8)
Des Moines, Washington
120 B&W T-Max 400 film

KENGO YORIOKA did not want to discuss his memories of Minidoka. He lived in Block 4, Barrack 7D, with his wife, young son, newborn daughter, and mother.

Patricia Tomoko Yorioka, the older of two daughters, said her father was a *Kibei* who returned to the Pacific Northwest when he was 16. A ship manifest dated April 15, 1928, lists the names of Kengo and his older sister, Hiroko. "He had a scholarship to study at the University of Washington, an art scholarship, but then his father passed away so he had to work on the farm. Then the war broke out. Missed opportunities, I guess," Patricia recalled.

In 1990 Patricia and her brother, Richard Kenji, took their parents to Japan for their 50th wedding anniversary. "My dad hadn't been back in sixty years so it was a very emotional trip for him. . . . You know that famous building in Hiroshima, the dome-shaped one [now Hiroshima Peace Memorial Museum]. That's where he went for art classes," she said.

Kengo worked for a *Nikkei* truck farmer in Spokane who sponsored his release from Minidoka. He then worked his way up to foreman of Crystal Laundry in Spokane. In retirement he enjoyed golf, drawing and gardening. Kengo and Patricia moved to Vancouver, Washington, in 2005, after his wife died. Kengo died four years later.

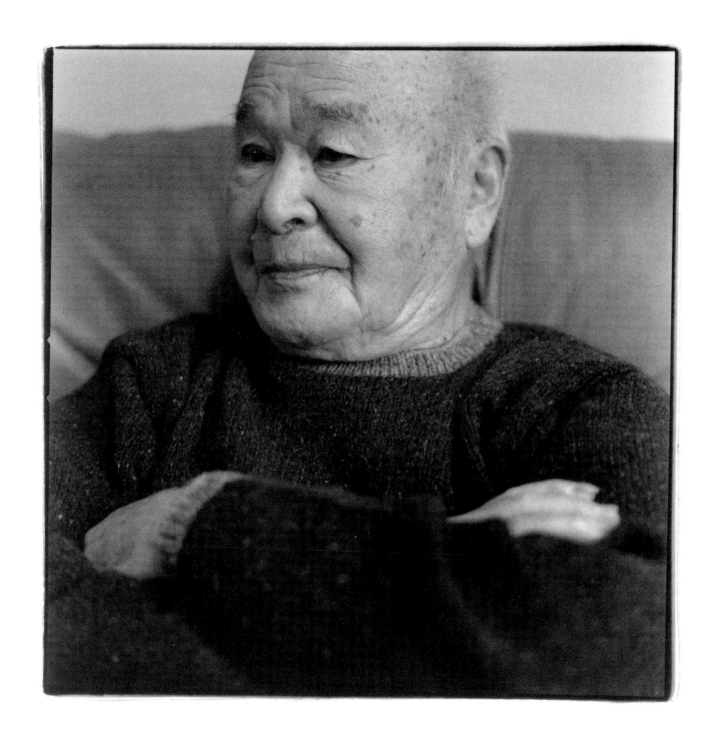

2007 (March 26)
Vancouver, Washington
120 B&W Tri-X film

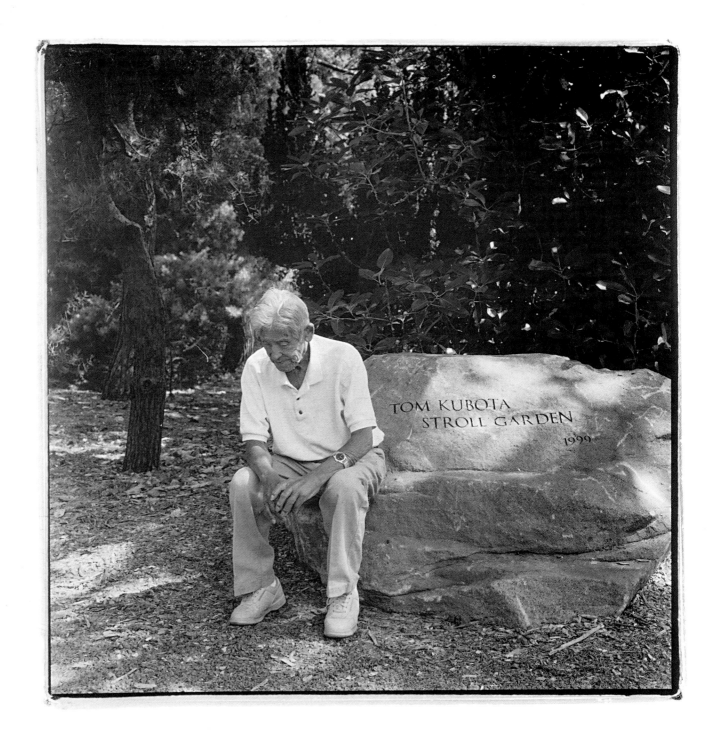

2003 (Aug. 6)
Seattle, Washington
120 B&W T-Max 400 film

180

TOM KUBOTA, Fujitaro Kubota's youngest son, served in the Military Intelligence Service, an Army unit divided into Japanese American and German-Austrian branches, while his parents were incarcerated in Minidoka. The Japanese American contingent primarily comprised *Nisei* trained as linguists.

Tom's father created a garden at the entrance to the Minidoka camp. Remnants of the garden are still visible at the site.

Tom remembers the state of his father's expansive but abandoned garden in Seattle when he returned there after the war. Tall grass had grown everywhere. His father needed a sickle to cut the growth. Tom and his brother, Takeshi, helped Fujitaro rebuild the garden and family landscaping business in the Rainier Beach area. What began as five acres of swampland evolved into 20 acres of "urban refuge." In 1981 Kubota Garden was designated a Seattle historical landmark. Six years later, the City of Seattle acquired the property, now maintained by the Department of Parks and Recreation.

When he was 82, Tom created the Tom Kubota Stroll Garden, an addition with wheelchair accessibility. He designed the garden without drawings — just as his father had done.

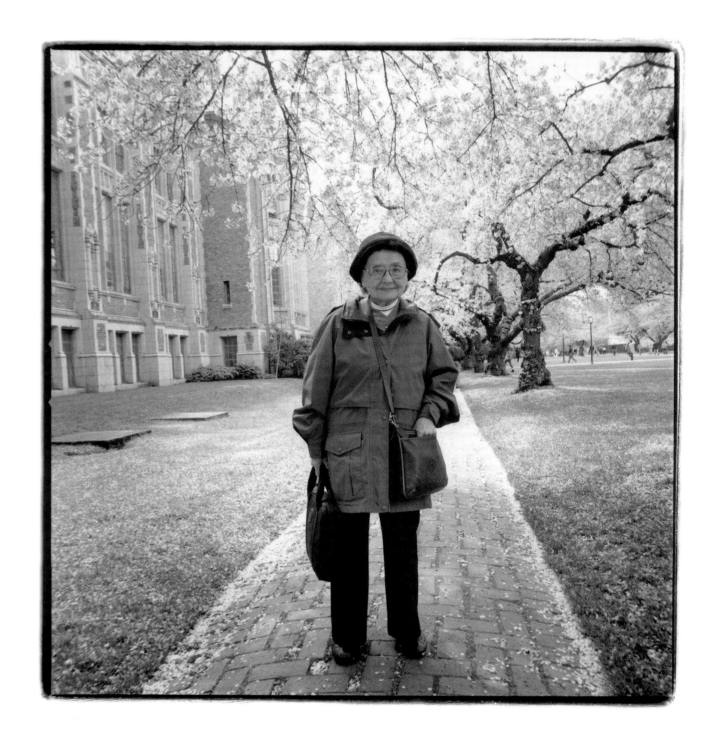

2008 (April 14)
Seattle, Washington
120 B&W Tri-X film

182

YUKIKO (KAWAKAMI) SATO turned 24 during her incarceration in the Puyallup Assembly Center (Camp Harmony). Her father, Kakuzo Kawakami, was arrested in February 1942 and sent to Fort Missoula. After his loyalty hearing before the Alien Enemy Hearing Board for western Washington, he was released and rejoined his wife, Fuku, and two of his four adult children at Camp Harmony, a temporary assembly center. One of his sons had been drafted into the Army; he was relegated to latrine service until Military Intelligence Service recruited him. Four Kawakamis were sent to Minidoka. Yukiko was incarcerated for 11 months. A supervisor at the Social Security Administration (SSA) in Seattle, where she worked before Executive Order 9066, granted her a leave of absence without pay when she was taken to Camp Harmony and then Minidoka. She applied for a work release and was able to transfer to other SSA offices in Denver and Chicago before she was able to return to the Seattle base. She continued to work for the SSA until her retirement in 1982. During that time she married Den D. Sato, had a son, Den J., was widowed and remained a single mother.

At 82, Yukiko Sato also was the oldest graduate in the University of Washington Class of 2001, earning a bachelor's degree — *magna cum laude* — in American Ethnic Studies. Sato took one course per quarter for 19 years. Her senior thesis focused on the fate of *Nisei* students during the period 1941-42.

In May 2008 the UW organized a special ceremony, "The Long Journey Home: Honoring UW Nikkei Students From 1941-42." Sato worked behind the scenes as a researcher for the project. She was particularly helpful with her knowledge of maiden names of the married female students.

Two months shy of her 90th birthday, Sato asked me: "Have you been to Minidoka? I hated that place."

ROBERT YOSHIHIKO HANDA, a University of Washington student in 1941-42, was among 447 *Nikkei* who received honorary degrees in a special ceremony held in Seattle on May 18, 2008. The university was second after University of California at Berkeley in *Nikkei* enrollment. Handa's family was assigned to Minidoka; Robert received a work release, lived in the Caldwell labor camp and worked for local farmers, harvesting sugar beets, potatoes, onions and lettuce.

On Nov. 2, 2011, Handa was honored with a Congressional Gold Medal for his World War II contributions in the Military Intelligence Service. President Obama signed legislation in 2010 to honor collectively the 442nd Regimental Combat Team, the 100th Infantry Battalion and the Japanese Americans who served in the MIS.

After the war, Handa returned to the Puget Sound area and resumed his studies at the University of Washington. He earned a degree in statistics, married Minnie Oyama and helped raise three sons. After thirty-five years as a senior research specialist (statistician) at The Boeing Company, he retired. Handa continues to live in Bellevue, Washington, his hometown. He keeps one reminder of Minidoka in his living room: a wooden bird sculpted by his father, Takeyoshi Handa, when he was imprisoned at Minidoka.

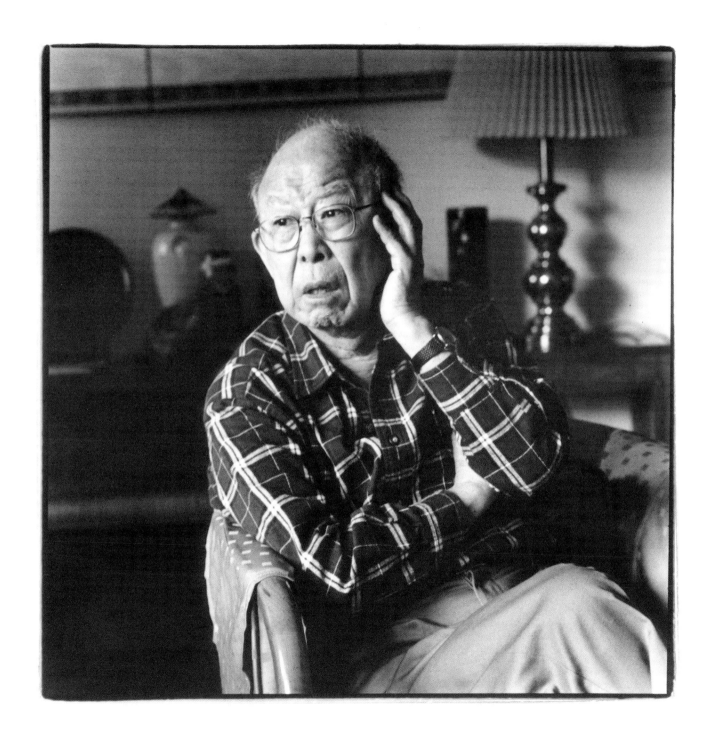

2005 (March 21)
Bellevue, Washington
120 B&W T-Max 400 film

ROBERT TERUO OHASHI and his wife, Marian Ayako (Tamura), met as students at the University of Washington after World War II, not when they were in Minidoka together. Marian, four years younger than Robert, was in the same eighth-grade class as his younger brother, Jiro. Despite the coincidence, she didn't know the Ohashi family from Ketchikan, Alaska, who lived in Block 24. Marian and her family came from Seattle and lived in Block 35. "My dad lost his business and store," Marian said. "We packed up and left things in the Baptist Church."

Adding to that loss, Marian's oldest brother, Yoshio Tom Tamura, accidently drowned to death in Minidoka's North Side Canal on Aug. 28, 1943. He was 21. Yoshio was an honors student in high school and a sophomore at the University of Washington when he was forced to abandon his studies and become a prisoner in Minidoka. In 2008 when honorary bachelor's degrees were awarded to the Japanese American students who were enrolled in the university during World War II, Marian accepted Yoshio's diploma on his behalf.

Robert's father, Buck Wakaichi Ohashi, an "alien," was immediately taken away from the family after Pearl Harbor was bombed. He was sent to Annette Island, Alaska, and eventually to Lordsburg, New Mexico. Buck reunited with his wife and five children at Minidoka in 1945. They returned to their home in Alaska and resumed life in Ketchikan. In 1958 Buck applied for and received U.S. citizenship.

Robert graduated from Minidoka's Hunt High School in July 1943. He worked on Idaho fruit farms before serving in the Army. He was assigned to Okinawa, Japan, from 1946 to 1948. After the war, he studied at the University of Washington and became a pharmacist. He opened his own business on Beacon Hill in Seattle and kept it for fifty years.

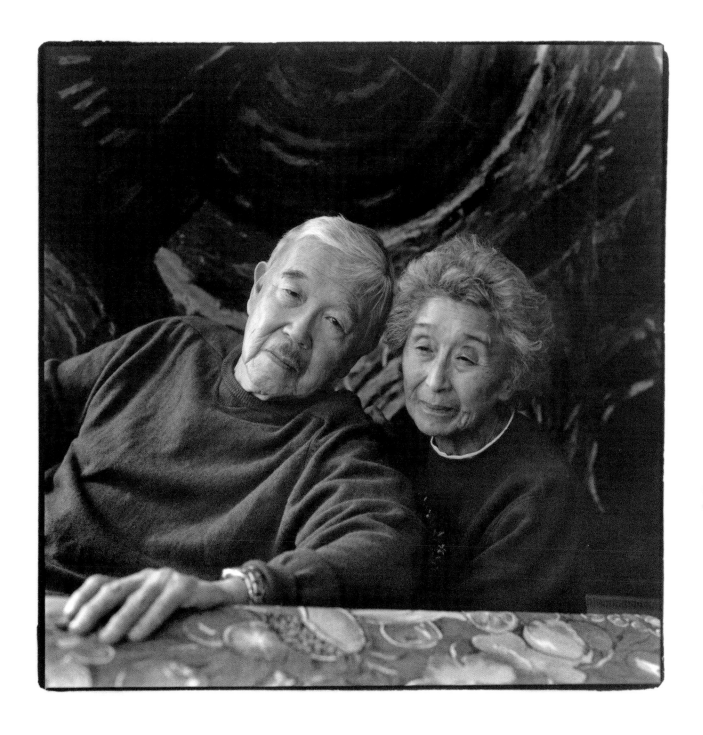

2009 (Oct. 11)
Seattle, Washington
120 B&W Tri-X film

NEIL JIRO OHASHI was named after his grandfather, Jiromatsu George Ohashi, a portrait of whom appears above him. Jiromatsu left Japan to work in Alaska's mines in 1900. He opened a boarding house at 223 Stedman Street in Ketchikan in 1908. Before World War II, Ketchikan had the largest population of Japanese in the Alaska Territory. The Ohashis were among the first Japanese to settle there. After the war, the family was among a small group who returned to Alaska to rebuild their lives. Other internees from Alaska remained in the Lower 48.

Neil is the last remaining Ohashi family member in Ketchikan. He lived in the Stedman St. building until 2008, when the family sold the property. He has traveled to Idaho several times but not to Minidoka. "I don't even want to see it," he said.

The new owner of the former Ohashi home and business plans to restore the building to its original design and display contributions made by the first Japanese families in the area.

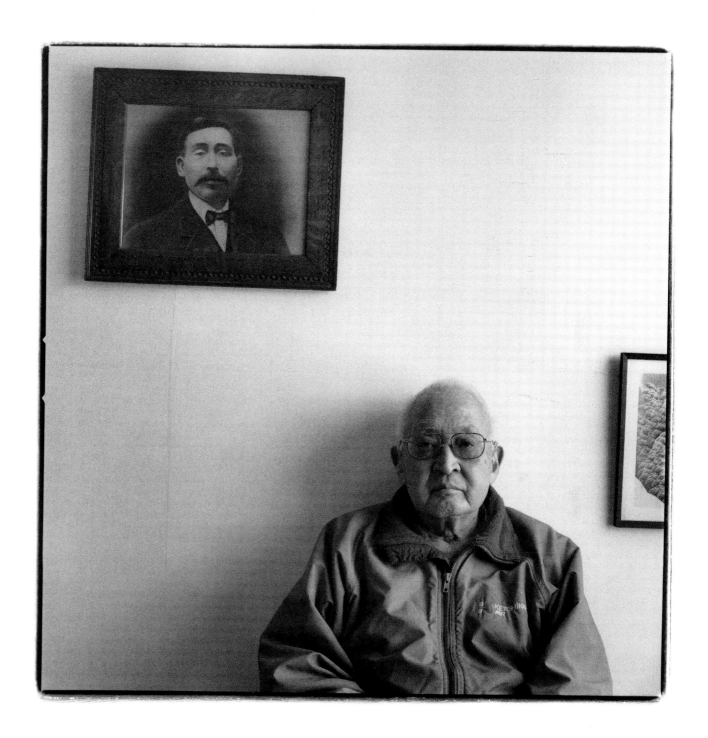

2008 (April 23)
Ketchikan, Alaska
120 B&W Tri-X film

189

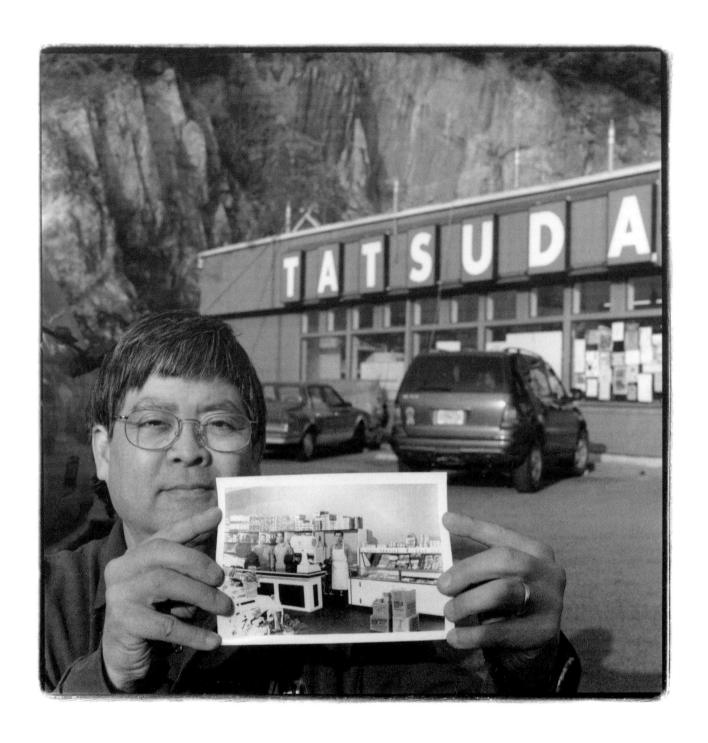

2008 (April 23)
Ketchikan, Alaska
120 B&W Tri-X film

KNOWN AS "JUNIOR" when his father was alive and as "Bill" now, William Bruce Tatsuda Jr., holds a photograph taken in 1948 of his grandfather, Jimmie; uncle, Jimmy; and father, William at their grocery store in Ketchikan. The Tatsuda store opened in 1916; it continues to operate as a family-owned business to this day. Bill is president and still works in the store. His daughter, Katherine Tatsuda, is co-owner, vice president, secretary and store manager.

"Jimmie" Kichirobei Tatsuda, Bill's grandfather, and Sen Seike, his grandmother, came to Alaska from Ehime-ken, Shikoku, the same Japanese village that was home to the Ohashis. In Ketchikan, the families lived across the street from each other on Stedman Street. The Tatsudas had nine children, but only five were still alive at the time of relocation.

Jimmie, an *Issei*, was separated from the family when they were removed from Ketchikan. His daughter, Cherry, was married in Minidoka. Jimmie, relocated to Lordsburgy, New Mexico, missed the ceremony. All three Tatsuda brothers served in the Army. Two of them returned to Ketchikan; the oldest resettled in Minnesota.

Bill's father, William Noboru Tatsuda, met his wife, Kazuko Hiyano, a zoology major, while they were students at the University of Washington prior to the war. Kazuko was a few credits short of graduation; William was able to complete his studies and earn a degree in economics. They married in 1938 and had three children.

"NO TWO IMPRESSIONS of life in a relocation center, from the evacuee's point of view, would be the same. The centers themselves differ each from the other. Minidoka in Idaho, Topaz in Utah, and Granada in Colorado — in the order named — are 'the cream of the lot.' Minidoka rates highest, on all counts, and there are at least a dozen explanations of the fact. The Minidoka evacuees are better adjusted; there has been virtually no trouble. One reason suggested is that most of the evacuees in Minidoka came from Portland where they were fairly well integrated in the community prior to evacuation. The theorizing about Minidoka is fancy and profuse." — Carey McWilliams, *Prejudice: Japanese-American, Symbol of Racial Intolerance,* 1945, p. 206

IN OREGON IN 1940, nearly 1,680 *Nikkei* residents lived in the Portland area. Harue Mae (Okazaki) Ninomiya was 21 at the time, the oldest of four children in her family. She was born March 22, 1919 in Portland to Hidekichi and Tetsuno Okazaki.

Hidekichi Okazaki came to America from Okayama, Japan, in 1907 when he was 20. Settling in Portland, he worked as a produce farmer on leased land, opened a fruit stand in 1933 and expanded his business into a grocery store.

The Okazakis were forced to move to the Portland Assembly Center set in the Pacific International Livestock Exposition Pavilion. Harue's boyfriend, Nagao "Nug" Ninomiya, also was assigned to live there. They arrived at Minidoka in September 1942, and both found work outside the camp. They married in the camp on Dec. 15, 1943. Their first child was born at the labor camp in Caldwell in June 1945. By August, Harue and her family returned to Portland and reopened the family's grocery store. Some food suppliers and customers were reluctant to do business with the family because of lingering anti-Japanese sentiment.

In 1985 Harue earned a bachelor's degree in general studies from Portland State University, fulfilling a lifelong ambition. She was 70. Ten years later she volunteered to teach *ikebana*, the Japanese art of flower arrangement, to children in Portland schools. From 1995 to 2004 Ninomiya taught more than 6,000 students how to create flower arrangements.

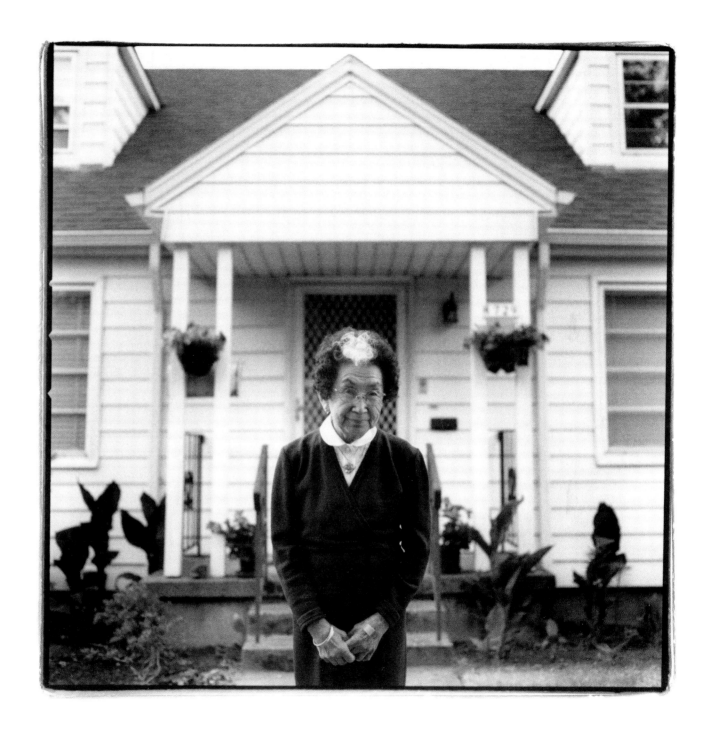

2004 (July 10)
Portland, Oregon
120 B&W T-Max 100 film

YOICHI "CANNON" KITAYAMA was 13 years old when Pearl Harbor was bombed. His father was arrested in January 1942, taken to Fort Missoula and released in May. The family was reunited at the Portland Assembly Center and relocated to Minidoka in September. WRA records indicate five groups from Portland comprising 2,318 Japanese Americans and Japanese were shipped to Idaho. Another two groups comprising 938 Japanese Americans and Japanese went to Heart Mountain, Wyoming.

Kitayama had enough credits to graduate early from Hunt High School, Class of 1945. He was 16 when he went to college in Kalamazoo, Michigan, earning a bachelor's degree in general studies. After working briefly in Portland, Kitayama joined the Army and was sent to Japan, where he was able to visit relatives. When he resettled in Portland, he worked as the production manager for a screen-printing company. He married Janie Fumiko, and the couple had two sons: Brad a resident of Auckland, New Zealand, and Stuart, who lives in Beaverton, Oregon, with his wife and two daughters.

Kitayama led the crew that built a replica of the Minidoka barrack block on display at the Oregon Nikkei Legacy Center in Portland. He serves on the board of directors of the Japanese Ancestral Society of Portland and on an advisory committee for the Neighborhood House Senior Center.

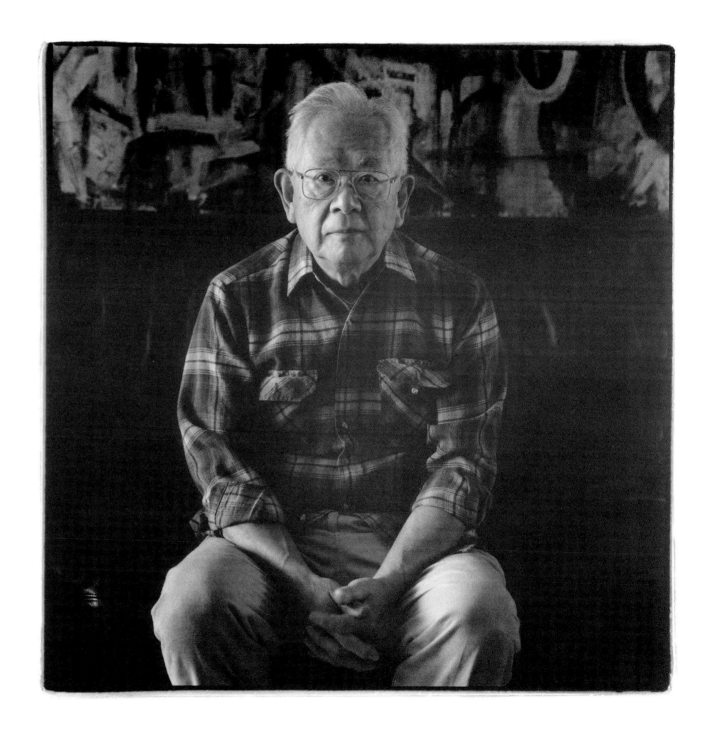

2004 (July 10)
Portland, Oregon
120 B&W T-Max 100 film

197

MINIDOKA WAS THE MEETING PLACE for Oregonians Ruth Shigeko (Inukai) Namba and Kenji (Kennie) Namba. Minneapolis provided a second, chance encounter. And Hood River, hometown of the bride, was the location of their marriage in 1946.

Kennie Namba volunteered for the Army from Minidoka as a 17-year-old. He served in the same unit of the 442nd Regimental Combat Team as his older brother, Tomimo (Tom) Namba. Kennie's first assignment in Europe was the misguided Battle of the Lost Battalion. He survived only to be injured by a hand grenade in another firefight.

Namba returned to Multnomah County with a Bronze Star, Purple Heart and two pieces of shrapnel still embedded in his body. He filed a case in 1949 challenging the unconstitutionality of Oregon's Alien Land Law, which prohibited "aliens" such as his father, Etsuo, from owning land. He won the case. In 2008, Kennie Namba was inducted into the Oregon Military Hall of Fame; three years later, he received the Congressional Gold Medal.

Ruth Namba was a senior at Hood River Valley High School in Oregon when her family was taken from their home. They relocated to the Pinedale Assembly Center in Fresno, California, then to Tule Lake War Relocation Center, and finally to Minidoka. Ruth moved to Minneapolis on a work release to make pup tents for the war effort. There she and Kennie met again.

Married more than sixty years, Ruth and Kennie have been frequent guest speakers for panels, programs and classroom discussions about the internment during World War II. Ruth shares stories about their return to the Pacific Northwest, including this one: "[Kennie and I] went back to Hood River. My folks were back from camp. On the way, we stopped by a little mini-store to buy groceries to take to my folks. We had two baskets full of groceries. [The cashier] said, 'We don't serve Japs.' And [Kennie] was still in an Army uniform. We had to walk out."

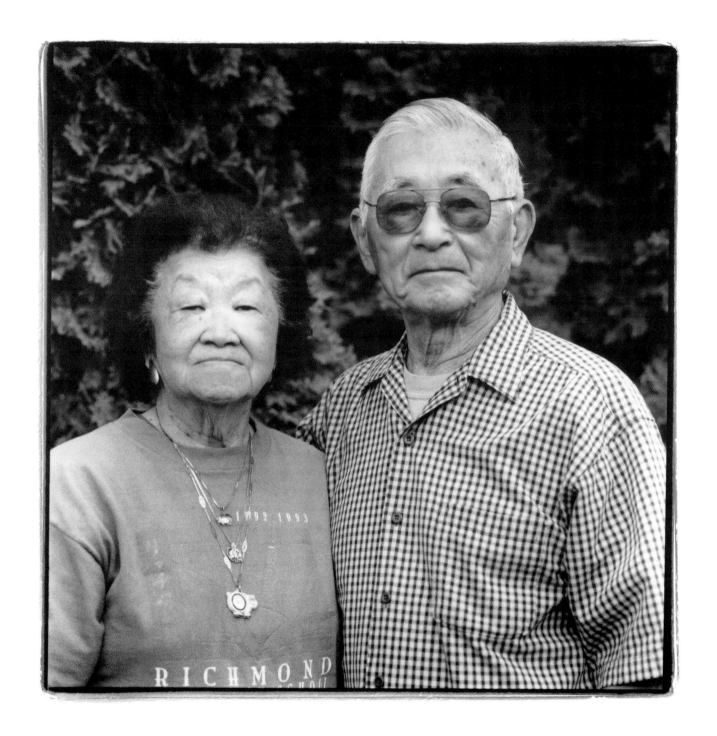

2004 (July 11)
Portland, Oregon
120 B&W T-Max 100 film

"**COMMENTS AND SUGGESTIONS:** The Nampa area, which is a fertile farming district west of Boise near the Oregon line, was the scene of further action concerning the evacuees. Because there is a large pre-evacuation settlement of Japanese Americans in this area and also because many evacuees have relocated on this land, the other farmers in the area have been concerned about the evacuee situation. The Nampa Valley Grange went on record this month opposing the sale or lease of any Idaho land to Japanese on the grounds that the value of surrounding land would be lowered and the social life of neighboring communities disrupted. The Idaho Free Press at Nampa carried an editorial 'A Sane View on The Jap Problem' regarding action taken by Deer Flat farmers. The Deer Flat farmers said that the evacuees could not be kept from returning to the coast after the war. 'Their homes are on the coast, not here . . . Idaho people have on the whole taken a rather decent view on this delicate question. . . . We have heard virtually no objection to Japanese who were in this locality before the war remaining afterward, but objection is made and proper to making this state a Japanese center merely because the coast states are seeking to place what is 'their baby' elsewhere."— Minidoka Monthly Report, January 1944, National Archives, RG210, Box 214, File 24.039_Monthly Report – Minidoka.

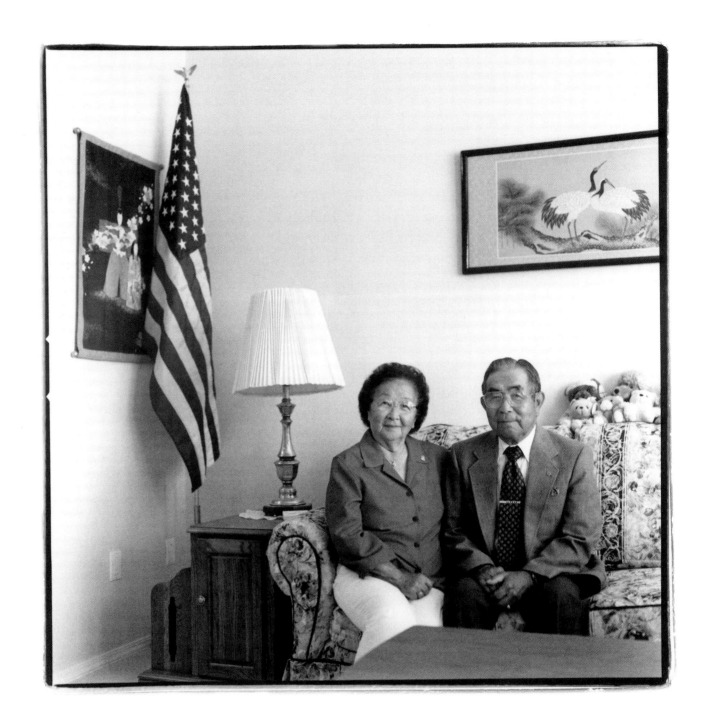

2004 (June 28)
Caldwell, Idaho
120 B&W T-Max 400 film

NORI (HAYASHIDA) OYAMA remembers clearly the day her father, Kenta Hayashida, an *Issei*, died of pneumonia. It was Dec. 31, 1940. Her older brother, Seichi, just two years out of high school, suddenly became the head of the family. He continued to raise strawberries and produce on leased land in Bellevue, Washington. Nori, her sister, Fumiko, and mother, Kame, all helped on the farm until Executive Order 9066 forced them to Pinedale Assembly Center and then to Tule Lake War Relocation Center.

Nori met Roy Oyama in Tule Lake before they were transferred to Minidoka. Roy, the son of a farmer from Auburn, Washington, was granted a work release to help harvest crops in Ontario, Oregon. He worked for the same farmer as Nori's brother and his new wife, Chiyeko. As Roy would be returning to Tule Lake, Chiyeko asked him to take six pairs of shoes back to the Hayashida family. Nori remembers that shoes were rationed, like so many other items during the war years.

Roy asked Nori to the Sweetheart Ball in Minidoka before he left camp to serve in the Army from December 1944 to October 1946. After Minidoka closed and Roy returned from the service, he and Nori were together again at the labor camp in Caldwell, working for area farmers. They were married in Caldwell on Feb. 26, 1949 by Reverend Tesshin Shibata, minister of the White River Buddhist Temple in Auburn before the war. Shibata relocated to Ontario, where a new temple was dedicated in 1947.

"We had no place else to go," said Nori of the transition from Minidoka.

Roy was hired by the Caldwell Post Office in 1954 and remained there until retirement in 1988. His older brother, Jim Oyama, was the first Japanese American postmaster in the U.S. He worked in the same post office in Caldwell. After her children were grown, Nori worked for a florist and then as secretary for an insurance company in Caldwell. Now in their late 80s, Nori and Roy continue to bowl in a league and remain involved in JACL and the Idaho-Oregon Buddhist Temple.

CHILDREN OF FARMERS, Frances (Yonemura) (left) and her husband Kay Yamamoto, were born in Sumner, Washington, and Nampa, Idaho, respectively. They met at a weekend dance at the labor camp in Caldwell, Idaho, soon after the war. They married on Dec. 14, 1947.

Fran, as she is known, had just entered high school when she was sent to Minidoka. She was an orphan; her mother died when she was a toddler, and her father passed away when she was 12.

Idaho farmers recruited workers from the camps because of labor shortages. Fran volunteered to work for a Caucasian farmer, harvesting sugar beets when she was 16. Many farmers credited workers from Minidoka for saving their crops. Fran also worked in one of the mess halls at Minidoka, serving coffee and tea. She then went to live with a family in Twin Falls, where she was a housekeeper for two and a half years. After the camp closed in 1945, Fran moved to Nampa to join a friend and older sister who had moved there.

Kay grew up in Nampa, a "free zone" area. His family was among a small group of *Nikkei* in the Treasure Valley who bought property before the Alien Land Law took effect. A photo taken in 1930 shows Kay among a group of 15 students who attended Japanese School. The photo caption reads: "The Japanese School, which met for six summers, was taught by students from Washington State University in Pullman. The instructor would live with one of the Japanese families. The class [was] held in Nampa with locations changing from summer to summer. The children were taught written and spoken Japanese. The school was held during the 1930s."

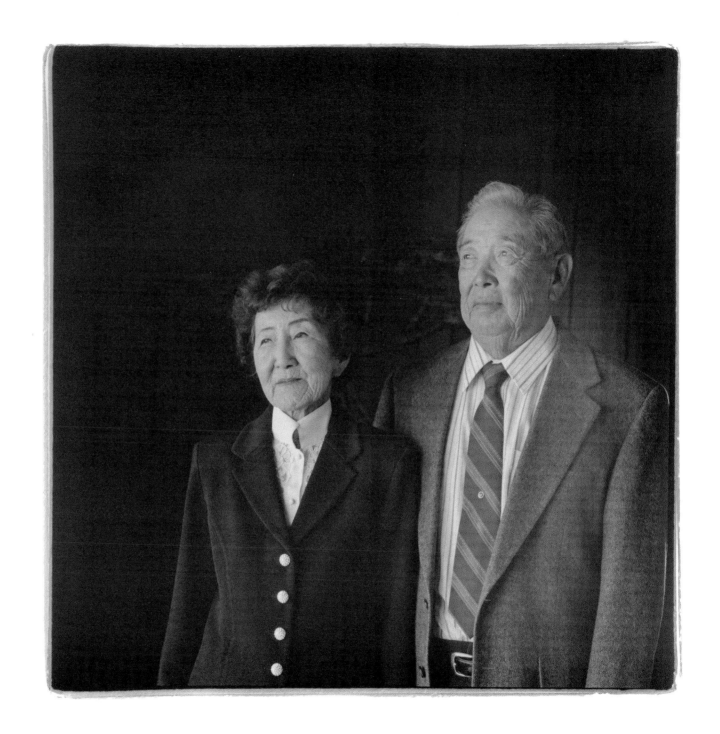

2004 (June 24)
Nampa, Idaho
120 B&W T-Max 400 film

205

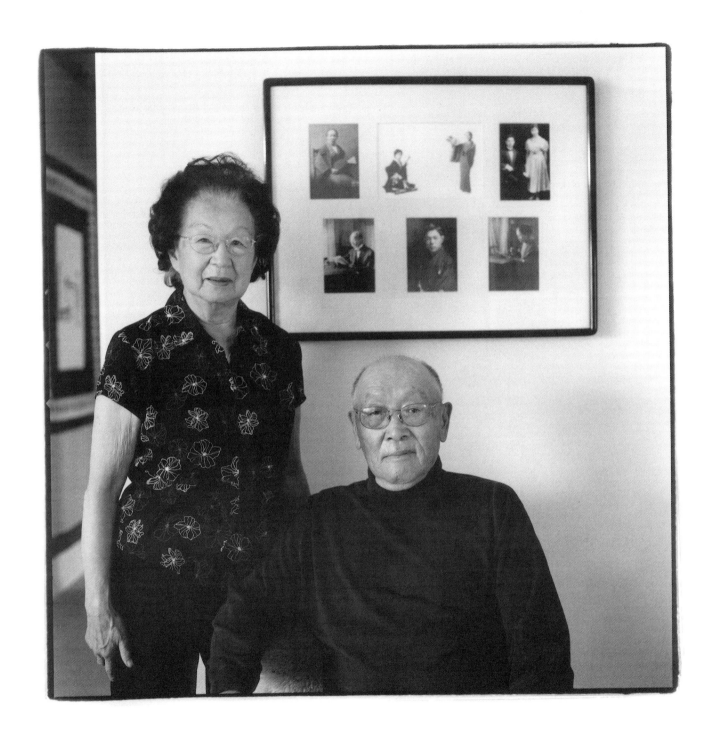

2004 (June 24)
Nampa, Idaho
120 B&W T-Max 400 film

206

ON THE MORNING OF DEC. 7, 1941, June Sato (Kikoshima) Itami was listening to a New York Philharmonic concert on the radio at her home in Seattle. She recalls the moment: "Suddenly the beautiful music was interrupted by a startling announcement: 'The Japanese have bombed Pearl Harbor, Hawaii.'" Five months later, June packed her violin when the Kikoshima family was forced out of their home.

June met Edward (Dyke) Daizo Itami when the two families were assigned to adjacent barracks at the Puyallup Assembly Center. Both June and Dyke were born in Seattle; the Itamis were farmers in Fife, Washington. Dyke, an outstanding athlete, volunteered to help relieve the farm worker shortage and spent little time incarcerated. June left her parents in Minidoka to work for a family in Libertyville, Illinois, before she and Dyke married in Spokane, Washington, in 1943.

The couple settled in Nampa. Dyke had befriended a German World War I veteran who loaned him $3,000. With the loan and another $3,000 he had saved from sugar beet harvests, Dyke was able to buy his own 40-acre farm and house. He and June raised eight children there. June taught violin to hundreds of students over a thirty-five-year period. She went to Japan five times to study the Suzuki method of violin instruction and founded the Idaho Suzuki Institute in 1972, serving as its director until 1987. She was honored with many awards such as Distinguished Citizen from the *Idaho Statesman* and Book of Golden Deeds recipient from the Nampa Exchange Club.

The framed pictures in the background show June's parents, Suye (Takahashi) Kikoshima and Zenshiro Kikoshima. When Zenshiro was 16, he emigrated to the U.S. to study automobile engineering at a vocational school in Seattle. He never returned to Japan. He bought a house on Beacon Hill in his son's name (due to the Asian Exclusion Act) and owned and operated an auto repair business. Suye was 7 when she came to the U.S. with her parents, who were restaurateurs in Tokyo. They opened a restaurant in Seattle; Suye and her sister taught Japanese singing and Japanese music on traditional instruments.

SHIZU (NAKANISHI) YAMAMOTO attended the Minidoka Pilgrimage with her family in June 2006, one month before her 100th birthday and five months before she died. Shizu told her family that it was good to see the site again, even though it looked very different. Daughter-in-law Judy Yamamoto remembers Shizu saying, "When we came here, you didn't see anything green."

Shizu, a *Nisei*, was 36 and a mother of three young children when she was sent to Minidoka in 1942. Her husband, Nobutaro Yamamoto, an *Issei*, farmed in Fife, Washington. He was arrested days after the U.S. declared war on Japan. He eventually joined his family in the camp, where another daughter, Ruth Katsumi, was born.

Shizu was born in Tacoma, Washington, the daughter of Yokichi and Masu (Iwasaki) Nakanishi, immigrants from Ehime, Japan. Yokichi's family was among the first Japanese to farm in Fife, near Tacoma. After his wife, Masu, died, Yoskichi moved several times, eventually settling in Idaho to farm with his youngest son, Mataro, long before the attack on Pearl Harbor. Yokichi and Mataro helped Shizu and her family start over in the Treasure Valley when they left Minidoka in 1944.

The Yamamotos bought a farm in Kuna, Idaho, in 1952. Shizu's third child, Minoru Duane Yamamoto, later served as Kuna's mayor. Yokichi Nakanishi, a devout Christian, lived with her family in his later years and translated the Bible from English to Japanese using a brush and ink.

2006 (July 8)
Jerome, Idaho
120 B&W Tri-X film

209

TOM SHINICHI HIRAI, 90 years old in this photo, and his wife, Dorothy Misao (Ozawa), 86, were newlyweds and among the first group of internees to arrive at the Minidoka War Relocation Center in 1942. The couple worked for the federal government, helping to set up the unfinished camp. Tom was responsible for transporting new internees to the camp; Dorothy was a secretary in the construction and maintenance department. Many of their peers remember Tom from his pre-war career as a professional wrestler known as "Oki."

The couple met in 1938 when Tom was hired at Pacific States Lumber Company in Selleck, Washington. Dorothy's father, Frank Nagayoshi Ozawa, was a foreman there. Dorothy recalls that all the Japanese men, women and children from the lumber company had to live in their own section, called "Jap Camp." Tom and Dorothy married on April 26, 1942 in Seattle.

Their first child, Karen, was born at Minidoka. After the camp closed, Dorothy wanted to move back to Seattle. But Tom, an avid fly fisherman and hunter, didn't want to return to wrestling, what he had done before, or truck farmering in Auburn, Washington, as his father had done. He wanted to farm in Idaho. The couple settled in the Twin Falls area about 30 minutes from the Minidoka site and raised four children.

When Dorothy visited Japan for the first time in 1977, she stayed with her mother's family, silkworm farmers in Nagano.

Tom's niece, Kimiko Hirai Soldalti, whose father was born in Minidoka, was a member of the U.S. Olympic diving team in 2004.

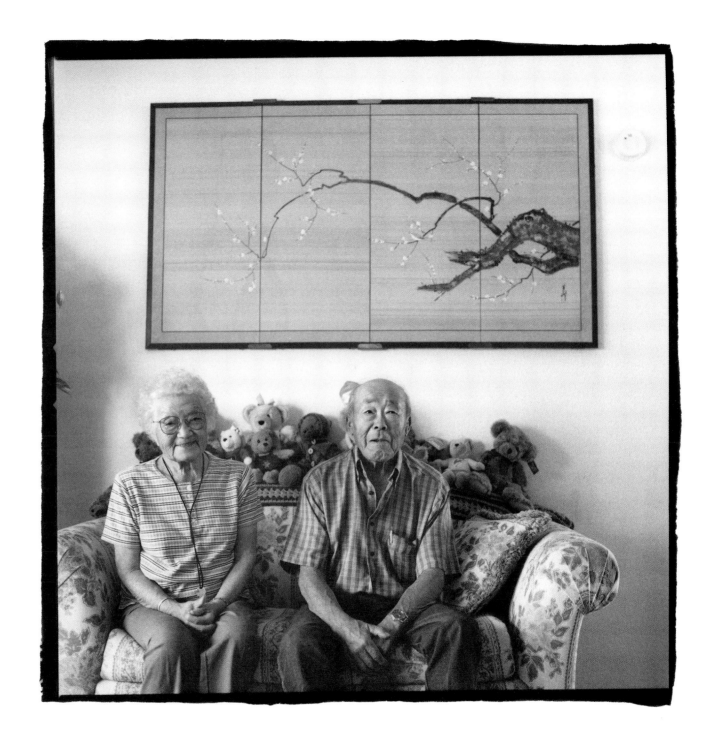

2002 (July 11)
Twin Falls, Idaho
120 B&W T-Max 400 film

"EVACUEES, ON THEIR OWN initiative, had begun to make things for themselves; they were doing the very thing I had wanted to encourage, and doing it better than I had imagined would be possible…Now, how could this story be told to the world outside the centers? It needed to be told. Knowing that there were good photographers among the evacuees, I tried to arrange by correspondence to get good photographs of art objects and exhibits. But there was a rule, I found out, prohibiting evacuees from taking photographs. I then took the matter up with the official photographic staff of the War Relocation Authority, but there were two obstacles; they already had more documentary photograph assignments than they could handle; and secondly, most of their men were not familiar enough with art subjects to locate and select the best things and then photograph them to advantage." — Allen H. Eaton, *Beauty Behind Barbed Wire,* 1952, p. 4

Circa 1943-1945
Minidoka War Relocation
Center, Hunt, Idaho
Duplicate 4x5 negative.
National Archives Photo
No. 210-CMB-V2-1890

214

RIGHT SECTION:

Shochuu omimai
Midsummer greetings (Wishing for your good health in the midst of hot summer.)

LEFT SECTION:

Toobun wa yappari saku ni oru to kime (haiku)
For the time being,
staying inside the fence
is my decision.

— Author unknown, translation by Takako Owada, Japanese English interpreter/translator, Seattle (Note: Japanese characters are read from right to left, top to bottom.)

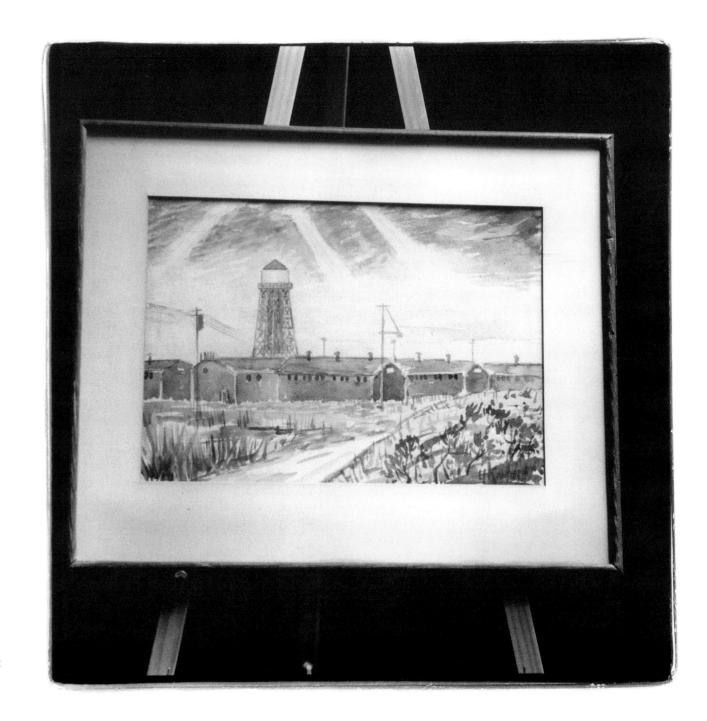

2005 (March 18)
Portland, Oregon
120 B&W T-Max 400 film
Courtesy of the Oregon Nikkei
Endowment, Portland, Oregon;
ONLC 1999.02.02

216

THIS WATERCOLOR of the Minidoka War Relocation Center by Y. Kamei was given to Kikuo Hiromura while he and his family were imprisoned in Minidoka. The painting, 17 ½ inches by 21 ½ inches, was made sometime between 1942 and 1945. No other information is available about the artist.

Hiromura, a journalist in Portland before World War II, collected paintings by Japanese artists. He and his wife, Seki, had five sons, three of whom served in the Army during the war. The middle son, Eisaku "Ace" Hiromura, donated the watercolor, in memory of his father, to the Oregon Nikkei Legacy Center in Portland, a history museum dedicated to preserving the culture of the Japanese American community.

After the war, the Hiromuras settled in New York City. Kikuo worked on Broadway in the early 1950s and performed in the original production of "Teahouse of the August Moon." He died in 1963 and is buried in Portland. Seki died in 1990. Eisaku Himomura graduated from college and worked as an accountant in the private sector. He retired in 1993 and moved to Vancouver, Washington, where he lives with his wife, Alice.

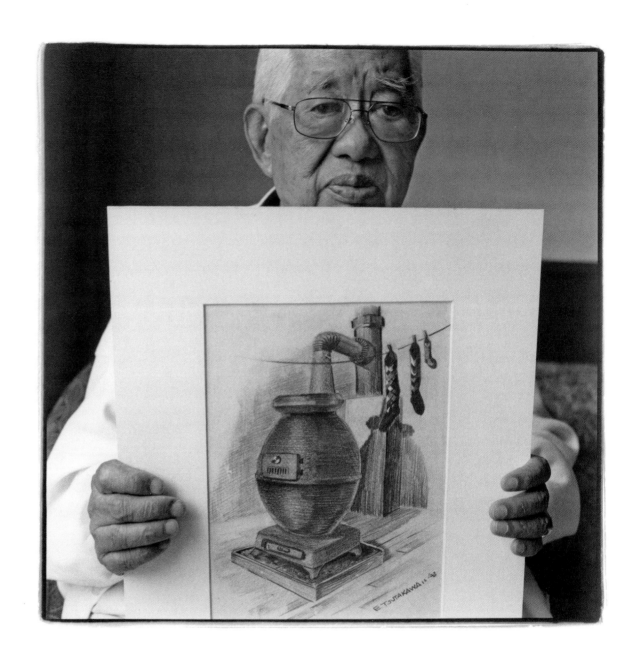

2005 (Aug. 10)
SeaTac, Washington
120 B&W Tri-X film

218

EDWARD MASAO TSUTAKAWA made this drawing in his Minidoka barrack. He had seen "The Stove in the Studio," by French painter Paul Cézanne, whose work Tsutakawa admired. He noted that the barrack stove in his drawing served three purposes: cooking, heating and drying laundry.

Tsutakawa, born in 1921 in Seattle, Washington, lived in Japan from age 5 to 15. In 1936 he returned to Seattle, where his father operated an import-export business. He was an art student at the University of Washington when World War II began, and was drafted from Minidoka. He was a military translator and Japanese language instructor during the war.

Tsutakawa married Hide Kunugi on Aug. 7, 1949 in a ceremony at the Sun Valley Lodge in Idaho. Hide's employer, a family who built one of the first homes in Sun Valley, paid for the wedding. The Tsutakawas recounted their experience of Minidoka, where they met, in the film, *In Time of War: Stories of the Japanese American Experience in World War II*, narrated by Patty Duke.

The Tsutakawas made Spokane, Washington, their permanent home. There, Edward renewed ties with his friend and fellow artist, Keith Oka. Both men worked as commercial artists. Tsutakawa went on to serve on numerous boards and commissions in Spokane while assisting various community organizations. He initiated Spokane's sister city relationship with Nishinomiya, Japan; established the Mukogawa Fort Wright Institute, a branch campus of Mukogawa Women's University in Nishinomiya that offers an American cultural program; and assisted in the planning and development of the Nishinomiya Japanese Garden in Manito Park. The largest *kasuga* lantern in the United States is found in the park. After Tsutakawa's death in October 2006, the garden was renamed Nishinomiya Tsutakawa Japanese Garden.

THIS TABLE WAS MADE by Tsuto Koba for his family to use during their imprisonment in Minidoka.

After the camp closed, Tsuto and his wife, Fumi, returned to Seattle, where they owned and managed an apartment building in the Capitol Hill District. Their oldest daughter Nobuko, married Keith Oka, one of a group of Minidoka artists who organized art classes in the camp. The Okas settled in Spokane where Keith was a commerical artist. Their son, Gareth, now owns the table.

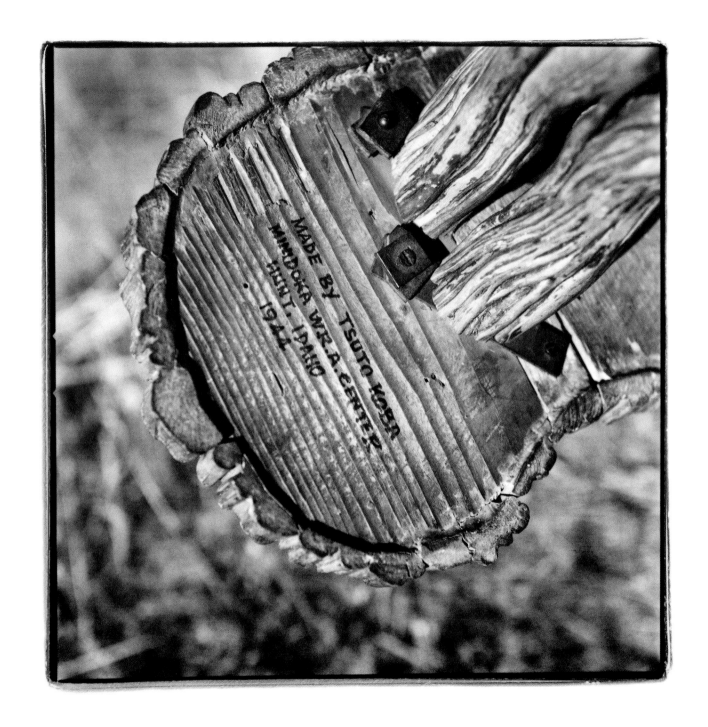

2003 (Aug. 9)
Spokane, Washington
120 B&W T-Max 400 film

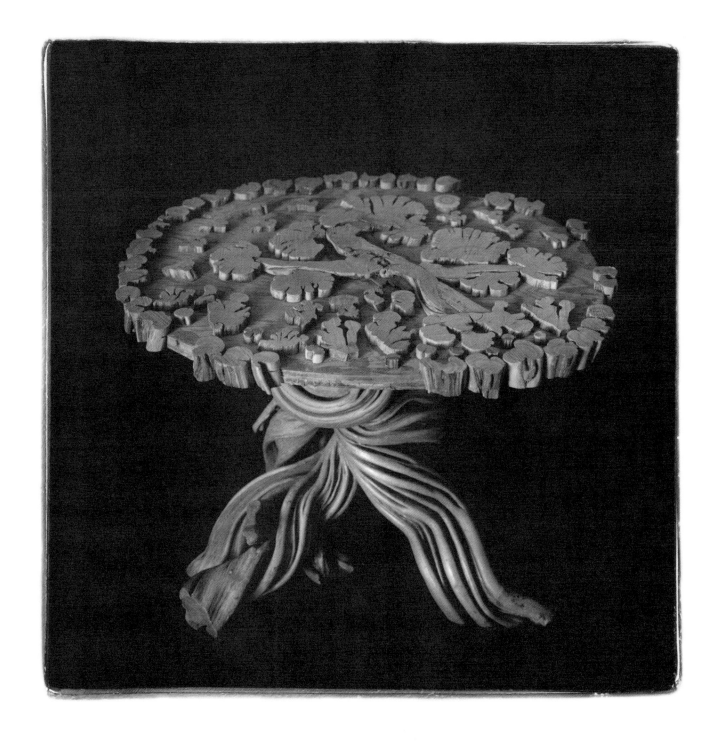

2003 (Aug. 4)
Seattle, Washington
120 B&W T-Max 400 film

222

YASUSUKE KOGITA was in his mid-50s when he made this table from greasewood that he found near the Minidoka War Relocation Center. The longer pieces incorporated into the surface design are sagebrush.

Before World War II, Kogita was the second owner of Cascade Soda Water Company in Seattle. He bought the business from Kitaro Shitana in 1929 and sold it to the Fujii family in 1935. Kogita invested the money in commercial property along Rainier Avenue in Seattle but was unable to pay the mortgage when he and his two sons, Ted and Paul, were incarcerated in Idaho. After the war, they returned to Seattle, where Yasusuke Kogita worked as a general contractor.

The table now belongs to Paul Kogita and remains unfinished. Paul Kogita worked for The Boeing Company for thirty-nine years, chiefly as supervisor of the graphics department. He and his family reside in Seattle. Brother Ted Kogita lives in Kent, Washington.

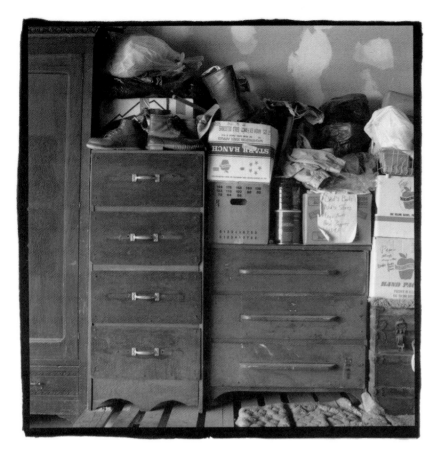

Hirai Dressers
2002 (Aug. 4)
Twin Falls, Idaho
120 B&W T-Max 100 film

DOROTHY (OZAWA) HIRAI'S HUSBAND, Tom, made the dresser on the left. Bill Ozawa, her younger brother, made the dresser on the right. Tom also made a crib and a high chair when he became a father in the summer of 1943 in Minidoka.

The dressers remain in use at the Hirai home in Twin Falls.

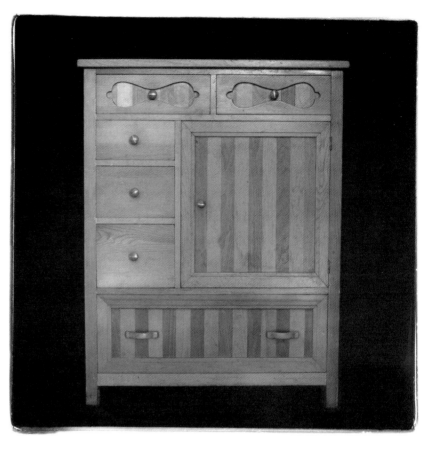

Takenaga Dresser
2003 (Aug. 4)
Seattle, Washington
120 B&W T-Max 400 film

TOMIZO TAKENAGA made this dresser from scrap lumber when he and his family were incarcerated in Minidoka. The dresser is now used to store picnic supplies in the basement of the home that Takenaga's daughter, Taka, and her husband, Paul Kogita, share on Beacon Hill.

Takenaga, a mechanic, co-owned a car-repair business in Seattle.

Tamura Dresser
2005 (Aug. 14)
Bellevue, Washington
120 B&W Tri-X film

THIS DRESSER WAS MADE for Gonnojo and Suma Tamura by Toshio Toyoji, a carpenter who lived in Block 36 at Minidoka along with the Tamuras. The Tamuras owned and operated a dry cleaning business in Seattle before the war but lost it when they were forced to relocate.

Ross Ohashi, son of Robert and Marian (Tamura) Ohashi, keeps the dresser at his home in Bellevue, Washington.

Koba Dresser with wood sculpture
2003 (Aug. 4)
West Seattle, Washington
120 B&W T-Max 400 film

MASAO KOBA remembers how his father, Tsuto, used his old tools to make all of the furniture that his family used at Minidoka. He worked by trial and error, exchanging ideas with other craftsmen who were cabinetmakers.

225

T. PAUL KAWAGUCHI and his wife, Miyoko, inherited this magazine rack made in Minidoka. It belonged to Paul's parents when they lived in Block 26, Barrack 6D.

"Mr. Hamada," a friend of the family, handcrafted the piece using wood from fruit crates on the camp site. One of the slats in the drawer is stamped "Loomis Fruit Growers Assn.," an established fruit producer in California.

Matahei and Sadaye (Onita) Kawaguchi, Paul's parents, operated two hotels in Seattle before they were forced to leave. After the war, they moved to Chicago, where Paul and his older sister, Yuriko, attended school. Yuriko studied at Gregg Business School, attended Vogue School of Design and worked as a secretary for the director of the Regional Weather Bureau in Chicago. Paul was accepted to Loyola University and went on to become a doctor with a specialty in research pathology. The initial "T" stands for Toshiyuki. (A mentor suggested that "Paul" would be a good name to use after a college application was denied.) Kawaguchi served in the U.S. Navy from 1956 to 1983, working in Egypt, Japan and various locations in the United States. He met Miyoko while working in Japan. After he retired, they moved to Seattle, his birthplace.

2008 (April 28)
Seattle, Washington
120 B&W Tri-X film

227

SANJIRO AND TOYO HORI, *Issei* from the Kumamoto area of Japan, made the serving tray and walking sticks while they were incarcerated at Minidoka. The tray is 11 inches in diameter and 2 inches high. The walking sticks are 36 inches and 29 inches, respectively. Takashi Hori, the couple's oldest son, and his wife, Lily (Morinaga) Hori (pictured) saved the pieces and kept them in their home.

Lily and Takashi met in Minidoka. They returned to Seattle after the camp closed and married on July 8, 1951. The family continued to own and operate the Panama Hotel, a 106-room hotel in Seattle's International District, until 1985 when the building was sold.

Takashi and Lily raised two children, Robert and Susan. Robert Hori is the director of advancement and strategic initiatives for the Japanese American Cultural & Community Center in Los Angeles. Susan Hori is an attorney in Newport Beach, California.

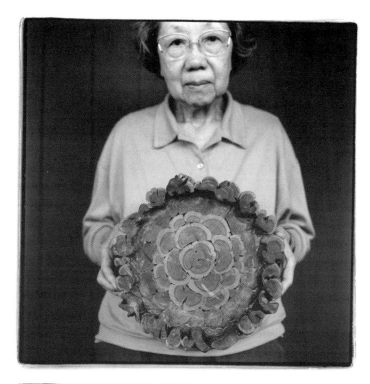

2004 (June 6)
Seattle, Washington
120 B&W T-Max 400 film

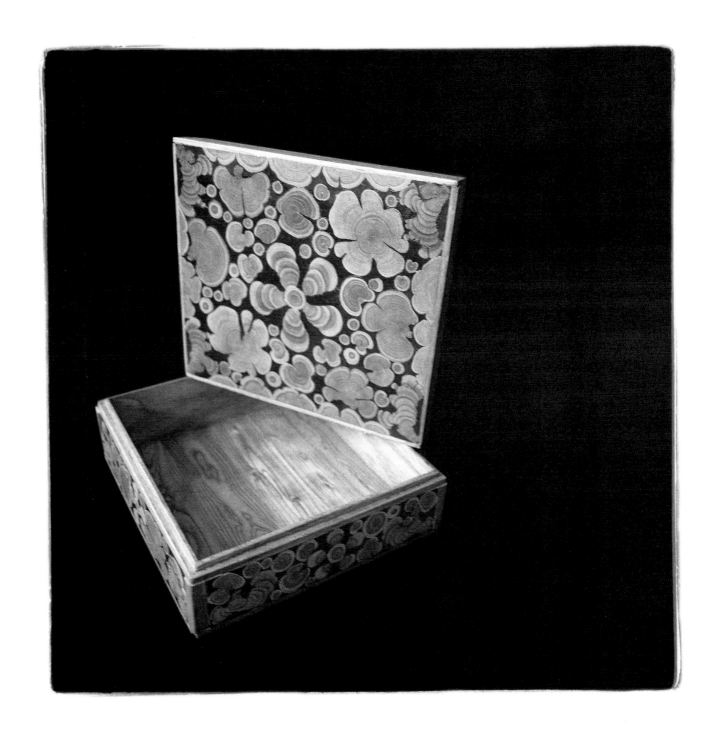

2006 (June 15)
Columbia, Missouri
120 B&W T-Max 400 film

HAROLD NAOTO TSUJIHARA, an *Issei* from Hiroshima, made this wooden box at Minidoka. The box, decorated with pieces of greasewood, is 7 inches by 6 ½ inches by 2 ⅝ inches.

Before the war, Tsujihara owned a hotel and had no time for creative pursuits. At Minidoka, he was a prolific artist. His daughter, Teruko (Tsujihara) Tsutakawa, kept this piece along with other items her father made in the camp.

The box was included in a special exhibit, "Sa Sa E: Objects of Memory," at the National Japanese American Historical Society's Peace Gallery in San Francisco. Historical artifacts, artwork and other objects created at the various incarceration sites were catalogued and displayed at the gallery in 2010.

1942 (Dec. 9)
Minidoka War Relocation Center, Hunt, Idaho
Copy photo, 120 film taken June 4, 2005, College Park, Maryland.
National Archives Photo No. 210-G-A755
Photo by Francis Stewart, WRA

"*VIEW IN THE HOME* of Mrs. Eizo Nishi. This view shows
*attractive scene in which this evacuee family has decorated
their barrack apartment.*" (War Relocation Authority caption) [Note
greasewood eagle sculpture on shelf.]

A FAVORITE MOTIF of the amateur craftsmen in the War
Relocation Centers was the American Eagle." — Allen H. Eaton, *Beauty
Behind Barbed Wire,* (1952), p. 130

MINIDOKA INCARCEREES produced a remarkable variety of fine
and functional art objects from greasewood, bitterbrush and
sagebrush found in the surrounding desert. Emiko (Amy) Nishi
Kawamoto, Eizo Nishi's daughter, recalls: "In December 1942,
an army photographer came to our barrack to take photos of
our one room. My father and mother had decorated the room by
putting up plywood and wallpapering the walls [from the Sears
mail-order catalog]. The United States government wanted to
show the country that the internees were living in very nice quarters as the photos conveyed. These photos were most likely
used for propaganda purposes. As the photos show, my parents made the best of a very sad and uncertain situation."

Kawamoto keeps the sculpture on the living room mantle of her home.

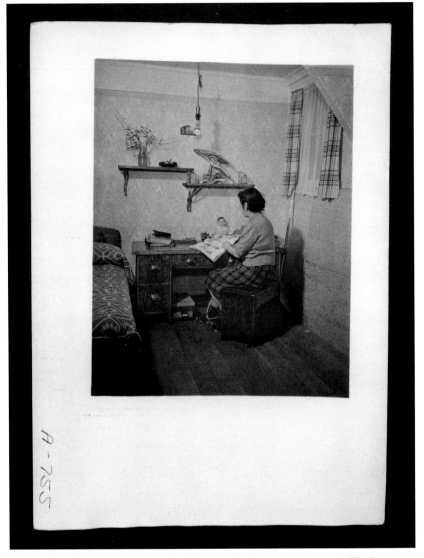

2006 (Oct. 5)
Lincolnwood, Illinois
120 B&W Tri-X film

233

"[MINIDOKA] WASN'T A PLEASANT EXPERIENCE, but Dad made [this bird] for his own enjoyment," said Robert Handa of Bellevue, Washington. Handa explained how his father, Takeyoshi Handa, would look for the "right" piece of greasewood for days on end. When he came upon a unique piece of wood, he would imagine what image best suited it.

Takeyoshi spent a year finding the right pieces for this bird. The beak, head and main body are all one piece. Two pieces were added to make the wings. The piece is 23 inches high and 4 ½ inches long.

No polish was used to create the sheen on the wood. Greasewood was rubbed on greasewood to make the surface smooth. "[Dad] had all the time in the world to work on it," said Robert. "He was no artist, but maybe he had a little creative talent."

Takeyoshi emigrated from Niigata, Japan, in the early 1900s. When Robert was a young boy, his father told him story after story of his adventures in Alaska as a crew member onboard a U.S. Revenue Cutter Service ship and the with the U.S. Navy from 1904 to 1914. "[The ship] was sort of a dream job in the old days because most Japanese that came to the U.S. worked on the railroads or canneries or farming, and they were having a real rough time. I guess he didn't make too much money working on the government ship but he said, 'They give you a uniform; they give you three meals a day; and you also got paid for it.'"

2005 (Aug. 10)
Bellevue, Washington
120 B&W Tri-X film

"**THE FURNITURE OF GEORGE NAKASHIMA**" was exhibited at the Sun Valley Center for the Arts in Ketchum, Idaho, in 2004. This piece was included in the show with the following information:

"Mounted Bitterbrush, 1942. Bitterbrush collected in Idaho desert on unfinished cedar base, found object, handcrafted base." Collection Nakashima Studios.

"Nakashima was fascinated by the bitterbrush surrounding the Minidoka internment camp. He used bitterbrush and other found objects to craft furniture for his family when they were interned. This piece of raw wood remained in his collection throughout his life."

Nakashima received the gold medal of craftsmanship from the American Institute of Architects in 1952 and was declared a National Living Treasure by the American Craft Museum in 1989. His furniture is in the collections of the Metropolitan Museum of Art, the Museum of Modern Art, Nelson Rockefeller, the Monastery of Christ in the Desert in New Mexico and the Museum of Fine Arts in Boston.

2004 (July 16)
Ketchum, Idaho
120 B&W Tri-X film

DOCUMENTATION on the Oregon Nikkei Legacy Center's "Collection Information" form:

Name ("Depositor"): Kazuo Ochiai
Donating: Bitterbrush/greasewood scupltures / wood carving
 1. Sculpture #1 – approx. 22" in length by 9 ½" high by 15" wide (polished) [object pictured here]
 2. Sculpture #2 – hollowed-out tree trunk . . .
Owned or used by: Zenzaburo and Tamiyo Ochiai
Your relation to the above: Parents
Owners date of birth or death dates: Zenzaburo – b. 1/12/1894 – March 1982; Tamiyo – b. 6/10/03 – Sept. 1989
Date or age of object: Probably made sometime during 1943-1945.
Maker: ?
Location used or made: Minidoka Relocation Center, Hunt, Idaho
General comments on the condition: very good

2005 (March 18)
Portland, Oregon
120 B&W T-Max 400 film
Courtesy of the Oregon Nikkei
Endowment, Portland, Oregon;
ONLC 1999.3.1

239

NYLA NAKANO, a *Sansei* who lives in Seattle, received these wood pieces as a gift from her maternal grandfather, Masaaki Funakubo, an *Issei* incarcerated at Minidoka.

"He told me how he didn't have much to do at camp, so that when he found the root (pictured on this page), he started polishing it by hand," Nakano recalled. The polishing cloth used by Funakubo was a piece of moleskin.

The Minidoka Interlude lists Funakubo as a block representative living in Block 1, Barrack 10B.

Before the war, Funakubo worked as a banker for Sumitomo Bank in Seattle. He was born and educated in Japan, at Waseda University in Tokyo, one of Japan's top universities. After the war, he worked in various capacities for a railroad company before becoming a landscaper. He worked as a landscaper for more than thirty years and served as treasurer for the *Issei* at the Japanese Baptist Church in Seattle for more than forty years.

Nakano's parents were not incarcerated. Her mother, Lilli Hisako Funakubo-Kanegae, moved from Seattle to Spokane. Her father, Fred Yeichi Nakano of Los Angeles, volunteered for the Military Intelligence Service and met his future wife at Fort Snelling in Minnesota.

The sculpted piece of wood (right) is 30 inches high by 9 inches wide at the base.

2008 (April 29)
Seattle, Washington
120 B&W Tri-X film

2005 (March 20)
Olympia, Washington
120 B&W T-Max 400 film

SOME KOKITA, mother of four children, was also a doll maker. Carolyn Michael's book, *Enchanted Companions: Stories of Dolls in Our Lives,* notes that Kokita took a doll-making class during her incarceration at Minidoka.

"She saved rice from her dinner and mixed it with water until it was the right consistency to serve as glue. She carefully layered toilet paper and this glue over the mold until it was the proper thickness. For the final layer, she cut up their sheer curtains — her silk substitute — to give the face its wonderful texture." To create the delicate facial features, Kokita chewed the end of a toothpick to make a paintbrush.

2001 (Oct. 25)
Jerome, Idaho
120 B&W T-Max 100 film

THIS METAL DOLL was left behind after the Minidoka
War Relocation Center closed. The doll was recovered
from the site and donated, along with a box of dishes
and glass jars, to the Jerome County Historical Museum.

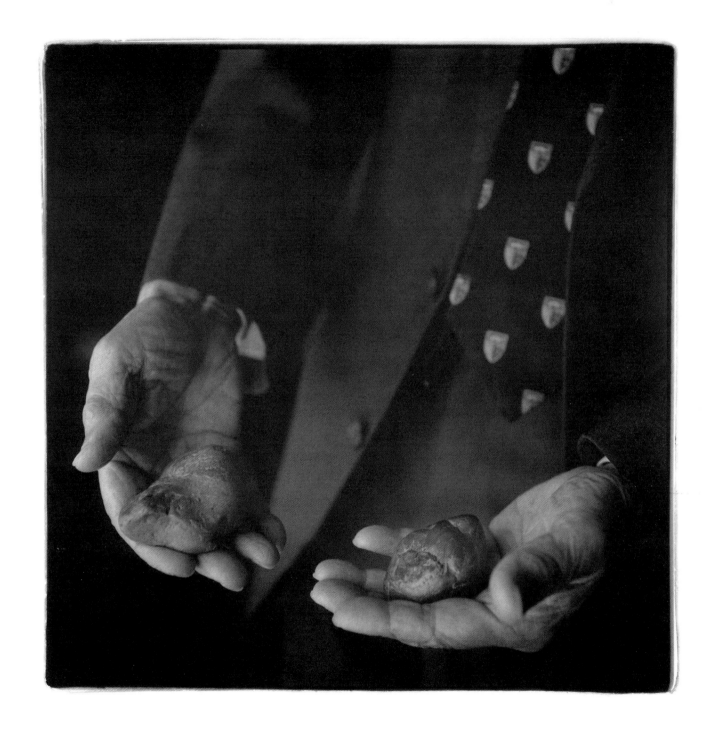

2007 (Feb. 16)
Sonoma, California
120 B&W Tri-X film

244

LUCIUS HORIUCHI recalls friends asking him why his parents always walked with their heads down while they were in Minidoka. He explained that they missed their art collection and antiques; they were looking for items of an artistic nature. Horiuchi's father, Shigetoshi, an art and antiques collector, and his mother, Takeko, a poet, sought special rocks in the Japanese art tradition of *suiseki*. Weathered, dark-colored stones are preferred to stones with no jagged edges.

Horiuchi kept several stones that his parents saved. The pair pictured here, basalt worn by water, are displayed in his home in Sonoma, California. Horiuchi retired from the U.S. Department of State after 42 years as a Foreign Service Officer. He now sells Japanese art. His wife, Maynard, is the daughter of four-star Admiral Charles M. Cooke Jr., a warship commander during World War II. Cooke was chief of naval plans and later commander of the Seventh Fleet of the U.S. Navy.

The Horiuchi family's Japanese antiques were exhibited at the Seattle Art Museum from 1933 until the advent of World War II. The collection was safely stored and returned to the family after the war.

Circa 1943-1945
Minidoka War Relocation Center, Hunt, Idaho
Duplicate 4x5 negative.
National Archives Photo No. 210-CMB-11

YASUSUKE KOGITA, far left, stands
in the garden he created outside his
barrack in Block 5.

"**THIS CHIMNEY ROCK** is a part of the
garden shown…it is of volcanic formation;
but this was the giant of them all, weighing
about a thousand pounds…Mr. Kogita's
young sons, 12 and 13 years old, gave him
a helping hand with the heavy pieces.…
To keep the wheels [of the handmade cart]
from sinking in the sand, Mr. Kogita cut
up oilcans [sic] and nailed wide strips of

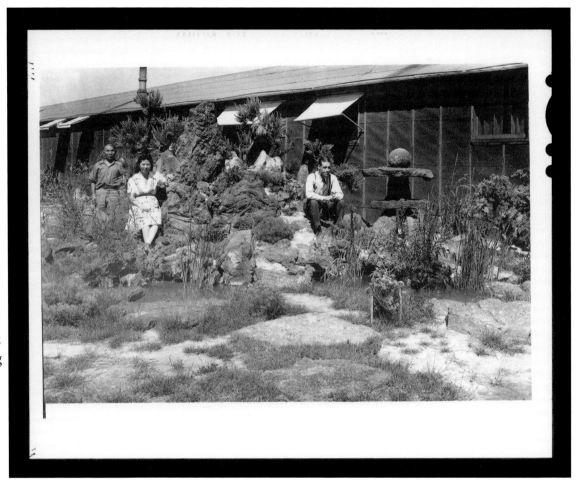

tin all around. It took him about two months to get the rocks in for the main garden, and an entire week to loosen and separate the
large rock from its bed. Fortunately, he owned a crowbar." — Allen H. Eaton, *Beauty Behind Barbed Wire,* 1952, p. 92

PAUL YOSHIAKI KOGITA and his wife, Taka (Takenaga), display in the front yard in their Seattle house a selection of rocks,
including the chimney rock from the Minidoka site, that Paul's father shipped to Seattle when the concentration camp closed.
Paul and his older brother, Ted Fusahide Kogita of Kent, Washington, were at Minidoka with their father. Paul, who was 12 at the
time, remembers venturing out into the desert to search for special rocks and pieces of wood.

"Oh, that garden meant so much to him, probably more than life. If he lost that garden, he would've lost his hope," Paul said
during a 2006 radio interview about the book, *Defiant Gardens: Making Gardens in Wartime,* by Kenneth I. Helphand.

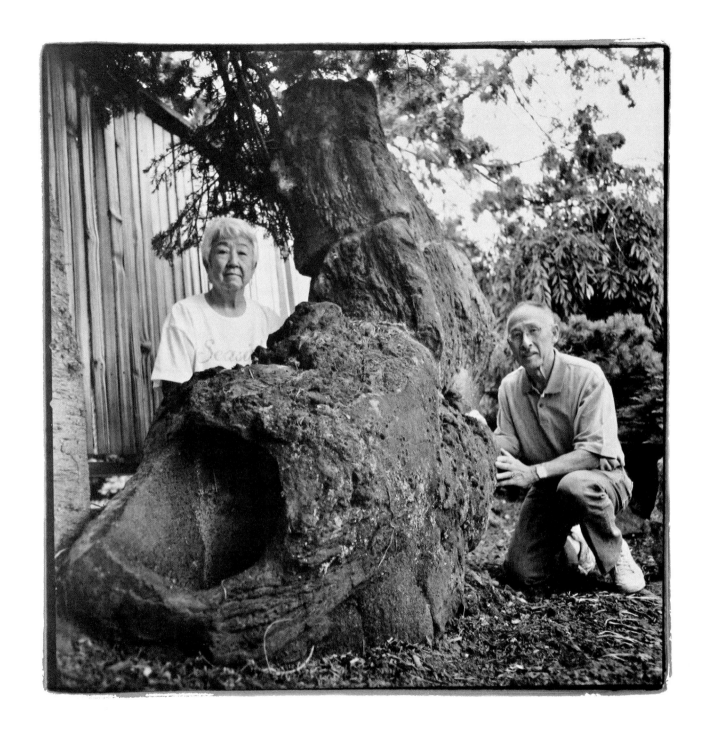

2004 (July 7))
Seattle, Washington
120 B&W T-Max 400 film

247

"**I RECEIVED** my long-awaited copy of *The Minidoka Interlude*. The publication of this book was sponsored by the community activities section. It contains more than 180 pages including administrative division and block pictures and a description of various activities. There are eighteen pages written in Japanese. The book is dedicated to the 'American of Tomorrow.' Practically all of the work of collecting material and organization was done by the residents. The book is a fine tribute to their skill and workmanship."
— Arthur Kleinkopf, *Relocation Center Diary: 1942-1946*, May 31, 1944 entry, p. 384

"**THOUGH IT IS NOT** a literary masterpiece by any means, we were proud to think that Minidoka was the only one of the ten centers that published such a book," wrote Thomas Takeuchi in 1989, in the introduction to a reprinted version of *The Minidoka Interlude*. Takeuchi, married and a father of two at the time of his incarceration, worked in Minidoka's Community Activities Division. He carried out his idea to create a "souvenir" similar to a high school yearbook. He requested and received government authorization to take pictures in the camp. The original *Minidoka Interlude* went to press at the end of 1943 and into the hands of subscribers in 1944. The first edition featured an embossed cover (pictured here) and cost $1.75. Demand exceeded supply.

After Thomas Takeuchi died in 1990, his children, Thomas Jr., Sylvia, Tomiko and Diane, decided to use their inheritance money to reprint the book with their father's introductory remarks. Copies were sold to individuals and sent free of charge to libraries and schools. In 2007 the Takeuchi family donated the remaining books and original layouts to the Friends of Minidoka, a nonprofit organization dedicated to educating future generations about the Japanese American incarceration. The second edition of the book sold for $60 in 2012. Used copies of the first edition with the embossed cover were posted for sale the same year on Amazon.com for $250 and $295.

2005 (March 18)
Portland, Oregon
120 B&W T-Max 400 film

A FEDERAL POST OFFICE opened at the Minidoka War Relocation Center on Dec. 7, 1942. Prior to that, mail was postmarked "Eden," a town approximately six miles away from the internment camp. "Minidoka" could not be used as the postmark because a town of the same name already existed in a neighboring county. The post office at Minidoka was called Hunt, thus the name Hunt Camp for the detention facility.

An entry in *The Minidoka Interlude* for "Postal Service Unit" reads: "The Hunt Post Office has been outstandingly successful in creating a close communication between the residents of the Center and those outside the project. The Twin Falls Postmaster and Project Director [H.L. Stafford] take special pride in the Hunt Post Office, for among the ten relocation centers, this is the only post office with an entire evacuee staff."

The letters on the facing page were written by Matsuye (Mats) Ishida, a resident of Block 37, Barrack 11C, to her fiancé, Tom Koto, a staff sergeant in the Army. Koto was born and raised in Twin Falls.

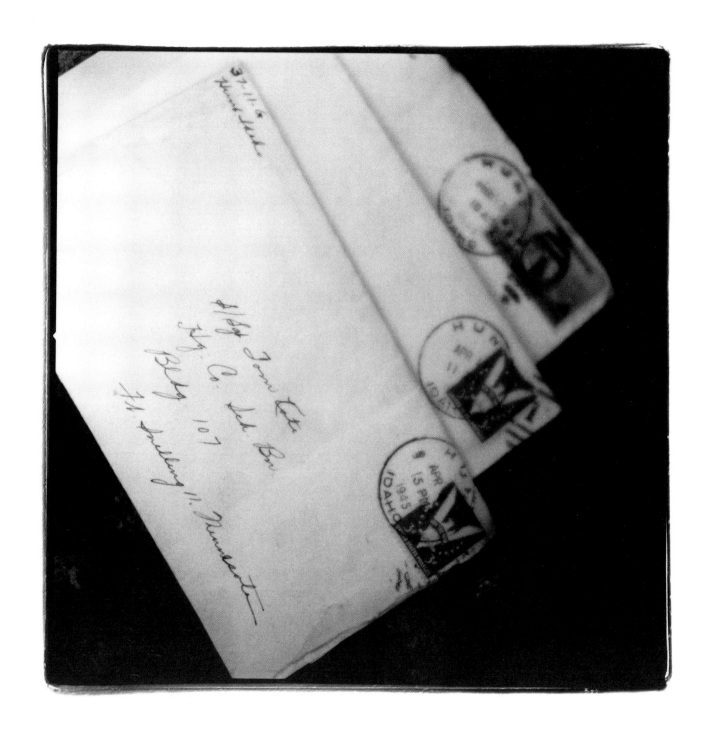

2004 (June 27)
Jerome, Idaho
120 B&W T-Max 100 film

2008 (August 23)
Shoreline, Washington
120 B&W Tri-X film

ASKED WHAT SHE TOOK to Minidoka, Tak (Yokoyama) Todo said, "Only what you could carry. But see, I can't get over how we took our phonograph player. We couldn't take radios because those were all confiscated. But we took our phonograph player and we had records. So, like in Camp Harmony in Puyallup and in Idaho, since we had [a record player] and we took the records, people used to come over and listen."

The music Tak and others in the camp listened to included the popular big-band swing of Glenn Miller, Artie Shaw and Guy Lombardo.

TAKA KOGITA'S FATHER, Tomizo Takenaga, made this trunk to ship the family's personal belongings from Minidoka after the announcement that the relocation center would be closed. The family name and an Ontario, Oregon, address are stenciled on the bottom of the trunk.

Takenaga worked for a farmer in Ontario for six months before he and his family returned to Seattle, where he taught *shigin*, a Japanese poetic form that is usually chanted, individually or as a group. He served as president of the local *shigin* group and wrote a book about the form and practice. Takenaga's wife, Misao, taught *ikebana*.

2003 (Aug. 4)
Seattle, Washington
120 B&W T-Max 400 film

Circa 1943-1945
Minidoka War Relocation
Center, Hunt, Idaho
Copy photo, 35mm digital
taken on June 4, 2005,
College Park, Maryland.
National Archives Photo
No. 210-CMA-R-4

NARA FINDING
aid lists"R-4" with
heading: "Departure
Scenes at Gate."

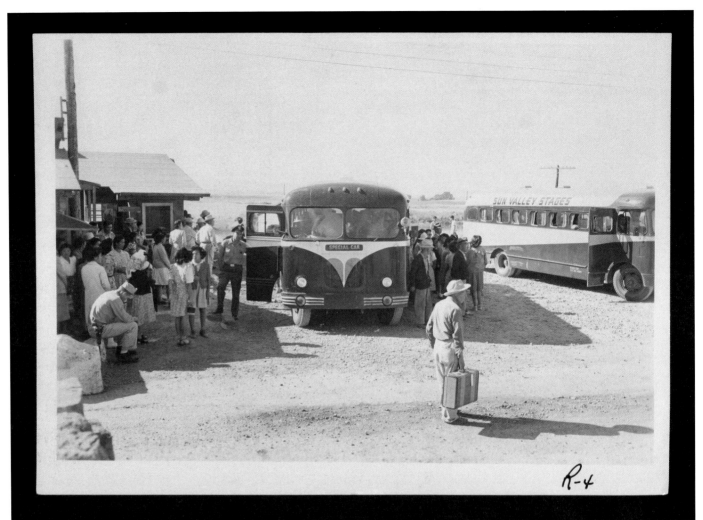

"THE WRA PROVIDED $25 per person, train fare, and meals en route for those with less than $500 in cash."

— *Minidoka Internment National Monument General Management Plan, 2006*, p. 39

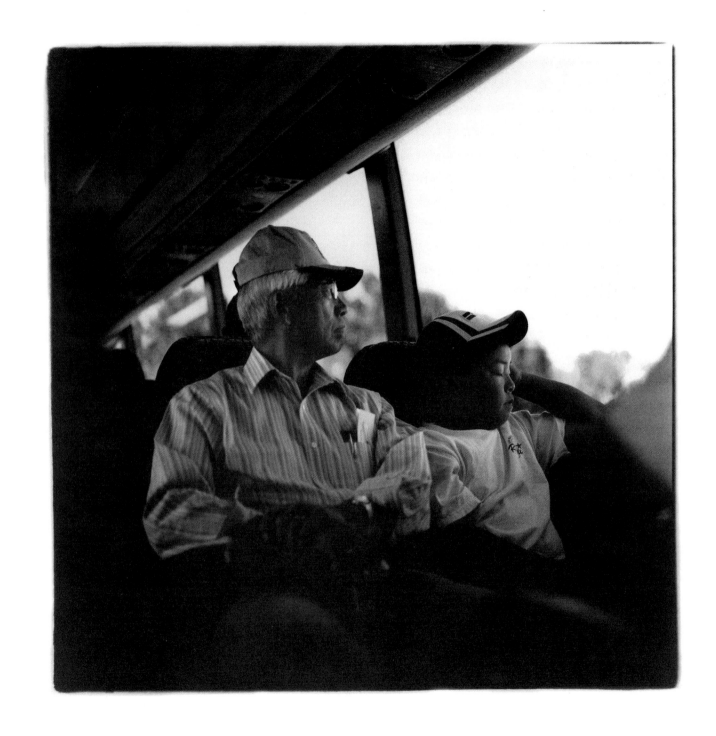

2006 (July 8)
Jerome, Idaho
120 B&W Tri-X film

258

FRED TAKASHI KAWAHARA (left), his wife, Deanna, and grandson, Derek Shigeo Kawahara (next to Fred in picture), drove from San Mateo, California, to Idaho for the Minidoka Pilgrimage in 2006. Sixty-four years earlier, Fred, then 5 years old, hid under barracks, dug dirt trenches to play in and went to a makeshift movie theater for entertainment. Only later would he come to understand the full effect of the incarceration on his parents. Fred and Deanna brought Derek to the pilgrimage so that he would know his all of his family's history, including the chapter in Block 24.

Fred's father, Masao Kawahara, was an *Issei* from Hiroshima. His mother, Masako (Nishikawa), was born in Fife, Washington. Fred was an only child for 15 years before his brother was born. Before the war, his father and two uncles owned a grocery store on Yesler Way in Seattle. The family was forced to sell the business when Executive Order 9066 was issued. After the war, the Kawahara family returned to Seattle, where Masao secured a job as a janitor for the Jewish Community Center's Neighborhood House, where the Kawaharas temporarily lived. Fred's mother worked at home as a seamstress for a local tailor.

Fred graduated from the University of Washington in 1959 with a degree in civil engineering. He met Deanna (Tomita) at Seattle's Buddhist Temple in 1950. They raised four children. In 1970 the Kawaharas moved to California, where Fred worked as an associate civil engineer with the Naval Facilities Engineering Command. He retired in 2002.

Derek is active in the Boy Scouts of America and became an Eagle Scout in 2011. He also participates in a Japanese American youth group and local sports teams. His parents are Jeffrey and Cindy (Ito) Kawahara of Foster City, California.

EMILY HANAKO MOMOHARA (left) and Anna Hosticka Tamura met through their mutual interest in the Minidoka site. Members of their families were incarcerated at Minidoka long before Momohara and Tamura were born. Momohara is *Yonsei* (fourth-generation Japanese American); Tamura is *Sansei*. Both women are *hapa*, or mixed-race Japanese Americans. Together with May Namba, a *Nisei* from Seattle who was incarcerated at Minidoka, Momohara and Tamura organized the first Minidoka Pilgrimage in 2003.

Momohara, a visual artist raised in the Seattle area, earned a Bachelor of Fine Arts in photography and a Bachelor of Arts in art history from the University of Washington in 2001. She photographed seven former war relocation centers and a U.S. Department of Justice internment facility for a photography series she titled "Gaman: Silent Endurance." The series included Minidoka, where her paternal grandparents were incarcerated. She also worked with the National Park Service after Minidoka was designated as a national monument and photographed an archeological excavation on the site in 2002.

Momohara is a founding board member of Friends of Minidoka, established in 2002, and serves as vice-chair on its executive board of directors. In 2003 she left the Pacific Northwest to study with Roger Shimomura at the University of Kansas. She earned a master's degree in Expanded Media in 2006 and taught art at the Art Academy of Cincinnati until 2013. Her work is exhibited and collected nationally.

Tamura is a landscape architect in the National Park Service's Pacific West office in Seattle. While completing a master's degree in landscape architecture at the University of Washington in 2001, Anna began to research the historic and current site conditions at Minidoka and Manzanar. This work led to a thesis on the Japanese-style gardens in the camps and an essay on the same subject that Tamura published in *Landscape Journal* (2004). From 2002 to 2006, Tamura worked on the general management plan for Minidoka, first as a team member and then as project manager. She logged thousands of miles and spoke to numerous groups and individuals to promote the project.

Tamura was born in Boston but grew up in Portland, Oregon, not far from Oregon City, where her mother and a dozen other family members were ordered to leave after the bombing of Pearl Harbor. She received a bachelor's degree in anthropology from Bard College in Annandale, New York, joined the Peace Corps, and served in small villages in Togo, West Africa, from 1996 to 1998.

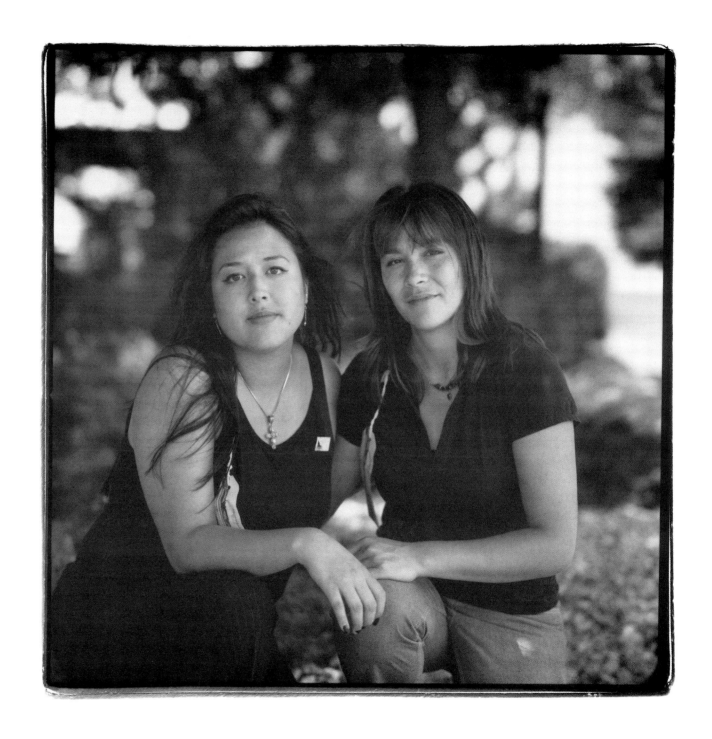

2004 (June 27)
Twin Falls, Idaho
120 B&W T-Max 100 film

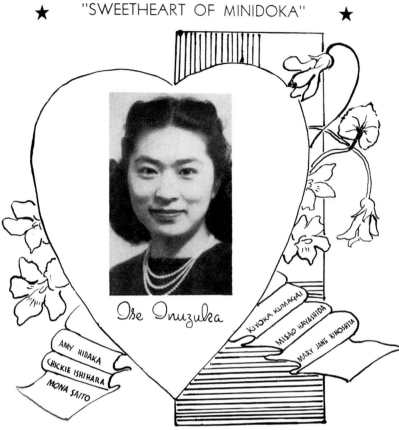

Circa 1943
Minidoka War Relocation Center, Hunt, Idaho
Copy photo, 35mm digital taken Feb. 7, 2009, Walla Walla, Washington.
The Minidoka Interlude

"THE SWEETHEART CONTEST held in event for the Valentine's Dances were of great social significance. Sponsored by Community Activities and the Irrigator (project newspaper) the Sweetheart endowed with all the queenly qualities of poise, personality and beauty was chosen by popular vote." — Minidoka Monthly Report, March 3 1944, National Archives, RG210, Box 214, File 24.039 Narrative Report Community Activities_Monthly Report – Minidoka

JAMES (JIM) F. AZUMANO, son of Ise Alice (Inuzuka) and George Ichiro Azumano, spoke during the closing ceremony of the 2004 Minidoka Pilgrimage. He mentioned that his mother was voted "Sweetheart of Minidoka." His parents, both 1940 graduates of the University of Oregon, married in Minidoka. Jim also graduated from the university in 1973.

Hatsutaro and Satsuki Azumano, Jim's *Issei* grandparents, settled in Portland, where they operated a grocery store. George Azumano was drafted into the Army in June 1941, only to be discharged after Executive Order 9066. His father, held in custody, was unprepared for the sudden departure. George was forced to sell store equipment and stock at 10 cents on the dollar.

When he returned to Portland after Minidoka, George founded the Azumano Agency, an insurance and travel company that became a corporate icon in Portland, promoting commerce between Oregon and Japan.

Jim Azumano held management positions in Lane, Hood River and Clatsop counties in Oregon. He also cultivated business relations in Japan and Korea. He served on the board of directors of the Friends of Minidoka in 2003-2005, when the group initiated the annual Civil Liberties Symposium at the College of Southern Idaho in Twin Falls. In 2004, Oregon Governor Ted Kulongoski appointed Jim to be the first director of the Governor's Office of Rural Policy. In 2008, Jim became director of the Education and Research Institute of the Northwest Food Processors Association in Portland.

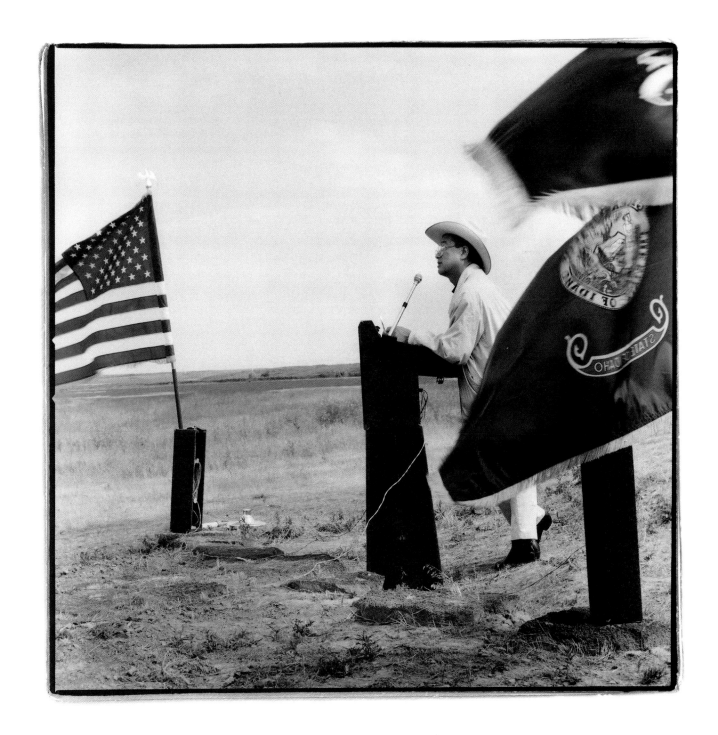

2004 (June 27)
Jerome, Idaho
120 B&W T-Max 100 film

"I CARE ABOUT THE PAST for the sake of my grandchildren, for the sake of my children," says Mitsuye (Yasutake) Yamada, who was a teenager when she was incarcerated in Minidoka. "We have a legacy to leave with them."

Yamada (front row, center), now of Irvine, California, and her brothers, William Toshio Yasutake of Bothell, Washington (next to her), and Joe Yasutake (next to William) of San Jose, California, returned to Minidoka with their children and grandchildren. Mitsuye was born on the island of Kyushu in Japan while her parents were visiting family. Both of her brothers were born in the United States. The siblings grew up in Seattle and were interned together at Minidoka. William volunteered for the Army and received the Congressional Gold Medal in 2011.

Their father, Jack Kaichiro Yasutake, an interpreter for the Immigration and Naturalization Service in Seattle, was arrested immediately after Pearl Harbor. He was separated from his family for several years, transferred from one internment camp to another in Montana, North Dakota, New Mexico and Texas.

Three generations of the Yamada family traveled from Washington, California, Maryland and Japan to participate in the 2004 Minidoka Pilgrimage.

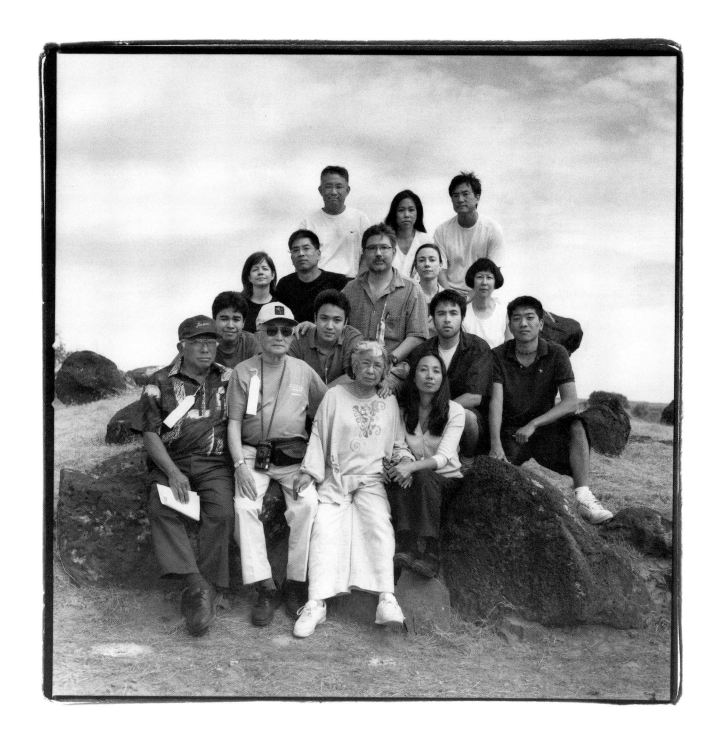

2004 (June 27)
Jerome, Idaho
120 B&W T-Max 400 film

265

"**IT WAS UNFORTUNATE** that the exigencies of the military situation were such as to require the same treatment of all persons of Japanese ancestry, regardless of their individual loyalty to the United States. But in emergencies, where the safety of the Nation is involved, consideration of the rights of individuals must be subordinated to the common security. As General DeWitt points out, great credit is due our Japanese population for the manner in which they responded to and complied with the orders of exclusion." — Henry L. Stimson, Secretary of War, *Final Report Japanese Evacuation from the West Coast 1942* (1943), Washington, D.C.

"THE IMPORTANCE OF . . . photographs lies in their power not only to inform, but to move us. They are at once interpretations and records; although they are no longer topical, they contain qualities that will last as long as man is concerned with his brother." — Beaumont Newhall, *The History of Photography,* fourth edition (1964), writing about the work of Jacob Riis, a documentary photographer who published *How the Other Half Lives* (1890), p. 142

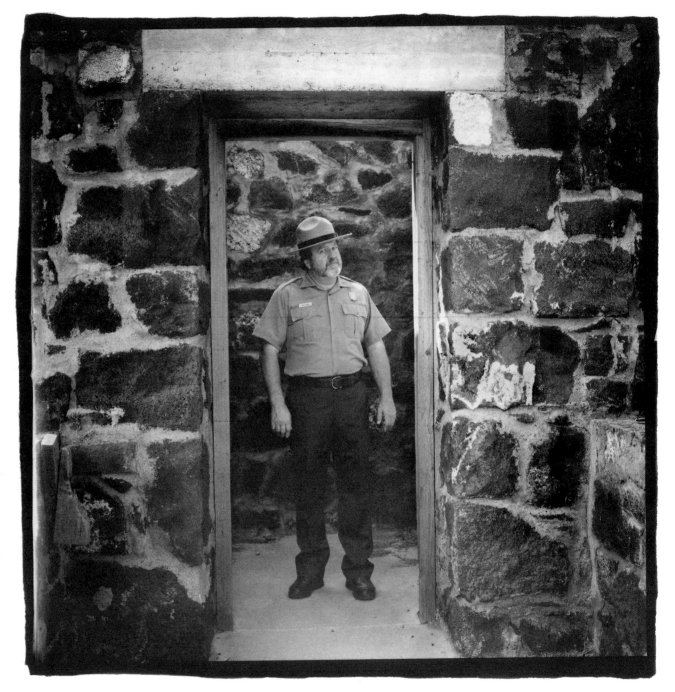

2002 (August 2)
Jerome, Idaho
120 B&W T-Max 100 film

NEIL KING worked in
public service for 40 years,
retiring in 2008. He was
National Park Service
Superintendent for the
Minidoka National Historic
Site and Hagerman Fossil
Beds National Monument,
chief ranger at Craters
of the Moon National
Monument and park ranger
at Mesa Verde National
Park and Indiana Dunes
National Lakeshore, where
he taught orienteering to
inner-city youth from Gary,
Indiana.

This is an edited transcript of an interview on Dec. 29, 2009 between Neil King and the author at King's home in Jerome, Idaho.

TAMURA: *Tell me about Minidoka — the National Historic Site.*

KING: It was late at night and I was at my office. Destry Jarvis called me. His brother, Jon, is now director of the [National] Park Service. Destry was Senior Advisor to the Assistant Secretary for Fish, Wildlife and Parks of the Department of the Interior. He said, 'We're sending out someone to look at Minidoka, would you represent the Department of Interior?'

I said, 'Yes, I would.' And so that person was Dan Sakura. This is January 2001, within days of [President] Clinton ending his tenure. I didn't know Dan . . . He shows up. My recollection was Maya [Hata Lemmon] and a couple of other folks such as Mike Mathews with [former U.S. Senator] Larry Craig's office, we get together and we drive out there. The wind is blowing. We walk around out there and come back.

I knew nothing about the place. I had heard about it — historically — but I was pretty ignorant, very ignorant. So after Destry called me, I went on the Internet and did some research. I was hooked. The whole story just seemed to fit the Park Service. Before Dan got here, I was hooked into the deal.

T: *What hooked you?*

K: What I recall most was the *Nisei* vets. I remember that being the most immediate thing — it's a part of our history.

T: *I sometimes meet people who weren't interned and aren't interested in knowing the Minidoka story. What do you say to them to help them understand that the story is so connected to all of us, whether we were in the camps or not? Has anyone said, 'Well, I don't care about that. It didn't affect me.'*

K: Well, people have said that. My response to them is, 'Gettysburg didn't impact you immediately either.' That is what I say. To me, it is because it's who we are. I guess that would be my quote, 'It's who we are.'

T: *Do you think the Nisei vets story resonated with you because you were a Vietnam War veteran?*

K: Very definitely. Immediately, there's a connection. There's definitely a connection.

T: *You talked about taking Dan Sakura out to the Minidoka site for the first time. It was your first visit as well. It was windy, and there wasn't much out there at that point — just the basalt fireplace with the sign that had been up there for quite some time.*

K: Right. There was nothing when I went out there. My concern was: *There is nothing.* I thought, 'How are we going to try to have something?' And later, Mike Ware, Larry Craig's chief of staff, he came out and he went absolutely ballistic. He went off because he was down on Clinton. We were sitting in my pickup at Minidoka. Mike Ware says, 'We are going to reverse this.' I put my hand on his knee and said, 'Mike, these *Nisei* vets died for this country, and you need to understand their story.' He didn't really react, but anyway, it didn't happen. That was February 2001, a month after the declaration [establishing Minidoka as a national monument].

T: *Was he against the designation of Minidoka just because Clinton was involved, or because nothing was on the site, or a combination of the two?*

K: Both. He was very upset that Clinton extended his presidential authority, most upset about the expansion of Craters of the Moon, and he did not like the fact that it was a Japanese site…The President can establish a national monument. Only Congress can establish any other designation for national parks. Minidoka [Minidoka Internment National Monument] was a declaration of law in 2001. It really doesn't matter as far as management.

T: *When Dan Sakura came out to do preliminary scouting, he looked at the site and said, 'Yes.' Even though there's nothing out there.*

K: Well, it wouldn't have happened without him. He worked as chief of staff on the President's Council on Environmental Quality at the White House. This is in the closing days of the Clinton administration in January. They looked at three or four sites. The reason Minidoka came into their focus [was because] the site was already in federal ownership — approximately sixty-four acres belonged to the Bureau of Reclamation. That was the whole deal. Plus, Dan Sakura's family was held there. He had a personal connection.

When he came here — Maya, Dan, Virginia Ricketts [Jerome County Historical Museum] — we all went to the [Jerome] County commissioners. They said, 'Well, we don't want the President to…' They were concerned about him issuing an edict without any public input or involvement. So I said to them, 'You all know me. I will promise you that I will have an open process…We will have public meetings. You will have your say.' I'm not saying that they went 'Well, gee OK.' They could kind of see the handwriting on the wall.

They could see it was going to go ahead anyway. But they said, 'OK.' We put in an extra step in the public process.

T: *What was the extra step?*

K: We initially had an 'OK, what do you think' session [public scoping workshop held in 2002]. Then we came back and said, 'OK, what do you really think?' [public draft alternatives workshop held in 2003]. We went back twice, which actually, I think, turned out to be a really good thing. I did that because I had promised to do that. I fought very hard for that extra step. That cost us a lot of money. I did a contract with the Wing Luke Museum for fifty-five thousand dollars — which was unique in the planning process.

T: *What did the contract with Wing Luke involve?*

K: The contract required the Wing Luke Museum to conduct its own [public process]. The significance of this was, 'You guys [in the Japanese American community] need to have your own conversation.'

I'm strung out in my organization. They're saying: 'What the hell are you doing?' And I say, 'These people need to have their own conversation.' They had never done that. And this is very, very, very important, Teresa, because your own community had never talked about Minidoka. Do you know Yosh [Nakagawa]?

T: *I've interviewed and photographed him.*

K: Yosh and a few of those people forced [the larger Japanese American community] to have the conversation amongst themselves. If that had not happened, this whole thing might not have happened…The controversy within my organization was, 'Well, you [as NPS representative] have to be there.' And I said, 'No. We can't be there. If we're there, they're not going to have the conversation.' There was this big debate about 'Well legally, how can they be carrying on this contractual fifty-five thousand dollar obligation and we're not there?' And I said, 'Let it go. Let it go.' It was a very risky deal but I just felt it had to be. I just held my ground. Anna Tamura was very supportive of the Wing Luke Museum contract. It worked out, luckily.

T: *Where was this in the process? Was this in the preliminary rounds of public hearings?*

K: Oh no, this is before we heard from them for the first time. I knew that they had to have this conversation amongst themselves. We

were getting ready to ask the public: 'What do you want?' I knew that if they didn't have this conversation with themselves, how could they possibly know what they wanted?

T: *Were people who were interned in Minidoka resistant to telling the story? I'm thinking about some of the elders I've met — one in particular. He said, 'You know, why do you want to remember this?' It was a haunting memory for him, and he did not want to have it known.*

K: My experience has been both. People just did not want to talk about [Minidoka], and yet, after talking in general for a while and gaining a little bit of confidence, they would begin to talk about it. I'm going to tell you a couple of stories. That will maybe be the best way to illustrate it.

I was at a Park Service public meeting in Seattle. This was at the Nisei Veterans Hall. We did our typical meeting thing. We were sitting around. We did our presentation. Then we broke up into groups. There were three guys sitting around the table. They had grown up together. All three went to Minidoka. All three joined the Army. All three went to Italy. They fought together. They came home. Every Saturday they went fishing — for years. And that night around the table was the first night they had ever talked about Minidoka… They looked at each other and said, 'We've never talked about this.'

They started talking about their experiences. It was just so profound to me that they had spent all of this time together and they had never, ever, ever talked about it.

And then the other story. Well, I'll tell you two more stories.

I was at a public meeting in Portland at the Oregon Nikkei [Legacy] Center. What I would usually do in those meetings is kind of bounce around from group to group and make sure that everything was going OK. I had told all of the people who were working, facilitating, to make sure that they tried to get everyone to say something.

I was in uniform. I noticed this elderly gentleman that had come in and hadn't said anything. The meeting was winding down, so I signaled to the facilitator to try to get him to say something. She started coaxing him, and he started talking. He was speaking in very broken English. He said, 'I was an officer for the enemy. I lead the infantry in Japan and I fought you.'

He was an officer in the Imperial Japanese Army. After the war, he became a merchant marine pilot, so he was taking ships from Japan to Alaska. He was mainly cargoing timber from Alaska to Japan. He ended up marrying an Eskimo woman and became an American citizen. This is the part that I remember so vividly. He stood up and said in very broken English, 'Not very many countries will tell the story, but this country tells the story.' He pointed to me and said, 'He is here today to tell the story.' It was just so profound. 'He's here to tell the story.'

He led the Japanese Army in the Philippines. And then he said — and this is important — he said, 'I am an American citizen.' He was very proud, very frail.

And then the final story. I get a little emotional about this. I had three different individuals tell me that their father told them: 'You are an American citizen. You go and fight for your country, and if you have to die, then you die.' I just remember my dad when I went to Vietnam in 1965. My dad said, 'You come home, no matter what.' And so, whatever that means. Three different men told me that, and [each story] came up very privately. None of them told me that story publicly. I always said [publicly], 'I'm a veteran.' But they all came up to me separately. That was very, very powerful.

T: *Did you go up to Alaska?*

K: I went up to Alaska. I was invited to a woman's house. Her name was Virginia Hirabayashi. I knocked on her door. I told her who I was. And she said, 'I knew you were coming. I knew you were coming.' This was in Anchorage. She said, 'I've saved all of these things.'

She had saved all of her memories of Minidoka. She came to one of the pilgrimages a couple of years ago and brought out all of this stuff. She said, 'I knew you would come. I knew you would come someday.' She understood the historical significance.

A person that needs to be recognized in all of this is Tom Ikeda. His contribution is so significant. I spent thirty-five years trying to protect our national heritage. And Minidoka — its heritage is the stories. I mean at Craters of the Moon and Mesa Verde, those are places but — at Minidoka — it's the stories. The work of Tom Ikeda is unique. He has found a way to preserve those stories. What he's doing is preserving [Minidoka] forever. It's very significant. His family was in Minidoka.

[Tom Ikeda is the founding executive director of DENSHO <http://www.densho.org>, a nonprofit organization founded in 1996. *Densho* is Japanese, meaning "to pass on to the next generation." The initial goal of DENSHO to "document oral histories from

273

Japanese Americans who were incarcerated during World War II" has evolved into a mission to educate, preserve, collaborate and inspire action for equality.]

T: *You've been instrumental in establishing and advancing the general management plan for Minidoka to this point. Whatever follows, you had the foresight to help shape the plan.*

K: Well, it's certainly been defining to me. My career has been important, but certainly Minidoka has been significant — not only the people I've met but how within this county, people say, 'Well, we shouldn't.' It's very controversial.

T: *Because people didn't want to see a historic site built?*

K: Yes. It's interesting. Now that a little time has passed, people are saying, 'Minidoka [as an NPS site] should happen.'

T: *What do you think caused their change of heart?*

K: I just think understanding the importance of history — that it happened.

T: *I have to ask this question. Bob Sims brought it up. He noted that the group of people who attend the Minidoka pilgrimage changes every year. The year before last, there was one* Issei *that still attended. Last year, there were no* Issei *but more descendants and people who weren't of an age to be interned or incarcerated. Bob talked about having a vision to educate future generations of people who might visit the Minidoka site. What would be the draw for someone to say, 'Oh, let's turn off and check out this historic site'? What might be there to help people understand?*

K: The connection. I don't know how else to put it. It's their family. I mean it's *Invictus* [the Clint Eastwood film, which had just been released at the time of the interview.] It's the story of Nelson Mandela: 'I am the master of my fate; I am the captain of my soul.'

It's who they are. They are fortunate in that they can go to a place that has such deep meaning. It may be dark and dreary, but it goes to the depths of what our country is. Like the gentleman said in Portland, 'It's their roots.' Those times defined several generations. They became something greater than they might been have otherwise.

Here's another story that an individual told me. His family was very poor, just workers on the dock. They went to 'camp.' The Amish sponsored the man to go to school back East. He became a chemical engineer. He would not have had that opportunity otherwise. They would have just continued to be, not that that's a bad thing. I think it's their roots. It's who they are.

T: *I'm moved by stories like this where people reached out and were so helpful. No one knows who they are, these individuals that helped get interned students into universities or who sponsored interned families. It was vital to getting them re-established in other places.*

K: The Quakers and the Amish did a lot of that. In the midwest, Chicago, there's a huge community of Japanese.

T: *Did you go there as part of the NPS project?*

K: No, not for this, but I learned of it. I went to the JACL convention — it was probably in 2000 or 2001 — in Las Vegas. There's a huge Japanese American community in Austin, Texas, and a large community in Chicago. In [both cities], there's a community of Japanese Americans who were sponsored out of the camps. One of the strongest JACL chapters is in Austin. They're very active.

T: *You said that working on Minidoka was a defining time for you. Do you think your life took a different turn? I'm thinking of the young man who became a chemical engineer because of his incarceration experience.*

K: I think it just had a lot of meaning for me because I could see the power of family and the conviction of *gaman* [Japanese for "perseverance," "patience" and "tolerance"]. I named my boat '*Gaman*.'

T: *This is your retirement boat?*

K: Yes. I bought a 16-foot jet boat in 2001. I take it on the Salmon River.

T: *Do people often ask you, 'What does* gaman *mean?'*

K: Oh yes, all the time. That's part of it. I get to tell them what it means. '*Gaman*' is painted on the back end of my boat. People say, 'Well, what the hell's that?' And I go, 'Well, *gaman*, that's a Japanese word. It derives from an experience that I went through. So I go through the story and tell them about Minidoka and how gaman means perseverance, and how important that is.

T: *I'd like to hear a version of what you say because it seems hard to distill Minidoka. I mean, it's possible, but how? What do you choose to tell?*

K: Oh, it depends. I'll picture a person that I told this story to: he's 6-foot-6, rides a Harley Davidson motorcycle, and comes from Pocatello, Idaho. I've known him for probably fifteen years fishing on the river, but I only see him once a year. Well, twice a year — spring and fall. He pulls in, and he's got a boat bigger than my living room, and mine's little.

> *'What's that word on the back of your boat there, Neil?'*
> *'Well, that says* gaman.'
> *'So, yeah, well, so what does that mean?'*
> *'It's a Japanese word. It reminds me of people I've met and of what they went through out at Minidoka.'*
> *'So, Minidoka. That's . . . isn't that down there by Power County?'*
> *'Well, that's a county, but this isn't what I'm talking about. In 1942, the federal government locked up about 120,000 Japanese Americans . . .'*

You go on from there. You just tell him the whole story of what happened. It's an opportunity I take advantage of because they don't know. Then, pretty quick, they're saying, 'Well, they bombed us.' I say, 'Well, actually, no. They didn't.' So you know, you go through the whole thing.

Very few individuals can't relate to the human part of it. A few times, they can't get past the bombing, but for the most part, when you get down to the personal story, they understand. That's the part I try and get to. The whole thing is just so rich.

HISTORIC SITE

IN AUGUST 2002 the National Park Service sent a team to what is now the Minidoka National Historic Site to conduct an archaeological excavation. Priority areas included buildings that appeared on original blueprints, an ornamental garden and the guard tower foundation at the entrance to the camp. The dig helped the NPS develop its general management plan for the site.

A year earlier, archaeologists Jeffery Burton and Mary Farrell conducted a survey of the Minidoka site. Their findings are summarized in *This is Minidoka, An Archeological Survey of Minidoka Internment National Monument, Idaho,* excerpted here:

"In all, the Minidoka facility encompassed some 33,000 acres and over 600 buildings. Five miles of barbed-wire fencing and eight guard towers surrounded the administrative and residential portions of the relocation center, which was located on 950 acres in the west-central portion of the reserve." (p. 10)

The following series of photographs documents the work completed in 2002.

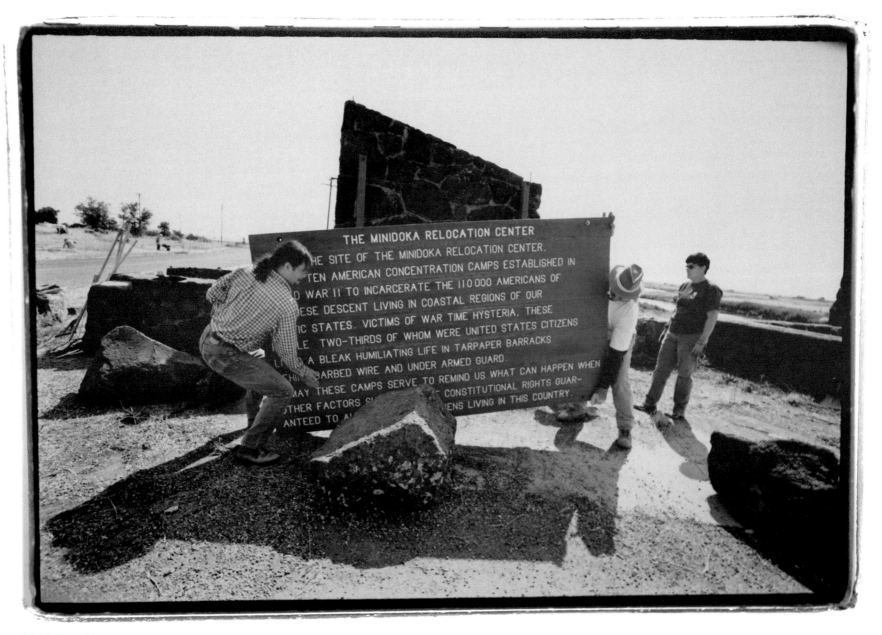

THE MINIDOKA RELOCATION CENTER
HE SITE OF THE MINIDOKA RELOCATION CENTER.
TEN AMERICAN CONCENTRATION CAMPS ESTABLISHED IN
D WAR II TO INCARCERATE THE 110.000 AMERICANS OF
ESE DESCENT LIVING IN COASTAL REGIONS OF OUR
IC STATES. VICTIMS OF WAR TIME HYSTERIA. THESE
LE TWO-THIRDS OF WHOM WERE UNITED STATES CITIZENS
A BLEAK HUMILIATING LIFE IN TARPAPER BARRACKS
BARBED WIRE AND UNDER ARMED GUARD.
MAY THESE CAMPS SERVE TO REMIND US WHAT CAN HAPPEN WHEN
THER FACTORS S CONSTITUTIONAL RIGHTS GUAR-
ANTEED TO A ENS LIVING IN THIS COUNTRY.

2002 (Aug. 2)
Jerome, Idaho
35mm B&W Tech film

JAN HARPER (far right) stands by as Phil Gensler (left) and Jim Burton remove a sign from the Gate House structure at the entrance to what is now known as the Minidoka National Historic Site. The sign was not an original feature.

2002 (Aug. 2)
Jerome, Idaho
35mm B&W Tri-X film

NPS ARCHEOLOGIST Jeffery Burton led the Minidoka excavation. Here he removes vegetation to prepare an excavation area next to the Gate House. By 2013, Burton had made seven trips to the Minidoka site.

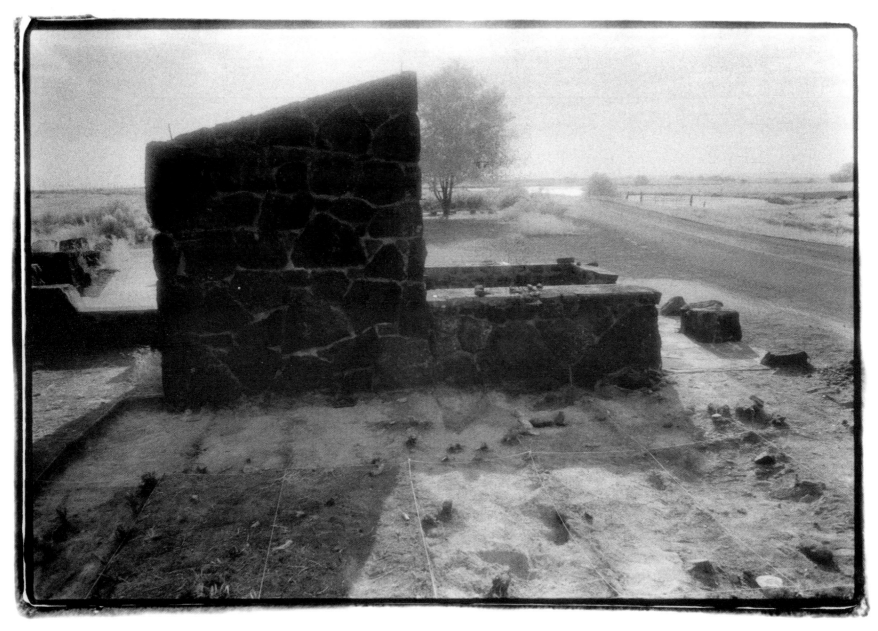

2002 (Aug. 5)
Jerome, Idaho
35mm B&W infrared film

CLEARED OF VEGETATION, the excavation area is sectioned off with string in a 1-by-2 meter grid to provide reference points.

2002 (Aug. 5)
Jerome, Idaho
35mm B&W infrared film

LAURA SUZANNE BERGSTRESSER, an archaeologist with the Western Archeological and Conservation Center, uses a ¼ inch mesh screen to sift for artifacts near the entrance to the Minidoka site. NPS landscape architect Anna Tamura works in the background.

2002 (Aug. 5)
Jerome, Idaho
35mm B&W infrared film

THE EXCAVATION uncovered basalt-lined pathways surrounding the ornamental garden at the entrance to the concentration camp. Pictured (left to right): NPS archaeologist Jim Burton, NPS volunteer Richard Lord, Jeffery Burton and Anna Tamura.

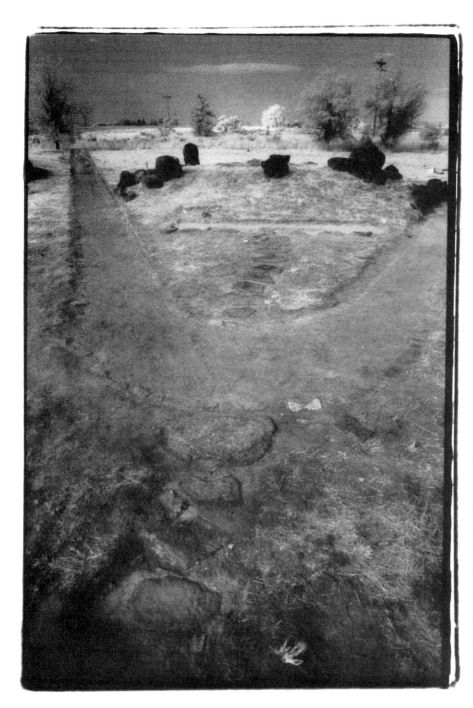

2002 (Aug. 5)
Jerome, Idaho
35mm B&W infrared film

"THE PATHWAYS running through the garden were fully uncovered and mapped, revealing two pathways forming a "V" and stepping stones leading up to the honor roll forming a "T." No indications of constructed water features in the garden were found. While no historic photographs or plans of the entrance garden have been located to date, the archaeological evidence illustrates a designed landscape mixing elements of patriotism with Japanese styling."— *Minidoka Internment National Monument General Management Plan* (2006), pp. 146-147

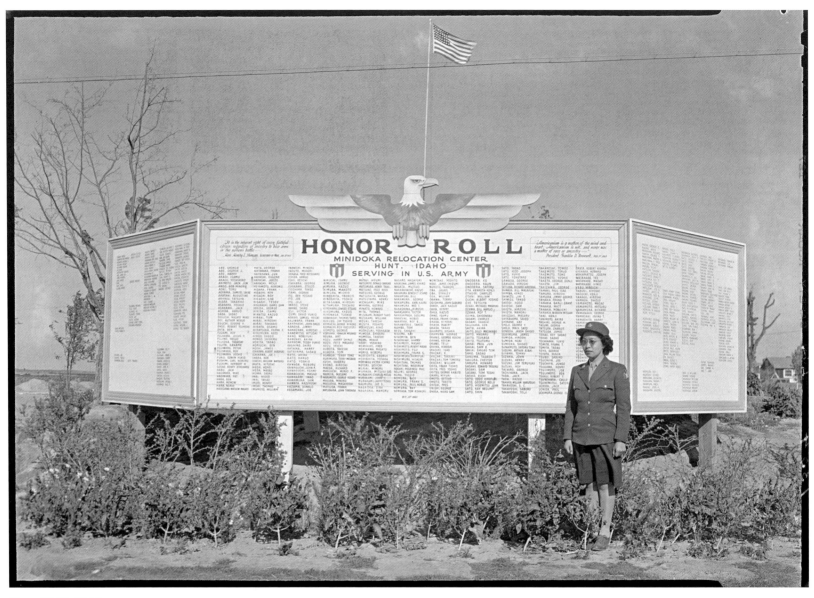

Circa 1943-1945
Hunt, Idaho
Electronic duplicate of 5x7 negative
National Archives Photo No. 210-CMB-i2-1354

THE ORIGINAL HONOR ROLL sign at Minidoka listed the names of internees who were serving in the Army at the time. The list included women who volunteered in the Women's Army Corps, the first unit to allow women other than nurses to serve. No caption information accompanies this archival photo; the woman in the picture remains unidentified.

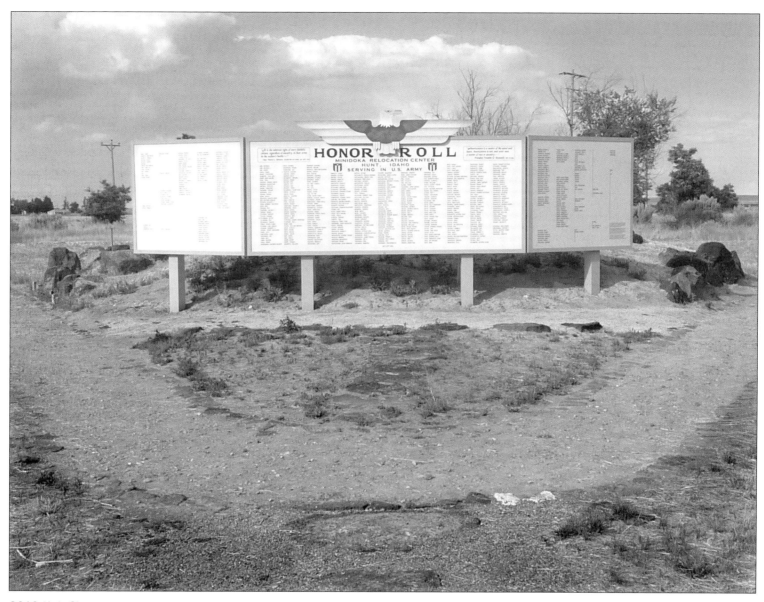

2012 (July 9)
Jerome, Idaho
35mm digital image converted to B&W

THE ORIGINAL HONOR ROLL sign was replicated from archival photographs. The Friends of Minidoka received a Japanese American Confinement Sites Grant of $17,295 to reconstruct and display the historic sign. A public dedication was held in July 2011.

MINIDOKA NATIONAL HISTORIC SITE

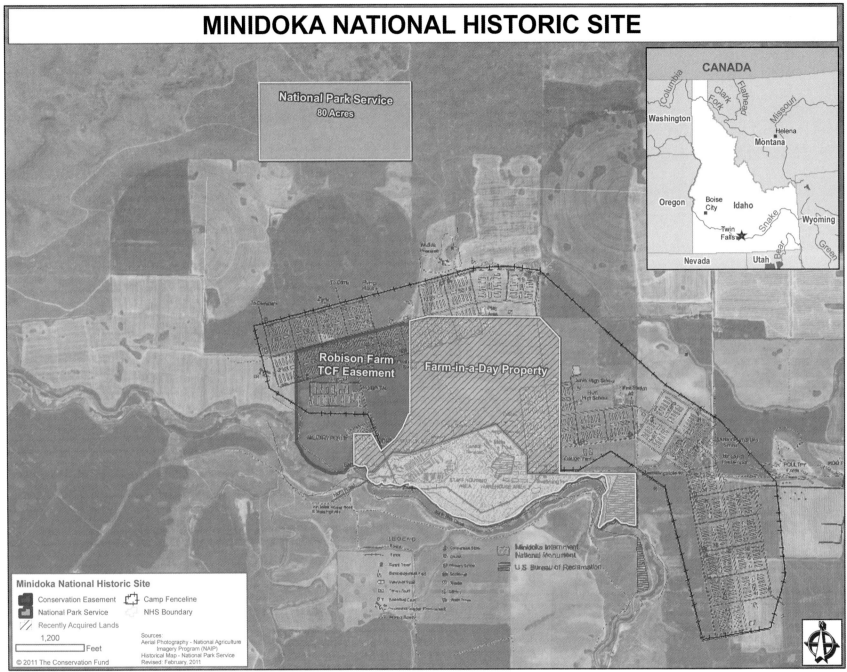

CANADA

Washington

Oregon

Boise
City

Idaho

Twin
Falls

Nevada

Utah

Wyoming

Montana

Helena

National Park Service
80 Acres

Robison Farm
TCF Easement

Farm-in-a-Day Property

Minidoka Internment
National Monument

U.S. Bureau of Reclamation

LEGEND

Minidoka National Historic Site

Conservation Easement

National Park Service

Recently Acquired Lands

Camp Fenceline

NHS Boundary

1,200

Feet

© 2011 The Conservation Fund

Sources:
Aerial Photography - National Agriculture
Imagery Program (NAIP)
Historical Map - National Park Service
Revised: February, 2011

EPILOGUE

The number of Japanese Americans and Japanese who were incarcerated in the Minidoka War Relocation Center and are still living continues to dwindle. More than twenty of the people photographed for this book have since died. Most Minidoka survivors were babies at the time of the mass incarceration with few, if any, memories of life behind barbed wire.

The Minidoka National Historic Site represents a major expansion from the original 72.75 acres of the internment camp. The site now comprises 300 acres.[1] The Conservation Fund acquired the neighboring Aberle and Herrmann properties with support from the Friends of Minidoka. The Consolidated Natural Resources Act of 2008 (S. 2739), signed by President George W. Bush, changed Minidoka's status from a national monument to a national historic site and expanded its boundary. A "minor" boundary adjustment was completed by the NPS in 2010.[2]

The Honor Roll sign, a list of Minidoka internees who also served in the Army (many as volunteers), was replicated and reconstructed at the entrance to the site. Educational signage and benches were installed along a 1.6-mile interpretive walking trail for visitors. A section of barbed-wire fencing was erected along a portion of the original boundary. Fire Station No. 1 is being restored; the original root cellar will soon be stabilized. Grant money awarded to the Friends of Minidoka by the federal Japanese American Confinement Sites program will be used to reconstruct a guard tower at the entrance to the historic site.[3]

Similar work is being carried out at the Historical Museum at Fort Missoula in Missoula, Montana, the largest intact World War II internment site. The museum received a $50,000 JACS grant in 2009 that funded the restoration of a courtroom in the Alien Detention Center, where "enemy alien" hearings took place during World War II.[4] A public dedication was held in September 2011. The courtroom is open to visitors by request.[5]

On July 8, 2012, this story appeared in the *Idaho Statesman*: "Idaho Supreme Court backs Jerome County's approval of factory farm near historic Minidoka site."[6] The ruling was made after years of court battles over a decision by Jerome County commissioners to approve a plan by Big Sky Dairy to build an 8,000-animal feedlot operation on land 1 ½ miles away from the Minidoka site.

[1] Jeff Burton, email correspondence to author, Sept. 19, 2012.
[2] Ann Simonelli, email correspondence to author, Nov. 28, 2012.
[3] Anna Webb, "Idaho's Minidoka, 70 years later," *Idaho Statesman*, June 22, 2012,
 <http://www.idahostatesman.com/2012/06/22/2164477/minidoka-70-years-later.html>.
[4] "A Report on Fiscal Year 2009 Japanese American Confinement Sites Grant Program Awards, National Park Service, November 2009,
 <http://www.nps.gov/hps/hpg/JACS/downloads/2009_newsletter.pdf>, 6.
[5] Nicole Webb, telephone interview by author, Aug. 23, 2012.
[6] Anna Webb, "Idaho Supreme Court backs Jerome County's approval of factory farm near historic Minidoka site, July 8, 2012,
 <http://www.idahostatesman.com/2012/07/08/2182712/court-backs-jerome-countys-approval.html>.

In October 2007, the same commission denied the dairy's bid for a 13,000-animal feedlot. In 2007 Minidoka was included on the National Trust for Historic Preservation's Most Endangered Historic Places list. The trust noted threats of "development" and "poor public policy."

Wendy Janssen, Neil King's successor as superintendent of the Minidoka National Historic Site and Hagerman Fossil Beds National Monument, notes on the website of The Conservation Fund: "The story of Minidoka is an important chapter of our collective American history. It is a site that addresses the violation of civil and constitutional rights and the fragility of democracy in times of crisis."

Janssen transferred to the Appalachian Trail in February 2013. Christine M. Smith stepped in as interim superintendent from March through June 2013. On June 26, 2013, the NPS issued a news release to announce Judy Geniac will be the new superintendent of Minidoka National Historic Site and Hagerman Fossil Beds National Monument. "Minidoka had an immense impact on U.S. citizens of Japanese heritage, and the site will forever be a sobering lens on U.S. civil liberties," Geniac said. The projected date for a staffed visitor center on the site is 2015. In the meantime, visitors can learn about Minidoka at the NPS office in Hagerman, a 50-minute drive from the historic site.

Some people still hold the belief that the forced removal and imprisonment of 120,000 Japanese and Japanese Americans from the West Coast and Alaska was for the *Nikkei's* own safety.

2004 (June 25)
Jerome, Idaho
120 B&W T-Max 400 film

ONE OF THE STOVES used
to heat the buildings at
Minidoka. The stove was
installed in the Motor Repair
and Tire Shop of the camp.
After the war, the auto-repair
building was used by the
North Side Canal Company
in Jerome.

ABOUT THE PHOTOGRAPHS

A year after I began this project, I received a grant from the Idaho Commission on the Arts to print, mat and frame ten 11-by-14-inch silver gelatin fiber prints. In 2002, Les Bock, then executive director of the Idaho Human Rights Education Center in Boise, invited me to exhibit these first photos of Minidoka. The exhibition, "Remnants: The Minidoka Internment," traveled to several Idaho locations, including the Idaho Historical Museum in Boise, the Bannock County Historical Museum in Pocatello and the Jerome Public Library in Jerome. Two years later, the project had grown to 30 prints and was exhibited in two other Idaho locations, the Herrett Center for Arts and Sciences in Twin Falls and the Mind's Eye Gallery on the campus of Idaho State University in Pocatello.

In 2009, the photos traveled out of state for the first time. The Missoula Art Museum in Montana paired my work, under the title "Made in Minidoka: The Incarceration of Japanese Americans in Idaho," with Roger Shimomura's series of paintings, "Minidoka on My Mind." Both exhibits were part of Missoula's annual "Fifth Grade Art Experience," a program that involved more than 1,000 young students in Missoula County. MAM docents took different approaches to the exhibits with the school groups. Some asked students to select a favorite picture before reading the corresponding caption information. Others had students analyze specific images. Still others invited students to come up with their own stories based on what they saw in the pictures.

I was curious to know how the students responded to the work, knowing that few, if any of them, were Japanese American or Japanese. I contacted several teachers who participated in the MAM program. Joan Kuchel, a fifth-grade teacher at Russell School in Missoula, was among those who replied. She said her students were very interested in the topic. She had introduced the Minidoka story to them by reading aloud *My America: The Journal of Ben Uchida*, a story about life in a concentration camp seen through the eyes of a 12-year-old boy. (Coincidentally, I had found a copy of the same book on my dad's bedroom dresser after he died in 2007. I read the book wondering what he had made of it.)

"I feel VERY strongly that kids should know that our country HAS made mistakes and is not all perfect," said Kuchel, a teacher for 41 years, in an e-mail to me. "They loved everything — mostly because they had a 'background' in it. I can't remember specific comments, but they made a lot of them, mostly trying to put themselves in that position. They really liked the photo of the families returning to the camp." Kuchel's students also visited Fort Missoula, the U.S. Department of Justice internment camp for Japanese nationals deemed "influential" and "potentially dangerous." Many of them came from Seattle.

Kuchel, born in Peoria, Illinois, in 1946, admitted that she wasn't aware of American concentration camps "until I was an adult!" She read about the Jewish death camps in Europe and the concentration camps for *Nikkei* in America. "Maybe one could say it was a 'lesson' to me that our great country hadn't been great all the time. I try to teach this to my fifth-graders also — that, as great a nation as we are today, it is not without any scars of injustice. So let us not forget, and do better."

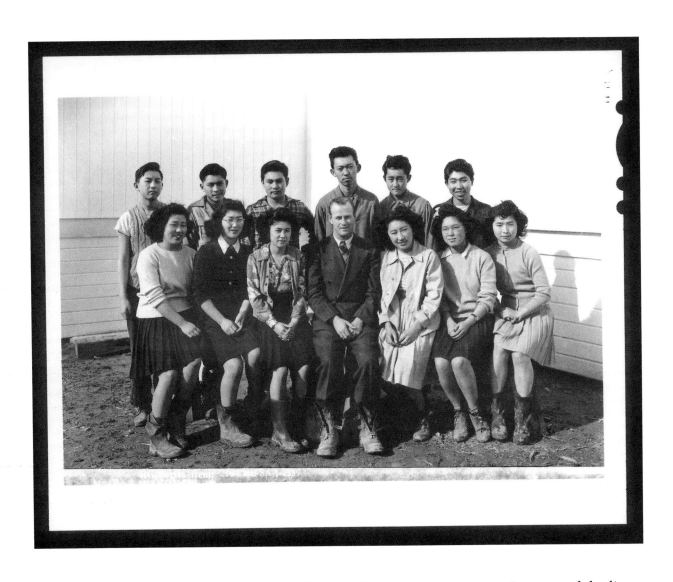

Circa 1942-1945
Minidoka War Relocation Center,
Hunt, Idaho
Duplicate 4x5 negative.
National Archives Photo
No. 210 CMB-SA-1-1589

I wanted to include archival photos in the Minidoka book to provide context and comparison to my own images. I converted duplicate 4x5 negatives into contact prints (identified by a series of notches along the upper right edge of the frame). Copy photos of actual prints include the original border and any handwritten notations. I cropped portions of black background to remove excess negative space but kept the copied image intact, full frame. I also cropped a few photos from the Hunt High School yearbook to save space. Lost from one picture were the galoshes needed to navigate the mud-heavy walkways of Minidoka.

When I began the Minidoka project, I experimented with different films — color-positive, color and black-and-white negative — to determine the medium most appropriate for the subject matter. The majority of the images in my book were captured on Kodak

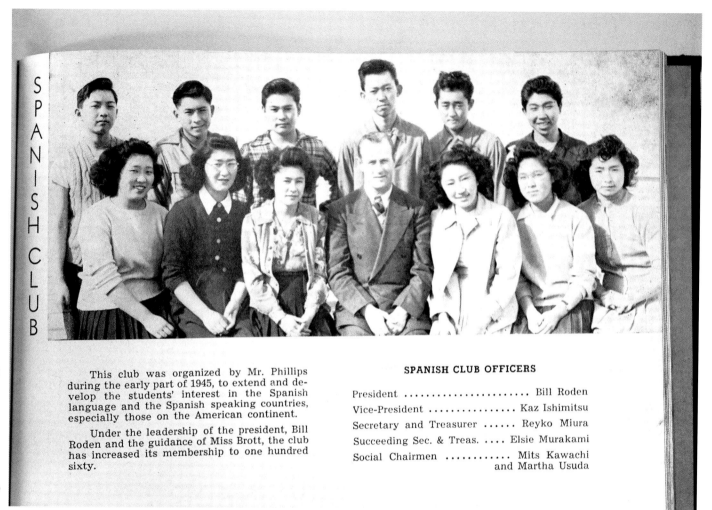

SPANISH CLUB

Circa 1944-1945
Minidoka War Relocation
Center, Hunt, Idaho
35mm digital copy photo
taken Oct. 10, 2009,
Seattle, Washington.
Courtesy Wing Luke
Asian Museum
Memoirs 1945, Hunt
High School yearbook, no
page number.

This club was organized by Mr. Phillips during the early part of 1945, to extend and develop the students' interest in the Spanish language and the Spanish speaking countries, especially those on the American continent.

Under the leadership of the president, Bill Roden and the guidance of Miss Brott, the club has increased its membership to one hundred sixty.

SPANISH CLUB OFFICERS

President Bill Roden
Vice-President Kaz Ishimitsu
Secretary and Treasurer Reyko Miura
Succeeding Sec. & Treas. Elsie Murakami
Social Chairmen Mits Kawachi
and Martha Usuda

black-and-white negative film: 120, or medium-format (square shape), mainly Tri-X or T-Max 400, for portraits; 35mm Tech Pan with its fine grain for interior shots; and infrared with its high contrast and timeless, surreal quality for outdoor locations. (Kodak discontinued Tech Pan in 2003 and infrared in 2007 due to steadily declining demand.) From the time I began to keep track — 2001 — I shot 221 rolls of black-and-white film in Alaska, California, Florida, Idaho, Illinois, Maryland, Missouri, Montana, Oregon, Utah and Washington. For economy of time, Panda Photographic Lab in Seattle, Washington, processed the majority of film and made contact sheets. I printed on 8-by-10-inch resin-coated paper, and scanned on a flatbed scanner or copied using a digital camera with a macro lens. The irregular black border around the images is produced by a filed-out negative carrier, which also serves to verify that the images are full frame. I used Photoshop CS3 software to balance contrast for reproduction.

The *Nikkei* who were forced to leave their homes, with no indication of where they were going or for how long, were allowed to take with them only what they could carry. I tried to do the same in my work. I traveled light and relied on available light. I pared equipment down to the basics. Long exposures required a tripod. A simple piece of black fabric often served as a backdrop when a setting was distracting.

All of the portraits in the book were made on location, not in a studio. When I asked people to think about Minidoka, their expressions often told much of the story and their experience of that story.

The Minidoka project was recently exhibited at the Japanese Cultural Community Center of Washington in Seattle (2010), Whitman College in Walla Walla, Washington (2011) and South Seattle Community College in Seattle (2012). After hearing so many stories about Minidoka and reading so much about the place and the chapter in American history that engulfed it, I decided that the title of these exhibitions should be the same as the title of my book: "Minidoka: An American Concentration Camp."

ACKNOWLEDGMENTS

This book could not have been made without the help and support of many people to whom I am grateful. First and foremost, I want to thank each person I was able to include in the book, all of whom allowed me to share their lives and memories. Your stories and photographs permitted the human experience — individual and collective — of Minidoka to be told. I was welcomed into homes and oftentimes treated like family. My gratitude also goes out to those who were photographed and interviewed but who do not appear in the book due to the limits of space. I am especially grateful to Gloria Shigeno in Seattle and Mark Hiratsuka in Anchorage, and to everyone who helped answer questions and identify and locate people in the archival photographs. I am indebted to Roger Shimomura, Bob Sims, Anna Tamura, and Neil King who helped me on this project from the start. Ron James and Maya Hatta Lemmon oriented me to the Twin Falls area with many helpful connections. Roger Daniels and Mako Nakagawa of Seattle, shared their knowledge, especially about the power of words. Thank you, all.

Mitsuye Yamada, whose poignant essay of courage and perseverance graces and informs this book, has shown me that hardships can foster creativity. She will remain an inspiration for the rest of my life. I'm also grateful for Lawrence Matsuda's honest, openhearted poem and the honor of showing the Minidoka photographs in conjunction with a dance project at Whitman College based on his writing.

While the Internet helped reduce the cost of research, travel was a requirement of this book. I would not have been able to reach half of the people in these pages without the financial and moral support of Connie and Richard Luebke. Thank you both for believing in my project and helping me see it through. My thanks to the University of Montana School of Journalism for funding research in Seattle and to the Idaho Commission on the Arts (ICA) for assistance with the first exhibition of my Minidoka photographs. Barbara Robinson, ICA Director of Artist Services, and Cort Conley, ICA Director of Literature and author of *Idaho Artists: A Contemporary Selection* (2011), brought additional attention to the project. A personal essay and photos of my project appeared in the *Seattle Times Pacific Northwest Magazine* in 2004; my thanks to Carol Nakagawa, art director of the magazine, for her part in its publication. Panda Photographic Lab in Seattle, Washington, owned by Dana Drake and Mary Fleenor, also provided invaluable service.

For the archival material from public collections that appears in the book, I wish to acknowledge and thank Holly Reed, archives specialist in still pictures at the National Archives in College Park, Maryland. Holly helped track down photos and identification numbers and promised not to retire for another ten to fifteen years. Many thanks as well to Janet Aviado, the librarian at Wing Luke Asian Museum in Seattle; Carolyn Marr, librarian at the Museum of History & Industry in Seattle, Washington; Todd Mayberry, director of collections and exhibits (and Nicole Nathan, former director) at the Oregon Nikkei Endowment in Portland, Oregon; Peg Roberson, curator for the Jerome County Historical Museum in Jerome, Idaho; and Susan Snyder, head of public services at the Bancroft Library, University of California at Berkeley.

Others whose knowledge and generosity made this book possible include Art Wright, my photography professor at Idaho State University, who taught me B&W photography and provided keen insight into the conception of the book as I wrestled with content. Lane Hirabayashi, a scholar and author, provided precise comments that guided me through the project. Keith Raether provided invaluable input and suggestions, and showed me through thought and action the meaning of partnership. Ginny Baxter helped me with the transcription of audio interviews. Homes away from home were provided by Doug Tamura (Boise and Ketchum, Idaho), Kenny and Joan Hamada (Seattle), Art and Janet Wright (Portland, Oregon) and Ame Kobayashi (Los Angeles). Takako Owada in Seattle assisted with translations. Marianne Uyeda, helped me "chunk it down" in Walla Walla, Washington.

I would also like to thank Barry Wong, former photo colleague at the *Seattle Times*, who has helped me at crucial stages; Sandy Banks, *Los Angeles Times* columnist who taught reporting to the 1989 METPRO group; Gayle Moore, my journalism teacher at Nampa High School; and Alli Kwesell and Mary Rizos, former University of Montana photojournalism students. Special thanks to Robert Morton for his generous support and feedback, book-publishing expertise and interest in seeing this project published.

A summer residency (2010) at the Helene Wurlitzer Foundation in Taos, New Mexico, gave me a community of artists and time to work on the book. Director Michael Knight generated a creative atmosphere during my stay, and my colleagues provided useful feedback about my project. Special thanks to novelist Karleen Koen, who provided helpful suggestions about writing. Ten weeks (2005) as a *National Geographic* Faculty Fellow in Washington, D.C., provided much inspiration and afforded me close proximity to collections in the National Archives. Thanks to Susan Smith and Elizabeth Krist of NG for their counsel.

Numerous nonprofit organizations exist for the sole purpose of preserving and educating future generations about the *Nikkei* experience in America. A portion of the royalties from this book will be donated to three groups including the Friends of Minidoka (http://www.minidoka.org), established in 2003 and based in Twin Falls; Densho, the Japanese American Legacy Project (http://www.densho.org) founded in Seattle in 1996; and Go For Broke National Education Center (http://www.goforbroke.org), incorporated in 1989 and headquartered in Torrance, California.

Scott Gipson, publisher of Caxton Press, made this book a reality. Thank you, Scott. Thanks also goes to Jocelyn Robertson for her work to design, help edit and shape this book through all its various stages. I also appreciate the help from Dennis Pattee, pre-press manager at Caxton Printers, and the University of Nebraska Press whose distribution network provides a wider reach.

Finally, I want to thank my parents, both now deceased, who gave me my first 35mm camera for my sixteenth birthday.

bento — a lunch

butsudan — a household or family Buddhist altar

chonan — the eldest son

densho — "to pass on to the next generation"

deshabatte — literally, "thrust one's nose into"

furukaki — condiment, sprinkled on the top of rice, usually consisting of sesame seeds, nori (dried seaweed), salt and dried fish

gaman — patience; perseverance; endurance; forbearance

haiku — Japanese poem of seventeen syllables in three lines of five, seven and five syllables

hapa — Hawaiian term for people of mixed Asian racial heritage

hiragana — Japanese cursive characters of the phonetic alphabet

ikebana — the art of Japanese flower arrangement

Issei — first-generation Japanese in America

kasuga — lantern style named for the Kasuga Taisha (Kasuga Grand Shrine), a Shinto shrine in Nara, Japan. The *kasuga*-style of lantern typically features a cylindrical column with a lantern box in the shape of a hexagon.

Kibei — American citizen of Japanese ancestry sent to Japan for educational purposes

Nikkei — all persons of Japanese ancestry

Nisei — American-born, second-generation Japanese

Nihonmachi — area where people of Japanese ancestry lived, worked or shopped, literally, "Japantown"

Sansei — American-born, third-generation Japanese

sensei — teacher

senryu — Japanese form of poetry similar to *haiku* but without excessive symbolism and abstraction

shigin — Chinese song in Japanese

shiren — trial, test, challenge, hardship

suiseki — Japanese appreciation of stones as art

sumi — black ink used for calligraphy and painting

tanka — Japanese poem of 31 syllables in five lines, the first and third lines with five syllables, the others with seven

Tenchosetsu — Emperor of Japan's birthday

Yonsei — American-born, fourth-generation Japanese

waka — Japanese poem/song

Adams, Ansel. *Born Free and Equal: The Story of Loyal Japanese Americans, Manzanar Relocation Center, Inyo County, California.* Bishop: Spotted Dog Press, 2001.

Burton, Jeffery F., Mary M. Farrell, Florence B. Lord and Richard W. Lord. *Confinement and Ethnicity: An Overview of World War II Japanese American Relocation Sites.* Tucson: Western Archeological and Conservation Center, National Park Service and U.S. Department of the Interior, 1999.

Burton, Jeffery F., and Mary M. Farrell. *This is Minidoka: An Archeological Survey of Minidoka Internment National Monument, Idaho.* Tucson: Western Archeological and Conservation Center, National Park Service and U.S. Department of the Interior, 2001.

Conrat, Maisie & Richard. *Executive Order 9066: The Internment of 110,000 Japanese Americans.* Los Angeles: California Historical Society, 1972.

Daniels, Roger. *Asian America: Chinese and Japanese in the United States since 1850.* Seattle: University of Washington Press, 1988.

Daniels, Roger. *Prisoners Without Trial.* New York: Hill and Wang, 1993.

Dubrow, Gail with Donna Graves. *Sento at Sixth and Main: Preserving Landmarks of Japanese American Heritage.* Seattle: Seattle Arts Commission, 2002.

Eaton, Allen H. *Beauty Behind Barbed Wire: the Arts of the Japanese in Our War Relocation Camps,* New York: Harper & Brothers Publishers, 1952.

Fiset, Louis. *Imprisoned Apart: The World War II Correspondence of an Issei Couple.* Seattle: University of Washington Press, 1997.

Fiset, Louis and Gail M. Nomura, ed. *Nikkei in the Pacific Northwest.* Seattle: University of Washington Press, 2005.

Gordon, Linda, and Gary Y. Okihiro. *Impounded: Dorothea Lange and the Censored Images of Japanese American Internment.* New York: W.W. Norton & Company, 2006.

Hausler, Donald E. "History of the Japanese-American Relocation Center at Hunt, Minidoka County [sic], Idaho." MS thesis, Utah State University, 1964.

Hayashi, Robert T. *Haunted by Waters*. Iowa City: University of Iowa Press, 2007.

Hirabayashi, Lane Ryo with Kenichiro Shimada. *Japanese American Resettlement through the Lens, Hikaru Iwasaki and the WRA's Photographic Section, 1943-1945*. Boulder: University Press of Colorado, 2009.

Hirasuna, Delphine. *The Art of Gaman: Arts and Crafts from the Japanese American Internment Camps 1942-1946*. Berkeley: Ten Speed Press, 2005.

Hosokawa, Bill. *Nisei: The Quiet American*. Boulder: University Press of Colorado, 2002.

Ichioka, Yuji. *The Issei: The World of the First Generation Japanese Immigrants 1885-1924*. New York: The Free Press, 1988.

Ichioka, Yuji, ed. *Views From Within: The Japanese American Evacuation and Resettlement Study*. Los Angeles: University of California Asian American Studies Center, 1989.

Inouye, Mamoru. *The Heart Mountain Story: Photographs by Hansel Mieth and Otto Hagel of the World War II Internment of Japanese Americans*. Los Gatos: Mamoru Inouye, 1997.

Ishizuka, Karen. *Lost & Found: Reclaiming the Japanese American Incarceration*. Urbana and Chicago: University of Illinois Press, 2006.

Ito, Toshiko Shoji. *Endure: A Novel*. Torrance: Bear River Press, 2005.

Kashima, Tetsuden. *Judgment without Trial: Japanese American Imprisonment during World War II*. Seattle: University of Washington Press, 2003.

Kessler, Lauren. *Stubborn Twig: Three Generations of a Japanese American Family*. Corvallis: Oregon State University Press, 2005.

Kleinkopf, Arthur. *Relocation Center Diary: 1942-1946*. Idaho and Pacific Northwest History Collection. Twin Falls Public Library.

Lew, William W. *Minidoka Revisited: The Paintings of Roger Shimomura*. Clemson: Lee Gallery, Clemson University, 2005.

Matsuda, Lawrence. *A Cold Wind From Idaho*. New York: Black Lawrence Press, 2010.

McWilliams, Carey. *Prejudice: Japanese-Americans, Symbol of Racial Intolerance*. Boston: Little, Brown and Company, 1945.

Muller, Eric L., ed. with photographs by Bill Manbo. *Colors of Confinement: Rare Kodachrome Photographs of Japanese American Incarceration in World War II*. Chapel Hill: University of North Carolina Press, 2012.

Muller, Eric L. *Free to Die for Their Country*. Chicago: The University of Chicago Press, 2001.

Myers, Joan and Gary Y. Okihiro. *Whispered Silences: Japanese Americans and World War II*. Seattle: University of Washington Press, 1996.

Niiya, Brian, ed. *Encyclopedia of Japanese American History: An A-to-Z Reference from 1868 to the Present,* updated edition. New York: Facts of File, 2001.

Okubo, Miné. *Citizen 13660*. Seattle: University of Washington Press, 1983.

Robinson, Gerald H. *Elusive Truth: Four Photographs at Manzanar*. Nevada City: Carl Mautz Publishing, 2002.

Sakota, James M. "The 'Reside': The Unresettled Minidokans, 1943-1945." In Views From Within, edited by Yuji Ichioka, 247-284. Los Angeles: University of California, 1989.

Sherman, Mark and George Hatagiri, ed. *Touching the Stones: Tracing One Hundred Years of Japanese American History*. Portland: An Oregon Nikkei Endowment Book, 1994.

Sims, Robert C. "The 'Free Zone' Nikkei." In *Nikkei in the Pacific Northwest*, edited by Louis Fiset and Gail M. Nomura, 236-53. Seattle: University of Washington Press, 2005.

Smith, Richard W. *Shoulder Sleeve Insignia of the U.S. Armed Forces 1941-1945.* Third edition. Erin: R.W. Smith, 1981.

Sone, Monica. *Nisei Daughter.* Seattle: University of Washington Press, 1991.

Sumner, Dawn. "Born Free and Equal: The Story of Loyal Japanese Americans by Ansel Adams." *Photo Life.* January 2003, 64-66.

Takami, David A. *Divided Destiny: A History of Japanese Americans in Seattle.* Seattle: Wing Luke Asian Museum, 1998.

U.S. Department of the Interior. *Minidoka Internment National Monument: General Management Plan.* Seattle: National Park Service, 2006.

U.S. Department of the Interior. War Relocation Authority. *The Evacuated People: A Quantitative Description.* Washington, D.C., 1946.

U.S. War Department. *Final Report: Japanese Evacuation from the West Coast, 1942.* Washington, D.C., 1943.

Van Valkenburg, Carol. *An Alien Place: The Fort Missoula, Montana, Detention Camp 1941-1944.* Missoula: Pictorial Histories Publishing, 1995.

Weglyn, Michi. *Years of Infamy: The Untold Story of America's Concentration Camps.* New York: William Morrow and Company, Inc., 1976.

Woodward, Mary. *In Defense of Our Neighbors: The Walt and Milly Woodward Story.* Bainbridge Island: Fenwick Publishing Group, Inc., 2008.

Yamada, Mitsuye. *Camp Notes and Other Writings.* New Brunswick: Rutgers University Press, 1992.

Yamaguchi, Jack Masajiro. *This Was Minidoka.* Nagaoka, Japan: Nagai Printing, 1989.

ADDITIONAL REFERENCE

Adams, Robert. *Why People Photograph*. New York, Aperture, 1994.

Dyer, Geoff. *The Ongoing Moment*. New York: Pantheon Books, 2005.

Huxley, Aldous. *The Art of Seeing*. New York: Harper and Brothers Publishers, 1942.

Newhall, Beaumont. *The History of Photography*. Fourth edition. New York: The Museum of Modern Art, 1964.

VIDEOS

After Silence: Civil Rights and the Japanese American Internment during World War II. VHS. Directed by Lois Shelton with Susan Buster Thomas. 2002; Bainbridge Island, WA: Bainbridge Island Historical Society, 2003.

Children of the Camps. DVD. Directed by Stephen Holsapple. 1999; Sacramento, CA: Hesono O Productions, 1999.

In Time of War: Stories of the Japanese American Experience in World War II. VHS. Directed by Andrea Palpant. 2004; Spokane, WA: North by Northwest Productions, 2004.

Toyo's Camera: Japanese American History during World War II. DVD. Directed by Junichi Suzuki. 2008; Hollywood, CA: United Television Broadcasting System, Inc. 2009.

Toyo Miyatake: Infinite Shades of Gray. VHS. Directed by Robert A. Nakamura. 2001; Los Angeles, CA: Japanese American National Museum, 2001.

TERESA TAMURA is a *Sansei* born and raised in Idaho. She received a bachelor's degree in journalism with an emphasis in photography from Idaho State University and an MFA in photography from the University of Washington. Her photographs have appeared in newspapers, magazines, books and on websites, and in solo and group exhibition in galleries and museums. She works in both film-based and digital photography and still makes silver gelatin prints in a darkroom.

MITSUYE YAMADA'S writings focus on her Japanese American heritage as well as women's and human rights issues. Her first book of poems, *Camp Notes and Other Poems*, was published by Shameless Hussy Press in 1976. Her second book, *Desert Run: Poems and Stories*, was published by Kitchen Table: Women of Color Press in 1988. Both collections were reprinted under one title by Rutgers University Press in 1998. Yamada taught at Cypress College, the University of California at Irvine and other universities in California. Now retired from teaching, she continues to write and publish poems and short prose.